U0063178

amm×sw–40

TIME WILL TELL

anothermountainman × stanley wong　40 years of work

時間的見證

又一山人 × 黃炳培　四十年習作

contents 目次

在臉書和微信，互聯網的世界裡，把全地球村人都拉在一起，捆綁在當下一刻（當然這跟佛的哲學「活在當下」是兩碼子的分別）。

　　這個即時，即刻的方便和享受，也帶來社會生活的偏航：因快，忘了慢，慣了快不能慢。沉醉「我與世界同步在這一秒」的意識，潛意識就跟過去切割得瀟灑俐落。「兩天太忙沒看 ig 或臉書⋯too bad，過去了，like 也太遲吧⋯」連兩天的都變成歷史往事，我們又怎樣看待時間脈絡在線性前進上面的關係和因果？

　　傳承概念，對於新世代人的理解又是如何⋯

　　看了賈樟柯之《山河故人》，散場時腦裡跳出來一句：「山河在，故人不在」又或「故人還在，山河不再」。時間不跟我們的主觀願望加快減慢，停步，轉後；它一直（也預告在先）立地恆速前進，不逆轉，不退後。

　　落差的只怕是人們對過去的思念或悔恨，和對未來的不安和恐懼，以至幻想。

　　是時候了，漫漫長路上，我們來想一想，時間和我們生存、生活、生命之間，真正的連繫是甚麼。

↓

In the world of facebook, WeChat and the internet, global citizens are inextricably bound together at every moment. (Of course, this is not to be confused with the buddhist philosophy of "living in the moment").

However the instant, immediate convenience and gratification can steer the society's life and living away from its normal course – forgetting to slow down because it is going too fast; not being able to slow down because too used to being fast.

Immersed in the idea of "keeping up with the world at every second", everyone unknowingly follows, indulging in the things of the moment, giving a clean-cut to the ties with the time past. "Was too busy and missed two days of Instagram and facebook... Too bad, the moment has passed... Too late to give a 'like'". When even events that happened two days ago have become a blurry thing of the past, how should we view the role that time plays in the course of events – the cause and effect of things?

How do young people see the concept of "passing down" from one generation to the next?

As I was exiting the cinema after Jia Zhangke's *Mountains May Depart*, the line, "the mountains still stand, but the people no longer live" or "people live, but the mountains are not the same anymore", popped up in my mind. Time does not stop, fast forward or slow down as we wish. It just steadily and steadfastly moves right along, no turning back, no backing out.

Perhaps, the instability and unsteadfastness is in the people's memories and regrets of things past, and the uneasiness and fear (or imagination) of the future.

It's about time. On the long journey, let's reflect on what the relationship between time and our existence, lives and living really is.

「這是一個關於過程、積累和沉澱的呈現，不是表述結果的一個展覽。」

由個人展轉化成雙人展，「時間的見證」帶你遊走視覺創作人黃炳培（又一山人）在商業設計、藝術創作，以至推廣生活及社會價值的轉化路途，發掘他倆截然不同的面貌：黃炳培和又一山人。

是次展覽又一山人 × 黃炳培展出涵蓋多方面的創作內容：

平面設計、廣告創作及製作、空間、服裝，以至攝影、藝術創作及創意策展。

展覽策劃主要分為黑、白、灰三個部分，分別展示又一山人的個人創作，包括其跨越近二十年的「正面香港」《紅白藍》系列；黃炳培的商業及文化設計，及廣告創作如成名作 90 年代初的地下鐵路廣告系列；以至又一山人×黃炳培從社會價值作為品牌及企業推廣出發項目。多組大型攝影作品及最新的攝影日記《80／20·明心見性·四十年》，亦會首次展現於觀眾面前。

展覽以新作《塵歸塵／302 日》開始，以藝術裝置作品《無常》作結，邀請觀眾靜心地回顧又一山人×黃炳培四十年的工作與習作，體驗人生的當下與無常。

回到過去。回到未來。

回到光速極速。回到基本還原。

向前走，是快，是探索。

往後看，是慢，是靈感所在。

漫漫長路上，大家來想一想。

又一山人×黃炳培 合十

TIME WILL TELL
anothermountainman × Stanley Wong
40 years of work
Hong Kong Heritage Museum
2019/11/10 > 2020/03/09
—
時間的見證
又一山人×黃炳培
四十年創意展
香港文化博物館
二〇一九年十一月十日至
二〇二〇年三月九日

"This is a presentation on process, building and preserving, and precipitating. It is not an exhibition to display accomplishments."

From a solo exhibition to a collaboration, "TIME WILL TELL" takes you on a journey on the evolution of visual artist, Stanley Wong (anothermountainman). From his commercial graphic designs, artistic creations, to the promotion of the meaning and values of life and the society, you can see him in his completely different roles, as Stanley Wong and as anothermountainman.

In this exhibition, anothermountainman × Stanley Wong showcase creations that covers different areas:

Graphic design, advertisement creation and production, interior, costumes and photographic and artistic creation as well as creative curation.

The exhibition is presented in 3 sections – black, white, grey. The three sections cover anothermountainman's personal works, including the Positive Hong Kong "redwhiteblue" series which spans two decades; Stanley Wong's graphic designs and advertising creatives such as the MTR advertisements in the early 90's, which propelled him to fame; and the brand building and promotion campaigns by anothermountainman × Stanley Wong which focus on the values of society. Various large-scale photography works are on show as well as the debut of his latest photography essay/diary "80/20 · Enlightenment · 40 years".

The exhibition begins with "from dust to dust / 302 days" and ends with "impermanence". We cordially invite everyone to peacefully walk back with anothermountainman × Stanley Wong on his 40-year path of work and its projects, while experiencing the impermanence of life.

Back to the past. Back to the future.

Back to the ultimate speed of light. Back to the basic.

Running forward, is fast, is exploration.

Looking backward, is slow, is inspirations.

On the long road, take some time to think.

anothermountainman × Stanley Wong palms together

born in hong kong.

香港出生。

1960'

rather frail, had to see doctor very often. suffered from motion sickness.

自小體弱多病。暈車浪，暈船浪。

1964' [4]

inspired by kan tai-keung's stamp design for the year of the rat, realized the possi- bilities of design.

被靳埭強的鼠年郵票設計引發思考， 設計的可能性。

1972' [12]

unable to memorize formulas and failed chem-
istry, no way to get into university in hong kong.

as a tailor, father did not allow me to apply
fashion courses in hong kong polytechnic,
and made it clear that the family could not
afford sending me to study in france.

after a year of evening design course, the
tutor discovered that i was not a full-time
designer joining evening courses (applica-
tion requirement at that time) and termi-
nated my remaining 3-year course.

got first pay check of $1500 and bought
the first camera (canon f1), never stop tak-
ing photos since then.

became a vegetarian to abstain from taking life.

adopted the pseudonym "anothermoun-
tainman" with respect to bada shanren
(mountain man of the eight greats), to
create another identity away from stanley.

1975' [15] got my first photography prize (2nd run-
ner-up) in a school competition.

1977' [17]

1980' [19] graduated from hong kong technical
teachers' college (design and technology).

starting working in a 3-person design firm
as graphic designer.

1985' [25] joined advertising firm to learn sound &
visual production skills of tv commercials, from
art director to creative director, from modern
advertising, grey(hk), to j. walter thompson (hk).

1990' [30] embraced success in advertising scene
with the mtr tv commercial series (red
light), a starting point of over 600 awards,
not until i worked for 10 years did i receive
my first award, not having so much luck.

1993' [33] held the first solo photography exhibition
named "1 ordinary man, 10 years, 100,000
kilometres on the road."

記不了公式，化學科不合格，
已注定不能考進香港大學學府。

任職裁縫的父親不贊成我報讀理工時裝科目，
也表明沒經濟能力送我到法國留學。

上了一年理工（晚間）設計課後，給老師知道
我並非日間在職設計師在晚間進修（當時入學
要求資格），停止了我繼續另外三年課程。

用第一份收到的薪金一千五百元買了人生第一
部相機（canon f1），往後就一直機不離身，
在路上拍照。

為不想殺生，開始茹素。

敬重八大山人，給自己別名又一山人，以另外
身份識別從事商業創作的黃炳培，為將來個人
創作準備。

在學校比賽，
第一次拿到攝影獎項（季軍）。

畢業於香港工商師範學院。

開始在一間連兩老闆的三人設計公司
當平面設計師。

為學習廣告片的聲／畫製作技能，開始進入廣
告公司；由美術指導，一直升至創作總監。由
現代廣告到精英廣告到智威湯遜廣告。

憑地下鐵路（紅綠燈篇）電視廣告系列在圈內
建立名聲，是六百多個獎項的起點。工作十年
才得到第一個獎，也不算順利或有運氣。

舉辦人生首場攝影個展「一個人。十年。十萬
公里路。」。

who is related to commercial world, getting prepared for future personal creative works.

set goals to voice for people's harmony and values of peace through communica-tion creation skills.

決定下目標，以溝通創作能力，為人之和諧，和平價值發聲。

1994' [34]

to try new tasks and challenges, quitted the job as creative director of the mtr account after four and a half years of part-nership, a position where i could give full play to creativity, receive awards every year, and with 100% trust from clients, industry insiders were pretty shocked indeed.

為要自己接受不同嘗試和挑戰，毅然辭任合作了四年半的地下鐵路廣告創作總監；一個能無限發揮，極得客戶信任，每年拿獎的工作。行內譁然了一陣子。

1996' [36]

without any prior planning, joined bartle bogle hegarty as regional creative director and moved to singapore, became the first chinese to undertake this position within the asian industry.

在沒有任何計劃下，答應擔任 bartle bogle hegarty 亞太區創作總監，遠赴新加坡開荒，為亞洲廣告圈中首位華人出任此職位。

1998' [38]

moved back to hong kong, since bbh had developed into a scale of 40 teammates, and everything was on track, and that regional (asian) advertising lacks colloquial language, which restricted creation.

became chief executive officer and execu-tive creative director of tbwa(hk),

至 bbh 發展到四十員工，一切上軌道之後，有感亞洲廣告欠缺地道語言，文字創作受制肘，斷然回歸香港從事有語文創作的廣告。

出任香港 tbwa 之行政總裁及行政創作總監。

realized on the day of my 40th birthday that the dream of becoming a film director was yet to explore, felt like everything has to start all over again.

四十歲生日當天，有感於導演夢還未打開。感覺一切由零開始。

2000' [40]

losing confidence in the professionalism and future of the entire advertising scene in hong kong, left the family of 4a advertising.

joined centro digital as chief creative officer,

對香港整個廣告業之專業和行業未來失去信心，終於離開 4A 廣告的大家庭。

出任先濤數碼創作總監。

been constantly invited by creative schools

相繼獲各大創意院校及創意業界單位邀請，

2001' [41]

invited by wang xu, designer from main-

獲國內設計師王序邀請負責服裝設計品牌「例

外」攝影工作，之後跟設計師馬可合作無間，從而開啟中國國內文化企業之市場推廣及創意之路。

land china, to take up photography work for clothing design brand exception de mixmind, working very close with clothing designer ma ke, then began working on marketing and creative work with cultural enterprises in the mainland since then.

開始二十年馬不停蹄的創意教育工作，視為社會責任。

and agencies in the creative industry to share experience, embarked on 20 years of creative education work, treating it as social responsibility.

2002'[42]

"redwhiteblue" poster made debut in hong kong heritage museum and enjoyed great popularity as being down-to-earth, with "redwhiteblue \ build hong kong" as a beginning, the series kept developing and continued to promote positive social values, was therefore named "mr. redwhiteblue".

「紅白藍」海報首次展出於香港文化博物館，地道親民的反應感受熱烈。往後從「紅白藍／香港建築」出發持續發展，推動正面積極的社會價值，後被冠名「紅白藍先生」。

invited by sabrina fung to join "art window" project and started personal creative works ever since, has been active in both local and overseas art scene, participated in more than 150 shows.

獲馮美榮邀請參與「藝術窗」項目開始，正式開展個人創作，活躍於香港及國際藝壇，參與超過一百五十場大小展覽。

2003'[43]

left centro digital and set up threetwoone film production limited with partner, has produced more than 200 tv commercials, mv and short clips, with own scripts and screenplays from advertising agencies.

離開先濤，與合夥人創立三二一聲畫製作有限公司。至今，拍了約二百個人家、自己的劇本，涵蓋電視廣告、MV和短片。

series of "redwhiteblue" poster was awarded the d&ad yellow pencil.

「紅白藍」海報系列獲倫敦 d&ad 黃鉛筆大獎。

went dharma drum mountain in taiwan to join the first meditation retreat, and made the commitment to take refuge, given the name "changchi".

赴台灣法鼓山參加人生第一次禪修營，皈依聖嚴法師，法名「常持」。

2004'[44]

inducted into alliance graphique international (agi) as a member, also served in agi international executive committee (iec) for 4 years.

獲邀加入國際平面設計聯盟 agi 成為會員，為大會擔任四年幹事工作。

2005' [45]

"redwhiteblue" poster series was acquired by victoria & albert museum in london as permanent collection.

invited by hong kong heritage museum to curate "building hong kong - redwhiteblue" exhibition as guest curator, more than a hundred artists, designers and students joined the project to express values and perspectives of hong kong spirit using the material. after that, has curated various design, photography and art events in hong kong and mainland china.

「紅白藍」海報系列被倫敦 victoria & albert museum 永久收藏。

受香港文化博物館邀請，客席策展「建：香港精神紅白藍」展覽，廣邀過百位藝術家、設計師和學生，以紅白藍創作提出香港精神價值觀點。及後也不斷在香港及中國內地策展設計、攝影和藝術活動。

2006' [46]

as one of two invited artists, presented in the 51st venice biennale representing hong kong, and showcased "redwhiteblue / tea and chat", which promotes face to face communication.

invited to participate in exhibitons around the world, including zkm in germany, groninger museum in the netherlands, contemporary art museum kumamoto in japan, total museum of contemporary art in south korea, chinese arts centre in manchester, uk, and lianzhou foto etc.

為兩名獲邀藝術家之一，代表香港參與威尼斯藝術雙年展，展出「紅白藍西遊記：飲杯茶．傾過飽」，提倡面對面溝通。

之後十多年獲邀前往多國展出作品，包括德國 zkm、荷蘭 groninger museum、日本熊本市現代美術館、南韓 total museum of contemporary art、英國曼徹斯特 chinese arts centre、連州國際攝影年展等。

2007' [47]

set up 84000 communications limited, continued to contribute in brand building, design and promotion for commercial and cultural projects.

成立八萬四千溝通事務所，繼續致力商業及文化項目之設計、推廣及品牌顧問工作。

since showing the "half \ half" installation in central prison (now tai kwun), and after focusing on social issues, began to incorporate studies of buddhism into art works, such as "impermanence", "to begin with, there's no matter", "heaven on earth" etc.

從「一半 \ 一半」裝置展於舊中區監獄（現大館）起。「無常」、「本來無一事」、「凡非凡」等，繼社會議題後，以佛學／哲學觀念為創作方向。

exhibited large-scale redwhiteblue installation for the 1st hong kong international art fair, and continued voicing for "positive hong kong".

在首屆香港國際藝術展中，展出大型紅白藍裝置，繼續為「正面香港」發聲。

2008' [48]

received the outstanding achievements award from graphic arts association of hong kong.

獲香港印藝學會頒發「傑出成就大獎」。

to summarize 30 years of work, curated "what's next 30x30 creative exhibition", and invited 30 units with the same vision to have dialogue and co-create, explore "what is creativity and why we create".

為總結三十年工作，策展「what's next 三十乘三十創意展」，邀請三十位志向相同的人，對話及共創，探討「何謂創作，為何創作」。

2011' [50]

awarded artist of the year (visual arts) from hong kong arts development awards, in my award acceptance speech, i said, "i am not an artist, and i dare not compare myself with one. i simply wish to voice for society and dreams through creative works."

獲香港藝術發展獎頒發「年度最佳藝術家獎（視覺藝術）」。獲獎在台上發言：「我不是或不敢高攀藝術家，只是藉個人創作為社會和理想發聲。」

2011' [51]

joined a theravada novitiate program in hong kong, to experience the wisdom of understanding and implementing the idea of "letting go".

在香港參加南傳短期出家，深入體驗「放下」的理解和執行奧妙。

worked with mao jihong and liao meili in planning and design, set up the first fangsuo in guangzhou in 2011. it became a new direction for cultural brands in mainland china, also a platform to interact with new generations in china, and explore spiritual and inner values together.

與毛繼鴻、廖美立共同策劃並設計方所書店，首間於二〇一一年在廣州誕生。成為今天中國國內一重要文化品牌標竿，一個跟中國新一代互動，在精神及生活價值共修之平台。

supported by exception de mixmind, created the first men's series "time will tell: exception × wang wen-hsing × anothermountainman", where the dream of clothing design finally came true. unfortunately, father passed away before the series launched, unable to witness how his son realized his long-time dream.

在例外服裝支持下，創作首個男裝系列「時間的見證 例外 × 王文興 × 又一山人」，終於一圓做衣服的志願。可惜父親黃祥（黃楚相）於系列發表前過世，未能見證兒子一直追求的夢想實現。

2012' [52]

13-minute short film *jing yat*, which was a personal work sponsored by commercial brand, received gold prize in direction in 4a awards. my first award since becoming a director.

商業品牌支持的個人十三分鐘短片「正」，獲得 4A 創意比賽之導演金獎。執導以來另一次零的突破。

named as "designer of the year" by city magazine.

獲《號外》雜誌封為「年度最佳設計師」。

in volume 2301 of *ming pao weekly*, introduced the creative work of "final exercise", previewing the very last piece of work in life.

在《明報周刊》第 2301 期，公開發表「最後習作」的創作項目。在雜誌上預展了人生最後一個發表的創意習作。

installation of "impermanence" was given the hong kong contemporary art award.

「無常」裝置獲香港當代藝術獎。

2013" [53]

received tdc award at the tokyo type direc-
tors club annual awards,

獲東京字體指導俱樂部比賽 tdc 大獎。

"lanwei" photography series, a total of 46 large
photographs, was acquired by m+ in hong kong
as collection.

「爛尾」攝影系列共四十六張大幅照片被香港
m+ 收藏。

2014' [54]

invited by hong kong heritage museum to
hold a solo exhibition, agreeing to make
time and process as the theme, and em-
barked a journey lasting 5.5 years, then
have a dialogue with the public.

獲香港文化博物館邀請舉辦設計師個展,並答
應以時間過程為題目,展開持續五年半的過
程,然後跟大眾對話。

2015' [55]

invited by ggg in japan to hold solo cre-
ative exhibition (2 men show: stanley wong
x anothermountainman), and was the 2nd
hong kong designer to be invited by this
world-class design gallery in the past 30
years, it was such an honour.

獲日本 ggg 邀請舉辦個人創意展(又一山人
× 黃炳培雙人展),是這世界級設計畫廊三十
年來邀請的第二位香港設計師,實屬榮幸。

2017' [57]

a total of 40 items of design and advertis-
ing creative works were acquired by m+ in
hong kong as collection.

香港 m+ 收藏設計/廣告創作共四十項。

2018' [58]

made my first documentary movie dance
goes on, expressing views on art, life and
things about hong kong through three
dancers, and send a message to hong
kong: life goes on.

首齣紀錄長片「冇照跳」面世,透過三位舞者
好友,道出藝術、人生、香港我城種種,並寄
語香港 life goes on。

established being hong kong with lung
king-cheong and jessica wong, with the
positioning of hong kong value, through
texts and papers, interacts with readers
by bringing out issues relating to life and
living.

與龍景昌、三三及團隊創辦《就係香港》季
刊。以香港價值定位,人本文本和紙本為本,
對生存、生活和生命帶出議題,跟讀者互動。

luoluo suosuo: what has been thought of, written, heard of and said in 60 years was published by joint publishing hk, co-written almost 100,000 words, hoping to shed light on values of being a person, and working in the creative industry and to explore the relationship and meaning between time and the ideas of life and living.

solo exhibition of "anothermountainman × stanley wong / 40 years of work" is launched in hong kong heritage museum.

summarizing 40 years of work and reaching 60th birthday, i wish to hit the road and start again.

2019 [59]

由三聯書店出版《囉囉唆唆——六十年 想過 寫過 聽過 說過的》，聯合編寫近十萬字，希望能帶給新一代人一點做人做創意的價值觀。希望跟大眾探討時間與生存、生活和生命之間的關係和意義。

個展「時間的見證 又一山人 × 黃炳培四十年創意展」於香港文化博物館展出。

總結歸納四十年工作後，踏入六十歲，希望重生再上路。

dance goes on was nominated in the chinese documentary section of the hong kong international documentary festival, and received bronze award. it is an enormous encouragement to someone first made a documentary film at the age of 57.

「拚照跳」入圍香港國際紀錄片節華語紀錄片競賽部分，並獲銅獎，對一個五十七歲高齡首作的電影人，是一個莫大的鼓勵。

Apart from loving design and creation, Stanley also thought about life a lot. Starting with vegetarianism, he pursued the Buddhist theory of harmony for all. In 1993, he used the name "anothermountainman" and deliberately delineated his identity with Stanley Wong, a well-known figure in the advertising industry. Meanwhile, he also changed from serving commercial customers to seeking his own creations. He was determined to do things that were worthy to himself and more meaningful to society.

He took up the new role as a TV commercial film director and transformed himself from a creative person in advertising to advertising film director, through which he could re-hone his skills in sound and visual. Meanwhile, he strived for room for independent art creation. This was his unexpected new starting point, which embarked him on the path of contemporary art practice.

Stepping into the 21st century, the artistic creation of anothermountainman continued to be rich and diverse. His concepts and the materials he used were fascinating. From the most basic attitude towards life to the simplest authentic materials, anything in the hands of anothermountainman could become extraordinary works that transmitting positive energy, truth, goodness and beauty. Works like "Building Hong Kong", "Investigation of a Journey to the West by Micro + Polo", and "You Should Love!", all demonstrated the spirit of "Positive Hong Kong", were selected to represent Hong Kong in The Venice Biennale. To recognize his fabulous achievement, Stanley was even honoured with the title of "Mr. Red White and Blue".

The name of anothermountainman signified art creation in spiritual practice. It enquires into the suffering and happiness, giving and receiving, form and emptiness, presence, and death of life. The traditional philosophical spirit, realized in contemporaneous breaths, exudes contemporary aesthetics and touches the heart of all beings. Knowing the common sense of impermanence, we should learn to be loved and spread the love.

Having developed his hobby in photography since his secondary school years, anothermountainman bought his first camera with his very first salary. In 2000, he was given the classic 8x10 large negative camera from the family of Lee Ka-sing, a photo-based artist. Since then, he became a "Sadhu" who found joy in sufferings through photographing moments that reflected different thoughts and ideologies. From what to shoot to what he could see from the images, he used his heart to capture every precious moment. Among all, "Lanwei", "Speechless", "To begin with, there's no matter" were all thought-provoking masterpieces that fascinated many people.

In the field of contemporary art, he climbed mountains after

Mountain After Mountain Brings Experience of Three Lives –

Spiritual Practice of Stanley Wong | 山 | 山山生　黃炳培的修行

● Kan Tai-keung | 靳埭強

As a world-renowned designer and artist, Dr. Kan has earned numerous awards and actively involved in educating and promoting art and design profession. He is now the Honorary Dean of the Cheung Kong School of Art and Design, Shantou University, the member of Chinese Committee of the Alliance Graphique Internationale and board member of the West Kowloon Cultural District Authority.

國際著名設計師及藝術家，於一九六七年開始從事設計工作，曾獲無數殊榮，熱心藝術及設計推展的工作，現為汕頭大學長江藝術與設計學院榮譽院長、國際平面設計聯盟 AGI 會員及香港西九文化區管理局董事。

I was the teacher of many outstanding graphic designers in Hong Kong. Legendary as it seems, everything started with my designs works in the early days.

In 1972, I designed the first series of the Chinese zodiac stamps in Hong Kong for the Year of the Rat. The modern and avant-garde design was not quite accepted by the general public. Unexpectedly, the design was appreciated by Stanley Wong, who was a secondary school student. It was surprising to see how a small stamp design could inspire a young man and make him fall in love with design art. Stanley later enrolled in an evening diploma course offered by the Hong Kong Polytechnic and became my student. After studying the course for a year, he was forced to discontinue his studies. With a firm will, he entered the advertising design industry and opened up the first chapter of his successful design career.

Stanley's design profession started in the 1980s when graphic design and advertising in Hong Kong flourished. It was the time when the first generation of local designers had already gained some good overseas reputation and the foreign advertising companies were competing fiercely in our local market. Through the synergistic effects, there were lots of brilliant works that emerged. After being a graphic designer and art director in advertising for nearly a decade, Stanley was recruited by a well-known advertising company in 1989 and was designated to handle the creation of advertisements for the Hong Kong Mass Transit Railway (MTR) Corporation. Demonstrating exceptional talents, he received praises year after year. During that time, Stanley would look for inspiration in his daily life when creating the advertisements for the MTR. In order to build a good reputation for the MTR service, he focused on stories that could touch the hearts of the public. Having successfully strengthened the image for his customers and promoted their services, Stanley earned the trust of their customers and was valued by his company. It was indeed a golden era where he embraced success and glory.

As Stanley was not contented with his stable and excellent professional status, he made a big choice and was determined to withdraw from projects that he had long enjoyed success. He moved on to look for new challenges! With a constant driving force for pioneering, he became the pride of the industry and many members of the industry attempted to compete over him. After moving to Singapore and returning home, his immense creativity won him countless triumphs. As his advertising career has reached a peak, he had a high introspection, enlightenment, and finally retreated, not forgetting the original intention. In fact, he was determined to look for another turning point in life.

"Three Times As Rich As Others".

As an artist who has been designing, painting, and teaching for many years of my life (Stanley also engages in education and is a brilliant teacher), I am contented to have done the works that I would have needed three lives to complete. Hence, I once made the statement of "lucky to experience three lives". This phrase now seems to echo and be in line with anothermountainman's description of "Three Times As Rich As Others".

At the age of 60, Stanley, still full of energy and creativity, is undoubtedly an influential icon in the art and design industry. This year, he just published a semi-biographical memoir of "囉囉唆唆 (meaning "chattering and rattling")", summarizing the peaks in his career as he travelled through mountains and mountains. Having said that, there is still an infinite future ahead of him, for he still has a lot of new beginnings: he just directed the film "*Dance Goes On*" and realized his dream of becoming a film director. Last year, he joined his friends and set up "Being Media Limited" and published "Being Hong Kong" quarterly magazine. Such a new start has successfully made him a media person in the publishing industry.

No matter how many mountains are waiting in front of him, anothermountainman is happy to climb every one of them with all his will and energy. I can foresee that he will make even more achievements and will certainly be honoured for his past, present and future accomplishments! I also hope that the spiritual practice and wishes of anothermountainman will influence the public and provide guidance to the creative people of the younger generations.

我與多位傑出的香港平面設計師都結下師生的緣份，説來似是傳奇故事，都是由我早期的設計作品為起點。

1972 年，我設計的香港第一系列生肖鼠年郵票出版發行，風格現代前衛的設計不受當年普羅大眾郵迷的好評，卻獲一位中學生黃炳培的欣賞。想不到一枚方寸小小的郵票設計，誘發了一顆少年的心，愛上了設計藝術，考進香港理工學院夜間文憑課程，成為我的學生。他跟我學習一年就被迫離校，憑堅定的意志，進入廣告設計行業，開拓他設計事業成功的第一篇章。

黃炳培的設計事業起跑在香港平面設計與廣告發展蓬勃的 80 年代。第一代本土設計師已在海外享有聲望，外資廣告公司在港競爭熱烈，佳作湧現。任職平面設計師及廣告美術指導近十年後，於 1989 年，他受聘於知名廣告公司，有機會專責執行香港地下鐵路公司的廣告創作，連續數年好評不斷。這時期的地鐵廣告，他在日常生活中尋找靈感，能觸動市民大眾的共鳴，使地鐵服務建立良好的聲譽。他成功幫助客戶加強形象和推廣服務，又因而深得客戶信任；同時受公司重用，可謂名成利就。

mountains and made numerous remarkable achievements.

In 2007, Stanley founded his 84000 Communications Limited and devoted himself to the design, promotion and brand consulting work for commercial and cultural projects in Hong Kong and the Mainland.

In 1997, Hong Kong made a smooth transition and returned to the motherland. Stanley and other local designers built the golden age of the design industry before 1997 and also participated in the modernization of China's design industry after the launch of reform and opening-up. At the same time, he also encountered the Asian financial turmoil, the SARS epidemic, and impacts of the economic downturns such as the international financial crisis. With a strong will, he expanded the developing commercial design and cultural creative market in the Mainland. He consciously seeks new dimensions for the traditional culture, criticizes chasing the trend of European aesthetics as being Chinese, rejects expressions only on aesthetics, and realizes creations with spiritual and inner values.

For more than a decade, Stanley has created many commercial and cultural projects with a multi-media approach that reflected his spiritual values. For example, EXCEPTION de MIXMIND clothing, Fangsuo Book Store, rwb 330, etc. For brand image, advertising marketing, film and TV commercial production, space design, product design...... he also designed "Past/Future" and "anothermountainman×YNOT/T" with EXCEPTION de MIXMIND in the name of anothermountainman. Moreover, he collaborated with Mr. Wang Wen-hsing, a renowned Taiwanese writer, in designing the men's series of "Time Will Tell". Through integrating business and mind values into one, he insisted on seizing "every moment" and "doing things wholeheartedly". With such an indomitable will, he overcame challenges after challenges, in a triumphant way.

To celebrate his 30th Anniversary of joining the design industry, Stanley curated his "what's next 30×30" group exhibition. I was honoured to be one of the 30 exhibitors who he invited. Knowing the many common interests and ideas that I had with him, we later worked together and created a series of posters such as "Thirty Fruitful Years" and "Three Lives of Finding". As we both love collecting rulers, I let him choose the rulers that could best represent his three glorious decades and used an ink stroke to create the Chinese word of "Abundance (丰)", which symbolized the 30 years of abundant and prosperous career created by him. Meanwhile, as we both find joy in picking up and keeping objects, I used his leaves and my stones to construct the Chinese word of "30 (三拾), showing his wonderful life that is

一筆水墨線構成「丰」字，象徵他創造了豐盛的 30 年事業；我們都愛撿拾物件，就讓他的樹葉與我的石頭構成「三拾」，表現他活出「三生一世」的人生。

我長期做設計、畫畫、教學（黃炳培也做教育工作，而且是一位傑出的老師），自覺有幸活了三世人所做的事，因而曾說過「有幸三生」的話。這看來與又一山人的「三生一世」合意同心。

黃炳培年方六十，當下應屬盛年，當時得令！今年剛出版了《囉囉唆唆》半傳記式創意回憶錄，總結了他走過的一山又一山的事業高峯。然而，在他前面還有無可限量的未來。他還有不少新的開始：剛拍了電影《冇照跳》，實踐當大電影導演的心願；去年與友儕合創就係媒體有限公司，出版了《就係香港》季刊，成為出版界傳媒人⋯

無論又一山人前面有多少高山，以他的意志和能量，甚麼高山都樂於攀登。我可預見他再創更高的成就，也以他過去、當下、未來的建樹與有榮焉！更祈望山人的修行和理想，感染大眾，啟導青年一代的創意人。

黃炳培不滿足於安穩和優越的事業狀況，狠下決心退出長期勝任的項目，尋找新的挑戰！他有一股不斷拓荒的動力，也成為業界爭相禮聘的天之驕子。轉戰新加坡又回流香港，創造力無窮，佳績滿載。他的廣告事業已登上高峯，高處自省，頓悟而勇退，不忘初衷，找尋人生另一個轉折點。

黃炳培熱愛設計創作之餘，常思考人生，由茹素開始，追求眾生平等和諧的佛家理想。1993 年，他取號「又一山人」，刻意與譽滿廣告界的 Stanley Wong 劃清身份，由服務商業客戶轉而尋求自身創作，下決心多做對得起自己、對社會更加有意義的事。

他一方面轉職為電視廣告導演，由廣告創意人轉換角色為執導者，重新磨練影視技能；另一方面爭取自主藝術創作空間。這是他意想不到的新起點，踏上當代藝術修行之路。

踏入廿一世紀，又一山人的藝術創作是豐富多元的，概念上及素材上的出人意表，從最基本的生活態度到最樸實地道材料，在山人手中皆能化平凡為非凡，傳送正能量、真善美。《香港建築》、《紅白藍西遊記》、《你應愛》…盛載着「正面香港」精神的作品，獲選代表香港展於威尼斯雙年展，更贏得「紅白藍先生」之稱號。

又一山人寓藝術創作於修行，叩問人生的苦樂、施受、色空、有無、生死…傳統哲學精神，以當下的呼吸，吐納當代審美，感動眾生。知平常悟無常，理應愛傳大愛！

又一山人在中學時代開始攝影，第一份工資就購置了第一部相機。2000 年，他有緣得李家昇轉讓家傳的 8×10 大底片相機，就成為苦中作樂的觀念攝影苦行僧。他從去問拍甚麼，到懂得看甚麼，有心思，用心拍。《爛尾》、《無言》、《本來無一事》…都是令人用心欣賞，發人深省的代表作。

他在當代藝術的領域裡，又攀越了一山又一山，屢創高峯。

2007 年，黃炳培創立了八萬四千溝通事務所，致力香港和國內的商業及文化項目的設計、推廣與品牌顧問工作，開展了又一個新階段。

1997 年，香港平穩過渡，回歸祖國，黃炳培與香港設計師一起建設了前九七設計的黃金時代，也參與了國內改革開放後中國設計現代化發展；同時又面對亞洲金融風暴、非典流感病疫、國際金融海嘯等經濟低潮的衝擊。他以堅定的意志，拓展國內發展中的商業設計與文化創意市場。他自覺尋求傳統文化新面貌，批判追逐歐式美學潮流，背棄形式表現，重現具精神價值內涵的創作。

十多年來，黃炳培跨界創作了不少體現其精神價值的商業與文化個案。例如：例外時裝、方所書店和紅白藍 330 等，從品牌形象、廣告行銷、影視製作、空間設計、產品設計…他還以又一山人之名與例外設計了《過去／未來》和《又一山人× YNOT/T》，又與台灣作家王文興合作《時間的見證》服裝系列。他已將商業與設計融合為一體，每一刻「當下」都「用心行事」，一山又一山地跨越。

黃炳培在從事設計三十年的時候，舉行《what's next 三十乘三十》大展，我是他邀請的 30 位參展的朋友之一。鑒於與他有很多共同志趣和觀念，與他互動創作了《三十丰年》和《三生拾得》等系列海報。我們都愛收藏尺，就讓他選出代表他三個年代的尺，與

tation of real life career built up Stanley Wong's hardcore resume in the professional field and testifies Da Vinci's 'Dimostrazione' meaning a commitment to exam knowledge through experience, persistence, and a willingness to learn from mistakes. From production, post production and transmission, modern visual communication demands an array of advanced technologies; as a gatekeeper between seller and buyer, designers are armed with updated marketing skills beyond sheer cosmetic services. Stanley Wong's whole brain mind in the commercial sector bridging visual ideas with modern technological and business knowhow is a reflection of Da Vinci's 'Arte/Scienza', which is the balance between science and art, logic and imagination.

Stanley Wong coined himself 'anothermountainman' as an alternate personality for his private works; he initiated the famous 'redwhiteblue' series (2001-present) which is a comprehensive cultural identity design research on Hong Kong's iconic visual phenomenon and discovered its embedded essence through successive artistic explorations throughout the years. His 'rubbish hunting / existence vs. respect' series (2006-2007) rekindles the second life of found objects by re-arranging them as meaningful pictorial collages or assemblages. All these creative trajectories are samples of Da Vinci's 'Curiosita' which drives anothermountainman's insatiable interest on Hong Kong's social environment and a relentless quest for understanding or reviving our traditional heritages. 'lanwei' series (2006-2012) is an ambitious photography project to date, anothermountainman explored Asian's aborted architecture projects resulted from economic failures caused by regional over development or global financial crisis; this lonely sentiment is also revealed in 'to begin with, there's no matter' (2007-2010) where empty notice boards are featured with precise details to explore traces of human presence. Powered with unique aesthetical sense and large format view camera, anothermountainman is able to capture delicate subtleties of artistic expression and re-represent the realities like windows of his soul; these images is a contemporary edition of Da Vinci's 'Sensazione', which is the persistent refinement of the senses, especially sight as the means to invigorate experience. The human form is a recurring subject in anothermountainman's portfolios, in 'people' (2000) we could see truncated male torso and his body parts pairing semantic resemblances with dissected Chinese typographic characters, searching meaningful relationships in this absurd world. His latest documentary dance film, 'Dance Goes On' (2017) invited three prominent dancers, Mui Cheuk-yin, Yuri Ng and Xing Liang to explore the body mobility relating to Hong Kong urban space, collaborative movements and personal experimen-

● Blues Wong — 黃啟裕

A photography critic and independent curator. His writing was selected for Daido Moriyama's Reflection and Refraction exhibition catalogue. He is a contributor for Hong Kong section of Martin Parr and WassinkLundgren's *The Chinese Photobook: From the 1900s to the Present* (Aperture, 2015). He is the museum expert advisor (Hong Kong photography) for the Leisure and Cultural Services Department.

從事攝影藝評及獨立策展工作，評論入選《反射與折射：森山大道寫真展》場刊，亦參與撰寫 Martin Parr 和 WassinkLundgren 編著的《中國攝影書集》（Aperture，二〇一五）中有關香港的部分。現任香港特別行政區康樂及文化事務署博物館專家顧問（香港攝影）。

又一萬象

anothermegapix

It was rumored early this year there will be more than ten thousand images in Hong Kong Heritage Museum's 'anothermountainman / Stanley Wong / 40 Years of Work' show. This colossal amount of mega pictures define Stanley Wong's different talents throughout past four decades; to him this retrospection is not a conclusive exhibition, but rather a departure point for the artist's upcoming creative turn. Divided under three presentation sections Black-White-Grey which is a humble echo with the flying colors in his early 'redwhiteblue' series, we could see an alignment of independent, commissioned and social thinking collaborative projects. As both professional visual communicator and fine artist, Stanley Wong does not satisfy with the dichotomy between commercial and personal identities, he is able in recent decade blending white with black and tailors a social forward 'grey hat'. Grey is not a totally neutral color, grey can be a combination of all analog colors and when teams up with black and white, it results a full range of hidden hue or tints instead.

In ancient Greek the theatrical related word 'persona' includes twenty-seven different performative characters, therefore one could understand Stanley Wong's colorful creative spectrum beyond three definite mono-tonal appearances. The Italian Renaissance supreme man Leonardo Da Vinci is a global archetype of human potential in multi-disciplined areas from science, architecture to visual arts. The contemporary creativity specialist, Michael J. Gelb stated in his best-selling book, *Think Like Da Vinci: 7 Easy Steps to Boosting Your Everyday Genius* (1998) seven different thinking principles of this genius: Curiosita (curiosity), Dimostrazione (demonstration), Sensazione (sensation), Sfumato (smoke), Arte/Scienza (art and science), Corporalita (the body) and Connessione (connection). Da Vinci's whole brain thinking tools provide additional insightful entry points to analyze creativity; the parallel vision of this multiple intelligence with both Stanley Wong + anothermountainman's varied innovative paths from commercial (white), personal (black) and social oriented (grey) in due course will be illuminating.

Stanley Wong earned his international fame as an award-winning commercial advertising creative, graphic communicator and movie director, the professional standard of these sectors trained his stringent working discipline and ethics; successful marketing campaigns like the Hong Kong Mass Transit Railway-series (1990-1995) opened up more career opportunities while monetary reward from commissioned projects in return fosters financial resource for personal works. Da Vinci once noted he is a 'discepolo della experienza' (disciple of experience) and treated it the major source of wisdom. The practical and monetary orien-

I was once taught by my university teacher thirty years ago: 'the utmost important thing in creativity is to know when to start and realize when to stop', this is also my final question to our visual architect after his intellectual rendezvous with the Renaissance mastermind. The following is an unabridged reply according to his three identities:

stanley wong: sure i know when to start. / the time i receive the brief. / when the message goes to market… / who is audience, what they believe, where they live, at the timing we proposing the message and communicate.

of course i know when is deadline for my involvement. within the time frame, as a professional, i work 120% hard, with sincere and passion, the deadline to go out into the market is when i stop.

anothermountainman: i should use these two line from my book to answer this question/ everything is cause and consequence, 因和果. nothing comes as very beginning. nothing need to be stop becomes 'ending'. life goes on… everything leads to another thing…

stanley wong + anothermountainman: i try to challenge and not given up, disregard a lot of rule of game, norm in markets, so called reality… i try extra efforts, find ways to map anothermountainman's believe, values (a better harmonic world) into the public and real world, even client's marketing voices…

never stop although there are limitation and hurdles. one time fail, there always will be another chance. life is a single journey, i won't allow myself or giving myself excuses, keep going, never stop. it is a life game.

途中執着，不為己執。

i insist doing this and without stopping myself, for the benefit of all, us, no me myself. that's i feel easy 自在。

今年年初，傳言於香港文化博物館舉辦的「又一山人×黃炳培／四十年創意展」中將展出超過一萬多幅照片。龐大的作品集中展現出黃炳培在過去 40 年中的多變創作意念。對他來說，這次展覽不是一場總結，反而是創作路向的一個轉折點。展覽分為黑、白、灰三個區間部分，與他早期精彩的「紅白藍」系列相呼應，呈現出一個獨立、受委託和反映社會思維集於一身的作品。作為專業視覺傳達者和藝術家，他認為商業與個人身份的二分法甚為不妥。近十年來，他把白色與黑色融合在一起，定制了一頂推動社會的「灰色帽子」。灰色不是完全中性的顏色，灰色可以由所有色彩混合而成；當與黑色和白色組合使用時，便產生各種各樣的色調。

在古希臘語中，與戲劇相關的一個單字「角色」（persona）就涵蓋二十七個不同的人物角色，與之比較，黃炳培豐富多彩的色譜，雖只僅僅源自三種單調色彩，但亦可以變為千變萬化的顏色。於文藝復興時期最享負盛名的藝術大師達文西，同樣充分發揮

tal interactions. From still photographic shots to moving images, anothermountainman mirrors Da Vinci's 'Corporalita' which cultivates the human torso with grace, balance, fitness and dignity. The beauty among these elegant kinetic gestures come to a standstill in front of the artist's inert lying posture in 'Impermanence' (2009), a duo function sofa bed + coffin co-build which preserves the user's body warmth from life till death; this rest note perhaps marks the finale of our mortal coil and commence the spiritual cycle all at once.

In a frenzied world with diminishing happiness, positive thinking is a source for social, emotion and cognitive resilience; contemporary artists of all sorts are practicing the act of life fulfillment, using their gifts and talents to influence others through self-discovery on behalf of pursuing a more gratified life. As a Buddhist follower with optimistic, slow living and peaceful life attitude for decades, Stanley Wong + anothermountainman promote creative opportunities to blend positive social values in professional branding projects. We could see from the slogan 'Life is Beautiful' and the contented portraitures in the IFC series (2016), he advocates forward thinking and harmonic family living instead of ceaseless obsession with consumerism; in a short film for *sun life financials: jing yat* (2012) the concord relationships between old and young generations is highly praised and imprinted through their artistic imagination. Da Vinci's 'Sfumato' connotes a willingness to embrace ambiguity, paradox and uncertainty, through these kind of chances, Stanley Wong + anothermountainman relief the tension of uncertainty and become a mindful 'Visual Architect' who builds not only a functional space but a value added habitual home for his target audiences in times of social commotion and political turmoil. He further provides meditative spaces and emotional vaccines in cross-disciplinary projects like 'exception' (since 2000) and 'painting by god' (2008-2017) + 'fujifilm' (2017) which connect Chinese literature with fashion design and nature's moving shades with photo cameras. The recent launched book-magazine publication, *Being HK* (since 2018) is possibly another anchorage of social value branding, bridging traditional printed matter with eloquent contents and stimulating people within the visual architect's RE-thinking tank. *Being HK* harbors both local cultural identity and historical renderings of this city, it is a key reference of appreciating the contemporary Hong Kong life. Da Vinci's 'Connessione' implies a recognition for the interconnectedness of all things and phenomena; Stanley Wong + anothermountainman succeeded to initiate inclusive professional projects and materialized the merits of cross disciplinary creative platforms.

在這個幸福感不斷下降的瘋狂世界中，積極正面思考唯有源於個人的社交、情感、認知能力。當代藝術家正從藝術中實踐生活，通過他們的天賦和才能，自我發現來影響他人，以追求更充實的生活。作為佛教徒，黃炳培＋又一山人數十年來一直保持樂觀心境，實踐慢活與和平的生活態度，在每次創作機會中，把積極的社會價值融入專業品牌推廣計劃中。從「生活就是美麗」的標語和IFC系列（2016）中滿足的肖像中就可看到，他提倡前瞻性思維和追求和諧的人倫生活，而不是沉迷於消費主義。在短片《香港永明金融：正一》（2012）中，其藝術想像力展示出老年人和年輕人兩代人之間的和諧關係，深受表揚和讚譽。達文西的「Sfumato」意指接受、擁抱模棱兩可、矛盾和不安，黃炳培＋又一山人紓緩不安定的壓力，作為用心的「視覺建築師」，他不僅構建實用性空間，還在社會動盪時代為觀眾創造一個有意義的家。在不少跨學科項目中，他亦提供冥想空間和「情感疫苗」，例如《例外》（自2000年起）、《神畫》（2008—2017）和《fujifilm》（2017年），這些項目利用相機聯繫起中國文學、服裝設計和大自然的顏色。最近發行的雜誌型書刊《Being HK》（自2018年起）或是社會價值品牌的又一支柱，傳統出版物加上內容，激發視覺設計師的重新思考。《Being HK》既涵蓋本地文化，亦回顧這座城市的歷史遺跡，是欣賞當代香港生活的重要參考。達文西的「Connessione」意味着對所有事物和現象之間相互聯繫的認知。黃炳培＋又一山人成功發起了這個廣泛的計劃，實現一個跨學科創意平台。

三十年前，我的大學老師曾對我說：「創意的要訣是，知道何時開始、何時停止。」在文藝復興大師與又一山人隔空會面後，我對視覺建築師發問最後一個問題，以下是他以三個身份所作的完整答覆：

黃炳培：當然，我知道甚麼時候開始。／當我收到客人要求的時候。／當信息發佈到市場上時。／當我們提議要表達的信息時，會先了解對象的觀眾群，他們的價值觀以至身處的地方城市。

我當然知道我的工作有截止時間。在時間許可的範圍內，作為一位稱職專業人士，我會付出120%的努力，真誠、熱情地工作，直至發佈到的截止日期，才停下。

又一山人：或者我可引用我書中兩句回答這個問題，所有事物都有因果關係。凡事沒有清楚的起點，也沒有一個絕對的終結。生活都會繼續下去⋯每件事情都是環環相扣⋯

黃炳培＋又一山人：我嘗試不同挑戰，不輕言放棄，途中縱然有很多遊戲規則、比如市場規範，也就是所謂的現實⋯但我會更努力地嘗試，在現實世界中尋找又一山人的信念（一個更美好更和諧的世界），傳遞給大眾和現實世界，甚至從客戶的市場策劃平台出發。

儘管有限制和障礙，但永不止步。一次失敗後，總會遇上另一次機會。生命是一趟單程之旅，我不會允許為自己尋找藉口，要繼續前進、永不歇息，這是一場生命競賽。

途中執着，不為己執。我堅持這樣做，都是為我們或是大眾的利益出發，而並不是「我」，因此感到自在。

人類廣泛潛能的表者者，其作品、貢獻橫跨科學、建築、視覺藝術等多學科領域。當代創意專家邁克爾·J·格爾布（Michael J. Gelb）在其暢銷作品《7 Brains——怎樣擁有達文西的七種天才》中列舉七項天才的思維原則：Curiosita（好奇）、Dimostrazione（實證）、Sensazione（感受）、Sfumato（包容）、Arte / Scienza（藝術與科學）、Corporalita（儀態）和 Connessione（關連）。達文西的思維模式為分析創造力提供許多有見地的切入點；這種多元智慧，對分析又一山人＋黃炳培的多樣創作路線（商業：白色，個人：黑色，以社會為本：灰色），極具啟發性。

黃炳培在廣告界屢獲殊榮，從事商業廣告、視覺傳播和電影三方面，在國際上享有盛譽，這三個領域的專業訓練培養了他嚴謹的工作紀律和職業道德。成功的市場推廣活動例如「香港地鐵」系列（1990—1995 年），為他提供更多工作機會，而受委託項目的金錢回報則為其個人作品奠下經濟基礎。達文西曾指出他是「經驗的信徒」，視其為智慧來源。黃炳培的職業生涯中，以實用和金錢考量為定位方向，打造一張輝煌履歷表，並印證達文西的實證思維「Dimostrazione」（透過經驗、毅力和從錯誤中學習的知識）。從生產、後期製作到傳播，現代視覺傳遞需要一系列先進技術幫助。設計師擔當着買賣雙方之間的把關工作與橋樑，不單在美術還是市場推廣上都必需具備專業知識。黃炳培的商業頭腦，將視覺創意與現代技術和商業知識相結合，反映了達文西的「Arte / Scienza」，即科學與藝術、邏輯與想像力之間的平衡。

黃炳培創造了「又一山人」，用之發表其私人作品。他創作著名的《紅白藍》系列（2001 年至今），該系列是對香港標誌性視覺現象文化的研究，並通過多年的藝術探討發現其內在本質。他的《拾吓拾吓／存在和尊重》系列（2006—2007）將各種拾獲物件重新佈置為有意義的圖形拼貼或組合，重燃了它們的第二次生命。這些創作都反映了達文西的「Curiosita」，激發着又一山人對香港社會環境的無止興趣，以及對理解、復興傳統的不懈追求。《爛尾》系列（2006—2012）是迄今為止最野心勃勃的攝影計劃，又一山人探討由於地區過度發展或全球金融危機而導致失敗、戛然停止的亞洲建築項目。相類的落寞情緒也展現於《本來無一事》（2007—2010）中，從空寂的告示板之中，探索人類存在痕跡和細節。憑藉獨特的審美觀和大畫幅相機，又一山人捕捉了藝術的微妙，敞開心靈之窗重塑現實，這些照片是達文西「Sensazione」的當代體現，對感官的不斷刺激，尤其是視覺，把體驗帶往另一層次。人體是又一山人作品集中反覆出現的主題，《人》（2000）將男女性的各個身體部位與漢字配對起來，在荒唐世界中尋找有意義的關係。在最近的紀錄舞蹈電影《冇照跳》（2017）中，他邀請了三位傑出舞蹈家伍宇烈、梅卓燕及邢亮，探討在香港城市空間下的身體活動性、協調性運動和個人實驗性互動。不管是靜態拍攝抑或動態影片，又一山人表達了達文西的「Corporalita」，意指以優雅、平衡、健康和有尊嚴的方式支撐起身體。這些優雅的動作在《無常》（2009）前停止，《無常》是一個雙功能沙發床＋棺材，用意在保留着使用者從生到死的身體溫度；這或許標記着肉體束縛的終結、精神層面的開始。

tainman. Either way, they make him look like a scholar or philosopher from a bygone age.

Two pair of black-framed eyeglasses of profound significance: perhaps one to distinguish between himself and others, and another to gaze at the chaos of East and West and Asia. In either case, they, to me, signify four different perspectives of Stanley Wong. Having become a member of AGI at a young age, Wong often interacts passionately with people from 50 countries at the AGI Congress held in a designated country every year, somewhere in the world.

Whenever I see his "anothermountainman" name, I am reminded of Bada Shanren (literally, "mountain man of the eight greats"), a Chinese artist from the 17th century. For Bada Shanren, calligraphy and painting shared the same roots. I have a framed painting of his that I look at every day. It depicts two haughty-looking quails facing each other with looks of hostility in their eyes. Are they about to fight? Or just intimidating each other?

anothermountainman is another man for whom calligraphy and painting share common roots. He is a brilliant image creator, producing numerous outsize photographs. Among his oeuvre, one particular video impresses me the most. It captures, from a bird's-eye view, a piece of calligraphy created by a calligrapher from Guangzhou with water on a concrete pavement. The written calligraphy consists of the character "空", meaning "emptiness" or "void". As it is written with water, the character evaporates and disappears completely after a while. Merely by watching this character fade into oblivion, the video gave me an understanding of its subject's source: the Buddhist scripture known in English as "The Heart Sutra". Stanley Wong is almost always accompanied by his beautiful wife, who looks even more beautiful since she began practicing calligraphy circa 10 years ago. When I was 19, I had a calligraphy teacher named Shunso Machi. She left me a piece of calligraphy that reads, "I lived. I wrote. I loved."

Several years ago a major exhibition titled "what's next 30x30", curated by anothermountainman, was organized at the OCT Art & Design Gallery. It took place in Shenzhen, just across the "border" with Hong Kong. Thirty years ago when I went to Shenzhen as a member of a group of artists who were fans of ping-pong, the city was a small port with a population of only 45,000. Today it's a megalopolis, already home to 20 million people. At the time when I was participating in "what's next 30×30", Stanley Wong gave me a long ping-pong table made as a gift. With his brilliant competence at observation and at delighting people, I think of him as a strange visitor from the future.

original: gggBooks 115 stanley wong x anothermountainman / 2015

普通の人は本名と呼び名があり、本名・黄炳培（ホワン・ビン・ベイ）は呼び名が stanley wong、そして彼のもうひとつの名は又一山人。三つも名前を持っているのはめずらしい。ぼくは普段はスタンリー・ウォンと呼んでいる。香港という東洋×西洋がフュージョン（溶解）した国からムクムクと湧き上る入道雲のように登場して来た怪しい人物だ。黒縁の丸いメガネを二つ持っていて、ひとつはスタンリー・ウォン用、もう一つは又一山人用だ。明治か大正時代の文豪か哲学者のような風貌だ。

自者と他者を見分ける視線なのか、東洋と西洋とアジアの混沌を見つめる奥深い二つの黒縁メガネ。それは四つの眼なのだと僕は思っている。若くして AGI の会員になり、毎年どこかの国で開かれる国際デザイン会議、例えばイスタンブールのボスボラス海峡を見ながら、50 の国から来た人に混じって我々と行動を共にするのだ。

ぼくは又一山人という名を見ると、明末清初の画家・八大山人のことを思い出す。八大山人は書画同根の人で、ぼくは彼の額装した画を 1 枚持っていて毎日見ている。それは怪しい鵄が二羽、いじわるそうな眼をして対峙している。戦いなのか、威嚇なのか。

又一山人も書画同根の人だ。画作りがうまい。大掛かりな撮影も沢山している。

一番驚いたのは広州の水書家が水でコンクリートの地面に書くその水書を、真俯瞰から撮影した動画だ。般若心経の「空」の字が水書だから乾燥して消えてゆく。この消え行く「空」の字を見るだけで、般若心経を理解させてくれた。いつも美しいご婦人と一緒の時が多い。夫人は 10 年前から書道を始めて、よけい美しく見える。ぼくの 19 歳の時の書の先生は町春草さんだ。「生きた。書いた。恋した。」の書を遺した。数年前に「what's next 30 × 30」という大きな展覧会が OCT 華・美術館からはじまった。香港の隣町深圳という、中国入国の入り口の町だ。

30 年前に日中友好卓球愛好芸術団で入国した時は 4 万 5 千人の港町だったが、現在は 2 千万人の大都会。この時スタンリー・ウォンさんは、ぼくのために長い長い卓球台を制作してくれた。観察眼のすばらしさ、人を喜ばすことの名人。彼をぼくは怪しい未来人だと思っている。

original: gggBooks 115 stanley wong x anothermountainman / 2015

The man I usually call Stanley Wong, like most of his compatriots in Hong Kong, has another, official Chinese name: in his case, Wong Ping-pui. But Stanley Wong is unusual for his possession of a third name: anothermountainman. There is something suspicious about this man who emerged out of nowhere, like cumulonimbus clouds, from this land that is a fusion of East and West. He has two pairs of eyeglasses, both with round black frames: one for use by Stanley Wong, another for anothermoun-

●Katsumi Asaba ｜浅葉克己

A Strange Visitor from the Future ｜不可思議的未來人

怪しい未来人。

Born in 1940 in Kanagawa Prefecture, Japan, and graduated from Kuwasawa Design School. He established Asaba Design Co. Ltd in 1975. Since then he has taken an active role at the forefront of Japanese design industry. He is chairman of Tokyo Type Directors Club and maintains an interest in the Asian culture of written characters. Awards he has won include Tokyo ADC Award Grand Prize, Purple Ribbon Medal etc., and was awarded the Order of the Rising Sun, Gold Rays with Rosette, from the Government of Japan in 2013. He also holds the title of sixth degree master in table tennis (Japan Table Tennis Association).

一九四〇年在日本神奈川縣出生，畢業於桑澤設計研究所。一九七五年設立淺葉克己設計室，此後一直活躍於日本廣告設計界。現為東京 TDC 理事長，致力研究亞洲文字。曾獲東京 ADC 獎冠軍、紫綬褒章等，二〇一三年獲日本政府頒授旭日小綬章，表彰其對文化藝術的貢獻。乒乓球六段。

這個我向來稱呼他為 Stanley Wong 的人，如其他香港人一樣，有一個正式的中文名——黃炳培。不過，比較特別的是，他還有第三個名字：又一山人。這個人帶點神祕感，就像積雨雲般，莫名其妙地在香港這個東、西方文化交匯點出現。

他擁有兩副黑色圓框眼鏡，分別屬於 Stanley Wong 和又一山人；無論哪個身份，他戴起這眼鏡時，看上去都甚具明治或大正年代大文豪或哲學家的風采。兩副黑框眼鏡蘊含深奧意義：或許一副拿來區分自己和他人，另一副用作凝視東西方和亞洲的混亂。於我而言，兩副眼鏡背後四隻眼睛，代表着四個不同方面的 Stanley Wong。他年紀輕輕已成為 AGI 的成員，自此在每年的大會上，與其他來自 50 個國家和地區的同儕熱烈交流。

每當我看到「又一山人」這個名字，就會想到明末清初、認為書畫同源的畫家八大山人。我收藏了一幅八大山人的畫作，擺放在我每天都看到的地方。作品描繪兩隻看似高傲的鵪鶉在對峙，眼神充滿敵意。牠倆將會打起來，還是裝腔作勢、互相威嚇？

同樣認為書畫同源的又一山人，是一位出色的圖像創作者，製作過許多大型攝影作品。在其眾多作品中，其中一段影片給我留下尤其深刻的印象。片段從鳥瞰角度拍攝廣州一名書法家，用水在水泥地寫下源自《心經》的「空」。隨時間一點一滴流逝，「空」字逐漸蒸發、消散。單憑觀看整個過程，已足以令我對《心經》有所了解。

Stanley Wong 與他漂亮的太太幾乎形影不離，自從其夫人約 10 年前開始研習書法以來，更為美麗動人。我 19 歲的時候，曾跟隨町春草女士學習書法，當時她贈予一幅作品，寫着：「我活過。我寫過。我愛過。」

數年前，又一山人策劃《what's next 三十乘三十》大型展覽，在毗鄰香港的深圳舉行。尤記得 30 年前，我夥同一群愛好乒乓球的藝術創作者前往深圳，當時該處小港口，人口僅約 45,000；今時今日，深圳已經成為擁有 2,000 萬人口的大都市。參與展覽期間，Stanley Wong 送了一張長長的乒乓球桌給我，作為禮物。觀乎他出色的觀察力，以及予人歡喜親和的能力，我絕對相信他是不可思議的未來人。

原文：《gggBooks 115 黃炳培 × 又一山人》／ 2015

the '97 handover. While most people did not want to leave Hong Kong, they were mostly full of doubts about the future. The sense of uncertainties was totally understandable though, for who would have no doubts or concerns knowing he/she would be the subject for a brand-new political experiment?

In the thousands of years in the Chinese history, people had always used consensus, adaptation, and accommodation to complete the alternating process of old and new, and the resilience of the Confucian culture could even accommodate the separation brought by the wars of two different races. Because of the same cultural genes, the integration of one country, two systems in Hong Kong is actually successful. In the midst of constant social ups and downs as well as violent confrontations in today's society, I still feel that the issue is related to neither differences in political values nor cultural deviation. The core of the problem is that Hong Kong's business model has led to the deep-rooted oligarchy that has penetrated the political class that has changed the contents of law and social order. In this long and implicit rewriting process, the resources of Hong Kong are ultimately controlled by a very small number of tycoons, and young people are born into an unfair and stressful future. This contradiction will eventually come, resulting in fierce battles and occasional blaming on certain groups of innocent people. The development of capitalism, if lacks the criticism and supervision of intellectuals, will eventually fall into oligopoly. In the business world, designers often face the most pressure. Owing to the work nature, they almost always serve the implicit rewriting process. In fact, the skepticism and criticality of the artists can often see the flaws of the city. The goodwill of artistic creation, meanwhile, has drawn the artists close to the civilian culture of the city, thereby using the eyes of the people to observe and point out what actually is going on in our daily life.

The "Red, White and Blue" artwork series was the creation through the artist's vision of Stanley cum anothermountainman, a double-faceted identity that focused on the civil society in Hong Kong. This series of works, be it installations, objects or posters, showed Stanley's wisdom and enthusiasm for the general public in Hong Kong. This artist's concerns demonstrated a universal value filled with the sentiments of "compassion and benevolence".

The tri-colored nylon sheets of "Red, White and Blue", first appeared in Hong Kong from the 50s to 60s, were originally used to protect the exterior walls of buildings or to provide shelters to residents of wooden huts. The material was later used for making large plastic bags, which formed the fond memories of visiting relatives in the Mainland and hard work in setting up business-

● He Jianping | 何見平

IV

born in 1973, China and is now living in Berlin, working as a graphic designer and publisher. He had his PHD. of cultural history in Frei University of Berlin in 2011. His works have been globally awarded, including Gold prize at International Poster Biennial in Warsaw, German Design Award, Red Dot Design Award in Germany, Yellow Pencil of D&AD in UK etc., and received the Poster Art Yard in Rüttenscheid prize in Germany in 2006. His solo exhibitions have taken place in Germany, Hong Kong, Taiwan, Nanjing China and Japan.

一國兩制 · 一人雙貌

With "One Country, Two Systems", Here Comes "One Man, Two Visage"

一九七三年出生中國，現居柏林，平面設計師和自由出版人。二○一一年獲得柏林自由大學文化史博士學位，設計作品曾獲華沙海報雙年展金獎、德意志國家設計獎金獎、德國紅點獎、倫敦D&AD黃鉛筆獎等，並於二○○六年榮獲德國Ruettenscheid年度海報成就獎。曾在德國、中國南京、香港、台灣、日本等地舉辦個展。

I do not quite know how two different identities of "Stanley Wong" and "anothermountainman" interchange. I always feel that only designers will fall into the problem of defining their identities, for it is a struggle between the obligation for being commissioned to do creative works and the desire for to create according to one's own will. Equilibrium never exists between the numerous demands from the clients and the designers' own creativity. As the disharmony builds up, the rational mind will eventually break down.

I am not sure whether it was Stanley Wong or anothermountainman with whom I met in this earthly world. Anyway, the person I met has passion, talent, wisdom, but is also envious and wounded by his past experience and plights of human beings. In this city of Hong Kong, there should never be any doubts about identity. In the operation of an ultra-commercial city, there is no time for people to think too much. Although going with the flow is the best way to reach our goals in this rapid-moving world, Stanley Wong and anothermountainman tried his best in using his maximal power to slow down the acceleration in order to create a space for creativity. This space has helped him to think introspectively and shaped his identity as an artist. I think Stanley Wong and anothermountainman are the two identities that he defined between art and business design - though I can't really classify Stanley Wong or anothermountainman into either of the groups. Having said that, I do appreciate the works he created as an artist, which reflected the humanistic care that exists in Hong Kong, which were like springs in the desert.

I met him in Berlin in 2000, and I usually call him "Stanley".

Before that, I noticed his two posters entitled "One Country, Two Systems" and "Fifty Years Remain Unchanged", which should have been created before the '97 handover. The four sides of the "One Country, Two Systems" poster were used as the outer part of the Chinese character "國" (meaning "nation"). By using the concept of rulers, he used the top markings on the ruler of the Chinese measuring system and the bottom markings on the ruler of the British measuring system to represent the Chinese rule and the British rule respectively. In the empty space, there was a lonely Chinese character of "或" (meaning "maybe"). In the "Fifty Years Unchanged" poster, there were 50 characters of "年" (meaning "year") placed evenly over the poster. The common strokes in the characters form a huge "不變" (meaning "unchanged"). Ironically, the round seal, with the characters of "新紀元，新希望" (meaning "new era, new hope"), could not quite allay people's doubts. I intuitively think that it was a portrayal of what Hong Kong people were worrying about around the year of

efits, possession of more luxury goods, and, in particular, not an encouragement of lavishness. This is also a spiritual practice in itself. The "Stanley Wong" (or "anothermountainman") whom I know believes in Buddhism, is a vegetarian, frequently practices calligraphy, and loves photography… To me, such attributes were nothing compared to his kind concerns of others. Honestly speaking, I always think his creation of the "Red, White and Blue" series was, in fact, an achievement of his exceptional spiritual practice.

黃炳培和又一山人，不知這兩種身份如何調配。我總覺得，只有設計師才會陷入身份的定義問題中，這是受委託做創意工作的本職，和自我創作欲積壓的互搏造成的。被要求這樣那樣創作和個體自發的創作，那是無法陰陽調劑、總在上升的水位，心靈中的理性大堤總有決堤的一天。

我不知世俗之中，我遇到的是黃炳培，還是又一山人。反正我遇到的那個人，他有着激情、才華、智慧，也有着嫉妒心、塵世滄桑和人間煙火氣。香港這座城市，本來不會有身份的疑惑，超級商業城市的運轉中，沒有給人留出太多思考的時間，慣性自帶加速度，你跟着旋轉即可。黃炳培和又一山人卻費盡心機、費盡洪荒之力阻擾加速度，給自己營造了一個反作用力的空間。這個空間幫助他自省思考，成就他藝術家的一面。我想，黃炳培和又一山人是他在藝術和商業設計之間定義自己的兩種身份。我雖然分不清黃炳培和又一山人哪個是藝術家，哪個是商業設計師？但我欣賞他作為藝術家身份創作出來的那些折射香港人文關懷的作品。那是沙漠中的甘泉。

2000 年，我在柏林結識他，我平時稱呼他「Stanley」。

那之前，我就留意到他的兩件海報作品，《一國兩制》和《五十年不變》，應該是在回歸前創作的。《一國兩制》將海報四個邊打造成「國」字的外框，用了尺子的概念，上下兩把尺，有着中國和英制不同的刻度。空蕩蕩的空間中，留下一個孤獨的「或」字。《五十年不變》則在海報上平均排放了 50 個「年」字，利用筆畫的共用處，形成巨大的「不變」兩個字。「新紀元，新希望」的圓章蓋不住滿心的疑惑。我直覺那是 97 左右港人思想的傳神寫照，大部分的人不想離開香港，另一方面，卻對未來充滿了疑惑。試想在人類全新的政治實驗中，自己恰恰是這個實驗的個體，誰的心中不會有疑惑呢？

中國歷代都用求全、適應和包容來完成新舊的交替，儒家文化的韌性甚至可以將兩種不同民族的戰爭割裂包容在一起。一國兩制在香港因為文化基因的相同，融合其實是成功的。時至今日，遇到社會波折不斷，時有暴力的對峙，我還是覺得這個問題的核心不在於政治價值觀的分歧，更不是文化的分歧。問題核心在於，香港的商業模式導致了寡頭階層的根深蒂固，而寡頭階層滲透進政治階層，改變法律和社會秩序的內容。在這種漫長而隱性的改寫中，香港的資源最終被掌握在極少數的人手中，年輕人生來就陷入不公平和壓力巨大的未來中。這種矛盾終究會來，劍拔弩張中，衝着誰發洩有時卻是偶然的。資本主義的發展，如果缺乏知識分子的批評和

es. Today, the "Red, White and Blue" plastic bags are regarded as one of the representatives of Hong Kong culture. In his masterpiece of "Building Hong Kong – Red White Blue", Stanley replaced paper with red, white and blue nylon sheets and printed texts on them by using the silkscreen printing technique. The texts written by Stanley in this series of posters made the most exciting part of the entire creation, showing the brilliant writing skills that he developed from his early years while working for the advertising companies. By subtly replacing the ordinary warning texts on Hong Kong construction sites with some of his unique concepts, he had successfully promoted the finest advantages of Cantonese in terms of its long history in the ancient Chinese language. The words, which sometimes carried double meanings, consistently demonstrated his sense of black humor. As to how he usually thinks, the sense of urgency about Hong Kong's political and economic worries was mingled and demonstrated in his works. "power struggle threatens foundation", "first build a nation, then it will become a home", "no shady black market operation", "19°97 - 20°47 unchanged rules in 50 years", "for freedom of entry, do not close the door", "nine prohibitions for building: fabrication, without agenda, complaint, lack of interest, apathy, inequality, shameless, ignorance, without principle". These phrases, mostly double meaning with insinuation and mixed with familiar local slangs, were clearly sneak-ups that made the audiences feel a sense of helplessness or utter a speechless bitter smile.

By extending his concept of "Red, White and Blue", Stanley collaborated with Tsang Tsou Choi, King of Kowloon and created the series of "Hong Kong people running Hong Kong". The series combined red, white and blue nylon sheets and folk culture and produced works that demonstrated even more local colors. However, the words and the messages still ridiculed the society, wealth, and the future of Hong Kong. What's thought-provoking and surprising, besides the ridicules, was the persistence of a naive designer who resisted the trends in the high-speed and ever-changing Hong Kong society. Instead of following the commercial pursuit, the guy was still looking up for his dreams, gazing at the clear night sky, caring for the people's worries, and pondering about the future of Hong Kong.

Slowing down one's own speed, lowering his line of sight, seeing himself as a member in needy groups in the city, and creating more artworks with universal values can all be considered as spiritual practice and self-perfection for artists. Designers are no exception. Creating good-natured designs is consistent with maintaining kindness in human beings. In this regard, design should be a manifestation of wisdom, not just the pursuit of ben-

監督，終將陷入寡頭利益中去。在商業社會中，設計師是被捆綁最緊的群體，因為從事工作的內容，幾乎都是為隱性改寫服務。而藝術家的懷疑性和批判性，反而能看到這個城市的缺陷。藝術創作的善意，令他們親近這個城市的平民文化，借民眾的眼睛來觀察日常百態。

《紅白藍》就是 Stanley 一人雙貌中用藝術家的眼睛，聚焦於香港平民社會後的創作。這個系列的作品，無論是裝置、物件還是海報，盡顯 Stanley 的智慧，滿懷對香港普羅大眾的熱情，這種藝術家的關注，有着「悲天憫人」式的情感，有着普世價值。

《紅白藍》三色相間的尼龍布，最早出現於 50 至 60 年代的香港，原為保護建築外牆或供木屋區居民遮風擋雨之用。後來這種材料也被製作為大型膠袋，成了北上探親和艱辛創業的記憶。今天，紅白藍膠袋被視為香港文化的代表之一。Stanley 在他代表作《香港建築／紅白藍》系列中，將紅白藍尼龍布直接取代紙張，把文字用絲網印刷在上面。他在這個系列海報中的文字，是最精彩的部分，顯示他早年為廣告公司撰寫文案的功底。他將出現在香港建築工地上的普通警示文字，偷換了一些概念，發揚粵語中古漢語的精悍優勢，時有雙義，卻一貫地黑色幽默。一如他平時的思考，對香港社會政治、經濟弊端的憂患意識夾雜其間。「角位嚴禁勾心互鬥，以免危害架構穩定」；「先建國，後建家」；「嚴禁黑箱作業」；「19°97-20°47，不移不變」；「為保自由出入，請勿關閉此門」；「香港建造 9 忌：無中生有，無的放矢，無病呻吟，無動於衷，無精打采，無利損人，無羞無恥，無厘頭緒，無宗無旨。」這些大多雙關射影的文字，夾雜着熟悉的街頭俚語，還分明琅琅上口，讀來令人同嘆無奈，抑或啞然苦笑。

他將《紅白藍》的概念延續出去，和「九龍皇帝」曾灶財合作的系列作品《港人治港》，更將紅白藍尼龍布和俗俚文化結合起來，成為更有香港市井氣質的作品。但在字裡行間傳遞的還是對社會的揶揄，對財富的揶揄，對香港前途的揶揄。揶揄之外，發人深省，令人驚訝在高速旋轉的香港社會中，竟然也有不跟隨商業追求的傢伙，竟然還在抬眼發夢，靜望夜空，關愛民眾憂患，深慮香港的未來。

將自己的速度放得慢一些，將自己的視線放得低一些，將自己設身與城市中需要幫助的群體，創造更有普世價值的藝術作品。這是藝術家的修行，這也是完善自我的修行。設計師也一樣，創造善意的設計和與人為善是一致的，設計應該是智慧的體現，而不只是追求利益，增加奢侈品，更不是鼓勵浪費。那也是一種修行。我遇到的是黃炳培或是又一山人，他信佛吃齋、勤練書法、酷愛攝影⋯對我而言這些都比不上他關注普羅的善意。他的《紅白藍》作品，我總覺得那是他修行的成就。

我家睡房掛了四張照片。

每張照片均顯示一個由中國政府大樓中空空如也及早已被遺忘的告示牆所製成的正方形。這正方形在這裡被用作現代主義的象徵，涵蓋了從馬列維奇的俄羅斯一直到當代香港的近代歷史。當中黃炳培在官方保守的氛圍中，如何經過非常本地化的手法被演變成國際現象。

黃炳培的創作是我見過最具卓越智慧的作品之一。因為他創作的地道題目亦帶國際語境話題性。他的作品不但能在抽離情感制肘的同時，對抗虛偽的歷史，更能抵禦歷久不衰的中國保守和傳統模式，及避免取悅遊客式符號圖騰。

黃炳培在廣泛探索其紅白藍系列時依循了類似的路。他採用了一種固有的本地材料，在香港隨處可見及常用於建築棚架和洗衣袋的物料，並從中得到了許多與當代文化息息相關的靈感。對其他希望在本地當代文化生態中參與創作的設計師來說，這是一個實在及可跟隨的真確方向。

我們常常遊走於商業、個人和文化的世界之間。不同的世界一直在重疊和融合：當我們與朋友（社交）在香港博物館的書店（文化）購買一本書（商業）時，這三個世界便成為一體了。黃炳培一直努力在這三個世界中尋找啟發，並設法在當中尋找相關的創作元素。這其實是一項艱巨的任務，因為這三個範疇其實分別被充滿嫉妒的守衛者隔離和精心保護。

黃炳培是當今世上少數能在不同世界跳躍自如的人。他既能為電影執導，也能在這邊廂統籌大型活動的同時，在另一邊舉行攝影展覽及在其他地方展示其裝置藝術的才華。他重新團結了在我們心中早已分開的範疇。透過黃炳培這位又名「又一山人」的當代視覺創作，各藝術創意領域正被團結起來，並融為一體。

● Stefan Sagmeister

There are four photographs hanging in my bedroom.

Each image shows a square, made by an empty, forgotten pin-wall in a Chinese government building. The square is employed here as a modernist symbol, spanning a history from Malevich's Russia all the way to contemporary Hong Kong, created by a bureaucracy and transformed into a very local interpretation of an international phenomenon by Stanley Wong.

He created one of the smartest solutions I have seen for what it means to create local work in a global context, now. Work that resists the sentimental, fights the faux-historic, battles the reiteration of Chinese patterns and avoids the usual touristic tropes.

Stanley's extensive explorations within the red, white and blue series follow down a similar path. He appropriates an inherently local material, the ubiquitous fabric used on construction scaffoldings and laundry bags anywhere throughout the territory and creates a plethora of ideas from it, all inherently relevant to contemporary culture and a true path to follow for other designers who would want to create artifacts within a local, contemporary culture.

As people, we live in a commercial world, a personal world and a cultural world. These worlds overlap and merge all the time: When we buy a book (commercial) with a friend (social) at the Hong Kong Museum Store (cultural), the three worlds become one. Stanley works in in all three worlds, and manages to pull off relevant pieces in all three. This is surprisingly hard to do, as these three areas are each segregated and carefully guarded by jealous gate keepers.

Stanley is among the very few people worldwide who confidently jumps from one to the other, directs a film here, a campaign there, a photo exhibition over there and an installation elsewhere. He reunites areas that are separate in our minds, and with this Stanley Wong and anothermountainman actually, properly, do become united, do become one.

Stefan Sagmeister has designed for clients as diverse as the Rolling Stones, HBO, and the Guggenheim Museum. He's a two-time Grammies winner and also earned practically every important international design award. His books sell in the hundreds of thousands and his exhibitions have been mounted in museums around the world. His exhibit The Happy Show attracted way over half a million visitors worldwide and became the most visited graphic design show in history.

任職設計師，曾合作客戶包括滾石樂隊及古根漢美術館。兩度獲頒格林美獎，並奪得多個國際知名設計大獎。其著作售出數量數以十萬計，作品亦曾在世界各地博物館展出，當中「The Happy Show」展覽在全球吸引逾五十萬人參觀，為史上參觀人數最多的平面設計展。

「搭地下鐵路，話咁快就到」，這句廣告口號，相信香港四十歲以上的朋友必定耳熟能詳。

口號自地鐵 1979 年通車以來，一直沿用至 1997 回歸年。當年負責的廣告公司 JWT 智威湯遜公司，與地鐵廣告市務部關係非常密切，同心協力創造輕鬆有趣、深入民心的廣告，例如以「紅燈、小巴車轆」作題材，將路面交通堵塞的情況，對比地鐵在地下暢通無阻，一針見血地呈現地鐵的獨特優點。

全憑廣告創作人的市場分析及創意心思，一系列與民生息息相關的廣告短片陸續誕生，而這些短短 30 秒的片段，不但成功提升地鐵的形象，更榮獲多項亞洲及本地廣告獎項。

不少人提出疑問，為何地鐵公司可以一直用同一句廣告口號，長達近 20 年？回想當年我任職廣告經理時，每年都被總監們質疑同一問題。當時我闡述「市場定位」的重要元素，就是堅持地鐵的獨特優勢，持續傳達單一訊息；而「話咁快就到」代表準時到達，加上口語化的表達方式，令觀眾更易接受，訊息亦更深入民心。

當年主席李敦爵士只是對我說了一句：「你是這方面的專才，我們對你的決定絕對信任！」這句說話如同「強心針」，加強我和廣告公司的信心及熱誠，繼續努力不懈地創造出一連串別具創意，又凸顯生活共鳴感的廣告。

回想當年有一段小插曲，廣告公司當時建議採用幽默的比喻方式，用可愛粉紅色小豬排隊上車的畫面，勸喻乘客跟黃線排隊上車，毋須爭先恐後，但可惜引起部分乘客不滿，投訴地鐵公司將乘客比喻為畜牲——豬。這可愛電視廣告上畫兩星期後，它的海報廣告被迫抽起。

● Nancy Pang｜彭吳麗芬

A 35-year veteran in the education & service sectors, she spearheaded the brand development and marketing communications of HKUSPACE Continuous Studies and Community College, and had held senior responsibilities at the HK Olympic Equestrian Company, RoadShow, KMB and MTR Corporation. In the 90's, she won countless creative awards, including the first 'Advertiser of the Year' in 1994.

從事教育及服務行業三十五年，曾任香港大學專業進修學院品牌策劃顧問，並先後在奧運馬術香港公司、路訊通、九巴及港鐵公司身居要職。九十年代獲獎無數，包括一九九四年成為首位「年度傑出廣告人」。

"Say MTR and you're almost there!" - I believe any Hong-konger aged over 40 will be familiar with this advertisement slogan.

In fact, the slogan was used since the opening of the Mass Transit Railway (MTR) in 1979 until the '97 handover. J. Walter Thompson, the advertising company responsible for publicity campaigns, had a very close relationship with the advertising and marketing department of the MTR. The two parties collaborated and created an easy and interesting advertisement that won the heart of all citizens. For example, the serious traffic jam on the roads symbolized by "red lights and minibuses' wheel", a huge contrast to the smooth operation of MTR, highlighted the unique advantages of the new underground train in a straightforward and crisp manner.

With in-depth market analysis and creative ideas of the advertising creative teams, series of short films related to people's livelihood were promoted one after another. Those 30-second short clips did not only successfully promote the image of the MTR, but also won numerous Asian and local advertising awards.

Many people puzzled about why the MTR Corporation (MTRC) kept using the same slogan for nearly 20 years. Recalling the time when I was the Advertising Manager, the directors used to ask me this same question every year. During those times, I explained to them about the important element of "Market Positioning", which was to adhere to the unique advantages of the MTR and to persistently convey a single message. The phrase "Say MTR and you're almost there" means arriving on time. The strong note in the colloquial expression made it more acceptable for the audience, thereby popularizing the message among the public.

Sir Wilfrid Newton, the then chairman of MTR, just said to me, "We fully support and trust your decision, for you are a specialist in this area!" The affirmative statement was a boost to my morale, which strengthened confidence and enthusiasm in me and my teammates. We continued relentlessly to come up with series of original advertisements that created resonance in life.

That said, the road to creation was not without hiccups. There was once an episode when the advertising company used cute pink piglets in a TV advertisement as a humorous metaphor to educate passengers to line up along the yellow lines and not to scramble. Unfortunately, some passengers were offended and complained to the MTRC for symbolizing passengers as pigs. Two weeks after the cute advertisement was broadcasted on the TV, the poster advertisement was forced to be suspended.

Stanley was raised in the 'golden age' of Hong Kong commercial creativity.

When young designers had a fire in their belly. Competition was high. Ideas were everything. Design and art direction demanded perfection. Advertising was based on brutal simplicity. You could either cut it, or get left behind.

Stanley soared ahead. His passion and emotional passion for his work saw him contribute to some of the best advertising of the 1990s.

Disciplined. An obsessive perfectionist.

More than that, it was a generation that established a new voice in Chinese creativity. Drawing on personal experiences and influences that until then had been unexplored.

From typography to visual expression, to freeing the shackles of a predominantly Western-influenced past to create a style which was uniquely Hong Kong. Uniquely Cantonese.

This led to bucket-loads of awards, at the very highest level, and recognition on the international stage, which eventually would draw Stanley Wong the creative director to foreign shores.

But his heart had never left Hong Kong, and the legacy of his creative work remains to inspire future generations.

|

80、90 年代是香港廣告業的「黃金年代」,產下不少經典廣告到今日依然記憶尤新,同時培育了許多廣告人、創意人,當中你必定聽過的一位——黃炳培。

媒體產業興盛,廣告行業競爭激烈,要突圍而出,需要的是想法和創意。設計和美術指導是對美的追求,於廣告行業工作尤如逆流而上,不進則退。

黃炳培對藝術創作和工作的無比熱情使他能鶴立雞群,創作 90 年代不少家傳戶曉的經典廣告作品。

律己以嚴,黃炳培在工作和創作上一直力求完美。

黃炳培是香港創作新浪潮之一,對及後東方創作影響時至迄今。

從排版至視覺呈現,走出西方美學的枷鎖,創立出獨有的美學風格,屬於香港的風格。

黃炳培的突出成就為他帶來不同的國際獎項,將他帶上世界舞台,並出任海外廣告公司的創作總監。

生於斯,長於斯。黃炳培心繫香港,他的商業設計亦成香港廣告業的重要範本。

● Chris Kyme｜關思維

stanley wong. the art director.

黃炳培。美術指導

Chris has worked in advertising in Asia for over 30 years as a Creative Director with global agencies such as Leo Burnett, Grey and FCB, creating some of Hong Kong's best loved work in the 1990s. He has been Chairman of the Hong Kong 4As Kam Fan awards several times, and is the author of a book on Hong Kong creative advertising called "Made in Hong Kong".

關思維於廣告業界打滾逾三十年,曾在亞洲出任多間跨國廣告公司創作總監,如 Leo Burnett, Grey 及 FCB。不少九十年代為人熟悉的作品都出自其手筆。曾多次擔任 4As 金帆廣告大獎主席,並就香港創意廣告出版《Made in Hong Kong》一書。

SW

stanley wong

1980 > present

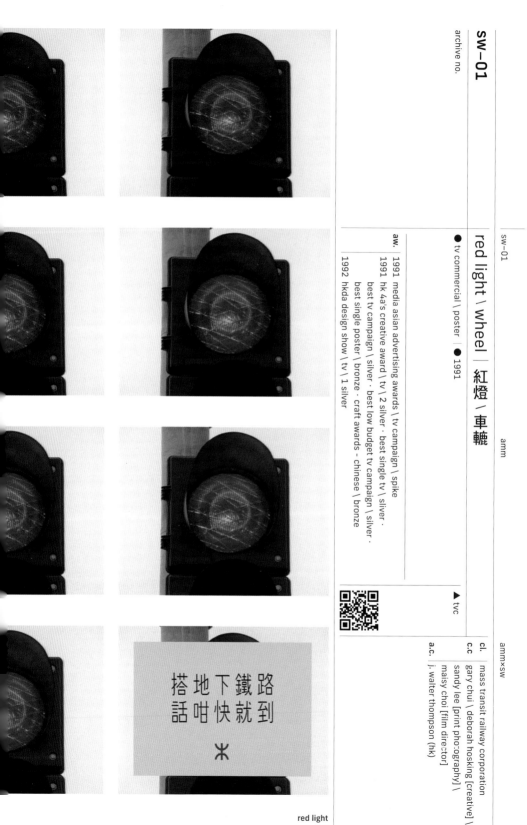

sw–01

amm

amm×sw

red light \ wheel | 紅燈 \ 車轆

● tv commercial \ poster \ ● 1991

▲ tvc

cl. mass transit railway corporation
c.c gary chui \ deborah hosking [creative] \
sandy lee [print photography] \
maisy choi [film director]
a.c. j. walter thompson (hk)

aw. 1991 media asian advertising awards \ tv campaign \ spike
1991 hk 4a's creative award \ tv \ 2 silver · best single tv \ silver ·
best tv campaign \ silver · best low budget tv campaign \ silver ·
best single poster \ bronze · craft awards - chinese \ bronze
1992 hkda design show \ tv \ 1 silver

搭地下鐵路
話咁快就到

米

red light
30"

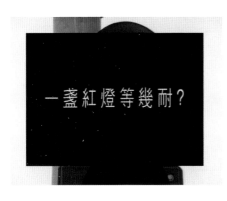

一盞紅燈等幾耐？

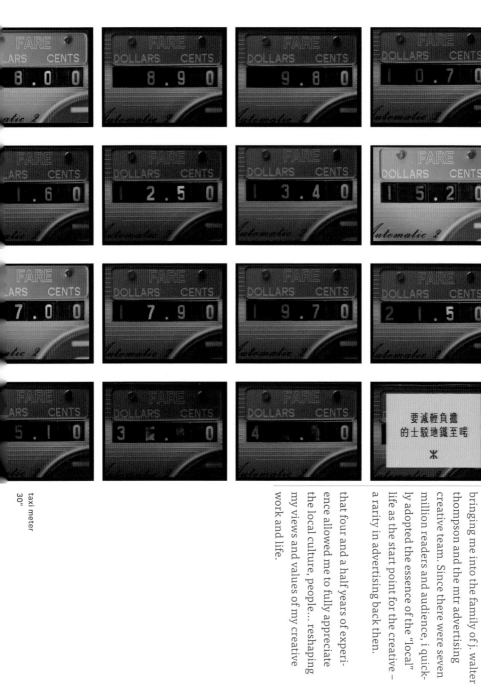

要減輕負擔
的士駁地鐵至啱

米

taxi meter
30"

i thank willde ng and gary chui for
bringing me into the family of j. walter
thompson and the mtr advertising
creative team. Since there were seven
million readers and audience, i quick-
ly adopted the essence of the "local"
life as the start point for the creative –
a rarity in advertising back then.

that four and a half years of experi-
ence allowed me to fully appreciate
the local culture, people… reshaping
my views and values of my creative
work and life.

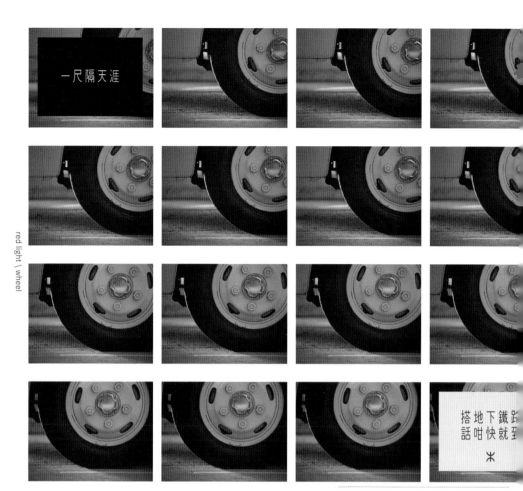

一尺隔天涯

感謝吳文芳和徐憶雄帶我進入智威湯遜這
大家庭，成為地下鐵路廣告創意團隊。

因七百萬人都是讀者和觀眾，
令我很快進入以「地道」生活元素出發
作為創意溝通的切入點，
這也是當年少見的廣告語言。

這四年半的經驗，
讓我切切實實落實到地道、人文種種，
改變我往後創作和做人的思路和價值觀。

amm

amm×sw

this is the project that brought me fame within the asian creative circle.
this brought me the first award in my career in advertising world.
this might be the most effective communication work throughout my career.
this tvc series might be the project with the lowest production cost in hong kong advertising scene.

這是令我在亞洲創意圈建立名聲的項目。
這是商業創作生涯得獎零的突破。
這可能是我工作以來，最有效的宣傳案子。
這電視廣告系列可能是香港廣告製作最低成本的其中一個。

閃一閃 令你遲到又誤點

搭地下鐵路 話咁快就

shopping \ eating \ movie | 無論想做乜

● tv commercial \ poster \ print advertising | ● 1992

▲ tvc

cl. mass transit railway corporation
c.c. gary chui \ raymond chau \ dennis chang \ deborah hosking [creative] \ david tsui [film director]
a.c. j. walter thompson (hk)
col. hong kong heritage museum \ m+

aw. | 1992 hk 4a's creative award \ tvc \ 1 gold \ 1 bronze

影 不 求 人 茸 指 甲 箱
磁 鐵 機 參 靈 南 白 藥
飛 的 確 皮 鞋 針 底 材
鏢 玉 電 涼 匹 頭 印 蕈
古 石 戒 動 牙 刷 花 蜜
朱 盆 磨 指 簽 線 衫 飛
義 景 泰 耳 筒 收 音 機
盛 高 腳 藍 瓷 碗 樂 恤
耳 爾 室 美 牛 墨 盒 袋
環 夫 內 毛 公 仔 手 招
迴 球 無 黑 色 皮 褲 財
立 棒 線 龍 真 波 斯 貓
體 儲 電 鬚 想 板 鞋 手
聲 火 話 池 筆 糖 浴 巾

橫直提示！

横直旋示！

1-10 凍冰冰夏日妙品係也？
11-20 暖笠笠地道風味係也？
21-30 生編鮮美好味道係也？
31-37 每逢知己份外話係也？

38-44 唔使筷子懶大餐係也？
45-58 香香滑滑涷甜品係也？
59-65 清清淡淡盆閘月係也？
66-70 無論您食也,搭＿就得！

橫直提示!

1–10 凍冰冰夏日妙品係也?
11–20 暖笠笠地道風味係也?
21–30 生猛鮮美好味道係也?
31–37 每逢知己份外啱係也?

38–44 唔使筷子幾大餐係也?
45–58 香香滑滑凍甜品係也?
59–65 清涼淡淡爽喉嚨係也?
66–70 無論想食也,搓幾就得!

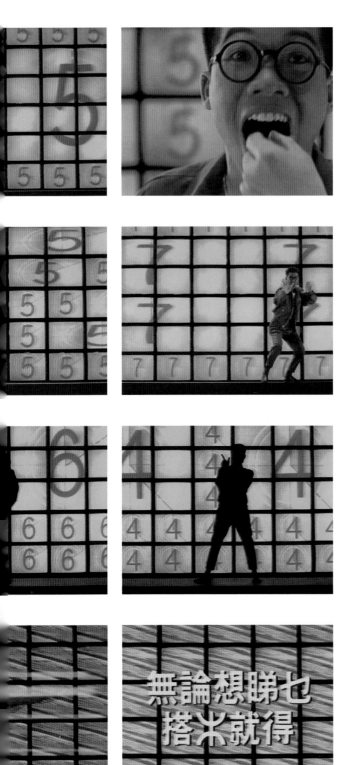

movie
30"

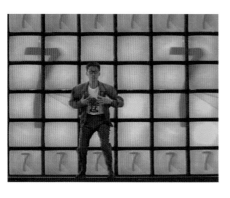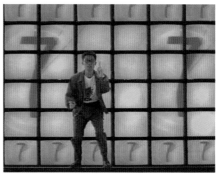

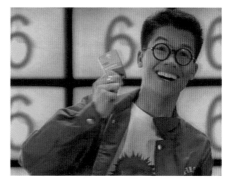

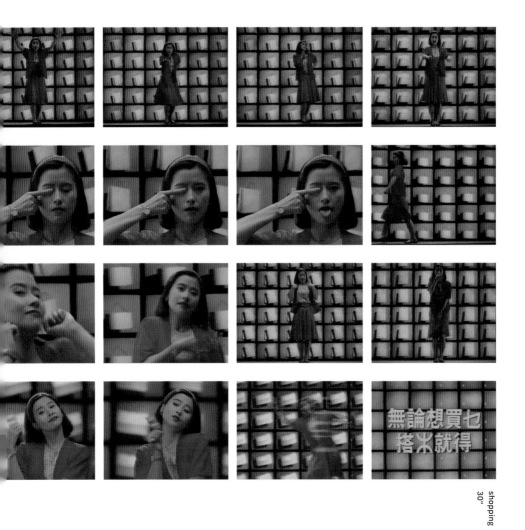

無論想買乜
搭米就得

shopping
30"

i seldom perform in front of screen.
this time i acted as an everyman play-
ing movie trivia game, because the
original cast was too good in acting.
i had a long night being "directed" by
the director...

food
30"

難得一次自己粉墨登場，出演一個生活
中佔戲名的街坊，皆因導演找來的演員
太有演的痕跡，也給導演「舞」了我一
個晚上⋯

archive no.

韻。强按住感情，不
可忍也，孰不可忍
忍酷熱，忍修路，忍
忍 ○○○○○ ✻ 搭地下鐵路　話咁快就到

endurance | 忍

● outdoor poster ● 1993

aw. | 1993 hk 4a's creative award \ poster \ silver

cl. | mass transit railway corporation
c.c. | fornita wong \ milker ho
a.c. | j walter thompson (hk)
col. | hong kong heritage museum \ m+

【忍】粵音隱 [jen²]。日引匕⋯⋯讓表現也。古語云：⋯⋯也。』（例）忍耐，忍受，忍⋯⋯紅燈，忍慢駛，忍塞車，忍無⋯⋯

in those days, the message that mtr wanted to promote was punctual, efficient, convenient and without the hassle of traffic jams. when i learnt that there would be huge outdoor billboards on the roadside from wan-chai to hung hom, i knew it was our chance. isn't this the black spot where buses and private cars are stuck day in day out?

i told the creative team, "usually, the messages of outdoor advertisements have to be read within 3-5 seconds. we have to make one that will take 5 minutes to read, just to remind the drivers that they are annoyed by being stuck in a traffic jam."

地鐵當年推廣的訊息是準時有效、沒塞車的便捷。當我們知道灣仔至紅磡路旁興建了全港首批戶外路旁廣告牌時，覺得機會來了，這裡不就是巴士、私家車無時無刻要塞車的黑點嗎？

然後跟創意團隊説：「人家説戶外廣告必須要在三至五秒內看得完，那我們做一個要五分鐘才讀完的廣告吧！那凸顯他們就是正在塞車不耐煩的一族。」

sw—04

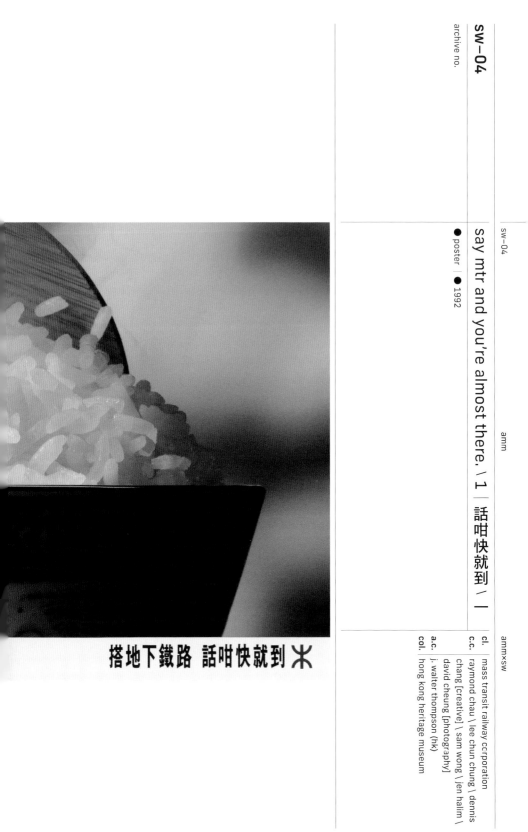

say mtr and you're almost there. \ 1 | 話咁快就到 \ |

● poster | ● 1992

cl. | mass transit railway corporation
c.c. | raymond chau \ lee chun chung \ dennis chang [creative] \ sam wong \ jen halim \ david cheung [photography]
a.c. | j. walter thompson (hk)
col. | hong kong heritage museum

搭地下鐵路 話咁快就到 米

香噴噴　家漸近

煙煙靭 會佳人 ...　　　　　　搭地下鐵路 話咁快就到 米

不日放映
COMING SOON

唔喕好 冇走寶 ...　　　　　　搭地下鐵路 話咁快就到 米

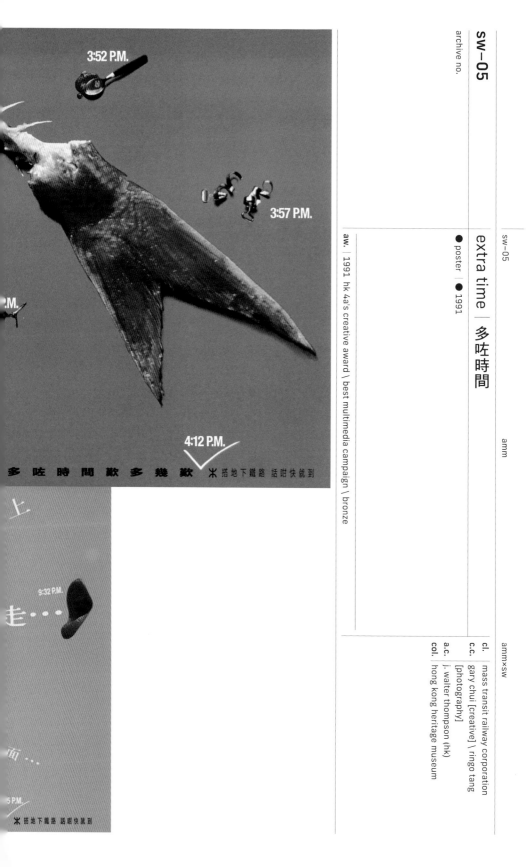

sw–05

archive no.

extra time │ 多咗時間

● poster │ ● 1991

cl. │ mass transit railway corporation
c.c. │ gary chui [creative] \ ringo tang [photography]
a.c. │ j. walter thompson (hk)
col. │ hong kong heritage museum

aw. │ 1991 hk 4a's creative award \ best multimedia campaign \ bronze

3:52 P.M.

3:57 P.M.

.M.

4:12 P.M.

多 咗 時 間 歎 多 幾 歎 搭地下鐵路 話咁快就到

上

9:32 P.M.

走 • • •

面 • • •

5 P.M.

搭地下鐵路 話咁快就到

去 跳 健 康 舞 減 肥 前 ...

3:30 P.M.

3:43 P.M.

3:36 P.M.

4:08 P.M.

去 卡 拉 OK 搶 咪 前 ...

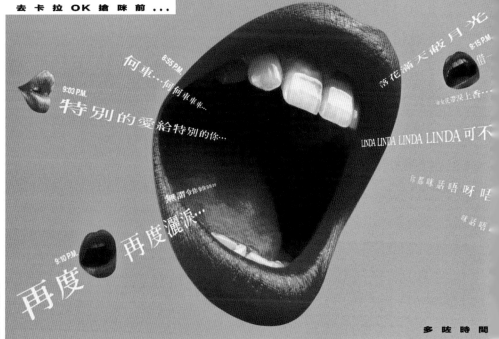

8:55 P.M.

9:03 P.M.

9:15 P.M.

何事…何事事事…

落花滿天蔽月光

借一…

特別的愛給特別的你…

*男女帶淚上香…

LINDA LINDA LINDA LINDA 可不

無謂令你令他999

你都咪話唔呀唔

9:10 P.M.

咪話唔

再度灑淚…

再度 再度灑淚…

多 咗 時 間

6:12 P.M.

6:22 P.M.

6:35 P.M.

6:42 P.M.

6:45 P.M.

多 咗 時 間 扮 多 幾 扮 米 搭地下鐵路 話咁快就到

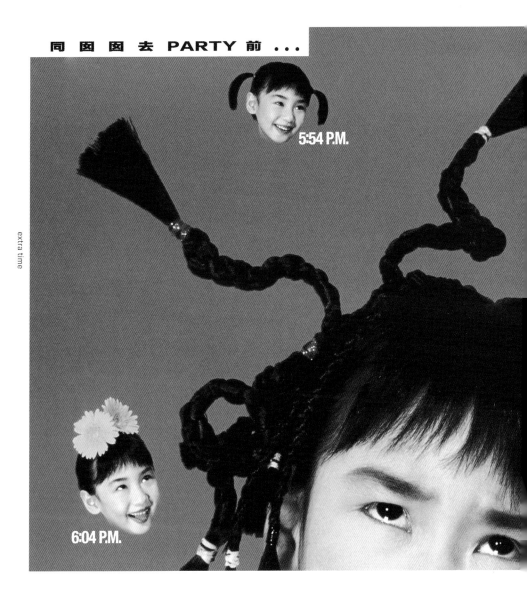

5:54 P.M.

6:04 P.M.

extra time

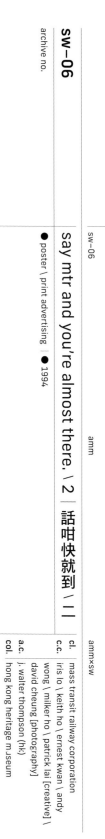

say mtr and you're almost there. \ 2 \ 話咁快就到 \ 二 \

● poster \ print advertising | ● 1994

aw. | 1994 hk 4a's creative award \ print \ bronze · poster \ bronze

amm×sw

cl. | mass transit railway corporation
c.c. | iris lo \ keith ho \ ernest kwan \ andy
wong \ milker ho \ patrick lai [creative] \
david cheung [photography]
a.c. | j. walter thompson (hk)
col. | hong kong heritage museum

快就到 �códe 　　搭地下鐵路 話咁快就到 ㊥ 　　搭地下鐵路 話

AR
45
RH

T TO
E BACK

背面之規例

83

THOMPSON ENTERTAIN

地・夏鐵勞管弦樂團輕

DAVE HARTINO PHILHA

HK CULTURAL CENTRE

YEAR 年 / MONTH 月 / DAY 日

1994/ 3/31 ⟨THU⟩

DOOR/GATE 閘 . SECTION/AISLE 段

R-41

搭地鐵準時入場，輕鬆

* GATE COLOUR 入閘顏色 : R-RED 紅 Y-YELLOW

處世真言

【人生十眼】

一、人生最大的敵人是自己
二、人生最大的成就是謙虛
三、人生最大的財富是健康
四、人生最大的錯誤是自棄
五、人生最大的幸福是知足
六、人生最大的感恩是布施
七、人生最大的快樂是自在
八、人生最大的智慧是自知
九、人生最大的美德是......

搭地下鐵缐
輕鬆自在鎖準
準滿時無享受是
人生問。
若有碰到
快到
囧

say mtr and you're almost there. \ 2

● poster ● 1991

why waiting in concourse │ 何必約喺大堂等

cl. │ mass transit railway corporation
c.c. │ j. walter thompson creative team [creative]
a.c. │ j. walter thompson (hk)
col. │ m+

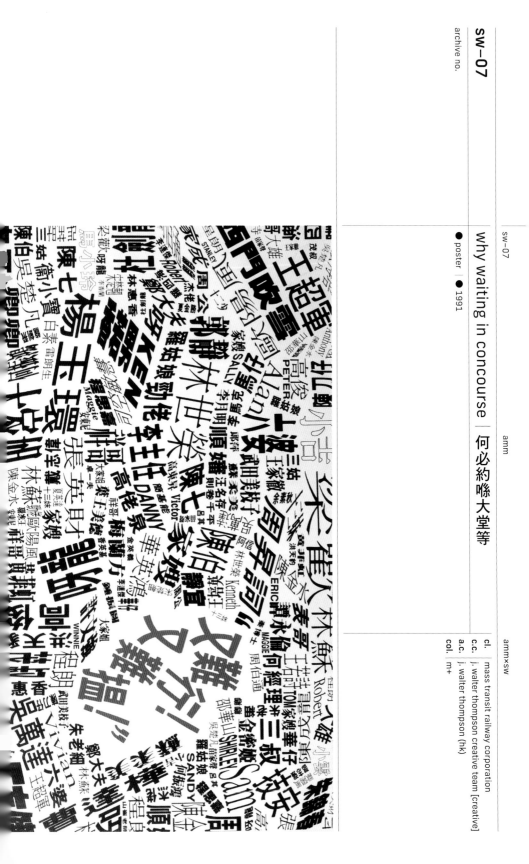

sw–08

archive no.

pigs know nothing about queuing | 傻豬點識排隊

● poster | ● 1993

cl. | mass transit railway corporation
c.c. | fornita wong [creative] \ sandy lee
[photography]
a.c. | j. walter thompson (hk)

we launched the mtr ad on the new "queuing up for boarding" instructions using the concept of pigs not knowing how to queue up. but hongkongers at that time (those who watch television) did not have a great sense of humour and complained about the ad and comparing them to animals. at last, after the first phase of the campaign finished, this large light box ad was never used.

排隊上車守秩序　先落後上更快趣　米

當年以豬不懂得排隊介紹地鐵新推出月台黃線排隊措施。奈何一般香港市民（電視觀眾）沒有太多幽默感，看畢電視廣告就致電投訴；硬要將自己和不懂排隊的動物相提並論。最後，電視放映時段完了以後，這大型月台海報便沒有上畫了。

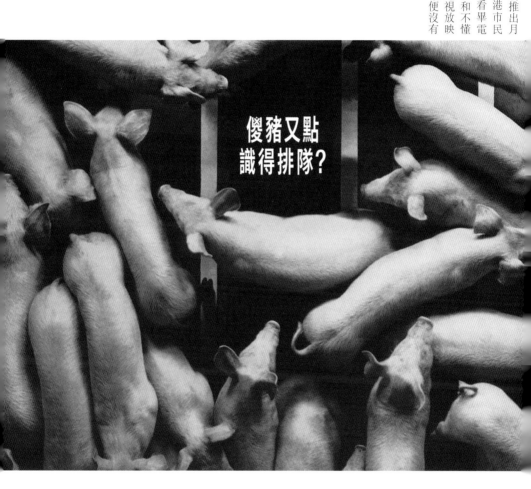

傻豬又點
識得排隊？

臨時改道, 大噢走寶!
搭地下鐵路, 話咁快就到. 米

if i had known earlier… \ 2 ┃ 早知… \ 1 ┃

● poster ┃ ● 1993

cl. ┃ mass transit railway corporation
c.c. ┃ iris lo \ keith ho [creative] \ david cheung
　　　[photography]
a.c. ┃ j. walter thompson (hk)
col. ┃ hong kong heritage museum

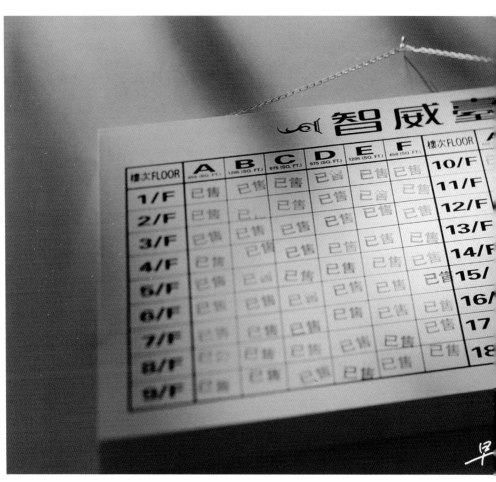

下鐵路,話咁快就列米

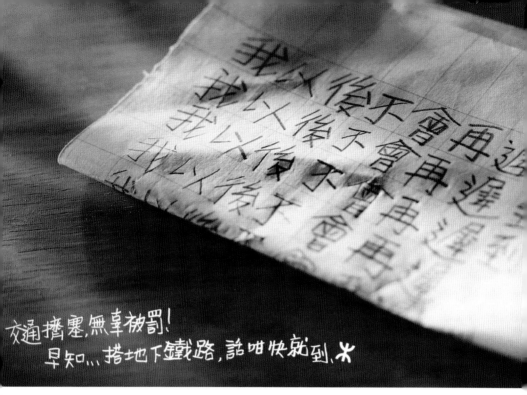

交通擠塞,無辜被罰!
早知...搭地下鐵路,話咁快就到.米

整路掘地,食少幾味!

sw–10

archive no.

if i had known earlier... \ 1 | 早知… \ |

● poster | ● 1993

cl. | mass transit railway corporation
c.c. | fornita wong \ danny ma \ keith ho \ milker ho \ andy wong \ cynthia mo [creative] \ sandy lee \ victor hung [photography]
a.c. | j. walter thompson (hk)
col. | hong kong heritage museum

aw. | 1994 hkda design show \ advertisement in series \ gold
1993 hk 4a's creative award \ print \ bronze

"風雨攔路... 今回又要捱貴... 早知..."　　　　搭地下鐵路 話咁

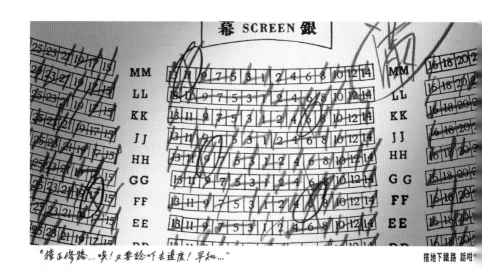

"撞正修路... 唉！又要諗吓去邊度！早知..."　　　　搭地下鐵路 話咁

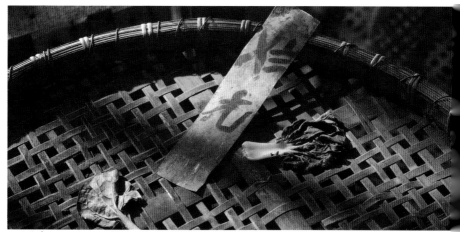

"行車緩慢... 今晚失訂錢？？？早知..."　　　　搭地下鐵路 話咁

night follows day | 有時有候　有如大自然節奏

● tv commercial \ poster　● 1994

▲ tvc

aw. | 1994　hkda design show \ tv commercial \ gold
1994　hk 4a's creative award \ tv \ best single tvc of the year \ 1 gold \ 1 bronze
1994　media asian advertising awards \ spike \ best use of music
1995　the 6th times asia-pacific advertising awards \ silver

cl. | mass transit railway corporation
c.c | iris lo \ tan shen guan \ keith ho \ kelvin hung \ andy wong \ patrick lai \ shirley chow [creative] \ louis ng [film director] \ nelson ng [film editing] \ romeo diaz [music] \ david cheung [photography]
a.c. | j. walter thompson (hk)

night follows day
60"

76 YEARS

♥ **0.7 SECOND**

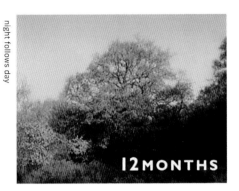

12 MONTHS

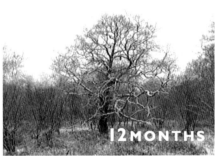

12 MONTHS

24 H

1 YEAR

48 HOURS

1 YEAR

6 MONTHS

靜。

amm

逸。

ammxsw

何時到埗，心中有數，心境自會如此。

搭地下鐵路 話咁快就到 ✳

看通前路，心中有數，心境自會如此。

搭地下鐵路 話咁快就到 ✳

閒。

時間掌握有道，心中有數，心境自會如此。

搭地下鐵路 話咁快就到 ✳

sw–12

archive no.

mtr tv commercial | 地鐵廣告

● tv commercial | ● 1990 → 1994

▲ tvc

cl. | mass transit railway corporation
a.c. | j. walter thompson (hk)

bobby | 時間啱啱好 | 45"

c.c. | raymond chau \ lee chun chung \ wong kin ho \ paul regan [creative] \ louis ng [film director] \ adrian brady [film editing] \ romeo diaz [music]
aw. | 1993 hk 4a's creative award \ tv \ 2 gold \ 2 silver
| 1992 hkda design show \ tv \ gold

monk | 心中有數 | 1'30"

c.c. | fornita wong \ keith ho \ cynthia mo \ milker ho \ andy wong \ paul regan [creative] \ david tsui [film director] \ adrian brady [film editing] \ eddie chung [music]
aw. | 1993 hk 4a's creative award \ tv \ silver
| 1994 hkda design show \ tv commercial \ gold

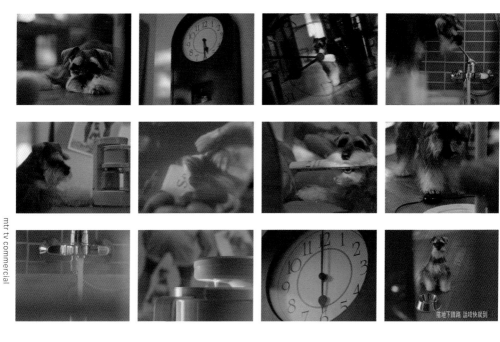

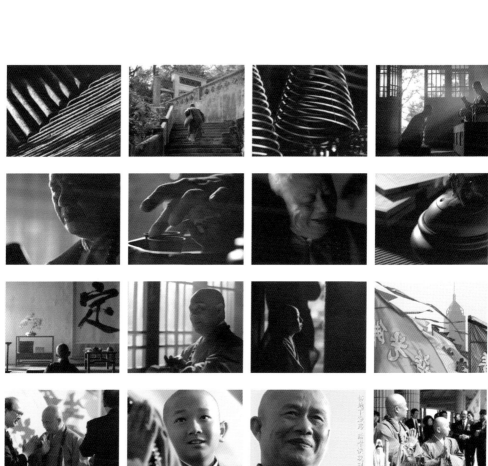

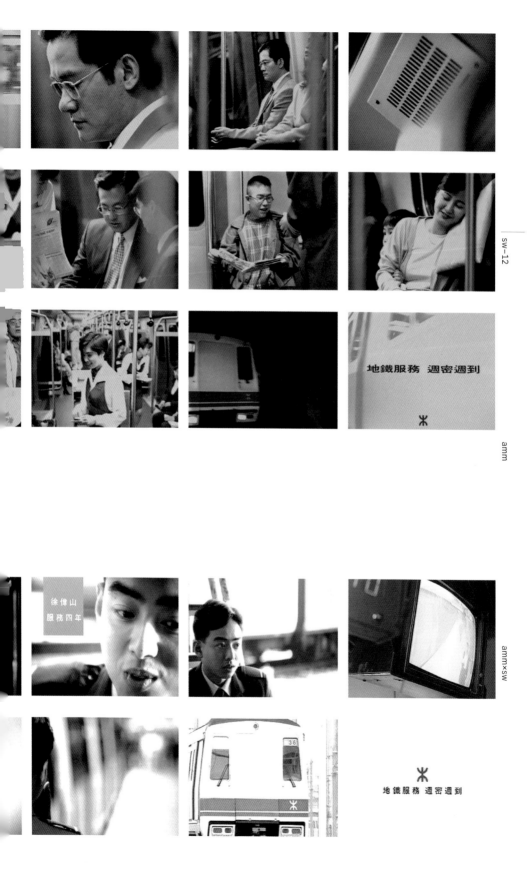

地鐵服務　週密週到

徐偉山
服務四年

地鐵服務　週密週到

fly mtr | **商務客位** | 30"
c.c. | iris lo \ keith ho \ andy wong \ milker ho \ patrick lai \
paul regan [creative] \ david tsui [film director]

train operator | **車長** | 45"
c.c. | gary chui [creative] \ louis ng [film director]

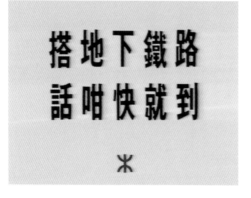

搭地下鐵路
話咁快就到
米

cross harbour | 一水隔天涯 | **30"**
c.c. | iris lo / andy wong / patrick lai / shirley chow / keith ho / kelvin hung [creative] / ringo tang [film director]
aw. | 1994 hkda design show / tv commercial / silver
1994 hk 4a's creative award / tv / 3 bronze

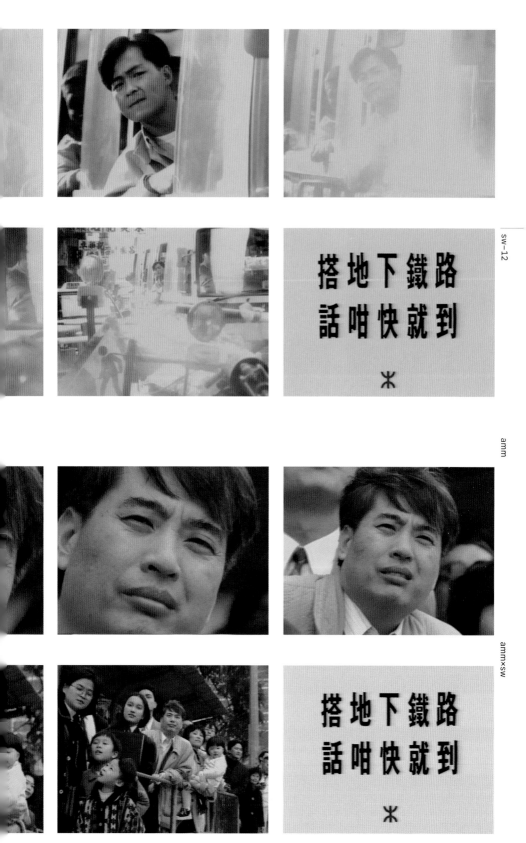

road works | 遺陷阱 | 30'

bus stop | 莫等待 | 30"

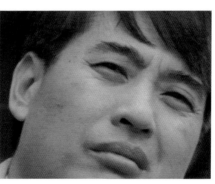

sw—13

chinese obituary | 訃聞

amm

● | poster \ print advertising \ tv commercial | ● 1992

▲ | tvc

aw. | 1992 media asian advertising awards \ print \ spike
1992 hkda design show \ poster \ print \ gold · advertising campaign \ silver
1992 hk 4a's creative award \ poster \ print \ bronze
1997 the first international chinese graphic design competition \ gold

cl. | friends of the earth (hk)
c.c. | raymond chau \ paul ragan
a.c. | j. walter thompson (hk)
col. | hong kong heritage museum \ m+

amm×sw

胞弟

一名脊索動物

生於
海洋 俗稱 魚 痛於

公曆 一九九一 年
農曆 辛未 正二月 壽終時家

園飽受人類工業廢料排
泄物有毒化學物重金屬
放射性物質原油等嚴重

體隨水飄浮葬於海上垃圾堆中　哀此訃

泣告

胞兄　海豚
大海龜
鯨魚

胞妹　珊瑚

表兄弟　大熊貓
大猩猩
犀牛
大象
金絲猴

親屬繁衍　不能盡錄

治喪處：地球之友　電話：五二八五五八八

聞

挚愛

一棵不開花的植物〔類別〕喬木〔又稱〕樹

痛於〔公曆一九九一〕〔農曆辛未〕年某月某日因被人類

過量砍伐壽終於熱帶雨林享壽一

百零二歲遺體隨即轉移人類工廠

用作造紙原料　哀此訃

未亡人　地球僅餘的熱帶雨林

胞兄弟　地球一半的熱帶雨林

胎兄弟　十二萬五千種雨林樹木

外侄　數以百萬種雨林動物

親屬繁衍　不能盡錄

泣告

治喪處：地球之友　電話：五二八五五八八

聞

先母清新空氣〔因〕飽受人類工業廢氣

及汽車廢氣嚴重污染引致長期呼吸

困難卒於〔公曆〕二十世紀窒息而終慟離

全球五大洲工商業城市　哀此訃

孝子　亞洲　孫香港

歐洲

北美洲

南美洲

非洲

泣告

治喪處：地球之友　電話：五二八五五八八

註：因《廣播條例》所限，訃聞訊息不能在電視平台播放，所以這系列的電視廣告未有正式「出街」。雖然我們有力爭這不是一般為人類死者發放訊息的訃聞，但最後都未有成功。

remark: due to the regulation of the broadcasting ordinance, obituaries cannot be televised, as such this series of television advertisements were never broadcasted. we have however, tried our best in explaining to the authority that this is not an obituary for a deceased person, but to no avail.

聞

愛兒 臭氧層 體質單薄易受損傷肩負過濾

太陽紫外線以保護地球生物因人類肆意

妄爲備受破壞卒慟於公曆一九八〇年代

首先於南極上空辭世其他地區之臭氧層

亦在彌留掙扎祈求天憫 哀此訃

父 地球
母 大氣層

泣告

治喪處：地球之友 電話：五二八五五八八

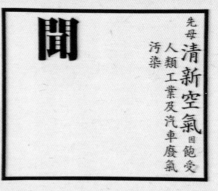

↑chinese obituary / ocean ｜訃聞 / 海洋 ｜30"

↑chinese obituary / air｜訃聞 / 空氣｜30"

↓chinese obituary / tree｜訃聞 / 樹｜30"

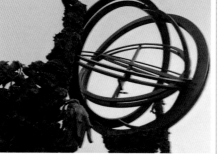

tv commercial creative ｜ 電視廣告創作

● tv commercial ｜ ● 1994

▶ tvc

a.c. ｜ j. walter thompson (hk)

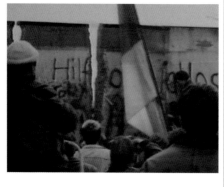

imagine ｜ 只要有夢想 ｜ **1'30"**
cl. ｜ hkt management ltd.
c.c. ｜ tan shen guan / iris lo [creative] / louis ng [film director]
aw. ｜ 1996 hkda design show / tv / bronze

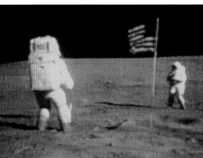

只要有夢想　凡事可成眞

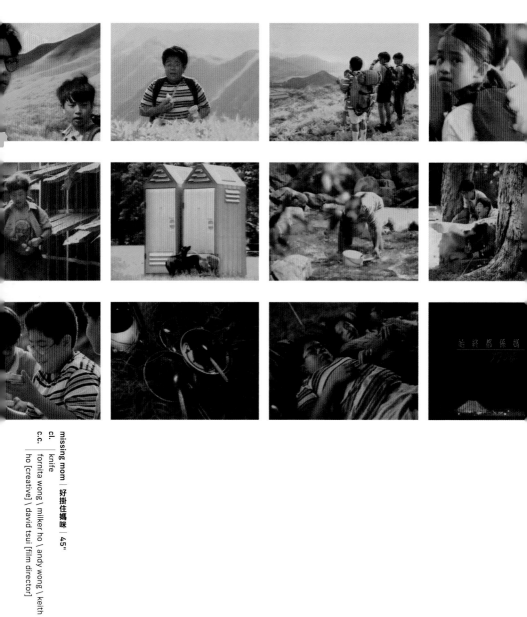

missing mom | 好掛住媽咪 | 45"

cl. | knife

c.c. | fornita wong \ milker ho \ andy wong \ keith
ho [creative] \ david tsui [film director]

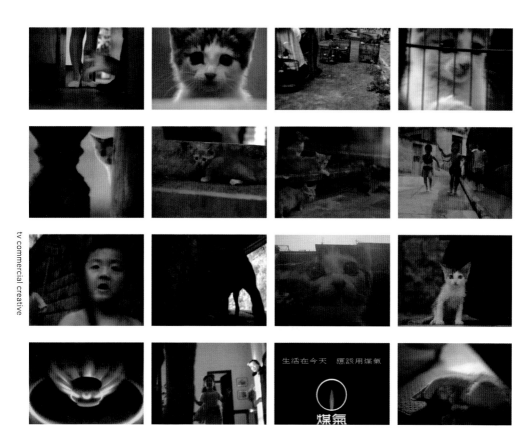

生活在今天　應該用煤氣

煤氣

cat 回家真好 | 45"
cl. the hong kong and china gas co.ltd.
c.c. fornita wong \ milker ho \ tony liu \ victor
chan [creative] \ louis ng [film director]

sw-15

archive no.

set your own boundaries | 無邊無界 · 生活之態

● tv commercial \ print advertising ● 1998

▲ tvc

cl.	festival walk
c.c.	flora chow \ simon jenkins [creative] \ tai heng [co-film director] \ john chang [photography]
a.c.	bartle bogle hegarty (asia)

in 1990s, this project was extraordinary in two ways:
1. a commercial brand in hong kong went all the way to singapore, looking for ideas from an asian advertising creative agency.
2. a breakthrough in the promotion of the commercial consumerist lifestyle.
an exploration into the values and goals of hongkongers at the moment after the handover.

在九十年代，這項目是兩個不尋常。

一．香港的商業品牌找一間遠在新加坡的亞洲廣告創意公司出方案。

二．一般商業的消費生活意識形態，推廣模式被打破，進而探索回歸中國當刻，香港人更關心生活上以至內心的價值和追求。

美食閣，

無邊無界 生活之態

又｜城

（為食

每日馬不停蹄，為口奔馳，不能馬
離開工作的框，應該坐下來細意品嚐豐富的一

又一城有二十家食
匯聚西班牙，意大利，日本，泰國，美國及各式中

放下工作後吃頓美味可口的，總算

（真真假假 是是非非 喜喜悲悲）

（日日如是，人生不過如此？）

日日如是，周而復始，何時終止？工作是永無休止，人生其實不必如此，
放盡懷癖乾崗玩樂，明天又是新開始。

老闆體溫3000°c

人生起伏三番五次

星期一

sw–16

hong kong broadband network | 香港寬頻

archive no.

● tv commercial [creative × film direction] ｜ ● 2003 → 2005

▲ tvc

i have a great time working with ricky wong and his team.
sometimes we are hilariously funny, other times deadpan serious, and that was
another cheerful time in my creative career.

sometimes my friends and colleagues around would say i am a bit of a square
and quiet, but when i create, write and film all on my own, i could be funny.

幾年間，跟王維基及團隊合作無間。
時而嘻哈抵死，時而嚴肅認真，
也是創作生涯中另一段歡樂時光。

有時身跟的朋友同業說我太古板沉默，
但當我創作、寫文案加親手拍攝一腳踢時，
我都有鬼馬的一面。

6m / 10m | **30"**
c.c. | schtung music [music]
a.c. | centro digital pictures ltd.

hong kong broadband network

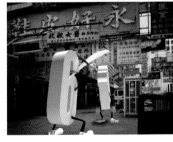

$\dfrac{6公}{2}$

$\dfrac{6公}{2}=3公$

$\dfrac{绿色}{2}$

$\dfrac{绿色}{2}=3色$

$\dfrac{6角形}{2}\neq3角$

$\dfrac{6}{2}=3$

登记热线
3499 0030

香港
寬頻

idd 0030 | 半收費 | 30"
c.c. | Peter millward [music]
a.c. | threetwoone film production ltd.

sw–16

amm

amm×sw

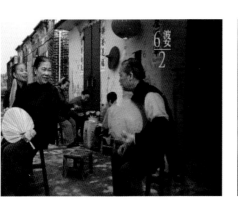

$$\frac{6婆}{2}$$

$$\frac{6婆}{2}=3姑$$

$$\frac{绿色波台}{2}$$

$$\frac{绿色波台}{2}→叫3飞$$

$$\frac{6根清静}{2}$$

$$\frac{6根清静}{2}=3温暖$$

$$\frac{0060}{2}=0030$$

IDD 0030

我不行，我就不上。

我只是一個有幸創造奇蹟的普通人。

甚至超越自己。

因為世界上只有一個人比誰更快

running ahead | 走在自己前面 | 60"
c.c. | nelson ng [film editing] \ eddie chung [music]
a.c. | threetwoone film production ltd.

sw–16

amm

amm×sw

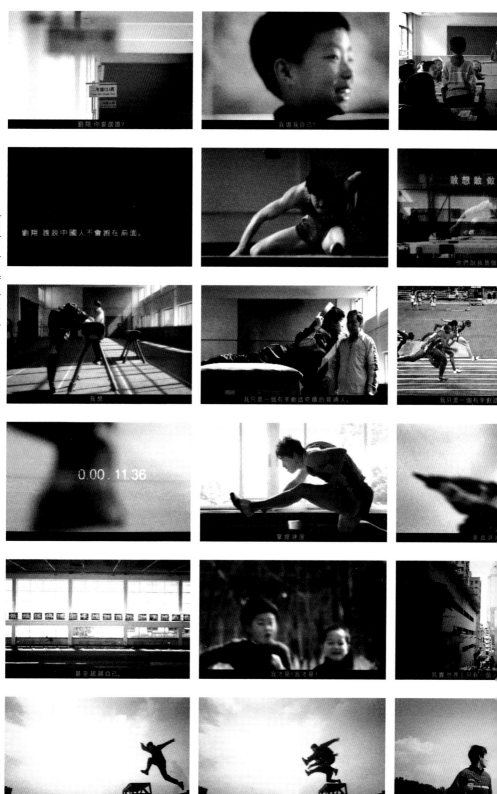

sw–17

aids concern | 關懷愛滋

● print advertising | ● 1994

cl. | aids concern
c.c. | iris lo \ paul ragan [creative]
a.c. | j. walter thompson (hk)

aw. | 1994 hk 4a's creative award \ print \ bronze

Per

omen,
eading
er per-
of fu-
urday
fringe
prior
ur old
ange.
26.

FRIENDLY COUPLE SEEKING adventurous lady to join them for exciting times. Photo please. #860

ABC, EXPAT, 31 Nice looking and easy going. Seeks intelligent, witty and cute Cantonese tutor. Photo/letter please. #861

JAPANESE EXPATORY, 34. Attractive, very sporty. Seeks kind, warm and beautiful lady for sports, travel etc. #862

GOT HIV? YOU'RE THE ONE FOR ME. Supportive, sensitive individual looking for people with HIV all ages and all races for unconditional friendship, care and confidential counselling. Call AIDS CONCERN Helpline 898 4422. (Thur & Sat 7-10 pm)

ATTRACTIVE AMERICAN PROFESSIONAL Fit and young looking 39 year old professional male, wishes to meet an attractive Chinese lady (25-35) for friendship/marriage. As a long-time Tai Chi practitioner, I enjoy Chinese culture and philosophy amongst other aspects. Am sincere, sensitive, generous, down-to-earth and enjoy travel, reading, music, cooking, long walks and quiet evenings. Divorced with no children. Photo please. #863

SINCERE, ATTRACTIVE, INTERESTING professional American, 28, working in

EN

URED
iberal
luring
rsonal

2, HK
oing,
r long-
ng ex-
fiden-
photo

s girls
film,
phone

sh guy
with
dven-

Personals

HELP WANTED

HK MAGAZINE SEEKS CANDIDATES FOR THE FOLLOWING POSITIONS:

■ **Advertising Sales Executive**
 Candidate should be enthusiastic and well-organized. Sales experience a plus.

■ **Shopping Magazine Editor**
 Candidate should be 2-3 yr. HK resident with good knowledge of local shops and services.

Send resumes and cover letters to: Personnel, HK Magazine, 181 Wanchai Rd., #4A, Wanchai, Hong Kong.

Charge Your Love Life!

Now you can charge your personals ad in HK Magazine.

Select the kind of ad you want:

Men who:
☐ Want Women
☐ Want Men

Women who:
☐ Want Men
☐ Want Women

Write your ad:

The following information will remain confidential:
Your Name _____
Address _____

Daytime phone _____

Figure the cost of your ad:

$50 for the first 10 words. $ 50 +
$5 for each additional word.
$5 x _____ words = $ _____
Add $50 for box number. Replies will be forwarded for 3 months. $ 50 +
Only $50 more for your ad (of any length!) to repeat in the following issue! $ _____
TOTAL $ _____

Choose payment:

☐ Check Enclosed
☐ Charge my credit card:
 ☐ Amex
 ☐ Mastercard
 ☐ Visa
For credit card purchases:
Cardholder name: _____
Signature: _____
Card No. _____
Exp Date _____

Please make checks payable to "Asia City Publishing Ltd," and mail with your ad to: Personals, HK Magazine, GPO Box 12618, Hong Kong.

...rais

Left column:

tractive men of any age for hot times and strings attached. Write e to ensure a reply. Dis-
846

ERICAN, INTELLEC-
ller, athletic build, seeks adventure. Strictly con-

lim and very mature who seeks a sincere slim, 30's, life-loving, fond of ature, back-packing, n cooking, music, litera-onversations etc ... If it on board! Picture ok, but appreciated. #852

CHINESE, student, 25, sic. Seeks 22-35 honest, Western guys for sincere , photo, address, phone #853

N-SMOKING Chinese s under 35 for serious hoto/phone please. #854

MBITIOUS, optimistic ys intimacy, conversa-Seeks masculine 30s for e. Nationality open. Dis-ality. Photo please. #855

NTING WOMEN

RETTY 21, seeks similar l, photo please. #865



Chinese, Singaporean or Japanese for cinema, sports, karaoke etc. Want to know more? Phone no and photo appreciated. #833

YOUNG PROFESSIONAL WESTERNER sincere and caring seeks fit and attractive young Chinese girl who is looking for romance, adventure and a long-term relationship. #834

ROMANTIC, CARING, SEMI-CULTURED Kiwi, looking for a sweet, attractive liberal minded young thing for a wild time during the summer holidays. Photo and personal details please. #835

NOW THAT YOU'VE tasted the food, how 'bout other Oriental magic? I am a Western-educated Chinese, 32 and hand-some, looking for an attractive expat lady to sample some Eastern delight. Photo and letter appreciated. #836

NEW YEAR OPPORTUNITY! Sincere English professional, 40 seeks attractive lady to share friendship and fun. Photo appreciated. #837

WESTERN, TALL, 30s would like to meet tall to very tall lady 25-35. For social and friendship. #838



BEEFC
profes
fun. C

CHIN
humo
gym.
friend

UNI H
under
moun
appre

FIVE S
32, lo
sense
ture.

FRENC
single
Photo

ATTRA
lady 4
#859

FRIEN
lady f
please

ABC,
going.
Canto

JAPA
sporty
lady f

ATTRA
Fit an
sional
Chine
riage.

Personals HK

WANT MEN

NICE, CARING, SLENDER, cute, attractive, professional Chinese lady, 31. Enjoys movies, dining-out, sports, travel. Sincerely seeking a steady Western/Chinese boyfriend. He must be a well-educated professional, 31-38, single, willing to have steady-girlfriend, good-looking, tall, gentle, considerate, mature, generous and not very busy. Sincere replies with photo and phone only, please. #841

BLONDE, BRIGHT and moderately chested (?), 26. Seeking orphaned veterinarian, aged 28-40. Generous sense of humor necessary. Photo please. #851

MEN WANTING MEN

QUIET, GENUINE, SLIM, Chinese, 23, 5'7". Seeks masculine, discreet and caring Caucasian/Asian guy between 25-45 for friendship/relationship. #830

CUTE CHINESE (21+), seeks GWM (30+) for walk in countryside and/or for language tuition. #844

BRIT, 35, living on Lantau seeks other islanders for friendship or more. Leave phone message ONLY! #845

GOOD-LOOKING, MARRIED, professional European, 34, 5'7" seeks other married/single attractive men of any nationality and age for hot times and friendship. No strings attached. Write with photo please to ensure a reply. Discretion assured. #846

AFRICAN-AMERICAN, INTELLECTUAL, world traveller, athletic build, seeks wealthy friend for adventure. Strictly confidential #850

IS THERE ANY slim and very mature Chinese, late 20's, who seeks a sincere slim, European, mid 30's, life-loving, fond of water-sports, nature, back-packing, photography, Asian cooking, music, literature, late-night conversations etc ... If it fits you, welcome on board! Picture ok, but not a must, letter appreciated. #852

GOOD-LOOKING CHINESE, student, 25, enjoys art and music. Seeks 22-35 honest, masculine Asian/Western guys for sincere friendship. Letter, photo, address, phone no ensures reply. #853

ATTRACTIVE, NON-SMOKING Chinese teacher, 30. Seeks under 35 for serious companionship. Photo/phone please. #854

CHINESE, 23, AMBITIOUS, optimistic professional. Enjoys intimacy, conversation, arts, sports. Seeks masculine 30s for friendship or more. Nationality open. Discretion, confidentiality. Photo please. #855

FUNNY AND FRIENDLY Chinese, 25, 5'6". Seeks gentle, sincere and mature guy for social and friendship. Please write with details. #868

LOCAL CHINESE, 30'S 5'10", slim, gentle, considerate. Seeks sincere Westerner, 25-40 for friendship. Discretion assured. Welcome those who live far away from main island or new to HK. #869

HOT YOUNG THAI Professional, 30's, 5'9". Recently moved to Hong Kong. Seeks dinner companion, must enjoy hot and spicy. Please respond with photo - all enquiries will be answered. #870

CHINESE, 35, 5'6", 130lbs. Seeks "Mr Right", 31+ who enjoys travelling, quiet and peaceful life of two and has a view of monogamous long term relationship. Photo and phone appreciated. #871

WOMEN WANTING WOMEN

FILIPINA, SLIM, PRETTY 21, seeks similar Asian/Filipina girl, photo please. #865

IS THERE ANY slim and very mature Chinese, late 20's, who seeks a sincere slim, European, mid 30's, life-loving, fond of water-sports, nature, back-packing, photography, Asian cooking, music, literature, late-night conversations etc ... If it fits you, welcome on board! Picture ok, but not a must, letter appreciated. #852

GOOD-LOOKING CHINESE, student, 25, enjoys art and music. Seeks 22-35 honest, masculine Asian/Western guys for sincere friendship. Letter, photo, address, phone no ensures reply. #853

ATTRACTIVE, NON-SMOKING Chinese teacher, 30. Seeks under 35 for serious companionship. Photo/phone please. #854

CHINESE, 23, AMBITIOUS, optimistic professional. Enjoys intimacy, conversation, arts, sports. Seeks masculine 30s for friendship or more. Nationality open. Discretion, confidentiality. Photo please. #855

WOMEN WANTING WOMEN

FILIPINA, SLIM, PRETTY 21, seeks similar Asian/Filipina girl, photo please. #865

HK MAGAZINE MARCH 31 - APRIL 7 1995

sw–18

archive no.

spikes are back | 千方百計

● print advertising | ● 1998

cl.	media magazine
c.c.	david droga \ yasmin ahmad \ amish mehta \ tang \ antony redman [creative] \ stanley wong \ yew leong [photography]
a.c.	bartle bogle hegarty (asia)
col.	hong kong heritage museum \ m+

aw. | 1999 the 10th times asia-pacific advertising awards \ silver
1999 the singapore creative circle awards \ magazine campaign \ 2 bronze
2000 hkda design show \ print campaign \ bronze
2000 longxi global chinese advertising awards \ graphic design \ bronze

five reputable masters in the asian advertsing industry, appeared in front of the camera at my disposal. we sailed through it and managed to have some fun on the way. we acted out the ridicule of scam ad, poking fun at all asian colleagues with their 'fake' creative projects so as to get into competitions. that's satisfying! (these real advertisements did win many awards...)

與五位亞洲舉足輕重廣告創意大師合作，更要配合我在鏡頭粉墨登場，無驚無險，嘻哈一下。大家扮演無所不用其極做 scam ad（飛機稿）的荒誕，揶揄所有亞洲做「假」創意參展比賽同業，快哉！（最後這批真實廣告拿了不少大獎⋯）

Hmmm... **Under** what category can I enter an ad for a temple?
Stanley Wong (c.d. Asia)

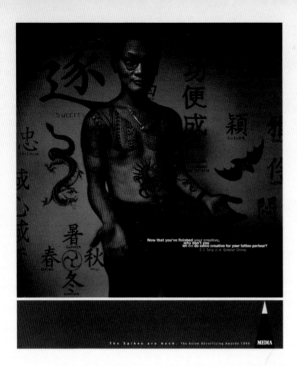

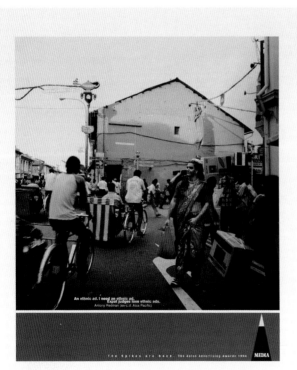

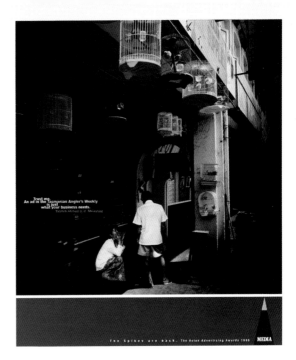

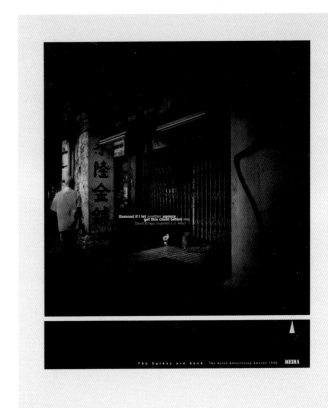

amm

amm×sw

sw—19

chance is out there ｜ 機會無處不在

● print advertising ｜ ● 2002

cl. ｜ media magazine
c.c. ｜ anothermountainman [photography]
col. ｜ hong kong heritage museum

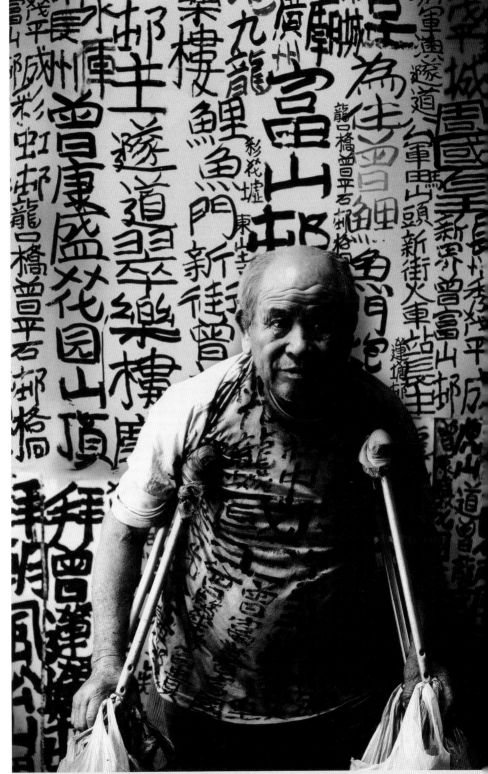

機會無處不在…第二屆亞洲戶外廣告
參賽評情：awards@medi

archive no.

● print advertising | ● 1999

cl. | media magazine
c.c. | enest mak \ kwok wai-ki \ jacqueline chau
a.c. | [creative] \ amazing twin [illustration]
 tbwa (hk)
col. | hong kong heritage museum \ m+

sw–20

black cat, white cat. | 黑貓 · 白貓

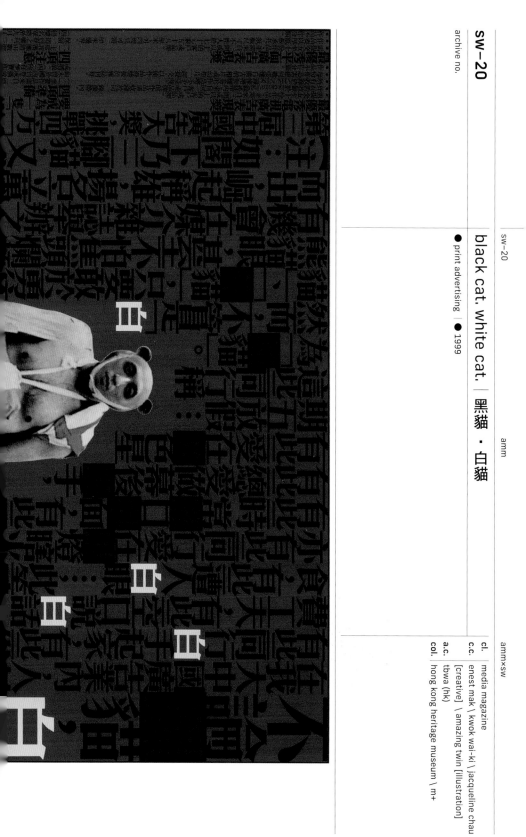

予最恨的，就是中案不怕，避善自用廉身段，敬善之古人受役，請止一隻失節，好戰的添止一隻好戰的添，請貓瞻就雙，別多加。【

犯作同日夜流貪官貪身，
抽此一破頭一會官會，
被捏到被有比，有害官手，
必善德為歡受必善見滿用大特，
行頤「貓官官工作」放好神
官的工作，是好神
有此日日妥神
好，3貓。

black cat. white cat.

sw–21

archive no.

meaning of awards | 獎的意義

● print advertising | ● 1999

cl. | media magazine
c.c. | patrick lai \ pessy chow [creative]
a.c. | tbwa (hk)

aw. | 2000 hk 4a's creative award \ best chinese copy \ bronze

hk

MEDIA： 是 A 君的免死金牌，讓他繼續每天三點不露（不到下午三時不露面）。

是 B 先生的偉哥，沒有時自視不成，擁有時凡事水到渠成。

是 C 妹的 Gucci 和 Prada。

是 D 和 E 的性事，初試時怕不成事⋯打後就覺得不外如是。

是 F 小姐在台上七十支射燈下，向千百同業展示她那三卡四十五份鑽石的最佳時機。

是 G 美指開給公司鄰房臭四的啞藥。

是 H 同志去年三百六十二晚沒回家吃飯後給老頭子的交待。

是亞 I 反擊無能老闆的秘密武器。

是小 J 的改錯水，可把是非黑白蒙敝。

是 K 大哥給仇家的毒咒，令他們的紅眼症永不痊癒。

是你的甚麼，由你自己決定。畢竟，誰不想創造自己⋯再造自己？

一切盡發生於九九年媒介雜誌亞洲廣告大獎。

索取參賽表格，請與媒介雜誌劉淑儀小姐或鄧碧珠小姐聯絡。　電話：(852)2577 2628　傳真：(852)2576 9171　地址：香港銅鑼灣怡和街48號麥當勞大廈11樓　電子郵

charity \ social \ tv commercial ‖ 公益 \ 社會 \ 廣告

● promotion video [creative × film direction] | ● 2000 → 2019

▲ tvc

mostly joining charity promotion projects as a half volunteer, being there, engaging in dialogues and working with the people in frames have taught me greatly.

大多數以半義工身份參與公益廣告推廣項目，其中親歷其境和鏡中主角對話、相處，對做人做事獲益良多。

 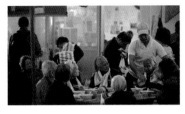

bless hong kong | 築福香港 | 2'45"

cl. | commission on poverty, the government of the hong kong special administrative region
c.c. | nelson ng / touches [film editing] / eddie chung [music]
a.c. | 84000 communications ltd.

drinking wine | 飲酒 | 4'40"
cl. | universal music hong kong
c.c. | alex fung [music] \ tao yuanming [poem] \
 | nathan shum [film editing]
a.c. | 84000 communications ltd.

the opportunity and freedom given by alex fung and the record company were rare, with the symphony combining alex's music and a poem by tao yuanming, i expressed my wishes towards my city of hong kong and a way for us all to live together.

難得馮翰銘及唱片公司給我機會和自由度，借他和陶淵明的詩合作而成的樂章，抒發我對香港我城的期盼和共處之道。

helping each other / designers | 同仁 · 共濟 / 薈英設計師 | 2'30"
cl. | yan chai hospital
c.c. | nathan shum [film editing] / benson fan [music]
a.c. | 84000 communications ltd.

helping each other / lai h. w. | 同仁 · 共濟 / 賴凱詠 | 3'00"

cl. | yan chai hospital
c.c. | nathan shum [film editing] / benson fan [music]
a.c. | 84000 communications ltd.

helping each other / law g.f. | 同仁 · 共濟 / 羅桂芳 | 2'17"

cl. | yan chai hospital
c.c. | nathan shum [film editing] / benson fan [music]
a.c. | 84000 communications ltd.

building hong kong. building yourself. | 建造香港・建造自己 \ 胡善姬 | 2'30"
cl. | hong kong institute of construction
c.c. | nathan shum [film editing]
a.c. | 84000 communications ltd.

SW–22

amm

amm×sw

as long as we're willing to work hard, we can do whatever they can do

很少看到女孩子從事這行業
It's rare to see women work in carpentry

Women are better at

This is what I find most fascinating about carpentry

木是有生命的，這樣時間和空間，如何去演繹它呢？
Wood has life right? At this time and space, how do you transform it?

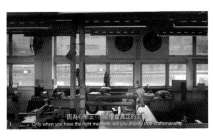
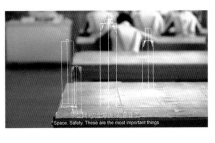

因為心態正了才能夠掌握真正的工藝
Only when you have the right mentality will you display true craftsmanship

Space. Safety. These are the most important things

It doesn't

賺錢當然重要，要夠我也要搵食
Of course earning money is important I still have to make a living after

多有能力也沒有用
It doesn't mean anything if you don't enjoy what you do

I want to

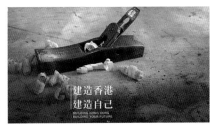

到我他朝有所成就
The day when I've achieved my goals

建造香港
建造自己
BUILDING HONG KONG
BUILDING YOUR FUTURE

香港
建造
學院

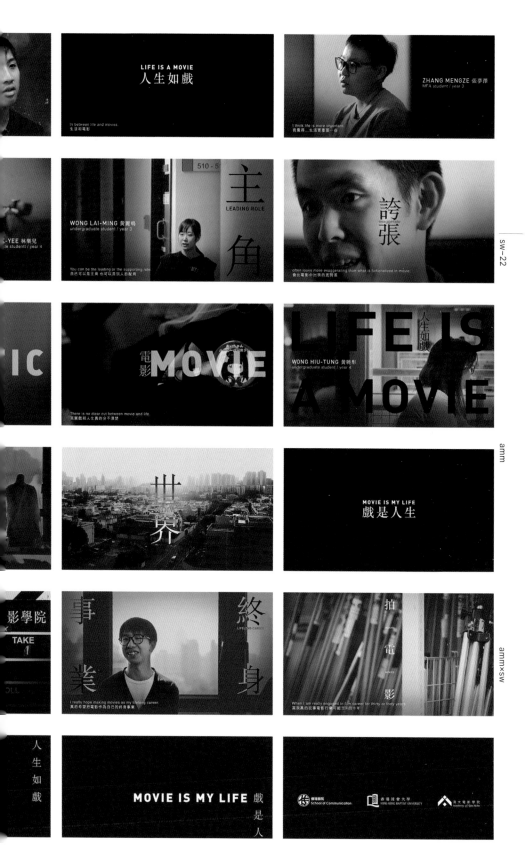

life is movie. movie is my life. | 人生如戲　戲是人生 | 3'30"

cl. academy of film, hong kong baptist university

c.c. kong man-ning \ lai mei-huen \ lam sze-long \ lam lok-yee \ lau ka-yin \ ma man-sing \ wong tak-kit \ yau hoi-chun \ zhang mengzet [co-directors \ students] \ nathan shum \ karen lai [film editing] \ dr.ellis-geiger robert jay [music] \ leung yau-cheong \ chiang kun-leong \ qureshi mohammad talha \ wong hiu-tung \ wong lai-ming [film production]

a.c. 84,000 communications ltd.

charity \ social \ tv commercial

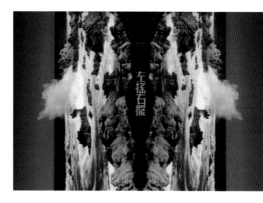
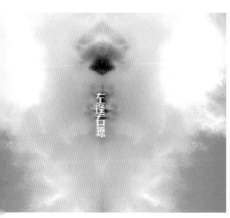

left / right / anthony wong concert video
左左右右 / 黃耀明光天化日演唱會錄像 ｜ 1'15"

archive no.

sw–23

i came here first... | 我先來到的...

● print advertising | ● 1998

cl. | levi strauss & co. (asia)
a.c. | bartle bogle hegarty (asia)
col. | m+

aw. | 1997 media asian advertising awards \ print \ spike

this was one of the indelible experiences in the forty years of my creative career. 'persistence' is...

the creative brief – a sale for levi's jeans in indonesia. just when it seemed that there was little need for creativity, we came up with a funny, a bit ridiculously crazy idea.

it was a big success in every sense, we even pocketed some big awards. haha.

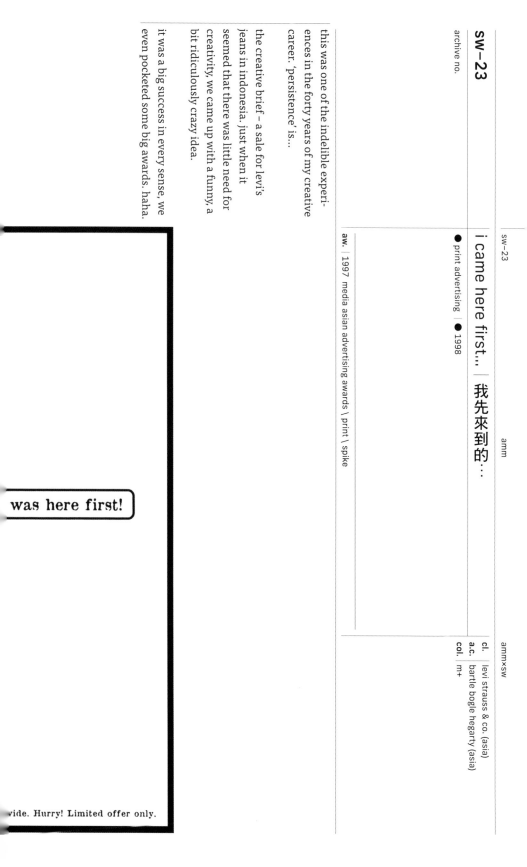

was here first!

vide. Hurry! Limited offer only.

這是四十年商業創作生涯中，
其中一次深刻感受，
「堅持」就是⋯

案子是印尼 levi's 牛仔褲大減價。
看似沒可創意發揮相提並論之時，
我們找到了一個令人發笑、
半帶荒謬的瘋狂出發點。
叫座並叫好，
還拿了些大獎。
haha。

They're mine....

sw—24

archive no.

make for life | 為生命而造

● print advertising | ● 1997

cl.	levi strauss & co. (asia)
a.c.	howard collinge [creative] \ john clang [photography]
a.c.	bartle bogle hegarty (asia)
col.	m+

aw. | 1997 the 8th times asia-pacific advertising awards \ gold

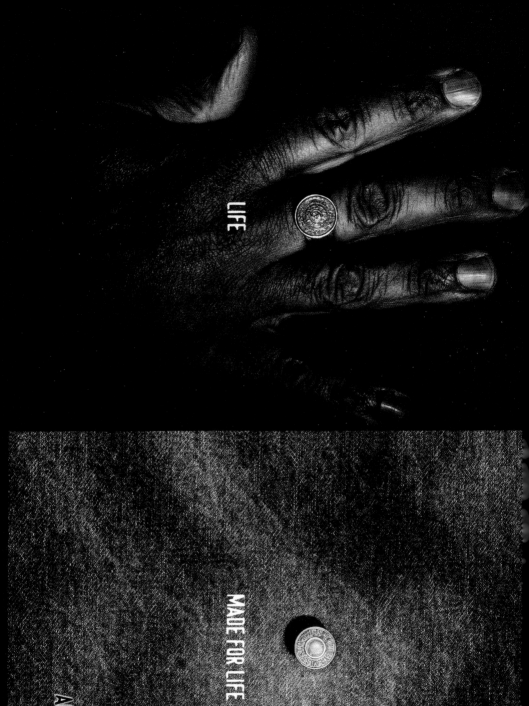

LIFE

MADE FOR LIFE

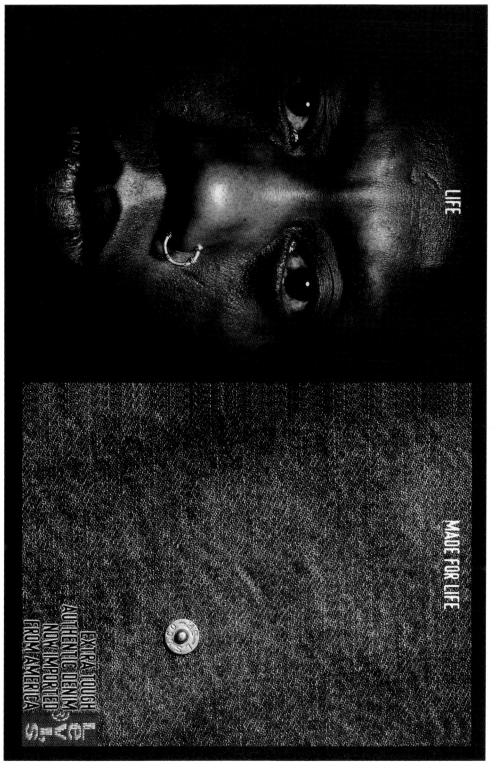

amm

ammxsw

sw–25

archive no.

tough | 堅強

● poster \ print advertising | ● 1997

cl. | levi strauss & co. (asia)
a.c. | howard collinge [creative] \ alex kai keong
[photography]
a.c. | bartle bogle hegarty (asia)
col. | m+

LEVI'S ORANGE TAB. 100% tough denim. Do not treat gently.

LEVI'S ORANGE TAB. 100% tough denim. Do not treat gently.

LEVI'S ORANGE TAB. 100% tough denim. Do not treat gently.

LEVI'S ORANGE TAB. 100% tough denim. Do not treat gently.

archive no.

sw–26

cl. | fuji photo products co.,ltd.
a.c. | 84000 communications ltd.

fujifilm tv commercial series | 富士相機廣告系列

● promotion video [creative × film direction] | ● 2017 → 2019

▲ tvc

the experiences of many collaborative projects with the japanese have increased my awareness of the differences and similarities between chinese and japanese cultures. along the way, making me believe in and promote asian cultures and aesthetics in a big picture.

多次跟日本合作項目的經驗，更加深刻感受到中、日文化之差異和共通。以致多年來，一直相信及推動的東方文化、美學之大圖畫。

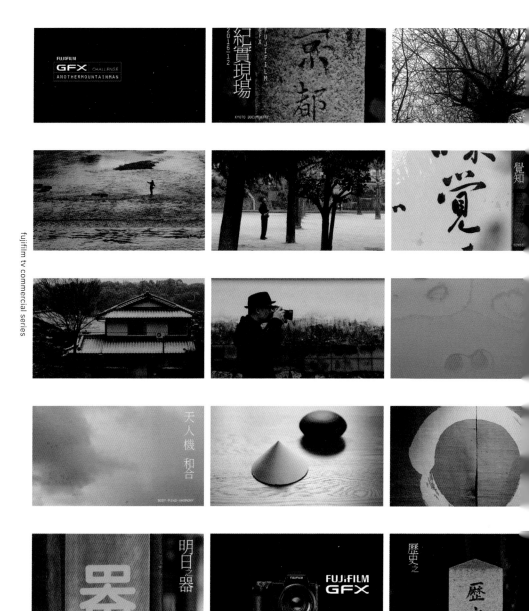

gfx challenges | **gfx 挑戰** | **2'00"**

c.c. | xu wai-hoi [film editing]

aw. | 2018 hkda global design awards biennial / short film / judges' choices / gold / hk best

proud of / xh1 | 引以為傲 | 1'20"
c.c. | nathan shum [film editing]

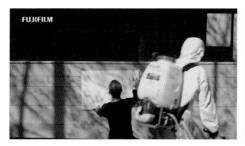

ONE:ALL

ONE:ALL

ONE=ALL

ALL=ONE

FUJIFILM GFX 50R X

FUJIFILM

GFX 50R X

一即一

ONE=ALL

一切即一

ALL=ONE

all=one / gfx | 一切即一 | 1'20"
c.c. | nathan shum [film editing]

GFX 50R

TITLE
ALL=ONE
主題
—切即—

ARTWORK VIDEO / 創作錄像

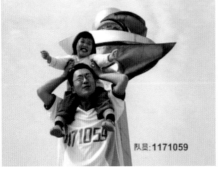

advertising creative × director \ production

廣告創作 × 導演 \ 製作

● 2001 → 2014

▶ tvc

china team │ 中國隊員 │ 60"

cl. │ adidas

c.c. │ chris kyme [creative] / yu yat-yiu [music]

a.c. │ bang! / threetwoone film production ltd.

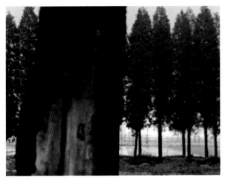
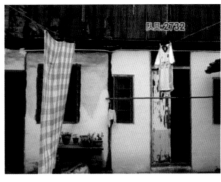

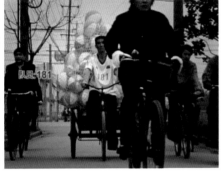
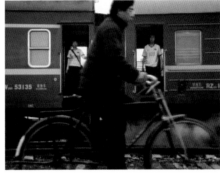

how are you │ 早晨 │ 45"
cl. │ circle k
a.c. │ threetwoone film production ltd.

easy · live | 自在 · 住在 | 2'16"
cl. | purple jade villa
a.c. | threetwoone film production ltd.

sw–28

tv commercial director \ production｜廣告導演 / 製作

● 2001 → 2006

▶ tvc

ever since i was 40 years old, i have interacted and worked with many advertising creatives in these twenty years. in a different position, i, as the film director, helped their ideas coming alive. these hundred times of experiences are learnings and another form of challenges.

打從四十歲開始，近二十年間，跟無數的廣告創作人互動合作；易地而處，身為導演，給他們的意念錦上添花，執行實現，百多次的經歷，是一種學問和另一種挑戰。

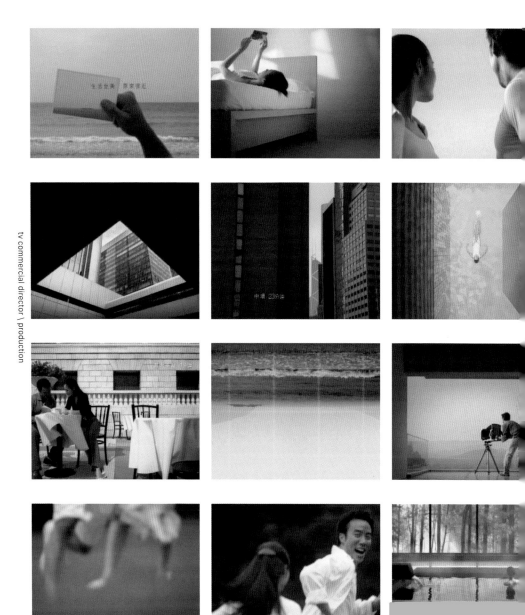

close to you │ **盡在分秒間** │ 1'30"
cl. │ caribbean coast
c.c. │ fcb creative team [creative] /
 │ threetwoone film production ltd. [production]
a.c. │ fcb advertising (hk)

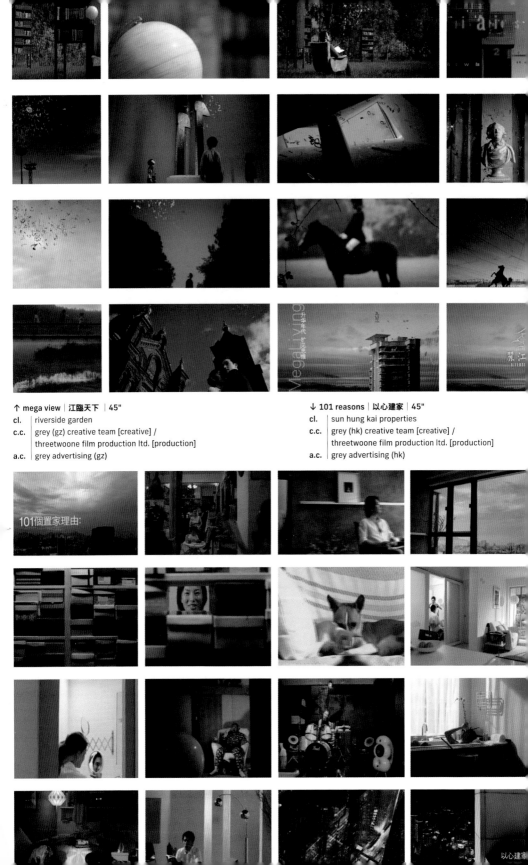

↑ **mega view** | 江臨天下 | 45"
cl. | riverside garden
c.c. | grey (gz) creative team [creative] /
threetwoone film production ltd. [production]
a.c. | grey advertising (gz)

↓ **101 reasons** | 以心建家 | 45"
cl. | sun hung kai properties
c.c. | grey (hk) creative team [creative] /
threetwoone film production ltd. [production]
a.c. | grey advertising (hk)

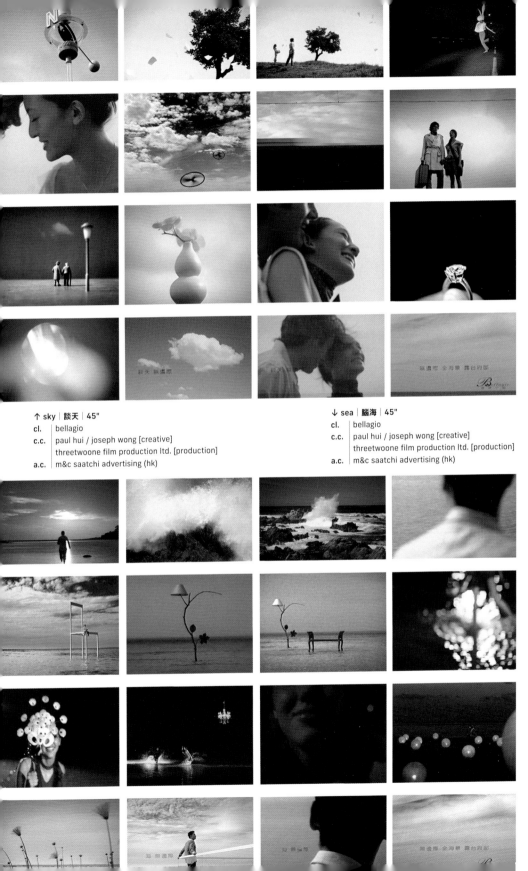

↑ sky｜談天｜45"
cl.　｜bellagio
c.c.　｜paul hui / joseph wong [creative]
　　　｜threetwoone film production ltd. [production]
a.c.　｜m&c saatchi advertising (hk)

↓ sea｜腦海｜45"
cl.　｜bellagio
c.c.　｜paul hui / joseph wong [creative]
　　　｜threetwoone film production ltd. [production]
a.c.　｜m&c saatchi advertising (hk)

jumping fence │ 沒有跳不過的欄 │ 30"

cl.	olympic equestrian
c.c.	spencer wong [creative] \
	84000 communications ltd. [production]
a.c.	mccann erickson advertising (hk)
aw.	hk 4a's kam fan awards \ best editing

sigh... │ 唉… │ 60"

cl.	bounce back – rebuild hong kong
c.c.	carol lam / ng fan [creative]
	threetwoone film production ltd. [production]
a.c.	ogilvy & mather advertising (hk)

世上沒有跳不過的欄

↑hakka lady │ 客家婆 │ 60"

cl.	clp power hong kong ltd.
c.c.	euro rscg creative team [creative] / threetwoone film production ltd. [production]
a.c.	euro rscg partnership (hk)

←hong kong spirit │ 香港精神 │ 60"

cl.	octopus cards ltd.
c.c.	spencer wong / affa lee [creative] / nelson ng [film editing]
a.c.	mccann erickson advertising (hk)

court | **法庭** | **30"**
cl. | hong kong breastfeeding mothers' association
c.c. | fcb creative team [creative] \
threetwoone film production ltd. [production]
a.c. | fcb advertising (hk)

teacher | **老師** | **30"**
cl. | hong kong breastfeeding mothers' association
c.c. | fcb creative team [creative] \
threetwoone film production ltd. [production]
a.c. | fcb advertising (hk)

news | **新聞報導** | **30"**
cl. | hong kong breastfeeding mothers' association
c.c. | fcb creative team [creative] \
threetwoone film production ltd. [production]
a.c. | fcb advertising (hk)

price gun | 罰你六百 | **30"**

cl. food and environmental hygiene department,
the government of the hong kong special administrative region

c.c. saatchi & saatchi (hk) creative team [creative] \
threetwoone film production ltd. [production]

a.c. saatchi & saatchi advertising (hk)

do.do.do. | 噔噔噔 | **30"**

cl. mtr corporation ltd.

c.c. christine pong \ derek wong \ o'poon \ edmond chan [creative] \
threetwoone film production ltd. [production]

a.c. ddb advertising (hk)

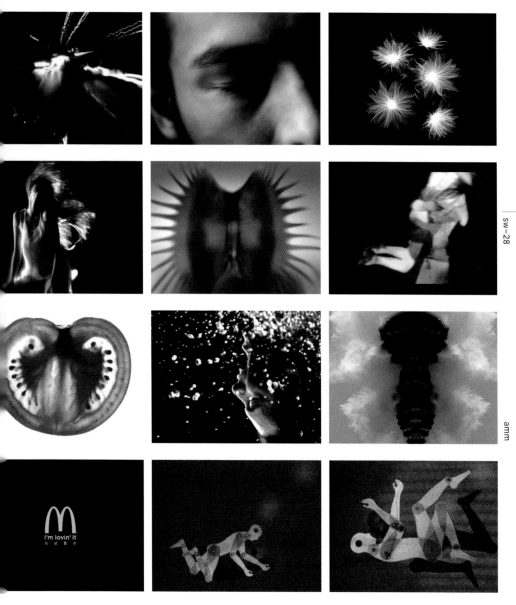

↓ jack | 30"
cl. | mcdonald's (china)
c.c. | jeffrey gamble & creative team [creative] /
threetwoone film production ltd. [production]
a.c. | ddb advertising (hk)

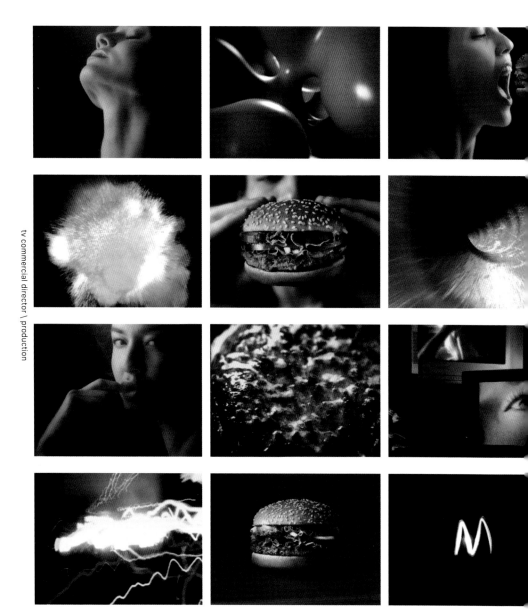

feel the beef | **60"**

cl.	mcdonald's (china)
c.c.	ruth lee / stephen kong / alexis mardapittas [creative] / threetwoone film production ltd. [production]
a.c.	leo burnett advertising (china)

a MYSTERIOUS NUGGETS LOVER, DUBBED JACK THE DIPPER,

a MYSTERIOUS NUGGETS LOVE

THAI CHILI MAYO

i'm lo

A MYSTERIOUS NUGGETS LOVER, DUBBED JACK THE DIPPER,

WHAT NOW?

香!

sw–29

wong kar-wai film poster｜王家衛電影海報

● poster [film promotion]｜● 1994 → 1995

cl.｜jet tone productions limited
c.c.｜william chang [film art director]
col.｜hong kong heritage museum \ m+

my collaboration with william chang is about the reading of the minds.
my interaction with wong kar-wai needs no words...
working on a hong kong movie that defines the spirit of the times with two
great creative masterminds of the times is indeed a great honour.

與張叔平的合作是神交。
和王家衛大導交流通常盡在不言中⋯
為香港時代性的一齣戲和背後兩位時代性的創意人共事，與有榮焉。

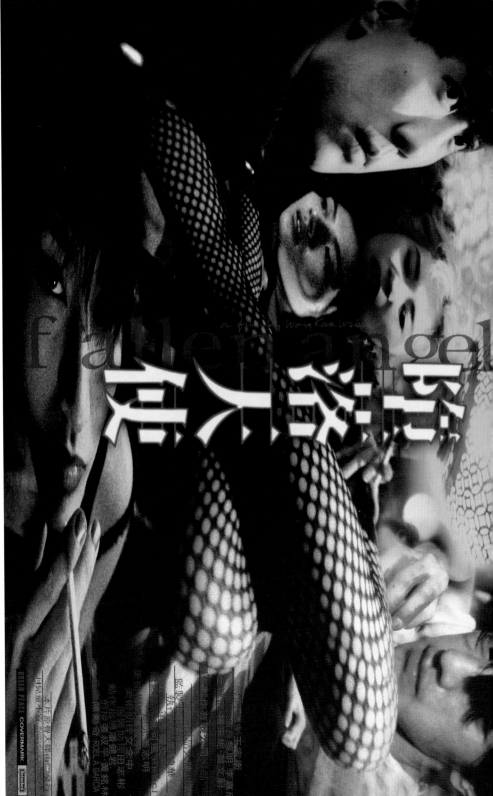

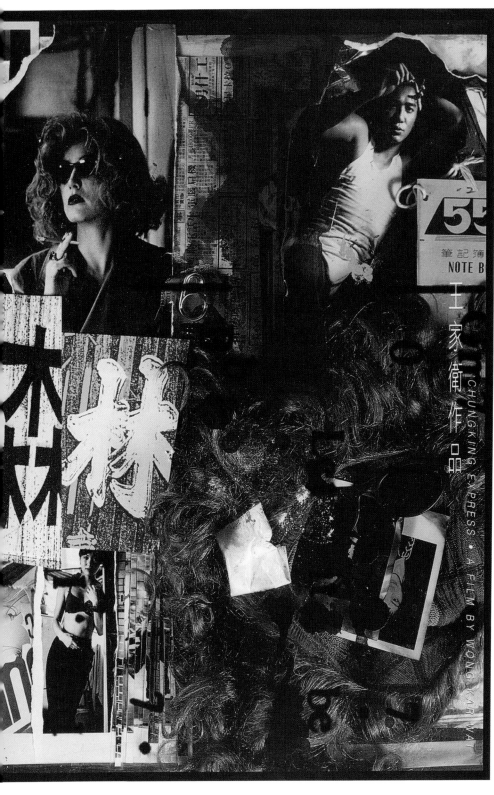

heaven & hell \ agi \ hong kong conference

天堂與地獄 \ 國際平面設計聯盟 \ 香港會議

amm×sw

cl. | alliance graphique internationale (agi)
c.c. | hung lam [exhibition design] \
| 84000 communications ltd.
col. | m+

● event visual \ book \ poster [cultural promotion] | ● 2012

"heaven and hell" is the theme of the agi 2012 held during the hong kong design conference and exhibition.

heaven and hell are relative,
there is always bad in good, and good in bad.
it is heaven and it is hell.

a long time ago, hong kong was a "shopping paradise" and
then it also became a "gourmet paradise".
heaven is perfection, is a dream,
a pursuit, an epitome...
a common line in movies – "there is a road to heaven but
you shun it, there is no door to hell yet you break in..."

or, another oft-heard line,
"if i do not risk going to hell, no one will."

heaven and hell exist in the mythical world.
heaven and hell exist in the religious world.
there is heaven and hell in the west.
there is heaven and hell in the east.
if hell is in the abyss between the east and the west,
then,
heaven should be up high,
closer to the sky...
in the buddhist world,
there are also two states of existence:
purified land (heaven) exists among us,
right before us, in our minds,
and so does hell.
one thought can take us to heaven,
another thought can bring us hell.

AGI OPEN
HONG KONG 2012

José Albergaria + Rik Bas Backer / Ian Anderson / Andrew Ashton /
Marian Bantjes / Tony Brook / Alvin Chan / Oded Ezer / Vince Frost /
Kenya Hara / Jiang Hua / Kan Tai-keung / René Knip / Hung Lam /
Tommy Li / Sascha Lobe / Anukam Edward Opara / Sean Perkins /
Dean Poole / Paula Scher / Adrian Shaugnessy / Antonio Silveira Gomes /
Wang Xu / Markus Weisbeck / Stanley Wong ... and more world class mast

24 - 25 September 2012
HK Jockey Club Amphitheatre
The Hong Kong Academy for Performing Arts

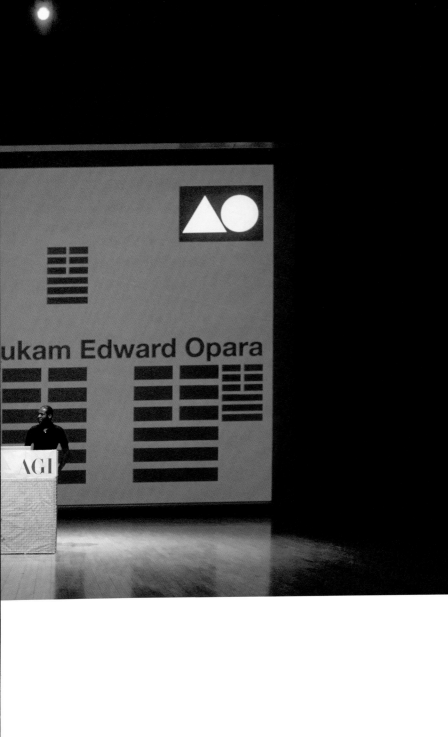

《天堂與地獄》是 AGI 二〇一二在香
港舉辦設計會議及活動的主題。

天堂與地獄是一個相對的，好中有壞，
壞中有好的概念。

也是地獄。也是天堂。

很久很久以前，

香港被譽為「購物天堂」

後又被稱「美食天堂」。

天堂是美好至極，是夢，是追求，
是指標⋯

電影常出現這句話：「天堂有路你不
走，地獄無門你闖進來⋯」

另外一句：「我不入地獄，誰入地獄。」

神話世界有天堂地獄。

宗教世界有天堂地獄。

西方有天堂地獄。

東方有天堂地獄。

如果地獄是在東西方之間地底最深處，

那麼，

天堂是較近哪一方之天空上面⋯

佛的世界也有另兩角度：

淨土（天堂）就在人間，

地獄也在眼前。

一念天堂，一念地獄。

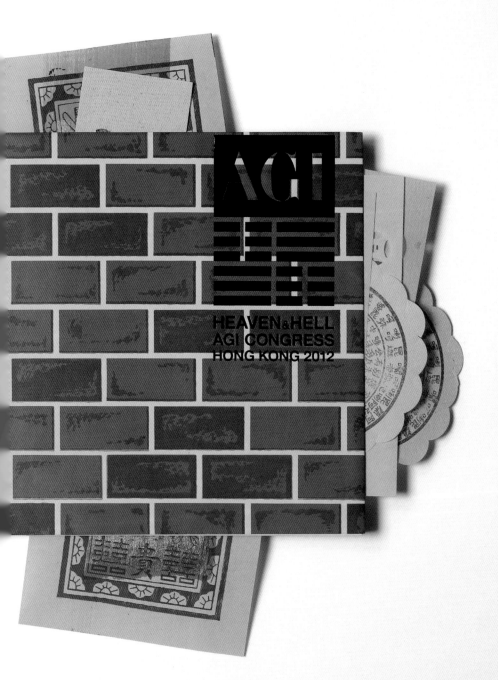

AGI OPEN
G KONG 2012

garia + Rik Bas Backer / Ian Anderson / Andrew Ashton /
ntjes / Tony Brook / Alvin Chan / Oded Ezer / Vince Frost /
a / Jiang Hua / Kan Tai-keung / René Knip / Hung Lam /
Sascha Lobe / Anukam Edward Opara / Sean Perkins /
e / Paula Scher / Adrian Shaugnessy / Antonio Silveira Gomes /
Markus Weisbeck / Stanley Wong ... and more world class masters.

tember 2012

Club Amphitheatre
Kong Academy for Performing Arts

ilable Now! Visit our website for more details
.agi-open.org

AGI OPEN
HONG KONG 2012

José Albergaria + Rik Bas Backer / Ian Anderson / Andrew Ashton /
Marian Bantjes / Tony Brook / Alvin Chan / Oded Ezer / Vince Frost /
Kenya Hara / Jiang Hua / Kan Tai-keung / René Knip / Hung Lam /
Tommy Li / Sascha Lobe / Anukam Edward Opara / Sean Perkins /
Dean Poole / Paula Scher / Adrian Shaugnessy / Antonio Silveira Gomes /
Wang Xu / Markus Weisbeck / Stanley Wong ... and more world class masters.

24 - 25 September 2012

HK Jockey Club Amphitheatre
The Hong Kong Academy for Performing Arts

Tickets Available Now! Visit our website for more details
http://www.agi-open.org

GI OPEN
G KONG 2012

/ 林偉雄 / 原研哉 / 黃炳培 / 靳埭強 / 蔣華 /
aria + Rik Bas Backer / Ian Anderson / Andrew Ashton /
jes / Tony Brook / Alvin Chan / Oded Ezer / Vince Frost /
Sascha Lobe / Anukam Edward Opara / Sean Perkins /
/ Paula Scher / Adrian Shaugnessy / Antonio Silveira Gomes /
sbeck ... 及更多大師級講者。

24 - 25 日

馬會演藝劇院

://www.agi-open.org 訂票！

AGI OPEN
HONG KONG 2012

王序 / 李永銓 / 林偉雄 / 原研哉 / 黃炳培 / 靳埭強 / 蔣華 /
José Albergaria + Rik Bas Backer / Ian Anderson / Andrew Ashton /
Marian Bantjes / Tony Brook / Alvin Chan / Oded Ezer / Vince Frost /
René Knip / Sascha Lobe / Anukam Edward Opara / Sean Perkins /
Dean Poole / Paula Scher / Adrian Shaugnessy / Antonio Silveira Gomes /
Markus Weisbeck ... 及更多大師級講者。

2012 年 9 月 24 - 25 日

香港演藝學院賽馬會演藝劇院

請即登入 http://www.agi-open.org 訂票！

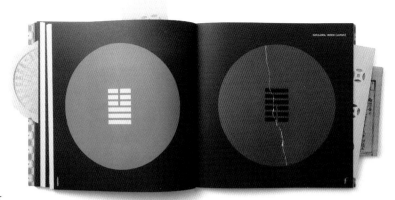

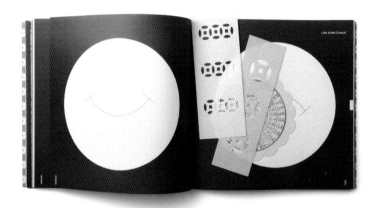

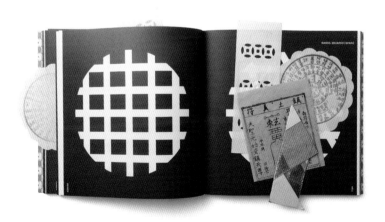

sw–31

blindness | 盲流感

● poster [cultural promotion] | ● 2006

cl. | hong kong repertory theatre
c.c. | anothermountainman [photography] \
　　　84000 communications ltd.

盲流感

blindness

看到，並不是全部…看不到，可能會見得更多…

諾貝爾文學獎得主小說，名作呈現香港舞台。[中國國家話劇院]、[香港話劇團]突破性合作…
一個迷城的荒誕故事，帶你進入如幻似真匪夷所思的「奶白色世界」

香港話劇團
HONG KONG REPERTORY THEATRE
Artistic Director · Fredric Mao
藝術總監 · 毛俊輝

小說原著
薩拉馬戈 jose saramago [1998年諾貝爾文學獎得主]

編劇
馮大慶 [中國國家話劇院編劇]

導演
王曉鷹博士 [中國國家話劇院副院長 · 國家一級導演]

日期
2006年8月26日至9月4日 (8月28日 休演 dark)
時間
晚上7時45分 (2006年9月3日下午2時45分)
地點
香港大會堂劇院 Hong Kong City Hall Theatre
票價
$420 $160 $100 (星期五至日) $120 $80 $60 (星期二至四)
門票現已於各城市電腦售票網 tickets available at urbtix outlets
訂票專線 reservation 2734 9009
信用卡訂票 credit card purchase 2111 5999
傳真訂票 fax on demand 3103 5900 enquiry@hkrep.com
節目查詢 programme enquiry 3103 5999
www.hkrep.com

看該演出附中英文字幕
presented in cantonese with chinese & english surtitles
票務優惠條款，請參閱宣傳單張
please refer to the leaflet for details of ticket discount scheme
遲到觀眾須待適當時候方可進場
no latecomers will be admitted until a suitable break in the programme
本節目含有粗俗言語及暴力成份 · 敬請留意
may have violence, indecent language and sexually suggestive scenes

主辦機構 media support

藝術地圖
ARTMAP

ampost

sw—32

archive no.

love on sale │ 硬銷

● stage design \ poster \ cultural promotion │ ● 2008

cl. │ city contemporary dance company
c.c. │ yuri ng [choreography] \
anothermountainman [photography]

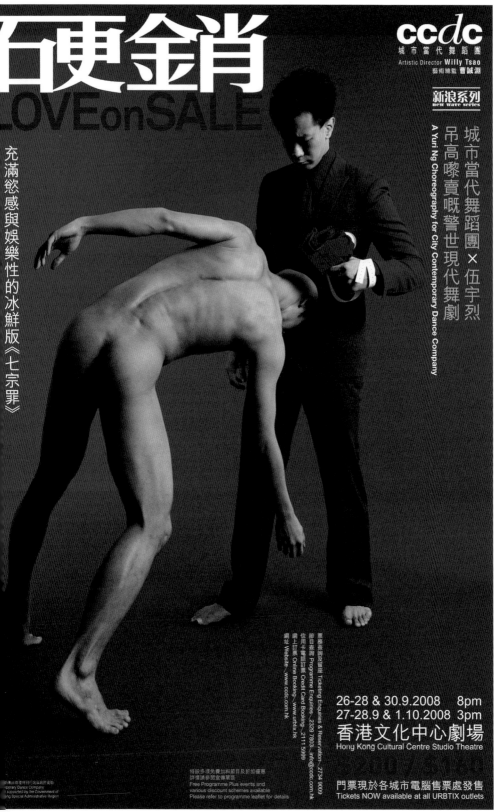

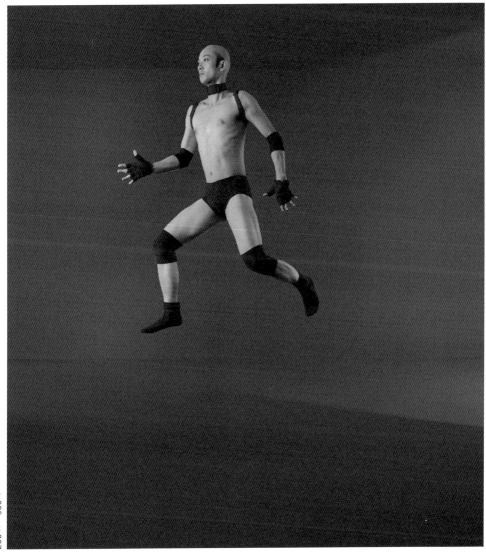

sw–33

amm

amm×sw

● poster \ graphic [cultural promotion] | ● 2008

cl. | hong kong repertory theatre
c.c. | firenze lai [illustration] \
84000 communications ltd.

secret love in peach blossom land | 暗戀桃花源

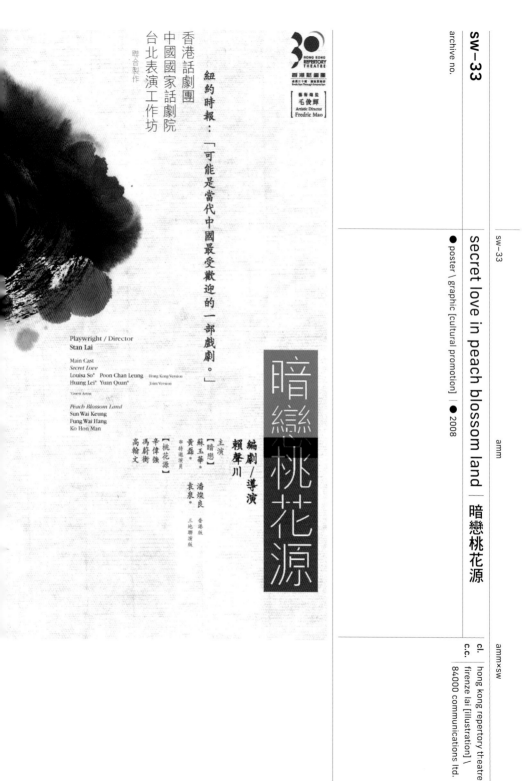

香港話劇團
中國國家話劇院
台北表演工作坊
聯合製作

紐約時報：「可能是當代中國最受歡迎的一部戲劇。」

30
HONG KONG
REPERTORY
THEATRE
香港三十週 誠意創新

藝術總監
毛俊輝
Artistic Director
Fredric Mao

暗戀桃花源

編劇／導演
賴聲川

【暗戀】
主演
蘇玉華*
潘燦良
黃磊*　　香港版
袁泉*
*特邀演員　三地聯演版

【桃花源】
辛偉強
馮蔚衡
高翰文

Playwright / Director
Stan Lai

Main Cast
Secret Love
Louisa So*　Poon Chan Leung　Hong Kong Version
Huang Lei*　Yuan Quan*　Joint Version

*Guest Artist

Peach Blossom Land
Sun Wai Keung
Fung Wai Hang
Ko Hon Man

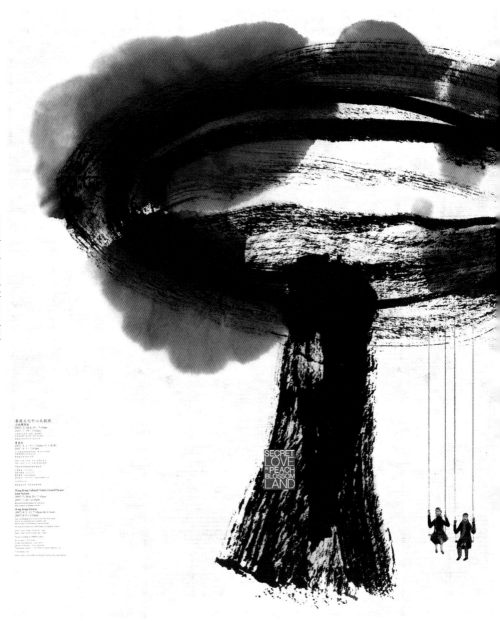

sw—34

archive no.

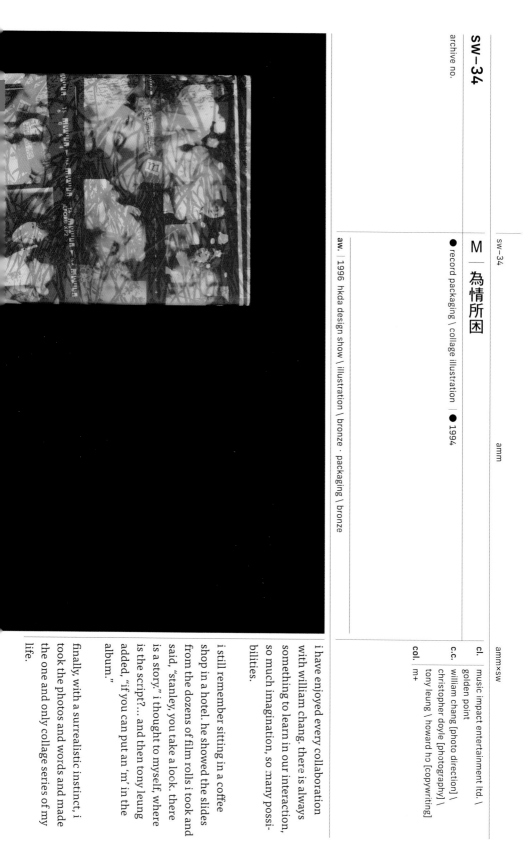

M | 為情所困

● record packaging \ collage illustration ● 1994

aw. | 1996 hkda design show \ illustration \ bronze · packaging \ bronze

cl. | music impact entertainment ltd. \
golden point

c.c. | william chang [photo direction] \
christopher doyle [photography] \
tony leung \ howard ho [copywriting]

col. | m+

i have enjoyed every collaboration with william chang. there is always something to learn in our interaction, so much imagination, so many possibilities.

i still remember sitting in a coffee shop in a hotel. he showed the slides from the dozens of film rolls i took and said, "stanley, you take a look. there is a story." i thought to myself, where is the script?... and then tony leung added, "if you can put an 'm' in the album."

finally, with a surrealistic instinct, i took the photos and words and made the one and only collage series of my life.

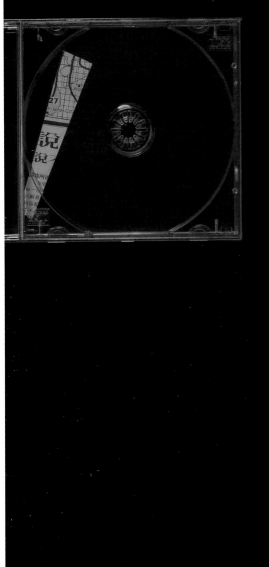

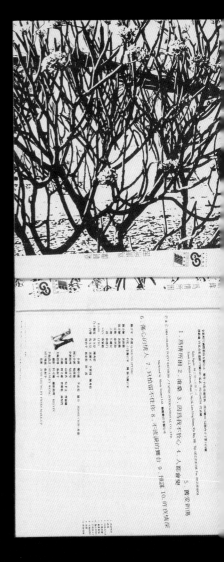

很享受每次跟張叔平的合作，
互動中總有學習、
想像和發揮無限可能⋯

還記得坐在酒店咖啡室，
張叔平將幾十卷沖出來的幻燈片放在我
面前說：「stanley，你慢慢看，裡面有
一個故事。」我心想，劇本在哪？⋯然
後梁朝偉補充了一句：「如可以放一個
『m』字在唱片裡面。」

最後，我憑着夢幻直覺，將圖片跟文案
做了我生平唯一一次拼貼插圖系列。

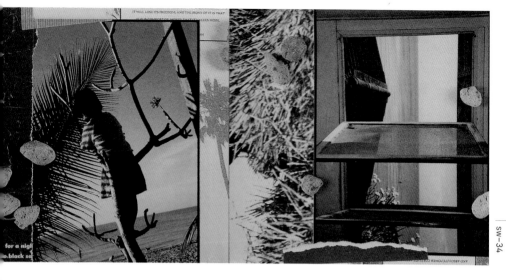

improvisation \ jazz & design \ niklaus troxler

即興 \ 爵士音樂設計展 \ niklaus troxler

● poster [cultural promotion] | ● 2013

aw. | 2013 design for asia hkdc awards \ posters \ silver

cl. | oct art and design gallery (shenzhen)
col. | oct art and design gallery (shenzhen)

the spirit of jazz,
impromptu.

the same experience is given to the
audience of the poster.
each viewer is invited to participate
and interact with the poster, drawing
circles.

limitless possibilities,
rhythmically jamming like music...

creating positive vibes and resonance.
through a series of "stamping", the
poster is created and completed.
it is a very efficient way,
to appreciate and experience the im-
promptu spirit of jazz music.

就如爵士音樂的精神，
即興。

同樣經驗給予了海報的觀眾。
每個觀眾都被邀請成為互動的一份子，
與海報互動並即興上圓圈。
無窮的可能性，
音樂般律動⋯

透過「印」的過程，
它營造了非常正面的互動回應，
去創作及完成海報設計。
這是非常有效率的方法，
去體會爵士音樂的即興意念。

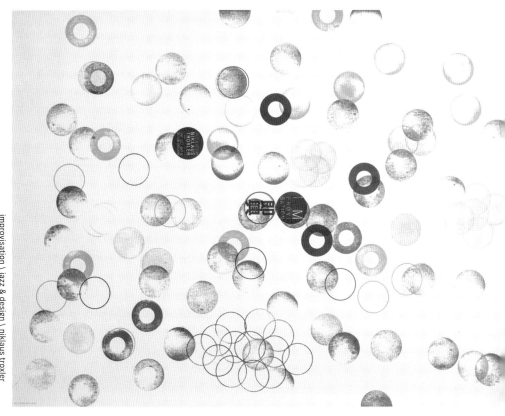

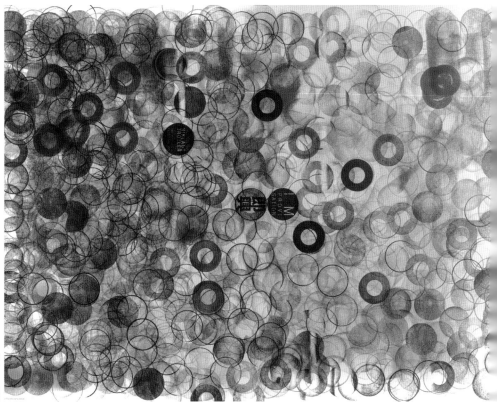

amm×sw

sw–36

archive no.

sw–36

one eye \ ahn sang-soo photo design show

一目了然 / 安尚秀攝影設計展

● poster [cultural promotion] ● 2012

cl. | oct art and design gallery (shenzhen)
c.c. | anothermountainman [illust·ation] \
| 84000 communications ltd.

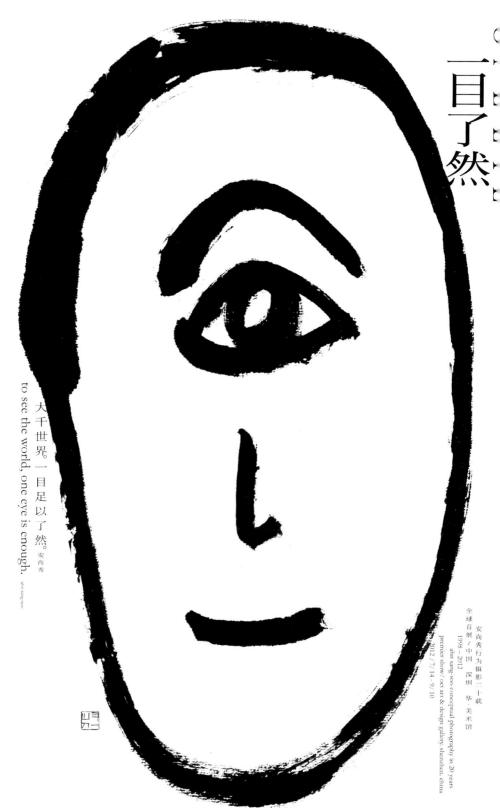

one eye \ ahn sang soo photo design show

大千世界。一目足以了然。安尚秀

to see the world, one eye is enough. ahn sang soo

安尚秀行为摄影二十载
全球首展／中国 深圳 华·美术馆
1998—2012
ahn sang-soo conceptual photography in 20 years
premier show／oct art & design gallery, shenzhen, china
2012／7/14 − 9/10

sw-37

archive no.

meaning of poster | 海報定義

● poster [cultural promotion] ● 2006

cl. hong kong heritage museum
c.c. anothermountainman [copywriting]

那年為香港文化博物館舉辦的香港國際海報三年展擔任評委後，傳統上要做一個公開的演講分享。機會來了，一次過講出我心目中關於海報的我知我見。用「海」做了張海報，心裡還想到像海的一匹布⋯

after serving as the judging panel member for the hong kong international poster triennial held by hong kong heritage museum, as a tradition, i had a public sharing. it was my chance to talk about all i know, feel and see in posters. i even created a poster with the theme of "sea" (poster in chinese characters mean sea-bulletin), and in my mind, i was envisioning a long piece of cloth, like the sea. (a long piece of cloth is a chinese idiom meaning having a lot to say)

22-24.
01.2010

hongkong icon｜標誌香港

● event visual \ poster [cultural promotion]｜● 2006

c.c.｜hamlet auyeung \ andrew wong [photography] \ 84000 communications ltd.

col.｜m+

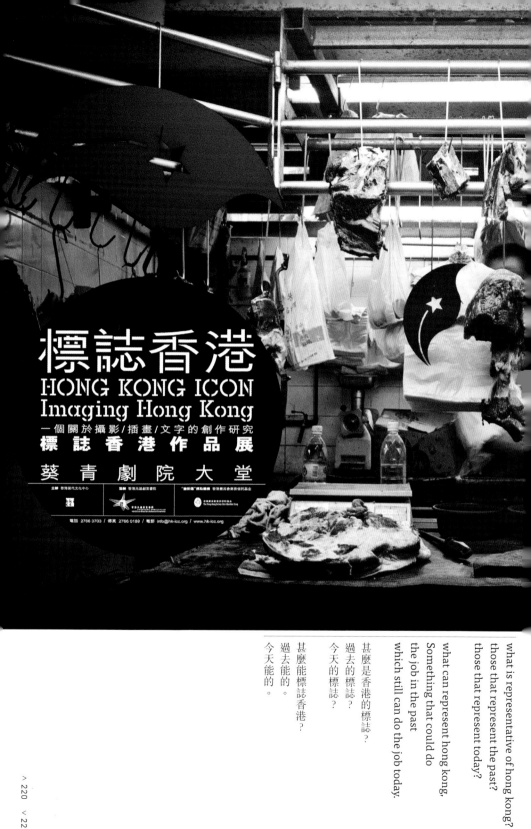

標誌香港
HONG KONG ICON
Imaging Hong Kong
一個關於攝影 / 插畫 / 文字 的創作研究
標誌香港作品展
葵青劇院大堂

主辦 香港當代文化中心　　協辦 香港流動創意書院　　"繪劇緣"構場線機 香港賽馬會慈善信託基金

電話 2766 3703 / 傳真 2766 0189 / 電郵 info@hk-icc.org / www.hk-icc.org

甚麼是香港的標誌？
過去的標誌？
今天的標誌？

甚麼能標誌香港？
過去能的。
今天能的。

what is representative of hong kong?
those that represent the past?
those that represent today?

what can represent hong kong,
Something that could do
the job in the past
which still can do the job today.

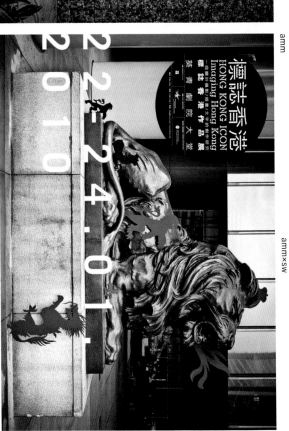

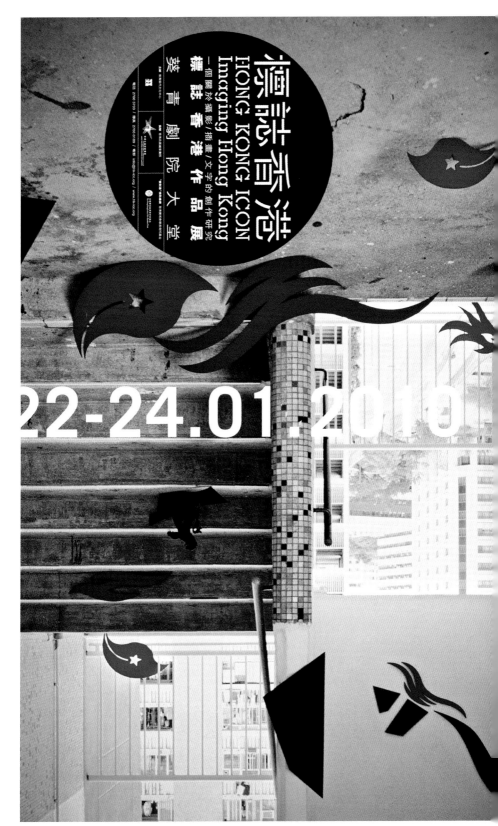

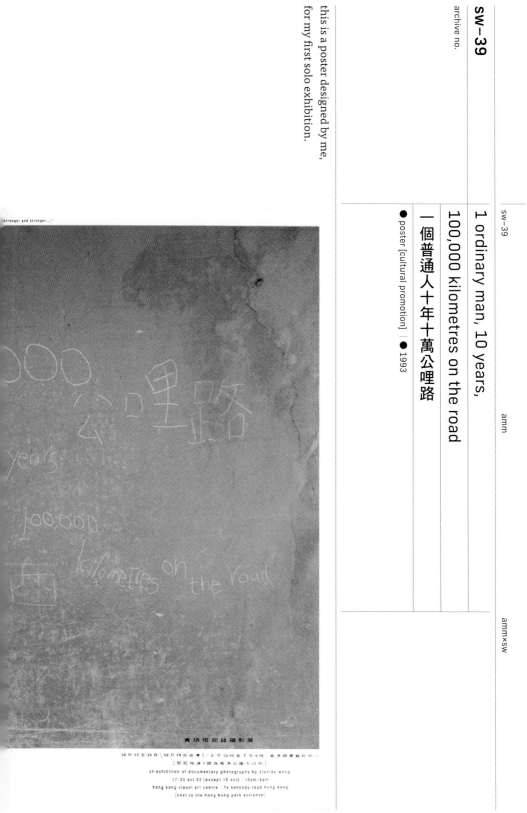

this is a poster designed by me,
for my first solo exhibition.

1 ordinary man, 10 years,

100,000 kilometres on the road

一個普通人十年十萬公哩路

● poster [cultural promotion] | ● 1993

黃炳培記錄攝影展

10月17至25日 [10月19日休息] / 上午10時至下午6時 / 香港視覺藝術中心
[堅尼地道7號A香港公園入口處]
an exhibition of documentary photography by stanley wong
17–25 oct 93 [except 19 oct] / 10am–6pm
hong kong visual art centre / 7a kennedy road hong kong
[next to the hong kong park entrance]

1 ordinary man, 10 years, 100,000 kilometres on the road

sw–40

hongkong dongxi | 香港東西

● poster [cultural promotion] | ● 1996

c.c. | almond chu [photography]
col. | hong kong heritage museum \ m+

aw. | 1998 asia-pacific posters exhibition \ selected

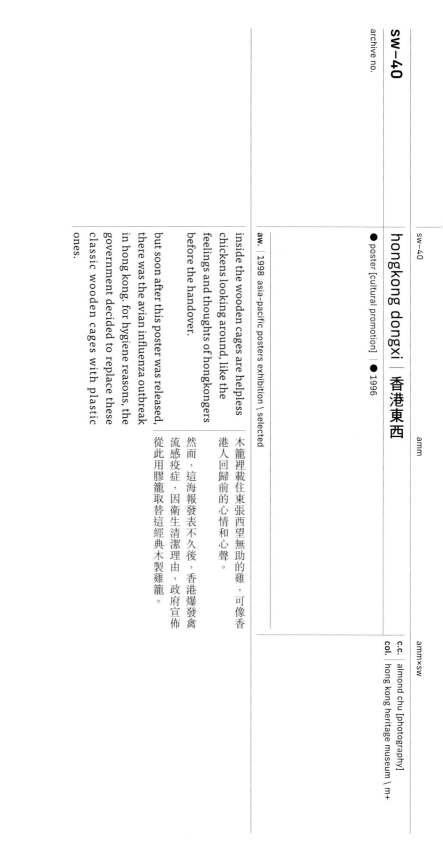

inside the wooden cages are helpless chickens looking around, like the feelings and thoughts of hongkongers before the handover.

but soon after this poster was released, there was the avian influenza outbreak in hong kong. for hygiene reasons, the government decided to replace these classic wooden cages with plastic ones.

木籠裡載住東張西望無助的雞，可像香港人回歸前的心情和心聲。

然而，這海報發表不久後，香港爆發禽流感疫症，因衛生清潔理由，政府宣佈從此用膠籠取替這經典木製雞籠。

Hongkong 香港
Dong 東
Xi 西

east 東
west 西

seven graphic designers from hongkong
a?anCHAN KANtaikeung tommytli?freemanLAU jennyLI JIMwang LANsunWONG

may21-may31 1996 [paper point] 83-84 long acre · covent garden · london · england

東張西望東西南風東西並南北

東家智打打西家忽東忽西西望東望你話東望我話東風壓倒西風捕九東西

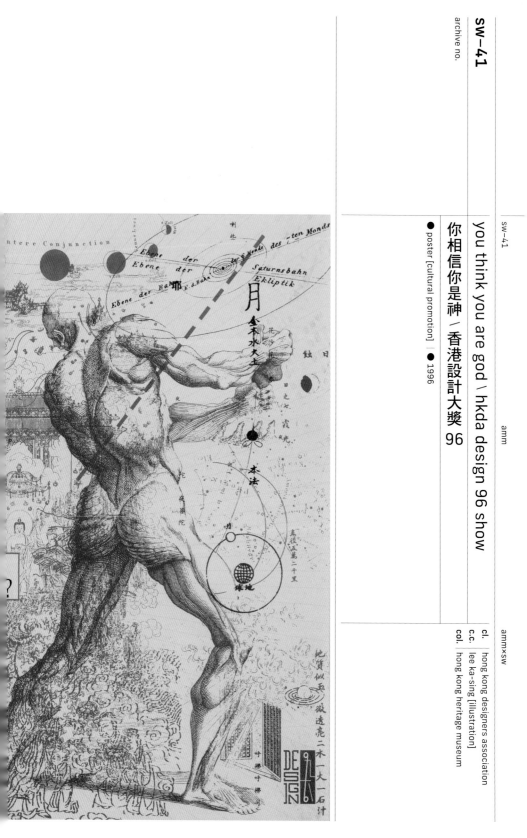

you think you are god \ hkda design 96 show

你相信你是神 \ 香港設計大獎 96

● poster [cultural promotion] | ● 1996

cl. | hong kong designers association
c.c. | lee ka-sing [illustration]
col. | hong kong heritage museum

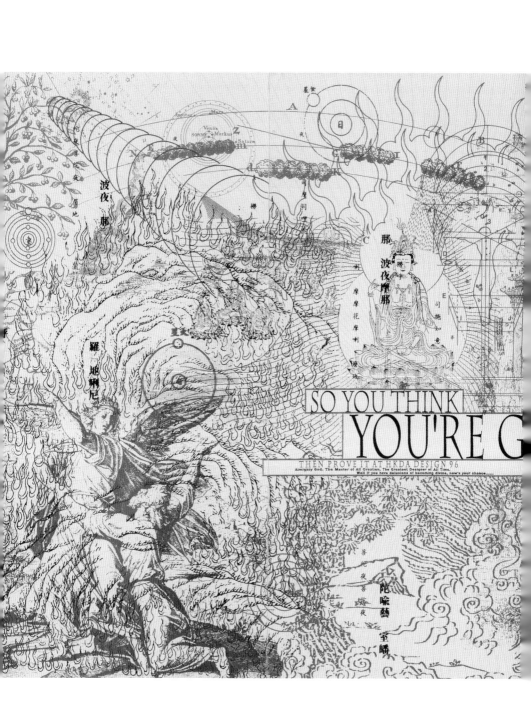

SO YOU THINK
YOU'RE G

THEN PROVE IT AT HKDA DESIGN 96
Almighty God. The Master of All Creation. The Greatest Designer of All Time.
Well if you have delusions of becoming divine, now's your chance......

sw–42

archive no.

art for sale | 藝術拍賣

● poster [art promotion] | ● 2003

cl. | para site art space
col. | hong kong heritage museum \ m+

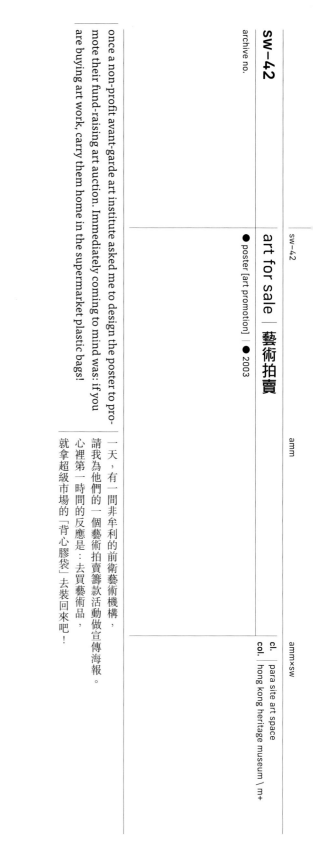

once a non-profit avant-garde art institute asked me to design the poster to pro-
mote their fund-raising art auction. Immediately coming to mind was: if you
are buying art work, carry them home in the supermarket plastic bags!

一天，有一間非牟利的前衛藝術機構，
請我為他們的一個藝術拍賣籌款活動做宣傳海報。
心裡第一時間的反應是⋯去買藝術品，
就拿超級市場的「背心膠袋」去裝回來吧！

art·dec·o 12

a major fundraising campaign promoting
hong kong art:
a three week exhibition involving over
50 local artists and more than 100 art works
to be sold in artmart03.

artmart 03

artmart artists party [tickets on sale $100]
para/site, g/f, 2 po yan street, sheung wan, hk
12 dec [fri] 2003 / 7.00pm till late

exhibition opens dec 12th and continues at
para/site art space through 19 dec [fri] 2003

for more info please e-mail work@passionworks.com.hk
or call 9520 7017 or 6197 4588.

MADE IN
HONG KONG
香港製造為香港
FOR HONG KONG

benefiting charity
PARA
SITE
art space
藝術空間

IKEA

martini
available at
1/5

a major fundraising campaign promoting
hong kong art;
a three week exhibition involving over
50 local artists and more than 100 art works
to be sold in artmart03.

artmart 03

artmart 2003 launch party [by invitation]
1/5, star crest, 9, star street, wanchai, hk
10 dec [wed] 2003 / 7.00-9.00 pm

for more info please e-mail work@aaaaiaworks.com.hk
or call 9520 7017 or 6197 4588.

MADE IN
HONG KONG
香港製造為香港
FOR HONG KONG

PARA
SITE
art space
藝術空間

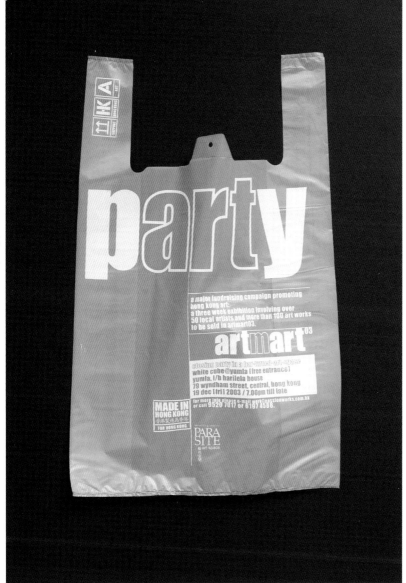

sw–43

archive no.

a blank paper | 白紙一張

● brand advertising | ● 2012

amm×sw

cl. | ming pao weekly (book b)
c.c. | lung king-cheong \ jessica wong \ lin xi
\ tse ho-yin \ ming pao weekly (book b)
design team

after helping with the revamping format layout of *ming pao weekly's book b*, i stayed on to be their visual director, and occasionally contributed to the contents, involved in planning events and exhibitions, and promoting the house brand etc...

i spent four splendid years with the mastermind lung king-cheong, jessica wong and their team, interacting and carrying on a dialogue with friends and readers, speaking on the same wavelengths, establishing the focus and values that i believe in, accept and advocate for the culture and living of the city.

為《明報周刊——book b》改版後，
留任成為他們的視覺創作總監，
以至客串參與雜誌內容、
項目及展覽策劃、自家品牌形象推廣…等。

與主腦龍景昌、三三及團隊共度了近四年美好時光，
跟同一頻道語境的讀者朋友互動對話，
為我城文化生活定出一個我們相信、
認同和倡導的聚焦和價值觀。

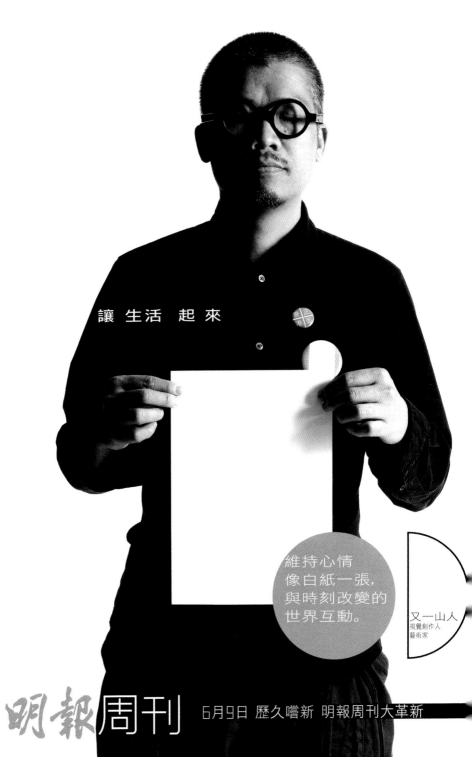

讓 生活 起 來

維持心情
像白紙一張，
與時刻改變的
世界互動。

又一山人
視覺創作人
藝術家

明報周刊　6月9日 歷久嚐新 明報周刊大革新

archive no.

sw—44

sw—44

amm

● magazine creative direction | ● 2012 → 2015

ming pao weekly \ book b | 明周 \ book b

aw. | 2013 hkda global design awards \ photography \ bronze
2016 hkda global design awards \ photography \ bronze \ hk best

▶ slide

amm×sw

cl. | ming pao weekly (book b)
c.c. | lung king-cheong \ jessica wong \
ming pao weekly (book b) design team

編輯部電話 3605 3705　訂閱部電話 2515 5481　E-mail: mpweekly@omghk.com　廣告部 mpwsales@omghk.com
HKD18
9 771018 483000

2310
16/02/2013

What's New
Albert Elbaz深入化妝界
卜公花園 足球少林
續香港
由山頂走到鴨脷洲
行到鯉魚門嘆蠔
Homelife
百家布的美學
Fashion
2013 S/S
Haute Couture

讓 時間
醃漬
醞釀味道

編輯部電話 3605 3705　訂閱部電話 2515 5481　E-mail: mpweekly@omghk.com　廣告部 mpwsales@omghk.com
HKD18
9 771018 483000

2323
18/05/2013

生活空間
Muji Go Local
小陶大尋
Housekeeping
美味追尋
品味芝士的完美法則
Fashion
Everyday Blue
Health
零食智慧

導遊
亞洲藝術

ART BASEL
@ HONG KONG

編輯部電話 3605 3705　訂閱部電話 2515 5481　E-mail｜mpweekly@omghk.com　廣告部 mpwsales@omghk.com

HKD18

明周 末日

再生

生活空間
PMQ：本地創意
與商業並行的可能？

美味追尋
尋，美味羊腩煲

日月舞台
走進胡金銓的影・畫世界

Fashion
X'Mas Special:
Love Is All Around

Ming Junior
科學 孩子要懂！

WEEKLY

去年，韓國中書籍設計師安尚秀（Ahn Sang-soo）到到城市進行設計論壇之後，當年逐漸備受國際矚目，向媒體的訪談。一日，韓國，現研究所舉辦設計師，同時受訪至分享如何在多年來對書籍設計的PaTI一群教育，時提升的。

與安尚秀相處理解釋，看到作品及見解讓你十分深刻的為同業，關注此種趣味設計介書籍以為體積的設計的程度的平面設計的平面。可能江湖古老不少新人入為難設計的人入門首先學習。

一但，最將許是設計1991年韓國獨自己的工作學校，老師指撰寫與前衛漢字設計「，真是。

遊下來事

「與華第一天，我指學生說：不要在己的夢想上。設些給自己建動的很好，你要自由的一，也是要做了「狼群」。安尚秀的語言的一些新思維。「走學學生的同步，學生與有的同步」的。「因為如將學問的理念上，因些這種不教育學生，設許多作家們也像中了這什麼的很多事事件的發展分的情況也處在社樣向不的。

DONGDAEMUN

仁人至尚，產業為副

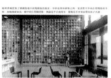

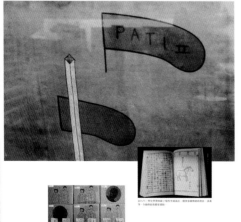

ANOTHER TRAVEL ISSUE/ SEOUL

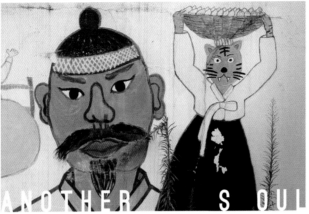

ANOTHER S OUL

後記

ANOTHER WAY, ANOTHER INSIGHT

婉蜓 的 傳統之美 BUKCHON

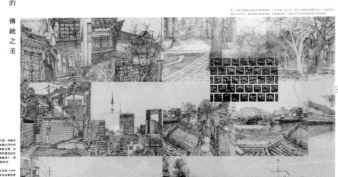

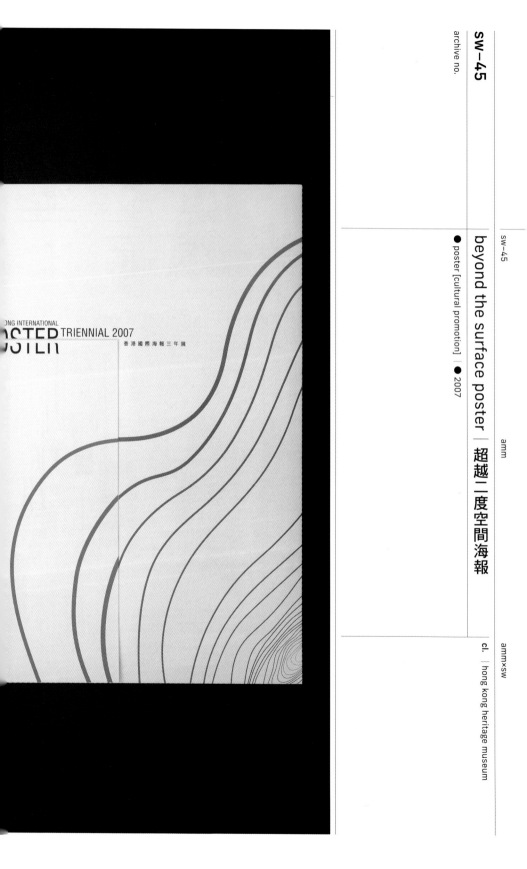

beyond the surface poster | 超越二度空間海報

● poster [cultural promotion] | ● 2007

cl. | hong kong heritage museum

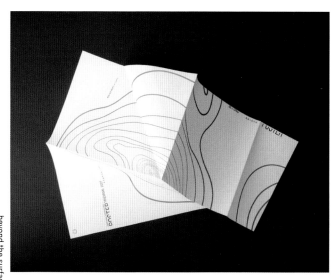

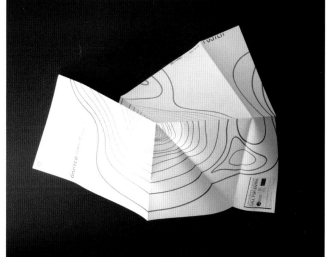

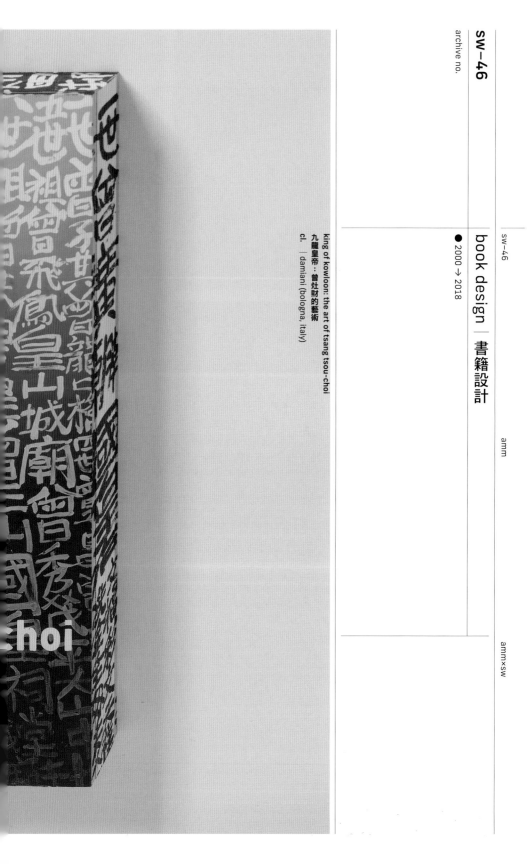

archive no.

book design ｜ 書籍設計

● 2000 → 2018

king of kowloon: the art of tsang tsou-choi

九龍皇帝：曾灶財的藝術

cl. ｜ damiani (bologna, italy)

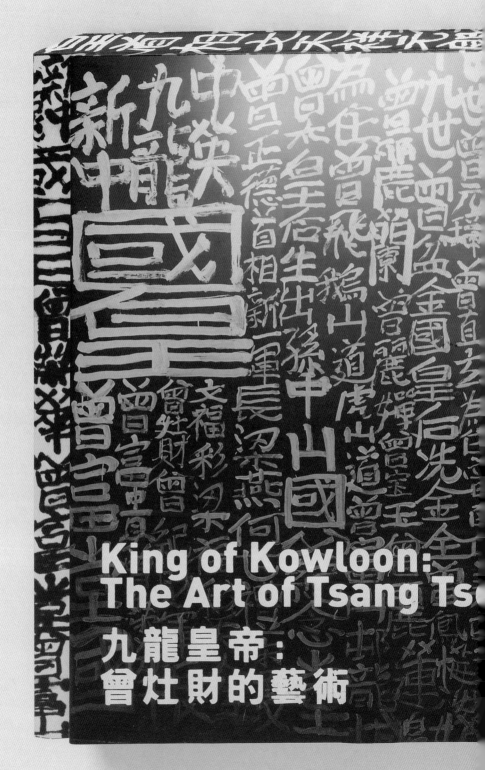

King of Kowloon:
The Art of Tsang Ts

九龍皇帝：
曾灶財的藝術

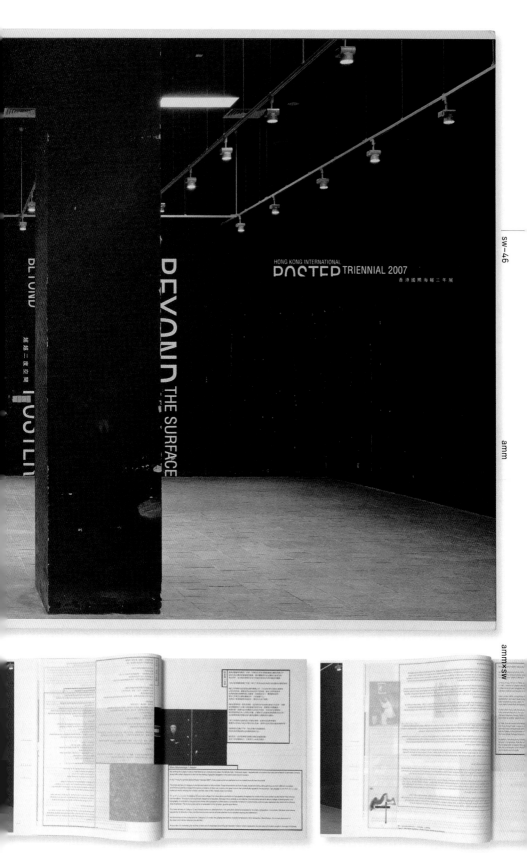

→ beyond the surface
超越丨度空間
cl. | hong kong heritage museum

← family letter [conceptual book]
一本家書 [概念書籍]

秀實詩選

盧文敏詩選

鬲魂詩選

羊城詩選

羅少文詩選

蔡炎培詩選

胡燕青詩選

韓牧詩選

contemporary hong kong poet series
當代香港詩人系列
cl. | offset printing

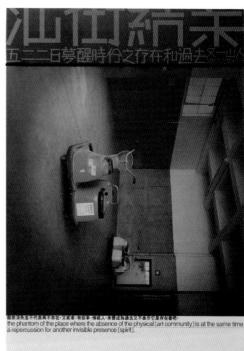

眼前消失並不代表再不存在，又或者：有些事、情或人，未曾成為過去又不表示它是存在著吧。
the phantom of the place where the absence of the physical [art community] is at the same time a repercussion for another invisible presence [spirit].

amm

ammxsw

before and ever after: 522 days of oil street
油街結業：五二二日夢醒時分之存在和過去
aw. | 2001 hkipp awards \ gold
2002 hkda design show \ book \ gold

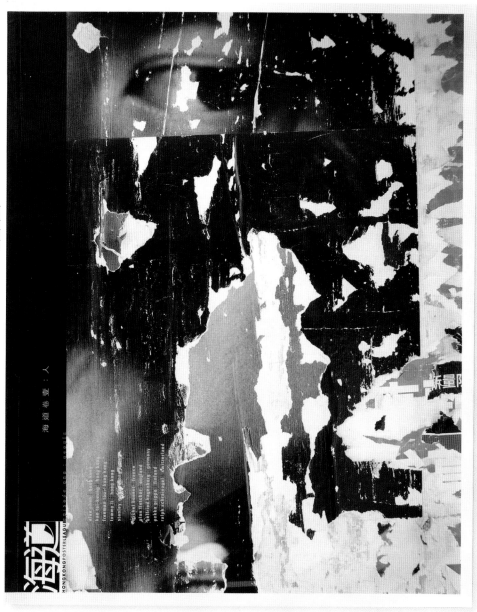

hong kong poster league / episode one: people
海道卷壹：人
aw. | 2000 hkda design show / literature / silver
2001 hkipp awards / commissioned series / silver
2001 hkipp awards / gold

報告書

平成

二十七年

二十八年

graphic art & design annual 15-16

cl. | dnp foundation for cultural promotion
aw. | 'ministry of economy, trade and industry / director - general, commerce and
information policy bureau' award / nationwide catalogue award (japan)

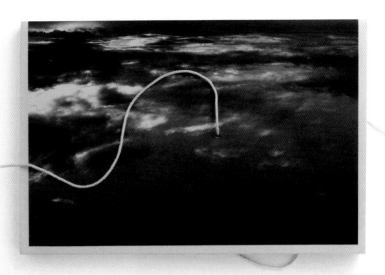

一天無語 ‖ 澤優 仰藝社

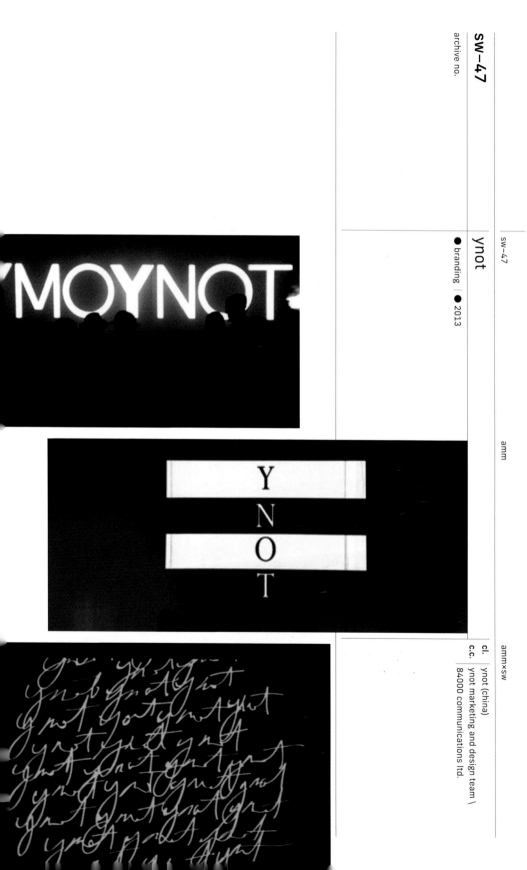

ynot

● branding | ● 2013

cl. | ynot (china)
c.c. | ynot marketing and design team \
84000 communications ltd.

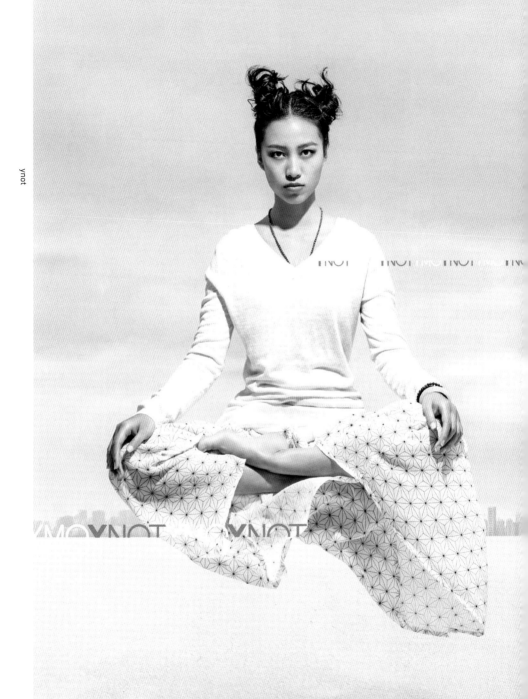

YMO**Y**NOT

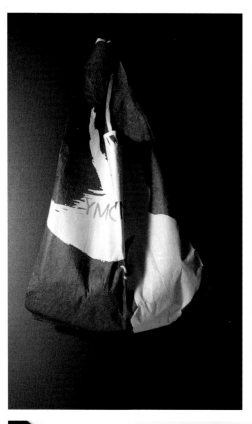
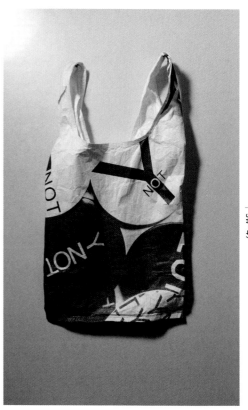

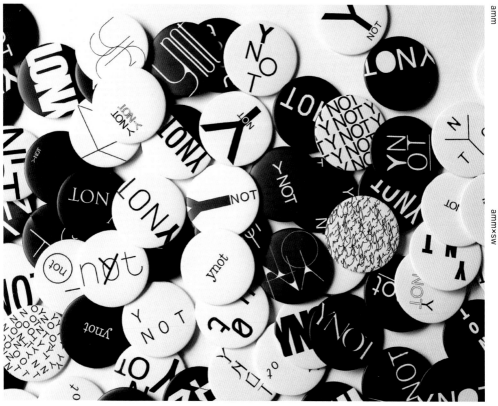

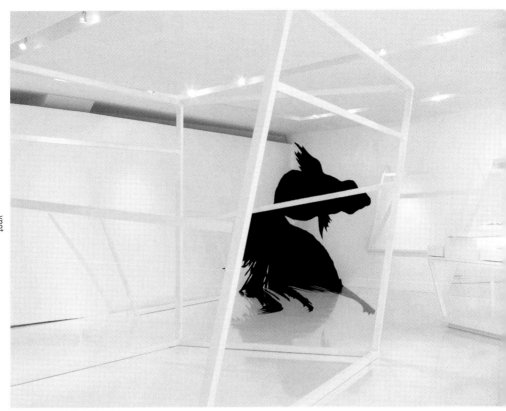

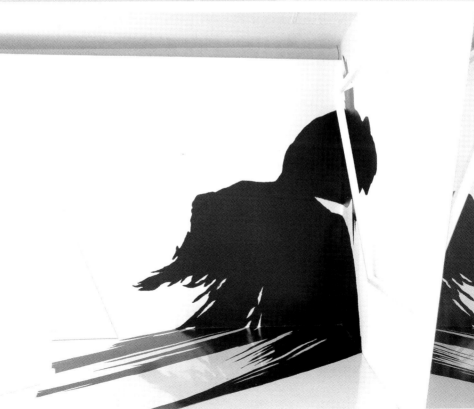

why produce?
why plagiarise?
from something to nothing.
from "this" to "that",
or,
from "it is" to "it isn't",
from ordinary to extraordinary.
from usual to unusual.
in fact,
in life... no matter.

為何製造？
為何抄襲？
由有到無。
由它抄到另一個它。
或是，
由它抄到沒有它。
由尋常到不尋常。
由普通到不普通。
其實，
這世間⋯本來無一物。

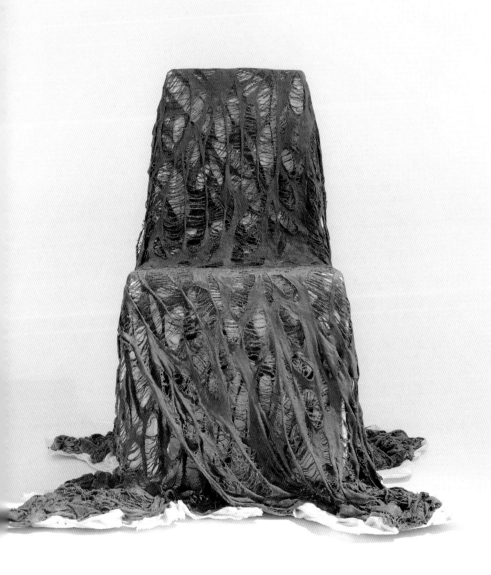

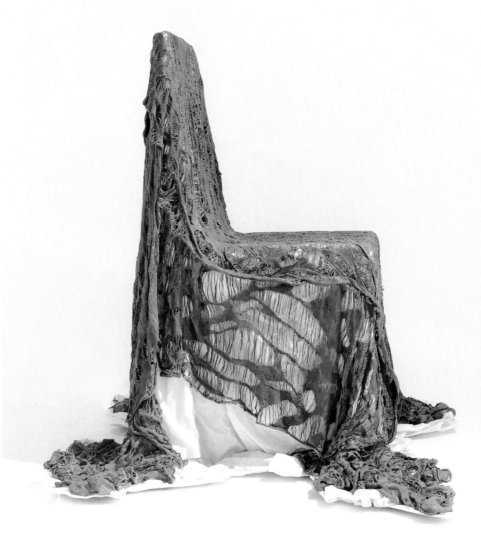

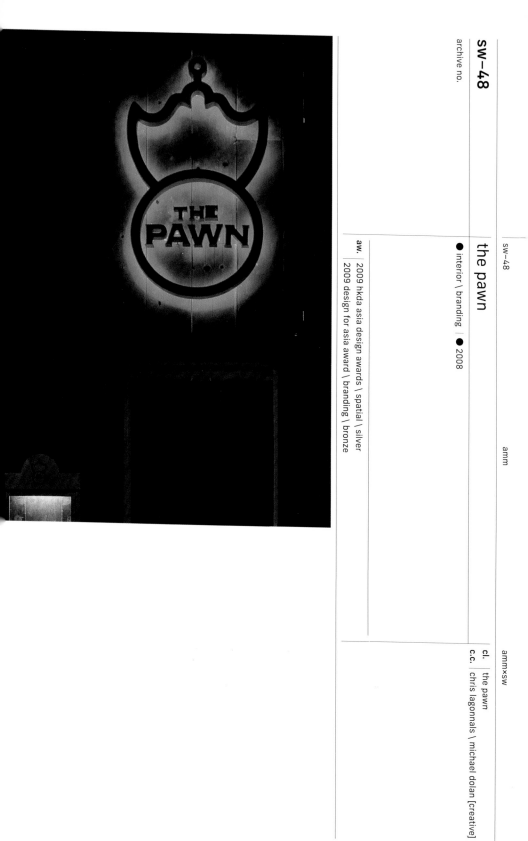

sw–48

archive no.

the pawn

● interior \ branding | ● 2008

cl. | the pawn
c.c. | chris lagonnals \ michael dolan [creative]

aw. | 2009 hkda asia design awards \ spatial \ silver
2009 design for asia award \ branding \ bronze

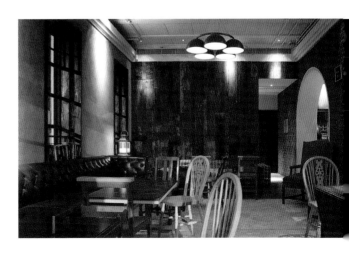

sw–49

archive no.

HMV ideal

● branding \ interior \ graphic ● 2008

cl. hmv
c.c. joey ho [interior] \ henry ch」[multi media]

hmv
ideal

TIM LAU

CANDY YEUNG

CLORIS NG 吳滿欣

PAUL CHOI 蔡亦善

GAGA WONG

ALEX CHEUNG 張啟華

ROGER LAU

ALVIN CHAN 陳偉斯

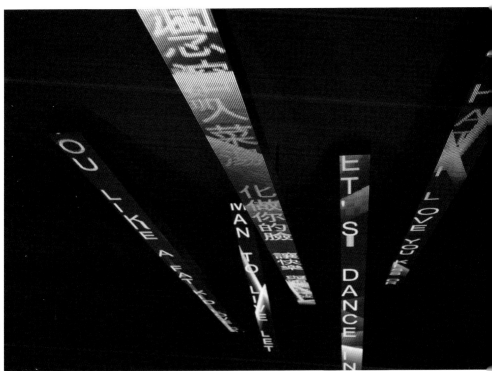

www.hmvideal.com
7/F The Hennessy,
256 Hennessy Road, Wanchai, Hong Kong
+852 3481 6189

5455 CASH-1 0001 0018 001

******* VOID * TRAINING MODE *******
H261212 x 1 $85
VA NOW 83 CD x 1 $139
OST: HO HOBBIT CD x 1 $99
EDWARD BLOOD DVD x 1 $79
JAMES B CASINO DVD x 1 $79
8897106 x 1 $155
DOCUMEN WONDER BR x 1 $329
DALE CA HOW TO BM x 1 $59
XBOX 36 2014 P GS x 1 $449
DISNEY USB FI SDK x 1 $199
COLOUD POP: 8 HP x 1 $199
MONSTER COSBAG TOY x 1 $78
 TOTAL $1,949

Cash $1,949
******** VOID * TRAINING MODE *******

In case of faulty product, this receipt
must be presented within 7 days of
purchase for exchange.
產品如有問題請7天內憑單更換

Spend $200 or up and get 10% off
food and drinks at hmv kafe with
this receipt.

*not to be combined with
other promotions.
*Offer expires 30 days
from date of issue.
END TRAINING SESSION 24/04/14 13:08
TRAINING TOTAL = 1,949

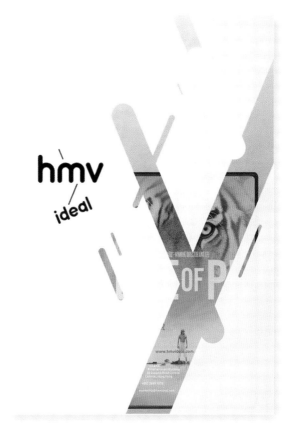

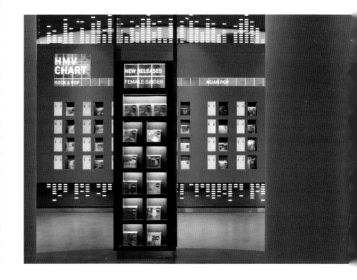

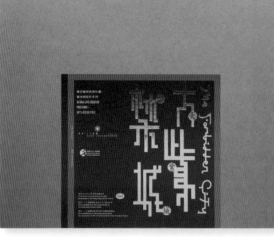

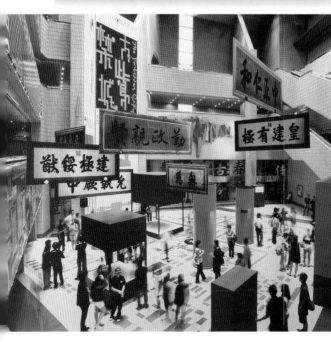

the forbidden city | 大紫禁城

● exhibition design \ graphic | ● 2009

cl. | zuni icosahedron
c.c. | mathias woo \ zuni design team

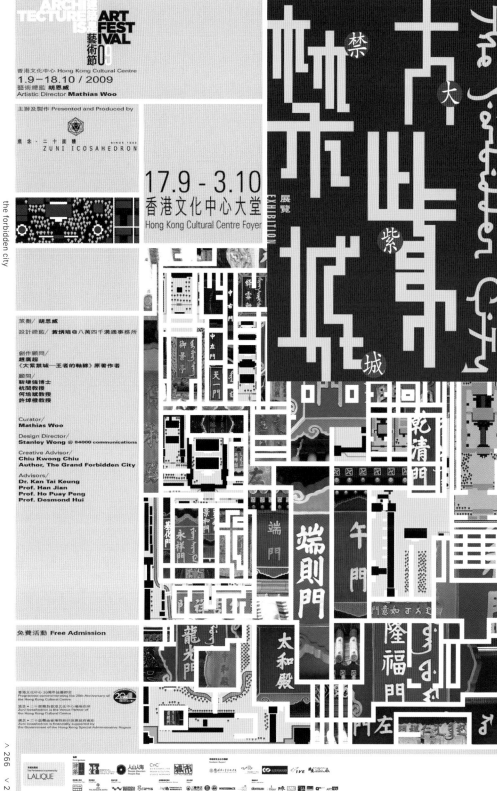

tian tian xiang shang │ 天天向上

● exhibition design \ graphic │ ● 2012

cl. │ zuni icosahedron
c.c. │ danny yung \ mathias woo \ zuni design
│ team

aw. │ 2013 design for asia hkdc award \ branding \ silver
│ 2014 golden pin design award \ visual communication \ winner

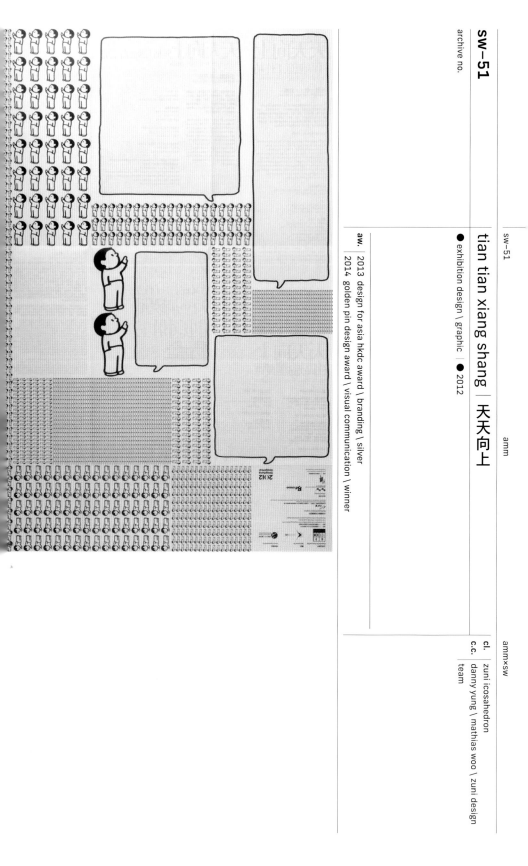

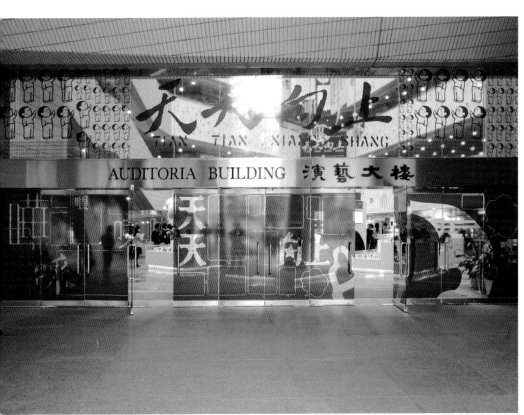

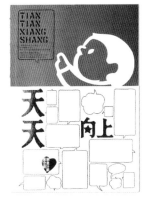

sw–52

phenomenon

● branding ● 1997

ph·e·no·men·on digital art

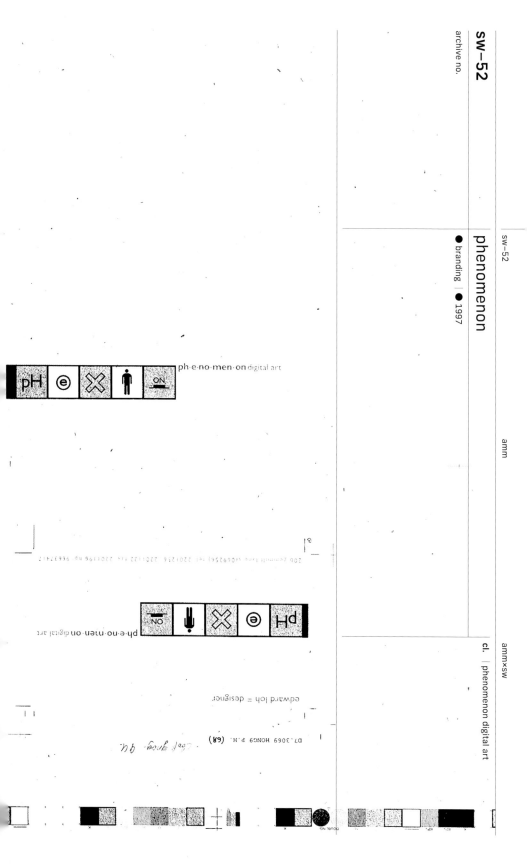

ph·e·no·men·on digital art

edward loh = designer

D7.3069 HONG9 P.H. (6A)

archive no.

sw–53

sw–53

am

ammxsw

logo identity │ 標識設計

● 1983 → present

Classified

香 港 藝 術 發 展 獎
Hong Kong Arts Development
AWARDS

THE
PAWN

ampost

THE
PRESS ROOM

ideal

香港國際 hkipf

EXCEPTION
de MIXMIND

The Board of Management of The Chinese Permanent Cemeteries

華人永遠墳場管理委員會

AGI OPEN
HONG KONG 2012

華人廟宇委員會
CHINESE TEMPLES COMMITTEE

HUSBAND RETAIL CONSULTING

A HONG KONG EXHIBITION

十如
integral

BEING
HK
就係
香港

人本 | 文本 | 紙本

築福香港
BLESS HK

FRESH WAVE
鮮浪潮 2011
國際短片展 INTERNATIONAL
SHORT FILM
FESTIVAL

84000communications

threetwoone film production limited

sw—54

archive no.

commissioned photography｜委約攝影

● 1996 → present

▲ slide

when i was 20, i bought my first camera with the hk$1500 i got on my first pay-check. photography is my bridge to see the world with my heart.

i did not know that one day, due to my taste in aesthetics, people would ask me to execute their creative campaigns. besides the audio visual production of the advertising , in photography, through the collaboration with art directors, creative directors, chief editors, i have also created a lot of memorable sparks.

打從二十歲那年拿到第一次薪金一千五百港元買了第一台相機，攝影就是我用心看世界的橋樑。

也不知道有一天，大家就着我的「美學」品味，來找我操刀他們的創意。除聲畫廣告製作外，硬照攝影部分也留給我很多很多跟美指、創作總監、媒體、總編輯們⋯合作、互動和擦出的火花。

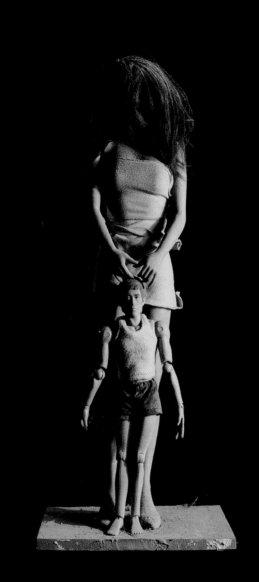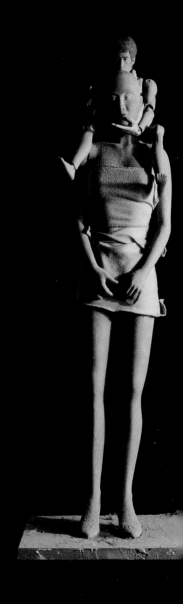

you see two dolls.
i see the triumph of woman over the hubris of male obstinacy, seduced forever
by the diaphanous mist of femininity despite hopelessly bovine resistance.

photography with another point of view 0001@anotherm

anothermountainman photograph

sw–54

amm

ammxsw

eless junk.

spirations of the galaxy, wearied of the synthesis

gh time yet in search of its catharsis.

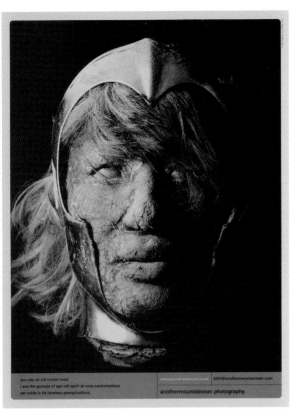

you see an old model head.
i see the genesis of age old spirit at once contumacious
yet noble in its timeless peregrinations.

photography with another point of view 0001@anothermountainman.com

anothermountainman photography

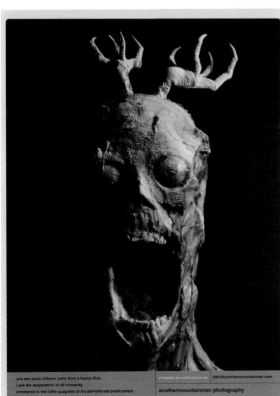

you see some leftover parts from a horror flick.
i see the desperation of all humanity.
enmeshed in the futile quagmire of it's self-inflicted predicament.

photography with another point of view 0001@anothermountainman.com

anothermountainman photography

These are not simply of the commercial realm, but are have nuances that remind us of what we are actually looking at. Time and again, in this the ferocity of the global spin, we forget we need to stop and look; instead we merely see in an optical burst of flashing visions, images, colours, texts. We add sound to this, and suddenly we are engulfed into the vortex of all experiences becoming none-experiences.

Words and images operate in two different spaces: intellectually, emotionally and physically. The collected composites of anothermountainman provokes us in complex ways; especially when we are reminded to take apart a word, an alphabet, and the image as it is laid over and under, depending on the nature of the finished print. Sensations can be manipulated by treating flat print as three dimensional entities; just like we can manipulate images of the three dimensional space projected as two dimensional in print, to take on features of both without suspicion. The context of making by anothermountainman mimics real life: in real life, we have all dimensions in the space-time continuum. With digital and electronic means in contemporary life, the space-time context becomes broken down into pixels and waves, signals encoded by numbers and borne on frequencies. The potential to enlarge our vocabulary of communication in an aesthetic experience has increased vibrantly and exponentially.

It is not easy to summarise the contents of anothermountainman and his practice. Similarly, to simply talk about and evaluate one or several of his outcomes and productions cannot properly harness the strengths of his critical work. What is more important is to understand his environment, and how he has evolved to embark on various endeavours. Producing a series of his work tends to overlap one with another; while he may extend one older series into a new perspective in later years.

In 2014, the Nanyang Academy of Fine Arts hosted anothermountainman's Perceive Emptiness exhibition. The exhibition selectively accumulated a body of work, but included the heaven

黑雲翻墨未遮山，白雨跳珠亂入船。

卷地風來忽吹散，望湖樓下水如天。

Dark clouds like spilt ink spread over the mountains quiet;
Raindrops like bouncing pearls into the boat run riot.
A sudden rolling gale dispels clouds far and nigh;
Calmed water in the lake becomes one with the sky.

Su Dongpo (Su Shi)

The global citizen is in crisis: he stands and moves in a world of extraordinary rapidity. Attempts to control his experiences are futile. At the best of times, life washes over him like a thunderstorm without warning. At the worst of times, he begins to drown and fights for each breath to salvation. Who are we? Do we own this earth that we inhabit? Does the ability to control something determine our strength of purpose while we live? We of the present time will all die one day. How we measure our experiences will present to us how we lived.

In 40 years, anothermountainman has measured his experiences through his work and his practice. A creator and maker, he produces all manner of materials: from short film, to video documentation, photography and installations (heaven on earth and painting by god). His material compositions contain found objects, the 'trash' and disposables of the everyday (rubbish hunting/existence vs respect), as well as objects of utilitarian possibilities as we employ them in our lives (building hong kong/ redwhiteblue). The range of his applied skills and collaborative efforts extends to produce serial works; large collections of representations and items that speak variously about his intent, about his creative endeavour. Such collections become a renewed form once they are presented and installed; arranged like the grammatical syntax looking for meaning in a thousand different languages.

The corpus of anothermountainman cannot be located in a single philosophy or aesthetic concept. Often, the idea is rooted in something minute and momentary, yet something embracing and deep like of life itself (impermanence and form. emptiness) that resulted in an observation and expression we would not otherwise notice. Sometimes, there is an experience of something physical (from sushi to bada shanren, dust to dust and reborn ikebana) that then becomes an inspiration to remake and document; and while doing so, re-experience the absence of what we once saw and understood that may never come to us again.

As a creative director, anothermountainman's works also extend toward the public domain: the campaigns and collaborations involve texts, advertising, publications, fashion installation and performances as well as design for the common market.

● Bridget Tracy Tan | 陳莉玲

Bridget Tracy Tan is Director for the Institute of Southeast Asian Arts and Art Galleries at Nanyang Academy of Fine Arts. Formerly a curator at the Singapore Art Museum (now National Gallery Singapore) she graduated 1996 with a Master of Arts, obtaining First Class Honours in Art History from the University of Glasgow in Scotland. Her PhD was obtained from Chelsea College of Art, UAL, in practice-led research as a curator and critical art historian. The thesis critically explored Southeast Asian museology and Southeast Asian curating in contemporary paradigms that extend into global platforms, specifically, biennales.

又一山人 · 再走一回四十年

40 years hence with anothermountainman

陳莉玲博士為南洋藝術學院東南亞藝術研究所及展廳管理處處長，曾任新加坡美術館（現新加坡國家美術館）策展人。一九九六年在英國蘇格蘭格拉斯哥大學以一級榮譽畢業，獲得美術史碩士學位，並於倫敦藝術大學切爾西藝術學院獲得博士學位，期間以策展人及批判性藝術史學家身份，作出以實踐為主導的研究。論文探討東南亞博物館學，以及當代東南亞策展範例延伸至國際舞台，尤其雙年展的現象。

and everything bonded to the experience of appreciating the narrative fiction in that film. But in 90 minutes, all this, in being captured by a camera in slow exposure: all we have, is the white light. anothermountainman perhaps offers the counterpoint: he breaks down the white light not as a logical time and space (as most film narratives impose) but as a series of sensations, forms, thoughts and actions all as individual agents in our inexhaustive, voracious world. Through this, he intends, one word, one action, one process, one form while all the time inextricably linked, still have meaningfulness. This meaningfulness is not a stock idea, in that it teaches us a lesson or is uniformly perceived and regarded by all. Meaningfulness is the presence, (not simply existence) the sheer presence that we often overlook while we are consuming and being consumed, by the savagery of contemporary life, contemporary politics, contemporary cultures, contemporary absence.

A glance through the works of his 40 years, we see how anothermountainman uses his background, his environment and his community, to translate what we think we see and live everyday, into aesthetic blends of all his productions: photography, installations, fabrications, collaborations... He compels his community to reconnect to form and function in incredible yet tangible ways we never realised possible.

In truth, anothermountainman has carved his pursuits over these several decades from the heart of this earth and where he lives. To know ourselves, we must want to know our lives: not the lives lived that the world demands of us, but our real lives unaltered, unedited, unpackaged, unbound. The reality of living, is an encyclopaedia of the momentary. The momentary is everything in between what we believe is real life, everything that we lose as we rush through contemporary existence at its most potent and controlling.

The poem by Su shi aptly captures a notion to acquaint ourselves with anothermountainman. In 40 years, anothermountainman has proposed the freedom of individuals in the way we navigate time and space. His career thus far looks game, looks enviably enjoyable, colourful, commercial and viable, cutting edge and critical. Yet they all retain the element of the mundane, a residency in reservation and reflection without airs and without presumption. In a plethora of all the videos, imageries, fashion, words and experiences he has co-created and produced, we are constantly edged to the transformative. In 40 years hence, and possibly 40 years to come, he has coaxed us to reignite the sentience of being.

on earth project and its sister production, 'the point of view after heaven on earth', an extension of the conceptual foundation from the original work into a workshop execution for the academy's students in 2012. The involvement of anothermountainman with the students offered an extraordinary opportunity to visualise and stake a claim to heaven on earth. The collaborative workshop comprised different parts of research, discussions, practical explorations, the actual logistics in production, and the progressive and eventual documentation of the installation. This was not an idealised proposal to offer a 'beautiful' image. The journey was fuelled with rigour and attention to detail: mostly negotiating the realities of how we operate in both the natural environment and our urban communities. At best, we are operatives with intent. Ultimately, the agency of what we seek, lies in a cross-hatching of multiple elements and frequencies: where the prowess and unpredictability of nature, of life itself is temporarily stabilised by human tactics, human strategies, human efforts. We cannot control what outcomes are. The aesthetic of intent is to surrender to specific experiences that have momentarily attuned to the means we employ to try to capture them.

The experiences that anothermountainman finds ways to document and accumulate, foster a critical perspective that deserves reflection. In general, art cannot be said to be political in the formal sense of the word, in speaking of governments or policies for example. But art has must have an idea that it conveys: it must have intent regardless of directive; it must demonstrate intent as an imprint without a definition, but with an obscure transformative. In the 1970s, the photographer Hiroshi Sugimoto began photographing abandoned movie screens. His intention was to shoot the movie, with controlled exposures for the duration of the movies. The still images captured were simply a bright, white light. If we sat to watch the film over 90 minutes for example, we would be imbibing 90 minutes of imageries, sound

活當中，我們擁有時空連續體的所有維度。現代生活當中的各式數碼與電子工具，把時空語境分解為圖元和波長，還有以數位編碼和依靠頻率發送的各種信號。我們在美學體驗當中拓展傳達資訊語彙的潛力已經大為提升。

要為又一山人的作品內容和創作實踐進行概述並非易事。同樣的，若簡要介紹和評估他的某項或數項創作成果，就不能好好地掌握其重要作品的特點。更重要的是，我們必須瞭解其創作環境，以及他如何在變革中走向探索。在系列作品的創作上難免會出現重疊之處，說不定藝術家在若干年後，會把較早的系列加以延展，形成增添新視角的創作。

2014 年，南洋藝術學院在校內舉辦又一山人《觀空》個展，參展作品除了一批精選佳作之外，還包括《凡非凡》以及其姐妹製作《凡非凡以外的視角》，後者的產生可追溯至 2012 年為南藝學生主辦的一場專題工作坊，活動以原始創作為其概念基礎，學生通過與又一山人的互動，能夠想像甚至擁有「凡非凡」中的一片天地，這種機會何等難能可貴。這次的合作內容包含不同的研究範圍、互相討論、實際探索、製作過程中的實際後勤工作，以及對作品裝置過程和完成後的記錄。活動不以呈現「美麗」圖像為理想或目標。整個創作過程氛圍嚴謹，大家對細節觀察入微，同時着重於探討在自然環境和城市社群裡運作的我們所面臨的各種現實問題。我們最多只能是懷着意圖的執行者。我們最終探尋的目標，是在多種元素和頻率的交匯碰撞後的成果：那是自然界與生命本身之威力和不可預測性，因人類的手段、人類的策略和人類的努力而獲得短暫的穩定。事情的後果並非我們所能控制的。意圖的審美性在於降服於特定體驗，這些體驗已經暫時與我們試圖捕捉它們而採取的手段獲得協調。

又一山人在探索如何記錄和累積各種體驗之餘，為我們提供了一種值得反思的重要視角。總的來說，藝術在正式意義上不能被說成是政治性的，至少在論及政府、政策等課題上而言。但是藝術必須擁有它所要傳達的理念（idea）；不論導向為何方，藝術也必須表達意圖（intent）；它必須把意圖彰顯為一種沒有定義卻含有隱蔽變革性的印記。1970 年代，日籍攝影師杉本博司開始拍攝被遺棄的電影院銀幕。把一部電影呈現在一張照片中是他的意圖，為此他在劇院裡放映一整部電影，讓相機底片長時間曝光，直至電影結束為止，最終拍攝出來的是發着亮光的空白銀幕影像。如果我們親臨現場觀賞一套長達九十分鐘的電影，那麼我們便會在九十分鐘內體驗各種光影和音響的交錯，還有圍繞着劇情發展所引起的相關感受。然而相機底片在長時間曝光之下，花了九十分鐘拍攝出來的銀幕影像只有一片白光。又一山人或許提供了另一番解讀：他不把白光解構成邏輯性時空（這是一般電影劇情所遵循的），而是一系列在這個無盡貪婪的世界中扮演個別角色的感受、形體、思想和行動。他這麼做的意圖，是讓永遠密不可分的一個字、一個行為、一個過程、一個實象都擁有意義。這裡的意義並非是一種老套觀念，它並非在教訓我們甚麼，大家對它的看法也並非會一致。此意義即存在感（presence，不是單純的生存或 existence）；這種實

黑雲翻墨未遮山，白雨跳珠亂入船。
卷地風來忽吹散，望湖樓下水如天。
——出自北宋蘇軾《六月二十七日望湖樓醉書》

世界公民正面臨一場危機：他站在和行走於一個變化無比迅猛的世界之中。就算努力試圖掌控眼前的各種體驗，也終歸是徒勞的。生命中最美好的時光，就是在遇上一場毫無預警地灑透全身的雷雨時；若不幸陷入人生谷底，那感覺仿彿被海水淹沒卻仍需用盡全力掙扎求存。我們到底是誰呢？生活在地球上的我們，到底是否地球的主人？掌控事物的能力，是否決定人生意義的層次？生活在今時今日的我們，總有離開這個世界的一天。如何衡量各種人生體驗，將決定我們對各自人生軌跡的認識。

又一山人花了四十年時間藉着創作和實踐衡量了個人體驗。這名創作人採用各種媒介進行創作：從短片到紀錄電影、攝影和裝置作品（《凡非凡》、《神畫》）不等。他的裝置採用外面撿到的物件，甚至日常生活中找到的「垃圾」和即用即丟物品（《拾荒／存在和尊重》）以及人們熟悉的生活用品（《香港建築／紅白藍》）。創作系列也是他匠心獨運、實現合作的管道；規模龐大的具像表現作品和裝置藝術系列足見其創作意圖和藝術嘗試的方向。這些系列作品被呈現和展出之後，即成為被賦予新意的景象，好比被重新建構的句法，得以在上千種不同語言中尋獲意義。

又一山人的作品不是單獨一種哲學或美學概念能夠界定的。他的創作理念往往扎根於既細微渺小又瞬間即逝的事物，同時又不乏「浮生千萬緒」的深遠涵義（《無常》、《色·空》）。藝術家便憑着這份關懷和心思，去觀察和表達我們未曾好好留意的事物。某些實實在在的體驗，成為藝術家投入重新製作和進行記錄的靈感啟發（《從蘇東坡想起八大山人》、《塵歸塵》、《再生·花》），並在過程中，能夠重新體會我們曾經見過和了解的事物，儘管這些體驗已經一去不返。

身為創作總監的又一山人，把作品也擴展至公共空間，這包括各種涉及文字、廣告、出版、時尚裝置、表演以至設計給非常大眾的對象和市場。我們不能完全把它們視為純粹屬於商業性質的產物，因為其細微之處在在提醒大家，我們真正看到的事物到底是甚麼。在這迅速轉變的瘋狂世界裡，我們經常忘了停下腳步、用心觀看的必要；我們在當下看到的，往往是一閃而過的幻影、圖像、色彩和文字，一旦在這上面加入聲響，我們便會突然被捲入承載着所有體驗的漩渦之中，哪怕它們稍縱即逝。

文字和圖像在兩個不同空間內運行：一個是無形的，屬於思想和情感層面；另一個則是有形的，實體可見的。又一山人收集物件裝置而成的藝術品，激發我們進行複雜思考；尤其提醒我們，要把某個文字、字母或圖像拆開來的時候——而到底是把這些解構元素置於上方或下方，則必須視最終完成的印製品而定。把平面圖片處理成三維物體，是操縱人們感受的方法；就好比我們可以通過操縱三維空間的圖像，把它們呈現為平面圖片，在毫無破綻之下達到兩者特色兼得的效果。又一山人的創作語境映射出現實生活：現實生

實在在的存在感是我們常常會忽略的，因為我們忙於應付現代生活、現代政治、現代文化、甚至現代「不存在感」（absence）的種種殘酷現實，儘管它們也是我們消費和被消費的物件。

綜觀又一山人這四十年來的作品，就會發現他是如何運用個人背景、環境和社群，把我們認為每日看到的和經歷的，轉化為各種創造上的美學混合體：攝影、裝置、構造和組建、合作項目等等。他以意想不到卻又可以感覺得到的方式讓社群重新與形式和功能連接。

事實上，又一山人在過去數十年裡從地球核心和自己生活之處，鑿開了一條探索和創作之路。人要瞭解自己，必須先瞭解自己的人生：那不是按照世俗要求而經歷的人生，而是活出不經改造、沒有修飾、毫無包裝、無拘無束的真實人生。生活的現實狀態，是瞬間的百科全書。我們所認為的真實生活，還有我們在緊張得讓人透不過氣的現代生活中匆忙奔波而失去的一切，這兩者之間的所有，即是瞬間所在。

蘇軾的詩句折射出一種認識又一山人的理念。又一山人在這四十年裡提出個人必須有探索時空的自由。他在創作生涯中取得耀眼成就，而且令人羨慕的是，他是如此的享受這份既在商業上實際可行，又是走在時代前沿並獲得高度評價且精彩無比的事業。然而他的創作依然保持了一份平凡意味，那是定格在一種毫無架子和假設意味的保留和反思。藝術家藉着與他人合作或個人製作的各種影片、圖像、時尚、文字和體驗，顛覆了我們對事物的認識。在過去四十年，説不定在將來四十年，他會繼續勸導我們去喚醒存在的感知能力。

lighting in one fell swoop the formations of protest slogans and even the demonstration itself. Questioning the act of demonstrating through the demonstrations and revealing the media through the media itself – the effect of this work is tantamount to a public case.

From the perspective of art history and the history of aesthetics, 'expression of self' is one of the greatest formations in modern art and artists have long been trying different ways to deconstruct this notion which seemed to be self-evident. John Cage, who learnt the art of Zen from D. T. Suzuki, once questioned loftily, "what exactly is the self that was in the 'expression of self'? What kind of self was being expressed? What is the purpose for such an expression?" His works were random and could not be fully controlled, breaking the boundaries of music and noise and ranging in the intentional and unintentional – the best demonstration to his bunch of questions.

anothermountainman followed this trajectory of contemporary art and 'created' a set of work titled 'painting by god'. This is not so much of his work, it would be better to say that he provided a framework (another set of formations); by using a piece of square white paper to construct a space frame and allowing light to present light, he was alike to John Cage, who provided a time frame of 4 minutes and 33 seconds to allow sound to present as sound. In such a work, the artist's desire to dominate everything was disrupted by uncontrollable factors such as weather and environment and it became impracticable, transforming 'self' into a formation that simply let things happen and pass; this is how the principle of interdependent causation works – we can do without him, but we still need him. A clock could be considered as a formation of tool that communicates, it represents a dimension which is the most basic of human life: time. 24 hours in a day, 60 minutes in an hour, 60 seconds in a minute, all these are unnatural and only presented on the scales of the clock by convention. Hidden behind this convention is our perception of time: a thing which is linear and continues to disappear while moving forward. Therefore, we are able to differentiate between past and future. Therefore, through the living from past to future, we are able to construct a self that is continuous and complete.

In my opinion, 'live now' is the most challenging work among this batch of works created by anothermountainman, in terms of its expression of Buddhist philosophy. It made use of the formations of clocks to present the motionless of time through the usual manner of time flow; to be more precise, it used every moment of flow to subvert the linear concept of time and revert the true nature of past and future through the continuous pres-

● Leung Man-tao 梁文道

Born in Hong Kong in 1970, Leung has been actively involved in different cultural, art, educational and media-related work, and is known for passionately supporting social movements. He had been Director or Chairman of various non-governmental and art organizations, and is now the Chief Curator of Vistopia Production Company, and host of audio and video programs, such as One Thousand and One Night.

一九七〇年生於香港，長年參與各種文化、藝術、教育與媒體工作，熱心支持社會運動。曾任多個非政府組織及藝術團體董事或主席，目前為「看理想」文化公司策劃人，並參與《一千零一夜》等音頻及視頻節目。

造作

formations

This batch of works – in anothermountainman's own words – is steeped in Buddhist thoughts; he also made it clear to everyone that it is his responsibility to propagate the dharma. thus, while reviewing these works, I began pondering: could they be considered as Buddhist art? If so, what kind of Buddhist art could it be?

We can start from the etymology of the word 'art'. As we know, 'art' is a concept derived from Latin. A further probing and we could trace its origin to the word ar – an ancient Indo-European language which meant 'connection'. Coincidentally, ar is the root word for ara, a Sanskrit word for the spokes of a wheel which could also refer to lights that radiate in all directions like the spokes. Speaking of which, anyone who knows a little about Buddhism would recall the saying 'the turning of the dharmachakka (wheel of dharma) never stops' and is aware that the wheel is one of the most important symbols in Buddhism.

The wheel, footprint and Bodhi tree are important symbols in early Buddhism. Thereafter, statues of Buddha, Bodhisattva and Heavenly Gods began to appear. Buddhist art would simply be prosperous foliage and a fruit laden tree if we include the verses and songs of enlightenment, Zen poetries, Zen paintings and calligraphy from China and Japan and Thangka and Mandala from Tibet. However, despite the wide range of Buddhist art, there are two problems which we could not escape from. Firstly, Buddha prohibited the making of his statues, how should we explain the later practice which violated his intentions? Secondly, the dharma propagates the theory of anatta (no-self) and emptiness, yet art is understood in modern terms to be an expression of an artist's 'self', how should we speak in defence of such a contradiction?

anothermountainman has yet to work on traditional Buddhist art like the statues, thus we can set the first question aside. However, as an extremely outstanding contemporary artist, how did anothermountainman, who is a Buddhist, respond to the call from modern art to 'express oneself'? Would he feel awkward if someone praised that his works have a strong 'personal style'?

One method of resolving this contradiction is perhaps to start from the contradiction itself. For example, Zen Buddhism proclaimed that it 'did not stand upon words', but still it required documentation to pass on the dharma. In this world, words and all kinds of media that could facilitate communication are formations that are inevitable. The essence of Zen Buddhism lies in its ability to make use of formations to reveal the true nature of formations and to destroy it. Similarly, in 'speechless', we saw many placards that were frequently used in demonstrations; these people were, however, holding onto empty placards, high-

空白無言的標語牌，因此一舉凸顯了一切示威標語甚至示威遊行本身的造作。透過示威置疑示威，透過媒體揭示媒體，這件作品的果效無異於一樁公案。

從藝術史和美學史的角度來看，「表現自我」乃是現代藝術最大的造作之一，藝術家們早已透過不同的方法來解構這個似乎不言自明的觀念。曾經跟隨鈴木大拙（D.T.Suzuki）學禪的約翰·凱基（John Cage），便曾高調質問：「甚麼是『表現自我』裡的自我？甚麼自我被表現了？它為甚麼目的而表現？」他那些隨機的、不可完全操控的、突破了音樂與噪音之界限的、界乎於有意與無意之間的作品，則是他這一串疑問的最佳示範。又一山人沿襲這條當代藝術的軌跡，「創作」了「神畫」這組作品。與其說這是他的作品，倒不如說那是他提供的一個框架（又是一組造作）；猶如凱基提供了 4 分 33 秒的時間框架去讓聲音呈現為聲音一樣，他以一方白紙構成的空間框架去讓光影呈現為光影。在這樣的作品裡頭，天氣與環境等不可調控的因素架空了意欲主宰一切的藝術家自我，使自我變成了一個單純讓事物發生復又流逝的造作；雖然無他不可，但也非無他不可，因緣的邏輯大抵如是。

其實時鐘也可以算是一種溝通表意的工具造作，我們透過它來表示人類生活最基本的向度：時間。一天二十四小時，一小時六十分鐘，一分鐘六十秒，這並不自然，在時鐘上呈現出來的這些刻度只不過是我們的約定而已。潛藏在這約定背後的，則是我們對時間的感知；一種線性的，不斷向前又不斷消失的東西。由此我們能夠區分過去和未來。由此我們才能建立一個從過去活向未來的連續的完整自我。在我看來，「當下」是又一山人這批作品之中最具佛學意味的一個挑戰。它假借時鐘的造作，以它慣常顯現時間流動的方式去顯現時間的不動；或者更準確地說，是用每一刻流動的動作去顛覆了線性的時間觀念，用不斷的現在去還原出過去與未來的真正面目。既然究極而言，過去和未來都只不過是現在的幻覺，那麼建立在這套線性時間觀上的自我又怎能不是幻覺呢？這並不是要否定生滅，就像「當下」這具「時鐘」到底也是會不停跳動一樣，生生滅滅確實是發生了，只不過那不斷發生的生滅未必就是我們平常所理解的「過去」與「未來」而已；它們是一個接着一個的現在，我們只能活在一刻又一刻的現在。

又一山人的藝術是佛教藝術嗎？我不敢確定。我猜，這是一連串的造作，一連串的「水月道場」，以造作敞示造作，藉自我懸空自我，可以是藝術，也可以是佛法，好比又一山人所鍾情的弘一書法。

原文：新加坡南洋藝術大學《觀空》展覽場刊／2014

ent. Ultimately, the past and future were merely illusions of the present, how could it not be an illusion then, for the self that was constructed upon the linear concept of time? We are not denying the existence of life and death, just like how the 'clock' named 'live now' did not stop moving, life and death did happen; it continues to occur, but might not necessarily be alike to the 'past' and 'future' which we usually understand. They are a continuous sequence of the present; we could only live in every moment of the present.

Can the art of anothermountainman be considered as Buddhist art? I am uncertain. My guess is that this is a series of formations, a series of 'water moon monastery'; opening up the formation through its formation, vacating the self through self. Like the calligraphy of reverend Hong Yi which anothermountainman adored, it could be art and it could be dharma.

original: exhibition booklet of perceive emptiness (2014) at nanyang academy of fine arts singapore

|

這批作品，就像又一山人自己所說的，全都滲着佛家思想；而又一山人又很明確地告訴大家，他要以弘法為己任；所以我一邊重新觀看這批作品，就一邊思索：它們到底算不算是佛教藝術？如果是的話，那又是種怎麼樣的佛教藝術呢？

不妨從「art」這個字的字源講起。「art」，我們曉得，是個來自拉丁文的概念。再往前溯，原來還能追到古印歐語的「ar」，意思是「連結」。恰巧「ar」又是梵文「ara」的字根，而「ara」則是車輪的輻條，引申出去則可指示一切如車輪輻條般輻射出去的光線。説到這，任何對佛教略知一二的人大概都會想起「法輪常轉」，知道車輪乃是佛教最重要的象徵之一。

車輪、腳印和菩提樹，皆是早期佛教的重要象徵。後來開始有了佛像、菩薩像以及各種護法天神的造像。要是再加上證道偈、道歌、禪詩，中國和日本的禪畫、書法，西藏的唐卡與曼陀羅。佛教藝術簡直就是一棵枝葉繁盛、花果纍纍的老樹。然而，在這林林總總的佛教藝術裡頭，始終有兩個擺脱不了的難題。其一是佛陀本人曾經禁止為他造像，後來者應該如何解釋違其本意的做法才好呢？其二是佛法宣説萬物無我的究竟空見，而藝術卻又被今人理解為藝術家「自我」的表現，此間矛盾又該如何圓説？且不論第一個問題，因為又一山人到底還沒做過佛像之類的傳統佛教藝術。但是身為一個極其優秀的當代藝術家，學佛的又一山人會怎麼回應「表現自我」這個現代藝術的頭號訓令？要是有人稱讚他這一系列作品很有「個人風格」，他又會不會覺得尷尬呢？

解決這個矛盾的途徑之一，或許就是直接從矛盾下手。例如禪宗標榜「不立文字」，卻還是得以成文的公案傳燈。因為文字乃至於任何一切能夠拿來溝通傳意的媒介，皆是人在世間不可避免的造作。怎樣藉着這等造作揭示造作之為造作，以造作毀棄造作，才是禪門文藝的要旨所在。同樣地，我們在「無言一」這個作品之中，固然看到了一大堆示威遊行常見的標語牌；但那些人手中拿的卻是

tor", someone like a persuasive and talkative friend who uses visual symbols and images as tools to keep talking to you. By observing his creative process, it is obvious that in terms of intrinsic creativity, anothermountainman often observes himself, examines his soul, and talks to it. In a way, it is a curiosity for exploring the source of life and the nature of death. In terms of extrinsic creativity, he pays attention to others, responds to existing outstanding problems with a sense of social responsibility, and conveys positive energy. As John Donne wrote in his poem, "No man is an island." anothermountainman always shows, intentionally or unintentionally, the public meaning of an individual in the human population. This kind of quiet and meticulous mind, which is good at observing and focusing on expressing oneself, may be related to his religious and philosophical beliefs. As a Buddhist, he does not bother to pursue any constant materialistic items. Rather, he focuses on a free and seemingly illusory situation. Just like Bada Shanren that he has long admired, he aims at realizing emotional emancipation and spiritual uplifting in a lonely, creative mood.

The valuable thing is that anothermountainman has never stopped in the journey of exploring himself and art. He reflects on his state of mind and creation almost every ten years. In 2011, he used his 30 years of creative path as the theme and invited 30 creators from mainland China, Hong Kong, Taiwan, and overseas countries to conduct multiple dialogues around the topic of "what's next 30×30 Creative Exhibition". Apart from moving forward, he would reflect on his past from time to time. For artistic creators, it is undoubtedly a very intelligent way of spiritual practice. This time, he will reflect and conduct a summary of his creative life over the past forty years. Indeed, I believe that this summary is merely a phased outcome on his creative path. In the years to come, along with further in-depth exploration, his artistic personality will become even more profound.

我與黃炳培先生是多年的老友了。

或許他的別號「又一山人」近年來更為人所熟知。這個出源於八大山人的名字,更像是他對藝術創作生涯、對人生經歷的進一步思考。四十多年來,從早年致力於商業創作,到投入人文創思,他藝術設計中的美學意境正一步步地發生變化。他不願意成為受制於商業效益或潮流趨勢的「傀儡」,任其個人情懷被消磨殆盡。所以,在意識到已經將大半生的時間花費在商業設計中後,他迎來了人生的轉捩點,將自己「一分為二」,一邊是繼續商業設計的「黃炳培」,一邊是醉心於藝術文化創作的「又一山人」。他曾說,「一個人,兩個名字,三重身份,四個服裝夢,五種視覺領域」是對他的創作生涯的概括。若是在職業設計師眼中,又一山人這些年來的創作可能

● Wang Shaoqiang｜王紹強

Wang Shaoqiang, a.k.a Last Mountain, established Design 360° — Concept & Design Magazine in the 1990's and published a series of influential works. Wang became the Director of the Guangdong Museum of Art in 2015, and curated "Reform Mission: Guangdong Arts Centennial Exhibition" and a series of exhibitions which obtained widespread acclaim. In 2018 also saw his designation as an influential figure by National Fine Arts.

王紹強，號後山，九十年代末創辦《Design 360。——觀念與設計》等具國際影響力出版物。二〇一五年調任廣東美術館館長，主導《廣東美術百年大展》等，並策劃《廣州影像三年展》等展覽，獲廣泛好評，二〇一八年被《國家美術》評為風雲人物。

Perhaps his nickname of "anothermountainman" has been more well-known in recent years. This name, which originated from the name of "Bada Shanren" (Mountain Man of the Eight Greats), seems to be his more profound thoughts on his career in artistic creation and his life experience. From his early commercial projects to the recent works on humanity , the aesthetic mood in his artistic design has been going through gradual changes in the last forty years. He was unwilling to become a "puppet" controlled by business benefits or trends that exhaust his personal feelings. Hence, after realizing that he had spent most of his life in the field of commercial design, he ushered in the turning point of his life and "divided himself into halves". On one hand, he continued as "Stanley Wong" that focused on commercial design works, on the other, he was obsessed with artistic and cultural creation as "anothermountainman". He once said that the description of "one person, two names, three identities, four fashion dreams, and five visual domains" can be used to summarize his creative life. In the eyes of professional designers, anothermountainman may have created rather "irrelevant and unfocused" art pieces over these years. By involving in fields of photography, art installation, videography, calligraphy, etc., he is a designer, an educator, and a social worker all at one time. Perhaps it was because of these "multiple identities" that infiltrated his works with discussions of social issues and exploration of human concepts, which focused on expressing the values of personal social identity and philosophical thinking about life.

The minds of interesting people never stop thinking, and there is no doubt that anothermountainman is an interesting guy. He believes that design and life can never be separated, and every bit of life can be a source of inspiration for his creation. Therefore, he has a scavenging habit. By collecting leaves and items considered useless in the eyes of others, he created his unique works. For instance, through his adaptation, the seemingly inconspicuous symbol of "Red, White and Blue" had successfully introduced what he believed as extremely precious spirits and values of Hong Kong. In the torrent of time, however, such spirits and values are sadly fading. Meanwhile, the "Lanwei" photo series started with the towering, unattractive, and unfinished buildings seen in Guangzhou. In seven years, the phenomenon extended to twelve Asian cities, showing the desperation of economic prosperity in the great era. "Lanwei" is in fact layers of questions on the social outlooks and individual fates. Due to its profound nature, the series was collected by the M+ Museum in Hong Kong in 2013.

anothermountainman calls himself a "visual communica-

顯得有些「不務正業」，涉足攝影、藝術裝置、影像、書法等多個領域，同時他除了是設計師，還是教育工作者、社會工作者。大概正因為這「多重身份」的驅使，使他的作品在形式之餘，滲入了對社會問題、人性觀念的探討，着重表達個人社會身份的價值觀及對生命的哲學性思考。

毫無疑問，又一山人是個有趣的人，有趣的人往往難以停止思考。他認為設計與生活無法分開，生活中的點點滴滴都能夠成為他創作的靈感來源。因此他「撿破爛」，通過收集樹葉，收集他人眼中的無用之物來構成自己的作品。就如同看似不起眼的「紅白藍」的符號，在他手中能夠引申出香港本土那些他所認為極其珍貴的，但卻無可奈何正在消逝的精神與價值觀。而《爛尾》攝影系列以高聳入雲卻無人關注的廣州爛尾樓為開端，七年內，延伸到十二個亞洲城市，展示大時代經濟繁榮之餘的落魄，是對社會前景、個人命運的層層提問。正因其深刻性，該系列在 2013 年被香港 M+ 博物館所收藏。

又一山人自稱為「視覺溝通人（visual communicator）」，就像一位滔滔不絕、循循善誘的朋友，以圖像等視覺符號為媒介來與你不停地對話。觀察他的創作歷程，對內，他觀察自我，審視靈魂並與之對話，是對探索生命來源及死亡本質的求知欲；對外，他注重他者，以社會責任感來反應當下突出的問題，傳達一種正面的能量。正如 John Donne 的詩中所言，「沒有人是一座孤島」，又一山人總是在有意無意間表現出自我身為人類中一個個體的公共意義。這種善於觀察、專注於表達自我的恬靜細緻的心性，或許與他常年的信仰有關。作為一名佛教徒，他並不費心追求恒定的物質，而是寄情於自由的、看似虛幻的情境。就像他所憧憬的八大山人一般，在孤獨的創作心境中實現情感的解放和精神的昇華。

可貴的是，又一山人在探索自我、探索藝術的道路上從未止步。幾乎每隔十年，他便會重新審視彼時的心境與創作狀態。2011 年，他便以三十年的創作歷程為線索，邀請 30 位來自中港台及海外創作人，圍繞「what's next 三十乘三十對話創意展」這一主題展開多重對話。時而前行，時而自省，對藝術創作者而言無疑是極具智慧的修行方式，此次他又將對 40 年來的創作人生進行反思總結。當然，我相信這一次總結只是他創作道路上的階段性成果，在以後的歲月裡，他的藝術個性會隨着更深入的探索而愈發深刻。

el for his subsequent expedition as a creator.

anothermountainman is the most intelligent and hardworking creator in my circle of friends. Generally speaking, intelligent people are not diligent, while those who are hardworking are not quite smart. However, anothermountainman is an exception. He is prolific and is often able to seize the opportunities to create the best. He believes that he can prove his ability by overcoming challenges in different categories. In his early days, he already had a very high taste and sensitivity to various visual forms. With immense creativity, his ideas were just right to the point; with the ability to draw attention, he could present climaxes in a subtle way. Apart from work, he also pays much attention to details of life, which include his personal image that features his skinhead and round glasses, the large negative camera that is not so convenient, the aluminum box for miscellaneous items, the unforgettable "free form" interactive business card, etc. Before creating any other objects, he first created himself. As he is well-prepared for his 60th birthday, anothermountainman's charm has become more delicate, possibly because of his spiritual practice in Buddhism. Likewise, he has also developed a more easy-going attitude. With rich life experience accumulated over the years, he has also exerted more efforts in recent years on sharing with the new generations. This retrospective exhibition, which shows his iconic works throughout different stages, will allow younger generations to fully understand this almost omnipotent creator. Meanwhile, peers like me are eager to see more sparkles that will inspire the pride of artists in the same generation.

|

又一山人有好幾個名號,不同的名號又指涉他在創作領域中的不同身份,他是香港土生土長的創作人,他的作品涵蓋了廣告、設計與藝術。在遊走於最商業的廣告和最純粹的藝術中間,他又置入了對社會的關心和對佛學的追求,這種種的極端放在一個人身上,實在是有點不可思議;但當你看到他,和他傾談一會,又覺得這種種極端又毫無違和感地融和在一起。作為一個以設計為本業訓練的人,擁有這種豐富跨度能力的人,到底是設計出來的,還是透過創作實踐中成長出來的?

認識山人較深的時候是他的「紅白藍」時期,他不諱言是用廣告策略的手法來推動這系列作品的生成,這系列在當時的藝術界和流行文化界十分受注目,至今仍有其他人在模仿,甚或還在發揮其枝節的伸延…他用廣告的策略做藝術,打開了藝術圈的想像,也直接疏解了藝術家在追求藝術創作的純粹性,同時希望在市場獲得認可的矛盾。山人示範了不一樣的方法,達致了超出藝術家一般期望的結果。紅白藍的故事大抵上是我在香港所見首個成功直接用廣告策略完美地和藝術操作結合的案例,直接或間接地影響了不少人。

● Kurt Chan｜陳育強

Joined The Chinese University of Hong Kong in 1989, teaching studio courses and supervising M.F.A. students. He has retired since 2016. Kurt is an artist as well as an educator, his research interests cover a wide range of topics such as Hong Kong Art, Art in public realm and mixed media, whereas the outputs mostly presented as exhibition, curatorship, and publication.

一九八九年起於香港中文大學藝術系任教藝術課程，並於二〇一六年退休。陳氏是一位藝術家，亦是一位教育工作者，研究興趣範圍涵蓋多個領域，包括香港藝術、混合媒介及公共藝術，成果多以展覽、策展及出版發表。

anothermountainman actually has several names - each represents his identity in a specific art domain. Being a creative guy who was born and raised in Hong Kong, he has produced works that covered advertising, design and art. Cruising between the very commercial advertising industry and the purest of art, he has infused into his works his concern for the society and his pursuit for Buddhist teachings. It is actually a bit unbelievable that such extremes exist within the same person. However, after you've met and talked to him for a while, you'll feel that all these extremities can mingle so harmoniously in him. Being a designer by training, Stanley is a person with high adaptability. Is such a character specifically designed, or was it grown through his creative practice?

It was during his "Red, White and Blue" period that I really got to know anothermountainman. In fact, he admitted that he used advertising strategies as a promoting force to generate this series of works, which became very popular in the art and pop culture circles back then. Until today, there are still other artists who imitate Stanley's works or even extend his concepts to another level. By applying the strategy of advertising in art, he did not only open up the imagination of the art circle, but also directly relieved the dilemma between the artists' purity in pursuing artistic creation and their wish to be recognized by the industry. anothermountainman has intelligently demonstrated a different method that achieved results beyond the general expectations for artists. The story of "Red, White and Blue" is perhaps the first successful case in Hong Kong that directly and perfectly combined advertising strategies with artistic operations, which in turn directly or indirectly influenced many people.

In recent years, anothermountainman has concentrated on learning Buddhism and has shown particular interest in the Chinese culture. Hence, he also studied calligraphy and has made quite exceptional achievements. I once presumed that his fondness for Chinese classical culture originated from Japan, as the precision and accuracy in his works were rather rare in any other cultures. With an increase in age and experience, however, he became more interested in exploring and developing the long accustomed cultural practices through the rough raw materials of the Chinese culture full of rituals and habits. He further interpreted and presented the cultural practices in the form of contemporary art. In anothermountainman's design and artistic journey, the philosophy and belief of Buddhism have provided a cornerstone for his creation and added weight to his diverse range of creativity. Moreover, the philosophy also provided some channels for him to move freely among different creative topics and set a mod-

山人近年潛心學佛，對中國文化尤感興趣，所以也學習書法，已有相當的成績。我曾設想他對中國古典文化的興趣是源自日本，他作品那種精鍊準確，實在難以在其他文化中找到；但隨着年紀和經驗漸長，他更有興趣在充滿積習的、粗糙的中國文化原材料中，發掘和開拓這種本來習以為常的文化實踐，再用當代的藝術方式加以演繹和呈現。在設計與藝術旅程間，佛學作為一種哲學和信仰，為他的創作提供了一塊磐石，使山人多樣的創意產生某種重量，也提供了某種通道，他在不同的創作議題中自由往還，並確立往後作為創作人，作為做人行事的依傍。

山人是我朋友圈中兼具最聰慧、最勤力的創作人，通常聰慧的人不勤力，勤力的人不怎聰明，但山人是特例。他既多產又往往能別出機杼，相信來自他喜歡藉不同範疇的挑戰來證明自己。他較年青時對種種視覺形式的品味和敏感度已相當高；創意澎湃但點到即止，高潮迭起又含蓄洗練。除工作外，對生活細節的執着一絲不苟：包括他自己平頭圓框眼鏡的造型、不甚便利的大底片菲林相機、鋁製的雜件盒、令人難忘的 free form 互動名片，在創作他物之前，他先創作自己…現在的他正準備迎接花甲之年，山人的鋒芒或已因學佛而更為沉澱，態度更為舒坦；當自己儲備有成，近年他更多着力地向新一代分享他的經驗，而這次階段性的回顧式展覽，當可讓後輩全面地認識這位幾乎全能的創作人，同輩如我期待另一次鼓舞同代人引以為榮的花火。

he was already very famous in the art community. In 2004, we worked together on the exhibition he curated at the Hong Kong Heritage Museum that was one of his red-white-blue projects. Never could I have imagined how a leading figure in the creative field and a museum apprentice could exchange freely eye to eye. More surprisingly, the dialogue did not end with the exhibition. At the age of 50, anothermountainman held an exhibition celebrating his anniversary and extended the opening invitation to me. In that show, he initiated creative dialogues with different friends from the art and design circles in exploration of new visions and possibilities. When I attended his exhibition in Shenzhen, I was amazed to see his big group of friends from all cultural spectrum. It was also amazing to see top cultural icons showing alongside with relatively new members in the industry. This is the anothermountainman I knew - in the world of creativity and personal relationship, everyone is equally valued and appreciated in his own unique way.

People used to say: How many decades can one afford in one's life? Looking at every 10-year interval, we are sure to expect different degrees of changes. What is more interesting, perhaps, is what stays. The unchanged and the unshaken are usually what is fundamental and what one holds dear to one's heart. When talking about his father Wong Cheung, anothermountainman said, "He came to this world in peace (Cheung means peaceful), and left in peace". I imagine, when we bid farewell to this life, if we can bring a lovable piece of us as we were a newborn, that is already an achievement. If we can add some colours or meaning to it, it will be a real accomplishment.

To anothermountainman, his creative work is a form of preaching. I believe it is also a kind of spiritual practice. In this exhibition, we can see, by karma, how much he has converted, cultivated and harvested. I believe that if our work and life can also be transformed into sincere spiritual practice and sharing like that of anothermountainman, each of us can become an absolutely wonderful and moving piece of artwork in our exceptional way. With concerted efforts, we will create a different Hong Kong and a brand new world. While my best wishes goes to anothermountainman and his show, may I also wish every one of you the best of the best in your own quest.

世界急速地變化，儘管是一個再普通的香港人，作為大時代的小人物，見證到香港的發展和轉型，見證到不同時期各種歷史和社會事件的發生，我們都慶幸能活在一個不平凡的時代中。對於香港，我們都有濃烈的感情，在又一山人的作品裡，這感情更是一直濃得化不開。

● Eve Tam｜譚美兒

見山仍是山

The mountain that was, the mountain that is

Eve Tam has extensive curatorial experience working with different museums for over 20 years. As Museum Director, she took charge of the major renovation and extension of the Hong Kong Museum of Art from 2012 to 2019. Currently, she is the Assistant Director of the Leisure and Cultural Services Department responsible for the planning of new museum projects.

譚美兒從事博物館工作逾二十年，二○一二年開始擔任香港藝術館總館長，主理藝術館的大型維修及擴建工程，二○一九年轉任康樂及文化事務署助理署長（特別項目）。

Hong Kong has been experiencing tremendous transformation with the rapidly changing world. For us Hongkongers who are witnesses to the different historical moments and social changes, albeit ordinary and average we might be, all the same, we feel special living in an extraordinary time. As a Hong Kong citizen, we all love our home town. As an artist, anothermountainman's feeling for the city is even more intense as seen in his works.

In my days as curator, the usual questions raised by the audience are: What makes a good piece of work? What defines a good artist? To me, if there is no passion, it will be difficult for a work to touch its audience and to be everlasting. Before a work can move people, its creator must be passionate and sincere in the first place. Work that is pretentious can only fool a few for a while. It can never fascinate generations of audiences. In my belief, artists who can appeal to people's hearts are usually those who are curious about the world; caring and concerned about the fate of humanity. And often, only works that deal with subjects and issues relevant to all humankind can connect beyond temporal and spatial limits. Whether a work can live up to the test? Only time can tell.

anothermountainman is a versatile artist who has been involved in different creative media – advertising, graphic design, photography, installation, film-making, to name a few. To him, creativity knows no bounds. Over the years, he has been navigating freely across perceived boundaries: the commercial and the non-commercial, art and design, the spiritual and the material, and above all, between anothermountainman and Stanley Wong. His works are thought-provoking, full of gratitude, impermanence, sensibility and empathy, and most importantly, they are expressions of his attitude and vision about life.

The world we live in is diverse and complicate in many ways, yet more often than not, we are caught by our thinking habits and develop a kind of inertia, which could lead us to seeing the world as divided dichotomy, hindering critical and creative thinking. By questioning through his works, anothermountainman constantly challenges existing values and preconceptions. And by juxtaposing seemingly opposing values, he is continuously looking for the common ground in the midst of dynamics and cherishing differences in the collective. In this quest, he embraces others in his universe, lives in the rehearsal of his future death, craves for the living spring in a concrete jungle, and builds his pure land in the mortal world…

In my twenty years in the museum field, I have made many artist-friends and anothermountainman is certainly one of the special few. When I was still an inexperienced assistant curator,

觀眾常問，甚麼是一件好的作品？甚麼叫一個好的藝術家？我個人認為如果沒有情，作品難以動人，不能打動人就難以長久。要作品動人，藝術家本身首先要是個有情的人，而且要是一個感情真摯的人。矯情的作品極其量只能騙人於一時，不能世世代代地讓人迷倒。能觸動人心的藝術家，往往是一個對世界充滿好奇、關愛，對整體人類命運充滿關懷的人，能關心大家共同的命題、對大家共有的好奇問題有所啟發，才能使作品與大眾有超越時空的聯繫。這種能耐，需要時間，由觀眾去驗證。

　　又一山人曾涉獵不同的創作媒介——廣告、平面設計、攝影、裝置、影片…對他來說創作不劃分空間，創作沒有邊界，他靈巧地遊走在商業與非商業之間，遊走在藝術與設計之間，遊走在精神世界與物質社會之間，遊走在又一山人與黃炳培之間…他的作品充滿了思考、感恩、無常、人情味和人民關懷，他努力透過作品傳達對人生、對生命的看法。

　　生活在一個像多元的世界，思考的慣性卻容易令我們跌入只有二元的想像，把東西區分起來雖然便於理解，但很容易讓人墮入一種思考的惰性。又一山人透過作品不斷提問，甚至挑戰大家既有的價值觀或觀念，他把原本被視為對立的價值並置，在對立面裡尋找共性，在群體中尋找個人，在個人包容眾生，在生活裡與死亡共處，在都市尋找綠洲，在人間尋找淨土…

　　在博物館工作了超過 20 年，結交了不少藝術家朋友，又一山人是其中一個比較特別的。當我還是一個很稚嫩的助理館長時，他已經是一位大師，2004 年與他在香港文化博物館合作一個以紅白藍建構香港想像的展覽，沒想過大師與學師可以有這麼平等的交流，而且交流沒有因展覽結束而結束。又一山人 50 歲時做了一個展覽邀請我去參觀，那次他廣邀設計藝術界的朋友與他以作品對話，互相交流和激發想像與創意。在深圳看他的展覽時心想：他的朋友真多！當中有一些是大師，也有一些是比較新晉的，這就是我認識的又一山人，在創意與感情世界裡，多元兼容，人人平等。

　　人生有幾多個 10 年？每 10 年的一個回顧，變化可以很大，但可能更有趣的是尋找那沒有變的，因為永續不變的才是我們最核心的部份。在談起父親黃祥時，又一山人說：「來是祥，走也是祥。」我想像，如果我們離開這個世界的時候，能保存我們最初呱呱墮地時美好的一點甚麼，已經很不容易；如果能在這之上再昇華一點，那就相當不錯了。

　　又一山人說他的創作其實是一種傳道，我相信亦同時是一種修行。在這展覽中，大家可以親證他在這過程中結的不少緣，種的不少因，修的不少果。如果我們每個人的工作、人生都能如又一山人一樣幻化成誠心的修行與傳道，相信我們每個人都會是一件很美妙動人的作品，而我們相加在一起，會雕塑出一個不一樣的香港、不一樣的世界。在祝願又一山人展覽成功之餘，希望與大家共勉之。

● Lars Nittve ｜李立偉

An art historian, curator and writer. For almost thirty years he was the director of a number of major museums around the world, including the Louisiana Museum of Modern Art, Denmark; Tate Modern, London; Moderna Museet, Stockholm and most recently M+, Hong Kong. In 2016 he established Nittve Information Ltd, based in the mountain resort of Åre, Sweden, acting as an independent writer and advisor to museums and foundations worldwide.

Lars Nittve believes that what leads to success for an art centre is its close connection with the city pulse, so that citizens feel that the art centre is built for them and would be proud of it. "Given Hong Kong's uniqueness, M+ will therefore become a unique museum undoubtedly," he said.

He suggested, for instance, many artists in Hong Kong engage in different areas of work, such as Wong Ping-pui, a.k.a 'anothermountainman', who is both an artist and a successful advertising creative. He said, "Twenty years ago in Hong Kong, it was hard to make a living as a full-time artist, so the way Stanley developed his career was quite common among artists. At that time, they might not be valued academically, but their brilliant creations definitely earn recognitions nowadays. The development of these artists reflected Asia's cultural and economic development, and this phenomenon will be presented in M+ as well."

Extract from JET Magazine / Jul 2011 Vol.107

李立偉認為一個藝術中心要成功，必須與城市的脈搏緊緊相扣，讓市民感覺到藝術中心是為他們而設，令他們感到驕傲。「香港有很多獨特之處，足以讓 M+ 變得獨一無二。」

他舉例說，香港很多藝術家的工作涉獵多個領域，像原名黃炳培的「又一山人」，既是藝術家，也是成功的廣告人。「在二十年前的香港，全職藝術家恐怕難以維生，像黃炳培的情況很普遍。在當時的學術界也許不被重視，但他們出色的創作在今天卻受到極高評價。這些藝術家的成長過程正好反映了亞洲在文化與經濟的發展，M+ 也會呈現這個特徵。」

節錄自 JET Magazine ／ 2011 年 7 月 Vol.107

藝術史學家、策展人及作家，近三十年來曾在全球多間大型博物館出任總監，包括丹麥路易斯安娜現代藝術博物館、倫敦泰特現代藝術館、瑞典當代美術館，以及香港 M+ 博物館。二〇一六年，他成立 Nittve Information Ltd，駐於瑞典 Åre 山脈度假村，為世界各地的博物館和基金會擔任獨立作家及顧問。

● Sabrina Fung | 馮美瑩

Stanley Wong is an immensely focused and committed artist with intense creative energy. His Zen Buddhist approach and distinctive Hong Kong sensibility are consistent elements of his strikingly visual works, ranging from the iconic REDWHITEBLUE series, photography and multi-media installations to his recent film "冇照跳 (*Dance Goes On*)", which captures a special moment in time for three prominent dance choreographers and the city where they and we live. As Stanley's multi-discipline art and subtle aesthetic language have evolved over the years, he has continually pursued inspiration and meaning through in-depth explorations of space and emptiness, and, ultimately, the significance of nothingness. The dynamic tension among these phenomena is fundamental to Stanley's powerful artistic voice.

|

黃炳培（藝名又一山人）是位具有極度藝術觸覺及專注創造力的藝術家。禪宗思想以及對香港獨有的敏銳觸覺均是黃炳培視覺藝術作品中常見的元素，包括他標誌性的《紅白藍》系列、攝影、多媒體裝置創作，及在2017年他執導的卓越電影《冇照跳》中拍攝的香港三位傑出編舞家，在我們共同生活的城市中捕捉當下時光和回顧。隨着在跨媒介藝術和微妙美學語言的不斷發展，黃炳培多年來深入探討藝術中的空、虛、實，以及最終的「色·空」概念，並不斷追求靈感和意義。這富動態張力的表達，正是黃炳培震撼藝術的力量。

Ms Sabrina Fung has actively participated in contemporary, cross-cultural and multi-media art programs internationally since 1980. She has organized, curated and advised on cultural events, art collections, and exhibitions, including the Hong Kong Pavilion for the 51st Venice Biennale in 2005 and projects to promote public art awareness and contemporary art appreciation in Hong Kong. Ms Fung is a member of M+'s Acquisition Committee of the West Kowloon Cultural District.

馮美瑩自一九八〇年一直積極參與跨文化及多媒體活動，在世界各地之公共及商業環境提供藝術顧問服務、選購藝術藏品，及策展多元化的文化藝術活動，以推廣公共當代藝術的關注和欣賞，包括二〇〇五年為意大利第五十一屆威尼斯雙年展策展之香港展館。馮女士現為香港西九文化區 M+ 購藏委員會委員。

I believe it was Stanley's apprenticeship and career in the commercial world that shaped his persona as Stanley the artist – anothermountainman.

Like a butterfly emerging from a chrysalis, Stanley the artist escaped and found something deep inside of him that he needed complete freedom to express.

Art can be subjective and controversial, open to personal interpretation. But within the work of anothermountainman, is always a core idea.

Look beyond the beauty and the impeccable design, the message is always there. Something to say. Something to provoke. Something to arouse feelings inside of you.

From the iconic simplicity of 'Red, White & Blue', to the abandonment of unfinished buildings, anothermountainman sees things we don't.

Sees beauty where we see ugly. Sees possibility where we see same old same old. Sees unique, emotionally moving stories crying out to be told.

Always with absolute beauty. And the design. Always the design.

Where Stanley Wong has been, is the foundation for the journey that anothermountainman is constantly on.

在商業設計打滾多年,黃炳培走出工作,找到他的另一個身份——又一山人。

與商業廣告不同,又一山人希望透過藝術創作,表達自我。

藝術品存有不同的詮釋空間,受眾會投放不同的主觀感受,但又一山人的創作總帶着強烈的核心思想。

建基在美學和設計學上,又一山人將意念灌注在創作中。與作品對話,與作品交心。

「紅白藍」到「爛尾」,又一山人將日常化作藝術,呈現不一樣的視覺。

從平凡中發現美,從古老石山中發掘潛在可能,從生活日常中尋找出獨特動人故事。

對美和藝術的追求從一而終。

又一山人是由黃炳培的養分進化而成。

● Chris Kyme｜關思維

又一山人。藝術工作者

anothermountainman. the artist.

Chris has worked in advertising in Asia for over 30 years as a Creative Director with global agencies such as Leo Burnett, Grey and FCB, creating some of Hong Kong's best loved work in the 1990s. He has been Chairman of the Hong Kong 4As Kam Fan awards several times, and is the author of a book on Hong Kong creative advertising called "Made in Hong Kong".

關思維於廣告業界打滾逾三十年,曾在亞洲出任多間跨國廣告公司創作總監,如 Leo Burnett, Grey 及 FCB。不少九十年代為人熟悉的作品都出自其手筆。曾多次擔任 4As 金帆廣告大獎主席,並就香港創意廣告出版《Made in Hong Kong》一書。

amm

anothermountainman

2000 > present

amm-01

archive no.

: now live now \ 2 | : now 備卜\ | |

● object | ● 2011

aw. | 2011 hkda global design awards biennial \ product \ judges' choices ·
conceptual design \ bronze

when is now?
where do we go next?
what did we do just now?
work on "a" now ? or do "b" first?
thinking about "b" while working on "a"?

live now.
explicitly now.
focus myself at now.

the click of the : now clock
is like the chime at a buddhist temple,
calling my soul, my mind,
back to now.

現在是甚麼時候？
跟住我們去哪？
剛才我們做了甚麼？
現在先做甲？還是先做乙？
還是做甲途中，同時想乙？

活在當下。
清晰在當下。
將自己凝聚在當下。

當 : now 枱鐘咔地一聲，
就像禪堂引磬聲響起，
將心，神呼喚回來。
來到當下一己。

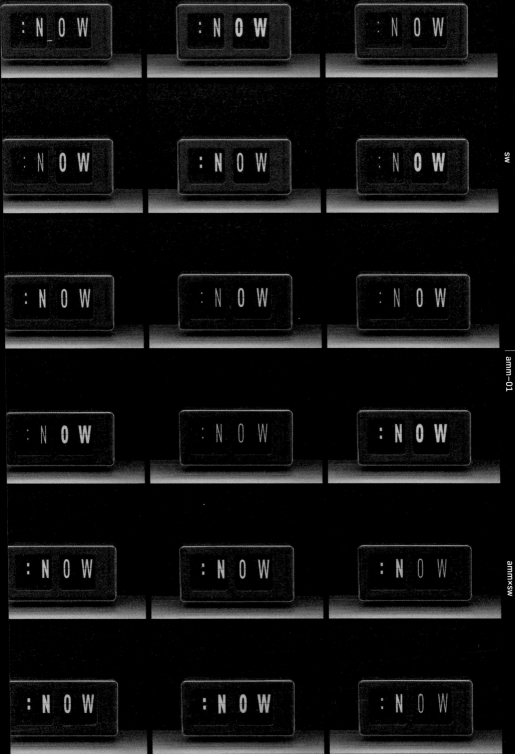

from dust to dust \ 302 days ｜ 塵歸塵 \ 302 日

● painting (canvas \ metal object) ● 2018 \ 2019

▶ video

info｜time \ 2018.09.29 – 2019.07.28
place \ e22.5° n11.4°

after 302 days, what should be left of
the metal, wood, water and earth is
still there,
but what has been hoped for, has dis-
appeared before my eyes.

time will tell

it witnessed
hopes and reality
it witnessed
permanence and impermanence
it witnessed
from dust to dust, earth to earth.

當金木水土融和三百零二天之後
應留下來的還在
希望衍生滅絕眼前

時間的見證

見證了
期望和現實之間
見證了
恆常和無常之間
見證了
塵總歸塵土總歸土

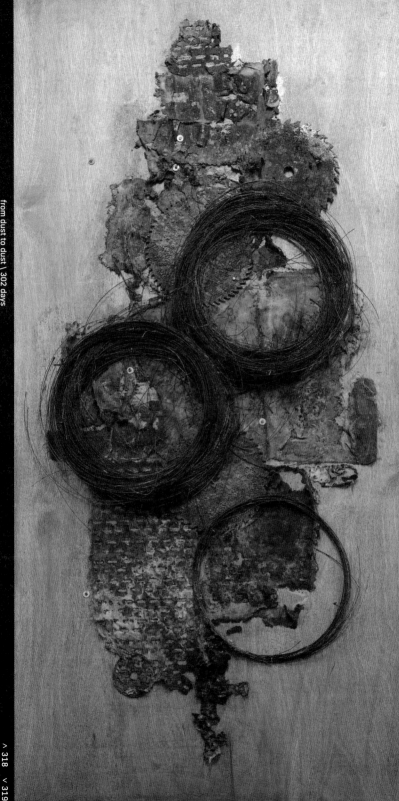

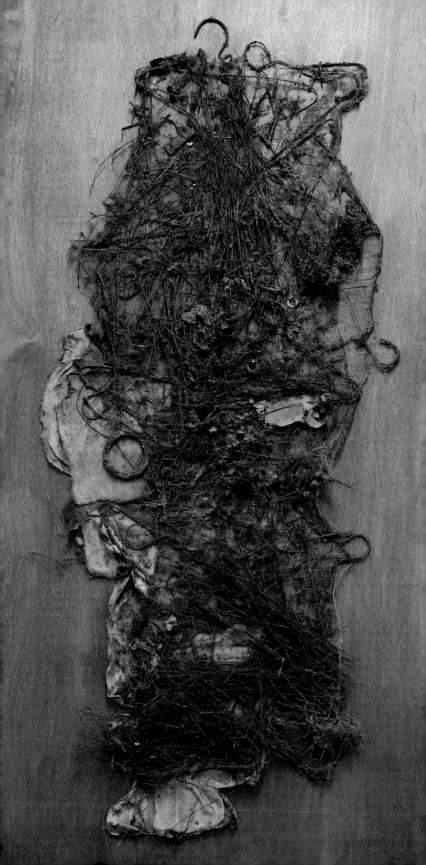

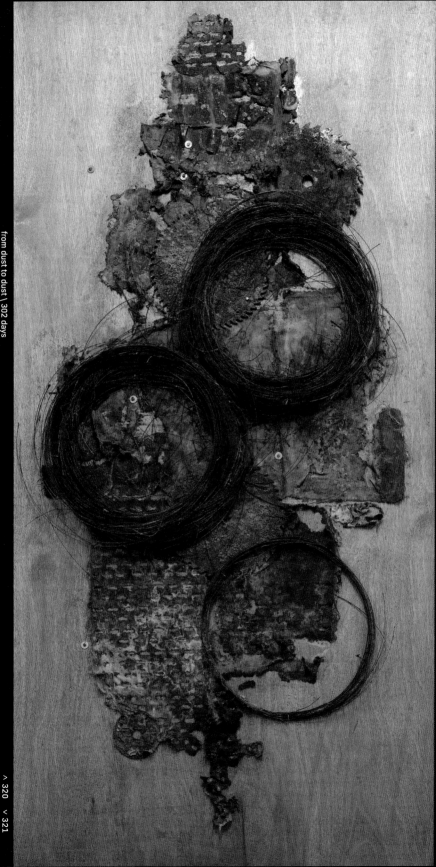

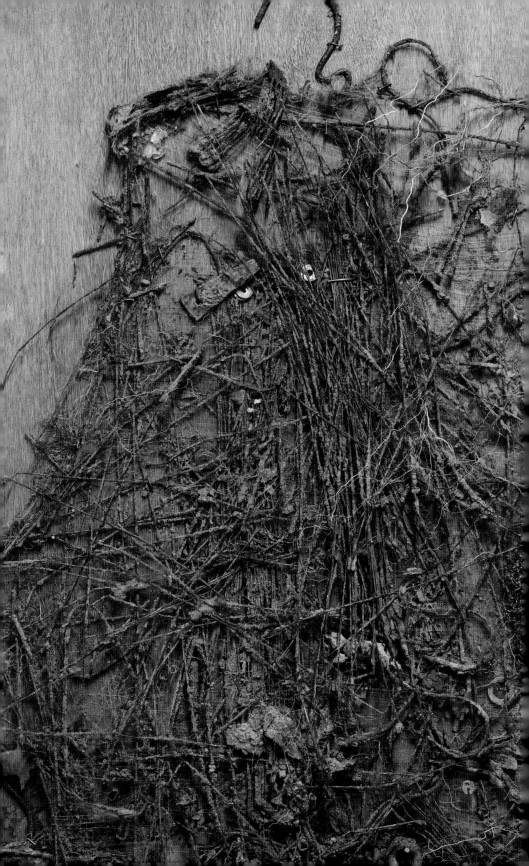

amm-03

archive no.

people | 人

● cultural poster | ● 2000

Co. | catherine yu [co-writing] \ almond chu [photography]
Col. | hong kong heritage museum \ m+

aw. | 2000 hkda design show \ poster \ bronze

combining human body parts with strokes of chinese characters to form a complete single chinese word, which serves as the basis of exploring human relations and attitudes.

people: questionable relationship
people: questionable roles
people: questionable existence
people: questionable conflicts of interest
people: questionable mentality

poster: questioning consciousness
poster: questioning attitude
poster: questioning agreement
poster: questioning positively
poster: questioning psychologically

利用人身體之部分與中國文字的筆劃合成單一字型。
從而探討人和人之間的關係和態度。

人：有關係的問題
人：有角色的問題
人：有存在的問題
人：有利害的問題
人：有心理的問題

海報：是意識的提問
海報：是態度的提問
海報：是共識的提問
海報：是正面的提問
海報：是心理的提問

命

喜歡毫不相干的人不喜歡毫無頭緒的事喜歡毫不熟悉的地方不喜歡毫無節制的生活喜歡毫不猶疑地喜歡

人 六

見笑勿見怪見風勿轉軚話見又唔見見異又思遷小平不肯見達賴克林頓就是見了太多萊溫斯基

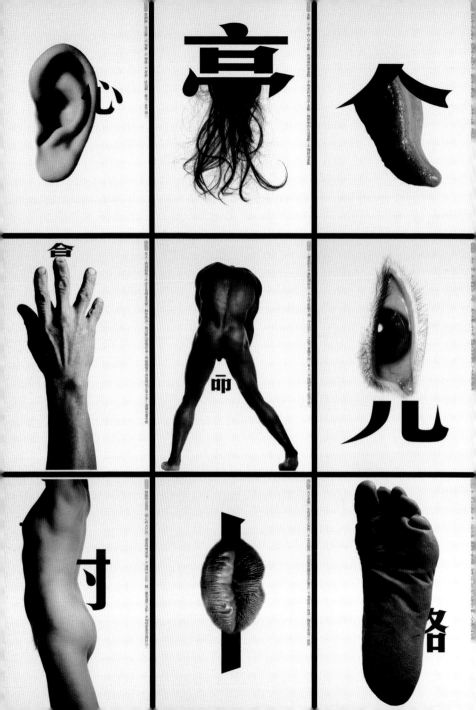

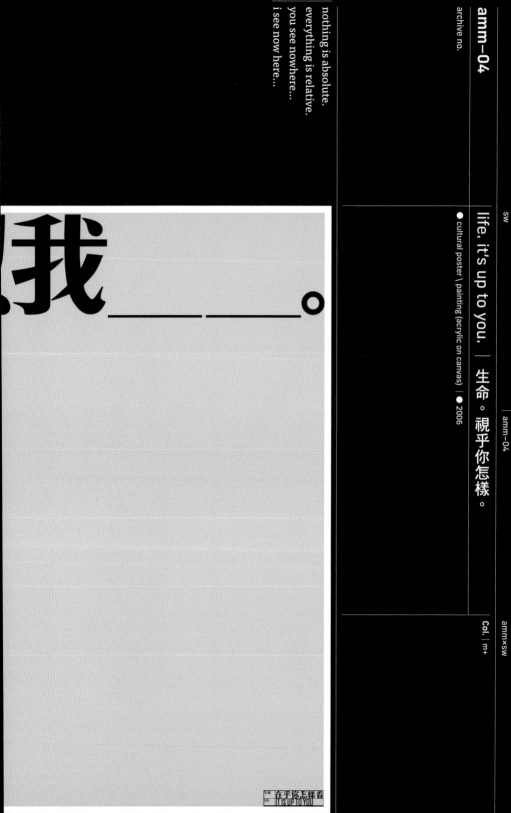

amm—04

archive no.

life, it's up to you. || 生命。視乎你怎樣。

● cultural poster \ painting (acrylic on canvas) | ● 2006

Col. | m+

nothing is absolute.
everything is relative.
you see nowhere...
i see now here...

我_____。

在乎你怎樣看
IT IS UP TO YOU

我＿＿＿，所

A	看見
B	不見
C	相信
D	不信

我看見，所以我相信…我相信，所以我看見。 ／又一山人 圖

成功

退身成功？

WHY NOT MY
NATION WHY
LOT MY

sw | amm-04 | amm×sw

NOW
HERE

NO
WHERE

life, it's up to you.

amm–05

archive no.

superwoman | 大女人

● cultural poster | ● 2002

amm×sw

c.c. | almond chu [photography]
col. | hong kong heritage museum \ m+

throughout the last 60 years, more than anyone else,
these 4 women have helped shape who I am today.
mother teresa: unrelenting sacrifice. undying compassion.
eileen chang: insightfully narrating life and living with her words.
rei kawakubo: boldly seeking diversity in the age of conformity.
my mother lam han: unconditional love. unremitting care.

做了六十年人，
影響我很多很多的莫過於這四個偉大女人。
德蘭修女：義無反顧的付出。至死不渝的摯情。
張愛玲：字裡行間閱透世間人情事。
川久保玲：在盲從的世代一份勇於求異的態度。
母親林恨：無量的愛。無止的關懷。

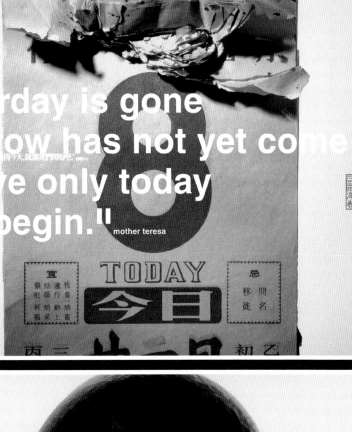

"yesterday is gone
tomorrow has not yet come
we have only today
let us begin."mother teresa

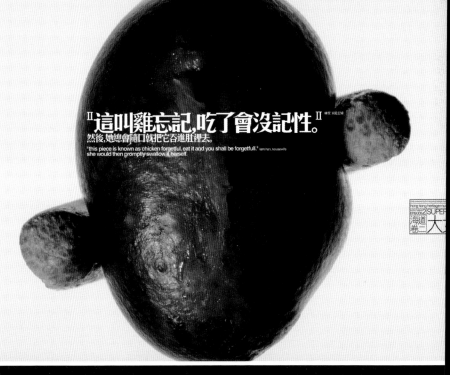

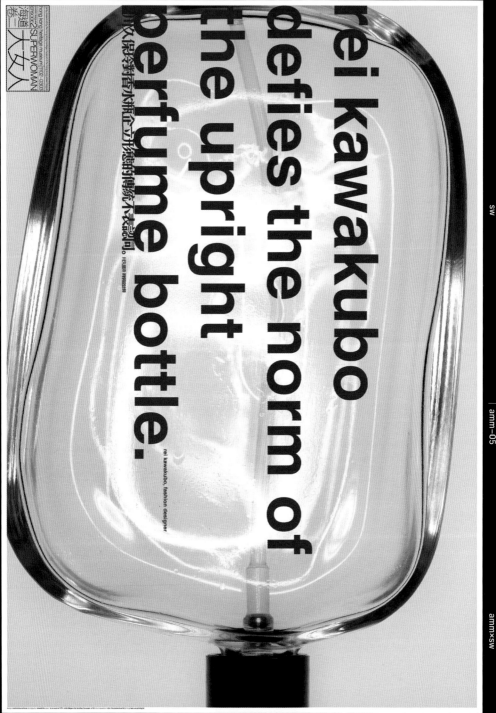

rei kawakubo
defies the norm of
the upright
perfume bottle.

rei kawakubo, fashion designer

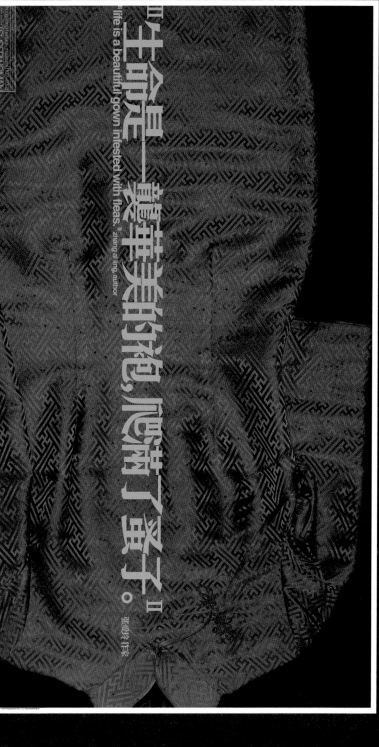

amm–06

archive no.

col. | hong kong heritage museum \ m+ \ oct art and design gallery (shenzhen) \ victoria and albert museum (london)

building hong kong redwhiteblue ∞

紅白藍 \ 無限

● cultural poster | ● 2001

aw. | 2003 d&ad \ poster \ yellow pencil
2002 hkda design show \ 3 x judge's award \ 1 gold \ 1 bronze
2003 the 5th china macau biennial design \ social \ cultural \ judges' choices ·
print \ 1 silver \ 1 bronze

right from the start,
it pops up in our minds that redwhiteblue have their own individuality...
as time goes by, they are activated in every place,
by everyone with any kind of identity or capability.
may redwhiteblue be with us forever.

RED
BLUE
WHITE 8

hong kong international poster triennial 2001
hong kong heritage · nobody's flag

THE LIVING HERITAGE

一開始就覺得紅白藍十分有個性⋯
日子久了，
它更發展到無處不在，
無人不用，無限的身份及能力。
願紅白藍與我們永在。

amm-07

archive no.

redwhiteblue: back to the future | 紅白藍 ·· 回到未來

col. | m+ \ deutsche bank (asia)

● object (redwhiteblue fabrics) | ● 2006

aw. | 2007 hkda awards \ beyond the boundary \ silver

a journey from industrialisation to art and culture.
a journey from the 21st century to the 15th century.
a journey from now to the future.

一個由工業到文藝之旅程。
一個由廿一到十五世紀之旅程。
一個由現在到未來之旅程。

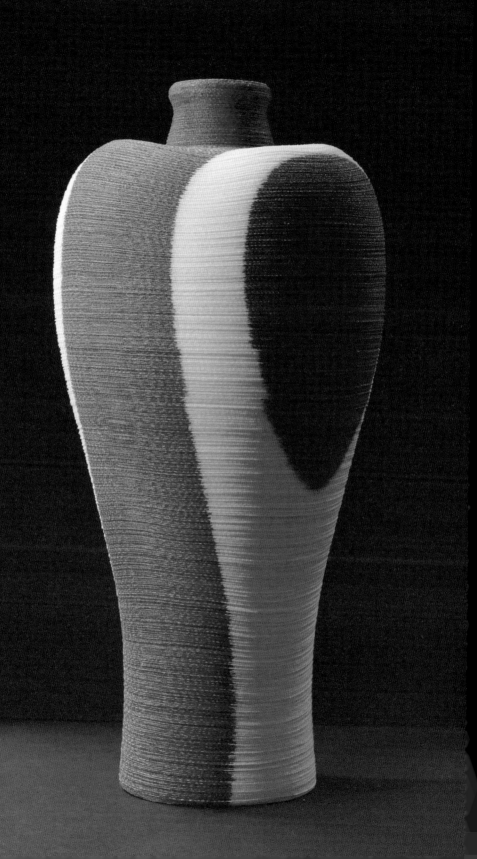

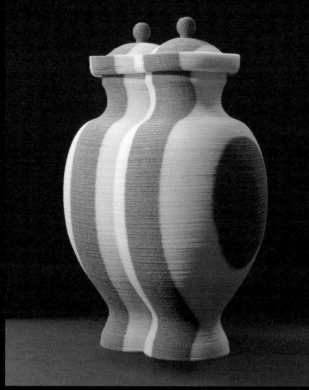

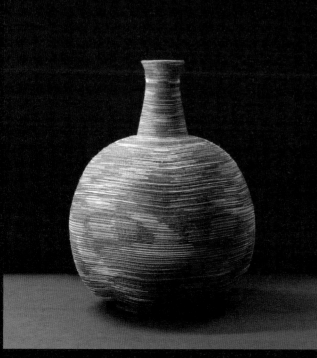

amm-08

archive no.

sw

redwhiteblue : timeline ｜ 紅白藍 : 時序

amm-08

ammxsw

▲ video

nobody is certain when "red, white and blue" first arrived in the world. nor does anybody know from where they originated. was it from hong kong? mainland china? or some other parts of the world?

building, a new life, future.
building, a refuge, a home, a sanctuary.
building, positioning, precision, clout.
building, unite, assemble, not disintegrate.
building, an answer, not a question.
building, optimistic, not observing.
building, a process; not a destination.

building hong kong, each unit has to contribute a part to make it whole...
people hope for hua tuo (famous physician) to save mankind.
i just want lu ban (famous carpenter) to live again,
with his magic axe, to build our home.

不知從何時開始，紅白藍降臨到世間來。
也不知它落到香港先，中國內地先還是地球另一角先。

建築。是新生，是明天。
建築。是庇陰，是家，是所。
建築。中正橫豎，準繩，是角力的學問。
建築。是凝聚，不是瓦解。
建築。是一個答案，不是一個問題。
建築。是樂觀，不是旁觀。
建築。是過渡，不是終點。

香港要得建築成，每個單位應承包一份去建築香港…
人總想華佗再世，救活人間。
我只想魯班再活，鬼斧神工，築家建國。

良心做平台

香港建造9忌

無中生有	無的放矢	無病呻吟	無動於衷	無精打采	無利損人	無羞無恥	無厘頭緒	無

角位嚴禁勾心互鬥
以免危害架構穩定

let your conscience be the foundation

nine prohibitions for building
1. fabrication
2. without agenda

3. complaint
4. lack of interest
5. apathy
6. inequality
7. shameless

8. ignorance
9. without principle

power struggle
threatens foundation

19°97 - 20°47
unchanged rules in 50 years

what comes down
must go up
do not give up half way

a wacked wall
must come down

1st rule of building
you must start with the 1st step

ammxsw

the story of redwhiteblue originates from construction sites. this set of building hong kong / 03 redwhiteblue silkscreen prints is a sequel to the [red whiteblue]∞ poster and building hong kong 01 installations.

first build a nation
then it will become a home

no shady black market operation

for freedom of entry
do not close the door

180 degree left wing
180 degree right wing
coming full circle

be straight up. avoid leaning

liberate

building hong kong 03 / redwhiteblue │香港建築 03 / 紅白藍│ 2002
aw. │ 2003 the 5th china macau biennial design / print / silver

當《紅白藍無限》海報和《香港建築01
裝置同時面世後，一方面本地觀眾對紅
白藍物料的認同和親切感反應很好，
另一方面紅白藍的出身地正正就是由建
築地盤開始；這套《香港建築03／紅白
藍》版畫也理所當然地由01變身登場：

the red part of redwhiteblue collected from construction sites of 18 districts in hong kong. gather the rise and prosperity of hong kong.

收集自香港十八區興建中地盤的「紅」白藍，集合了興建中，不斷成長的香港。

19°97·2047

discover asia rebuild hk 2002

發現亞洲 / 再建香港

discover asia / rebuild hong kong ｜發現亞洲 / 再建香港｜2002
aw. ｜2003 the 5th china macau biennial design / thematic / promotion / bronze

we might be strangers
and yet,
we are one team,
on the same side.

就是一隊球隊。
就在同一陣線。。
就算互不相識。。

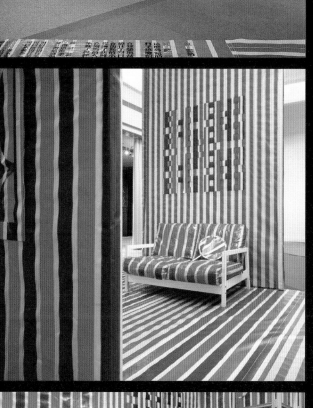
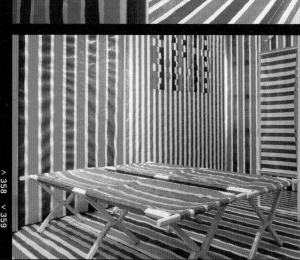

visiting show flat,
is believed to be a big pastime in the
life of hong kong people,
a big event in life.
let's build a better tomorrow.

參觀示範單位，
相信是很多香港人生活中一個很大的節目，
生命中一個很大的項目。
美好的明天，讓我們好好的建築起來。

building hong kong 09 \ 11 \ show flat |
香港建築 09 \ 11 \ 示範單位 | 2003 → 2004

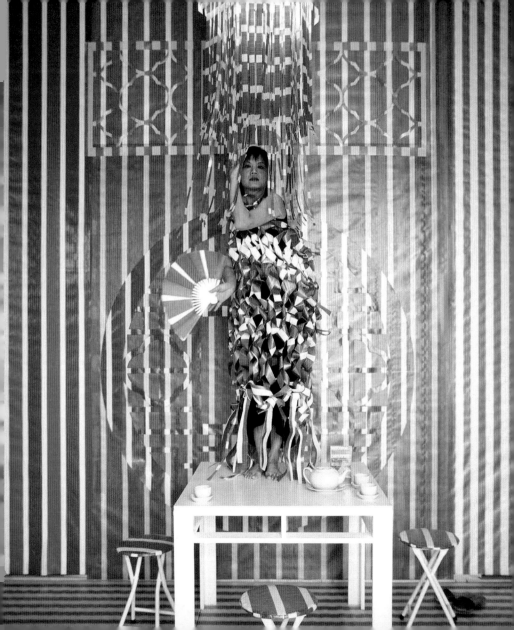

investigation of a journey to the west by
micro+polo: redwhiteblue \ tea and chat ｜ italy la biennale di venezi
紅白藍西遊記：: 飲杯茶．傾過飽 ｜意大利威尼斯雙年展 ｜ 2005

er hongkonger, chinese, or italian, is welcome to sit there and think about the 21st century [the computer age], mutual trust and the attitude of openness.

...cation began more than eight hundred years ago. when marco polo came to the east...

evidence 1: kublai khan trusted the western visitor, marco polo, put his talents to good use, and maintained an open attitude.

evidence 2: in his travels, marco polo talked about east asian and chinese cultures and gave detailed descriptions of places such as dunhuang, and discoveries such as printing and dynamite. but he said nothing about the great wall, calligraphy or tea. did people in the yuan dynasty not like tea? didn't they want marco polo to take the art of tea drinking home with him? didn't marco polo care about tea? i shall never know. but our art of tea drinking has given me much food for thought. more than eight hundred years later, as a chinese, i appreciate the richness of chinese culture. i am proud of it and yet i embrace it with an open mind. now that my visits to the mainland are more frequent, i care more about the issues of the country and my home [hong kong]...

smaller and smaller with the advancements in transportation and communication, and things are now a far cry from the way they were in the days of marco polo. the invention of computer interconnection [micro-technology] has cut the distance between men to zero. but this zero distance has led to an aversion to face-to-face intercommunication and contact. people have become even colder than a cave monitor...chatting over a cup of tea has become rare and strange.

association 2: our hong kong, our home, since the 1997 handover, has become shrouded in an atmosphere of mutual distrust, non-communication, and non-consensus...this makes me uneasy. with the premise that things in hong kong can be improved, under the alias of anothermountainman, i shall try to promote the positive spirit of hong kong in both two and three-dimensions.

redwhiteblue \ tea and chat wants to re-create a chinese tea-house using red, white and blue to ... sholise the

將人和人之間介入不重視面對面的溝通和接觸，人的感情就更甚於冷冷的電腦屏幕。坐下來喝口茶，談談天，談談家事國事的機會變得陌生罕有。

聯想二：我們的家，我們的香港在回歸後七年間大都在不互信、不溝通，不傾不講，沒共識的氣氛底下過活。這令我覺得最不是味道的⋯⋯在香港一定可以好一些的大前題下，以又一山人筆名一直在平面立體之不同空間去推銷香港正面精神。

紅白藍／飲杯茶．傾偈希望以紅白藍作為代表香港和中國的象徵，重現一間中國茶館，希望將茗茶的文化和藝術帶到西方，讓香港人、中國人、意大利人以至所有人在茶館坐下來，想想我們廿一世紀（computer age）：人與人之間的溝通，真誠的互信和開放態度。

八百多年前，中西文化交流由馬可孛羅東遊展開⋯

見証一：元世祖忽必烈對西方外來人馬可孛羅的信任，用才，開放的態度。

見証二：《東方見聞錄》對東亞、中國文化，發明都有詳錄如敦煌、印刷、火藥等⋯唯獨是對長城、書法和飲茶並未有介紹。元朝時人們不喜歡飲茶？元朝人不想給馬可孛羅帶走茶藝？馬可孛羅人不重視飲茶？⋯不得而知。中國人飲茶文化倒令我想起很多。八百多年後今天，身為中國人一份子的我，對中國文化深遠的欣賞，自豪之餘也帶着活學活用的心態去迎接和面對。回國回鄉次數越多，令我想起國和家（香港）的話題⋯

聯想一：世界之接近因旅遊交通之方便拉得越近，不像馬可孛羅之艱巨。電腦互通（micro-technology）的發明，更

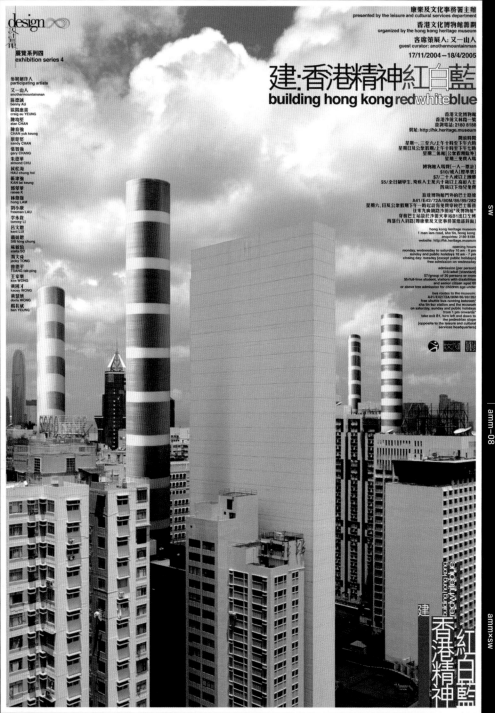

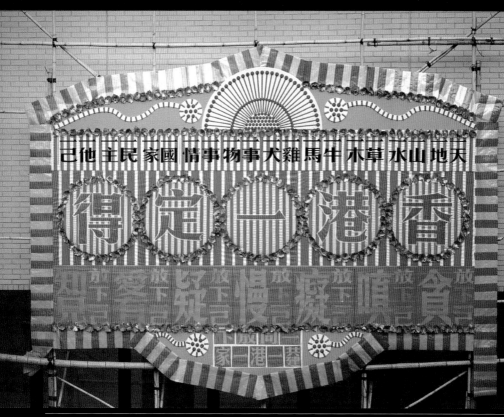

this is not wishful thinking, it is hope... this is not a dead end, but the way out ...

born in the 1960s, i was growing up in an atmosphere of forever "taking off" and "going forward". indeed, this is a blessing. as the saying goes: "what goes up, must come down". there are, as the buddhists say, impermanence along the path. so if the seven million people in hong kong do their best to strive, struggle forward and join together as one force, there will be a better tomorrow.

this is the reason why, i have been promoting the positive spirit of hong kong through the series "building hong kong redwhiteblue" over the past three years. the 2003 sars epidemic forged and strengthened the community spirit of the people in hong kong. let us leave behind the idea of seven million individuals, and join hands to march forward as one.

today, under the floral emblems of celebration, let us hope for the dawning of this heroic day.

不是一派妄想，是一個理想⋯不是一定沒路，是一條出路⋯六十年代出生的我，一直在「起飛」和「向前」的氣氛下成長，說來也是幸事。當然，世間有上必有落，佛家有云：無常⋯當七百萬人各自做好本份，精進，向前，無分你我；我深信香港一定可以好一些。

因此，我過去三年的「香港建築紅白藍系列」一直推銷正面的香港精神。〇三年沙士共患後，香港人的群體心，正面心無疑向前跨了一步。但願我們放下七百萬個一己，放下貪念，放下怒氣，憤怒，放下迷戀癡心，放下傲慢態度，放下疑心，放下佔有慾，放下主觀和偏見，真的攜手往前！

今天，就在花牌底下預祝這一天來臨。

redwhiteblue
here/there/everywhere
anothermountainman
無處不在紅白藍　又一山人

redwhiteblue / here / there / everywhere │ **2005**

aw. │ 2005 gdc / book design / gold
2006 design for asia awards / special merit
2007 hkda awards / publication / judges' choice / gold
2007 hkipp asia photo awards / photography / bronze

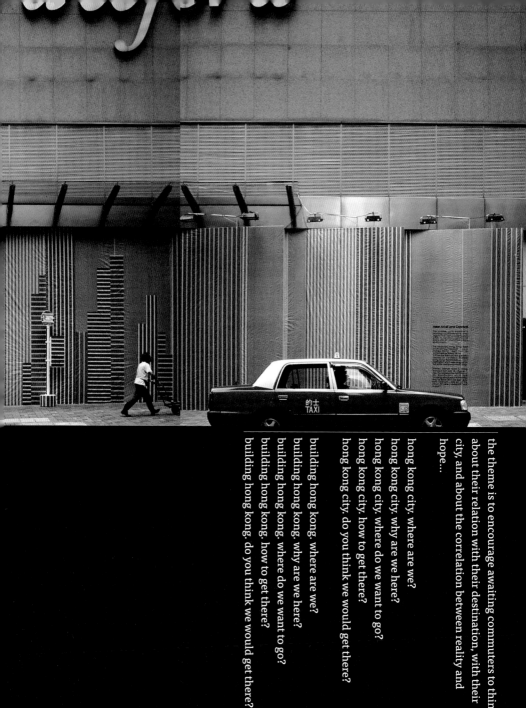

the theme is to encourage awaiting commuters to think about their relation with their destination, with their city, and about the correlation between reality and hope…

hong kong city: where are we?
hong kong city: why are we here?
hong kong city: where do we want to go?
hong kong city: how to get there?
hong kong city: do you think we would get there?

building hong kong: where are we?
building hong kong: why are we here?
building hong kong: where do we want to go?
building hong kong: how to get there?
building hong kong: do you think we would get there?

building hong kong 13 / redwhiteblue / what is the next stop?

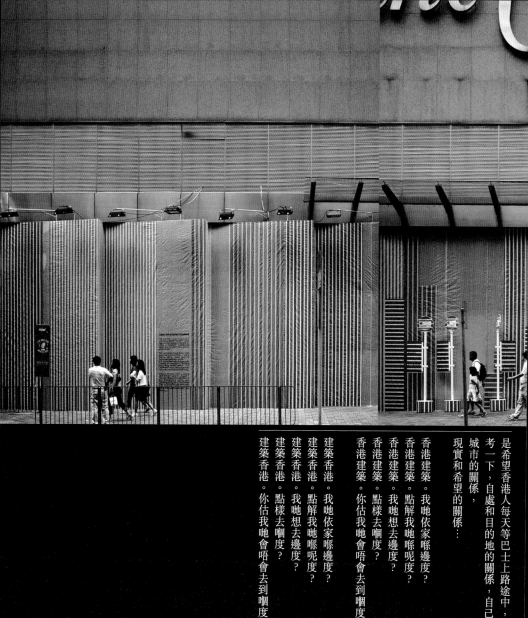

是希望香港人每天等巴士上路途中，
考一下，自處和目的地的關係，自己
城市的關係，
現實和希望的關係……

香港建築。我哋依家喺邊度？
香港建築。點解我哋喺呢度？
香港建築。我哋想去邊度？
香港建築。點樣去嗰度？
香港建築。你估我哋會唔會去到嗰度
建築香港。我哋依家喺邊度？
建築香港。點解我哋喺呢度？
建築香港。我哋想去邊度？
建築香港。點樣去嗰度？
建築香港。你估我哋會唔會去到嗰度

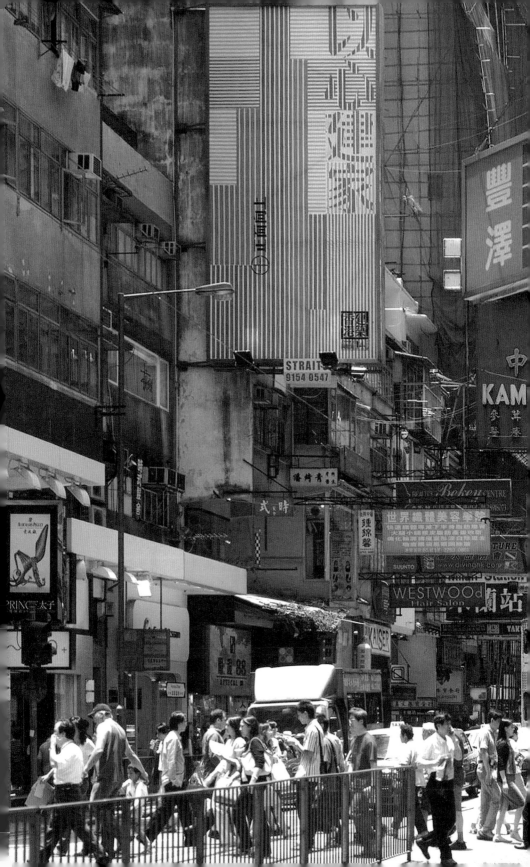

when lee young ae from the korean tv drama became talk of the town in hong kong, seeing "you should love" (pronounced "li ying ai"), we understand what exactly it means or just being distance and strange.

當韓劇中李英愛全城大熱時，你有聯想到「你應愛」這三個字？或這是一個很陌生，漠不關心的思維？

in france, redwhiteblue represents liberty, equality, fraternity. in thailand, redwhiteblue signifies the country, religion and monarchy. in the uk and usa it symbolises fortitude, courage; peace, integrity, innocence, perseverance and righteousness.

we used to have those majestic junks, we now have the dragon, and more recently, the phoenix... the earliest buddhists preached without forms or figures. there were neither temples nor statues. symbols were adopted later on to facilitate easier communications and deeper understanding.

as building hong kong/zou ma kan hua. and show flat reflected a mood of anticipation... in the past two years, the economy has revived and the property market is booming. ironically, the negative sentiments have once again risen... in politics, as in society.

redwhiteblue has been the subject of my photography for 15 years. from its debut in "building hong kong" to being featured in posters and installations on other topics. rwb has travelled far and wide. with this exhibition, it is making its 20th appearance. from hong kong to shenzhen, to london, to venice, to seoul... rwb has become a part of my life. i am adamant in using rwb because i see it as the means to convey the positive spirit of hong kong to the world.

the qualities exemplified in rwb will continue to evolve without end. persistence, diligence, unity... these and other virtues were saluted in previous works and exhibitions. in 2000, when pessimism prevailed over hong kong, being as positive as i always was, i launched "building hong kong". at art museums, shop windows,construction sites i shared my views and expectations with everyone. during sars, we witnessed and experienced true comradeship in times of trouble when people were drawn together to fight against adversity. in that period of time, the focus and tone of works such

come. let's put aside our ego and think for a moment what we really want for hong kong,our home. what is it that we love? what is there to believe in? and what is there to hope for? write down your thoughts on the wall to share and to inspire. it is my wish to offer rwb/faith, hope and love as the ultimate quest for everyone in hong kong.

finally, i hope that whenever we see the familiar redwhiteblue, we will feel, deep in our hearts, the faith, hope and love that we all have for this city.

i often come across hong kong people who question if there is only rwb that can represent hong kong. i doubt it.

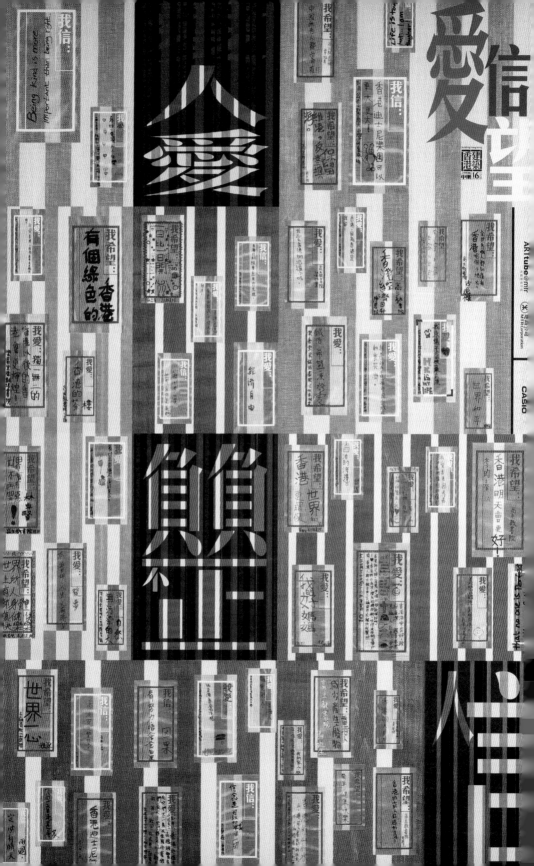

法國的紅白藍定義為自由、平等、博愛。泰國的紅白藍解讀為國家、宗教和君主制度。英、美的紅白藍共通象徵堅韌、英勇；和平、誠信、純潔；不屈不撓和公正。

轉眼間，紅白藍成為我的攝影題材已經十五年，將紅白藍作為「香港建築」或其他課題的平面海報以至立體裝置，現在已來到第二十次。由香港出發，到深圳、到倫敦、到威尼斯、到首爾：它已經成為我生活的一部分。堅持紅白藍不為甚麼，就是藉它作為工具，推銷香港

正面的態度吧。

不少香港人問我香港只有紅白藍嗎？我想不是吧。我們還有昔日的帆船，今日的飛龍標誌，甚至最近的飛鳳：最早期佛家弘法，也沒有寺廟和佛像等形相的；為方便溝通、接引；具像有時來得方便。

紅白藍的流動沒終點，堅毅、勤勞、參與社群：等美德性格早在作品或其他展覽表揚過。還記得二〇〇〇年，香港之負面情緒高漲，一向正面的我就開了

來。就讓我們每個香港人放下自己一刻

「香港建築」的課題，以不同的形式，鐘，為香港（我們的家）想一想，到底我們愛的是甚麼，信的是甚麼，希望的

在美術博物館、商店櫥窗、建築中地盤外牆與大家分享溝通我對香港人的看法和祈望。sars 之後，我們確實患難見真情；大家同舟共濟，社會聯結起來。

所以那時期的《香港建築》之《走馬看花》和《示範單位》等因而改變了憧憬的調子。過去兩年間，經濟復興了不少，樓市又大旺起來：我們的負面情緒和態度又升回高點。政治如是，民生如是：

分享和靈感的空間。《紅白藍／信望愛》就算是我向香港你我他的一份終極祈盼。

最後，謹希望我們每次見到熟悉的紅白藍，都能感受到我們每個人各自內心對香港這都市的信、望、愛。

你應愛己，你應愛人，你應愛他，愛她，愛牠，愛它…

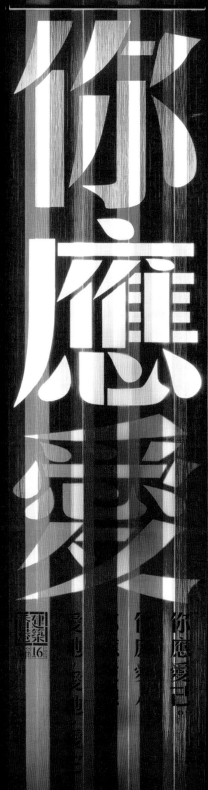

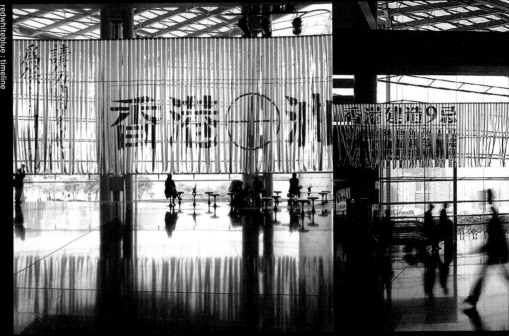

everywhere kowloon king / everywhere redwhiteblue / the kowloon king's code
無處不在曾灶財 / 無處不在紅白藍 / 曾灶財密碼 | 2011
aw. | 2009 hkda asia design awards / poster / gold
| 2009 gdc / poster / gold
| 2010 tokyo tdc / nomination award

← →

since the project of "building hong kong redwhiteblue", (keep promoting positive hong kong message through the plastic canvas "redwhiteblue") i targeted to be everywhere like king of kowloon but with a licence, not like our king who did it illegally...

the pair of posters are the messages to reflect (blue side) and to dream (red side) my eyes of hong kong now, in which the words are re-ordered from the 8 panels of original calligraphy works from the king who personally done for me years ago. the messages are about eat and buy, stock market and property, chasing for money, of course there are also political and social issues, dreams and hope of hong kong. wish this is our way of positive hong kong, it is a dream, it is not an illusion.

自從二〇〇一年「香港建築紅白藍」的開始，便打算做個「領正牌照」的曾灶財，「無處不在」作為目標，將紅白藍正面香港推銷滲透⋯

就借曾灶財給我這八板文字，重組轉化成我對香港的一些看法和祈望放在一對海報中。當中有吃喝玩樂，有拜金炒股（藍圖），亦有政治、社會、理想（紅圖）。謹希望我這個正面香港信念不是妄想和幻想⋯

show flat 04 is built in a french boutique gallery in singapore. over ten years experience from redwhiteblue exhibitions, some french visitors say "i think it is very french!" and of course, americans say "it belongs to the u.s.!" so how about thailand, russia or hong kong...

country and home, a matter of power. country and home, a question of subjective and prejudice.

第四次示範單位建於新加坡法國名店之畫廊，十多年紅白藍展示的經驗，老外們經常如斯反應：法國人喜悅感歎一句：「這太法國了！」美國人的說美國，英國人的說英國⋯那麼泰國、俄羅斯、或者香港呢⋯

國，家者。權力的學問。國，家者。主觀偏見的問題。

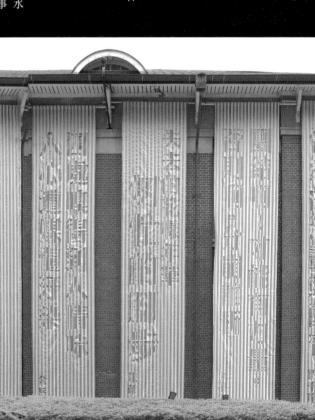

自六十年代起，台灣生產這引入自日本發明的防水防曬膠布時，就由藍色加進了紅色，為的是在喜事和喪事都能派上用場。自此，「紅白藍」就遊走全球華人社會⋯

從紅白藍看見生活，從紅白藍看見喜，看見悲。

活在當下，何謂喜，何謂悲。可見到過去半個世紀的台灣，有甚麼留下來的，失去的，錯過了的，或是，悲從中來的，或者仍是喜上眉梢的。

in the sixties, when taiwan imported this type of waterproof and sun-resistant plastic canvas from japan, people added the colour red into the blue canvas for the purpose that it could be used in both weddings and funerals. since then, the redwhiteblue has traversed the chinese society around the globe.

in the redwhiteblue one witnesses life. in the redwhiteblue one witnesses happiness as well as sadness.

live in the moment. what is happiness, and what is sadness?

it reveals taiwan of the past half a century, what has remained, lost, or missed, or, has overcome one with sorrow, or still made one's face radiate with joy?

it is my home. something happy. something sad. /in the name of art: hong kong contemporary art exhibition
這是我家　有喜有悲 / 以藝術之名：香港當代藝術展 ｜ 2015

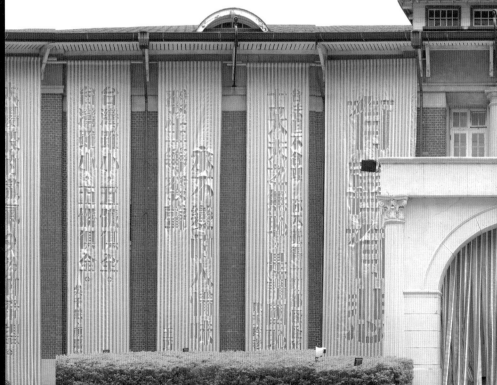

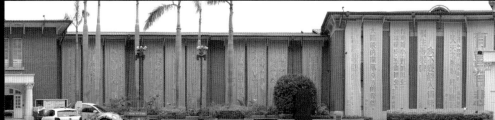

opposition, misunderstanding, intolerance and disrespect are a 360-degree impact on our lives today. the setting aside of self-interest and bias will allow us to have a broader view of the world. hong kong will thus move towards our goal. by applying the slogan "world without strangers," written by creator mr. richard lam chun keung, to "you and me" in today's hong kong, i hope the conflicting hearts of hongkongers can be reconciled and move forward together. we are the essence of home. we, hongkongers, are family.

對立、誤解、不包容、不尊重，三百六十度的包圍了我們香港人今天生活當中。放下一己利益，放下一己成見，先伸出雙手，世界定會開寬天空，香港當能向明朗目標啟程。借用創作人前輩林振強先生為品牌寫的一句標語「沒有陌生人的世界」套用在今天香港「你我」之間。祈盼正在分裂、分解的大家能並肩同步上路。大家，才是家。我們香港一家。

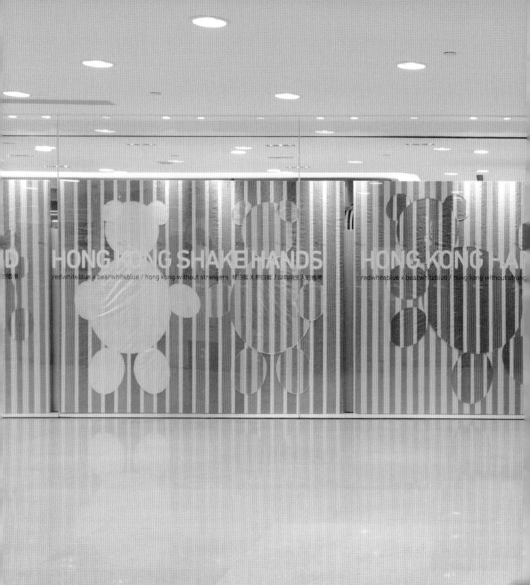

the eighth year of one hundred years of solitude

百年之孤寂第八年

● poster [art promotion] | ● 1996

cl. | zuni icosahedron
col. | hong kong heritage museum \ m+

this was the first time and also the start of my collaboration with theatre, dance and other cultural groups on creative projects.

my partnership with zuni icosahedron also began on this day. since then and we have worked continuously and closely on various projects including graphic designs, stage visuals, and design projects for exhibition, publication and costumes.

moreover, i have been on the board of directors for many years and served as the chairman from 2009 to 2011.

這是第一次跟戲劇、舞蹈及其他文化藝術組織做創作推廣的開始。

跟進念二十面體的緣份也由這一天起步，平面設計、視像、展覽設計、出版設計，以至舞台服裝，無斷無間合作至今。

另外，本人還一直是團中多年董事，二〇〇九至一一年度主席。

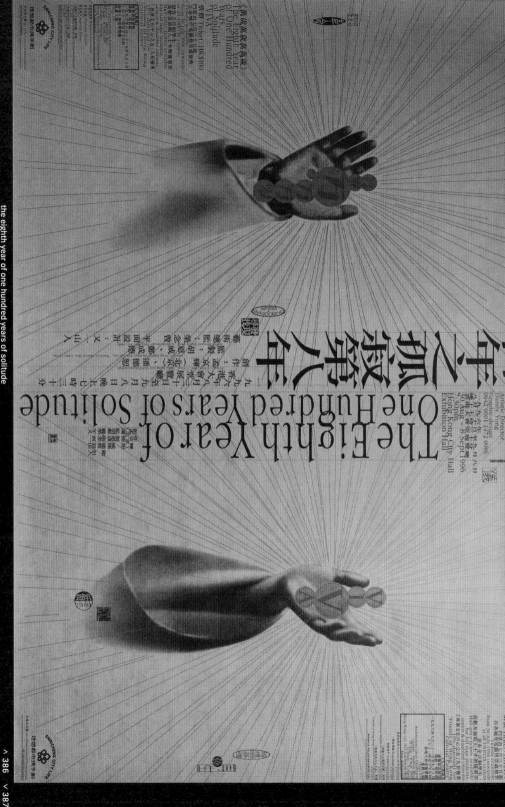

amm–10

archive no.

the ceaseless change of *qian* | 乾 \ 元亨利貞

● costume design \ cultural poster | ● 2015

cl. | zuni icosahedron
c.c. | zuni icosahedron \ mathias woo [director]
\ johnny au [photographer]

qian – the ceaseless change of *yuan heng li zhen*. starting with *qian* as the heavenly position in the hexagram in *yuan heng li zhen*, building the four words on the features of the *qian* hexagram, the four posters can be rearranged into different order of appearance.
forming 24 different possibilities…
responding to *yi jing's* (book of changes) endless and transient changes, impermanent. going up and down; ceaselessly, continuously changing, growing, waning.

乾，元亨利貞之變動不居。以乾為天卦辭元亨利貞出發，將四字建構於乾卦卦象，四張海報可作不同上下排序。
二十四變化可能∶∶回應易之變易無定，變動不居。上下無常，不停無間地生滅變動。

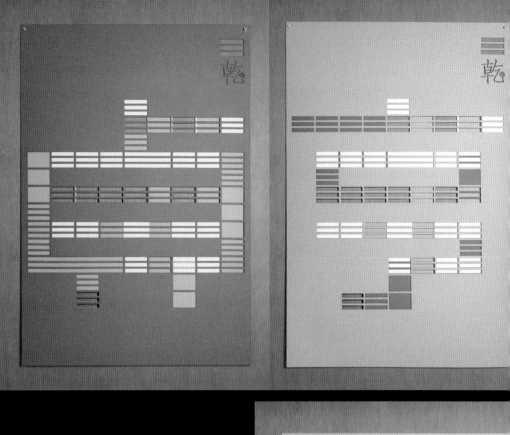
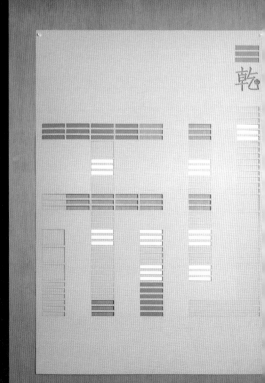

amm-11

archive no.

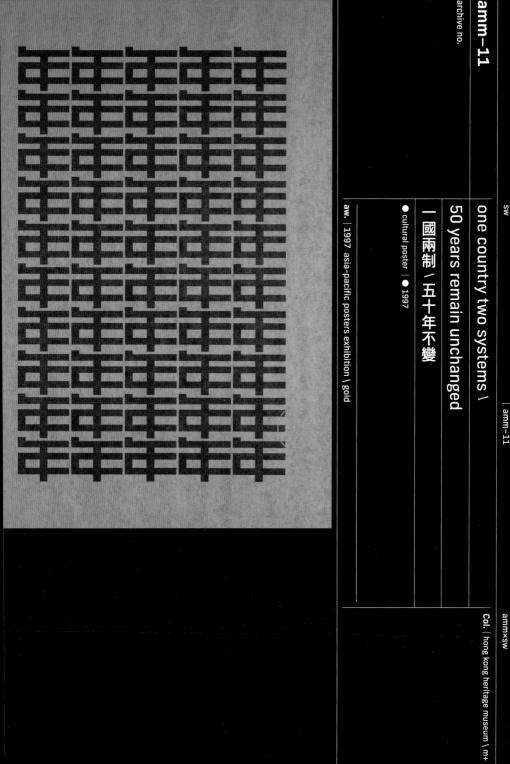

one country two systems \

50 years remain unchanged

一國兩制 \ 五十年不變

● cultural poster | ● 1997

aw | 1997 asia-pacific posters exhibition \ gold

Col. | hong kong heritage museum | m+

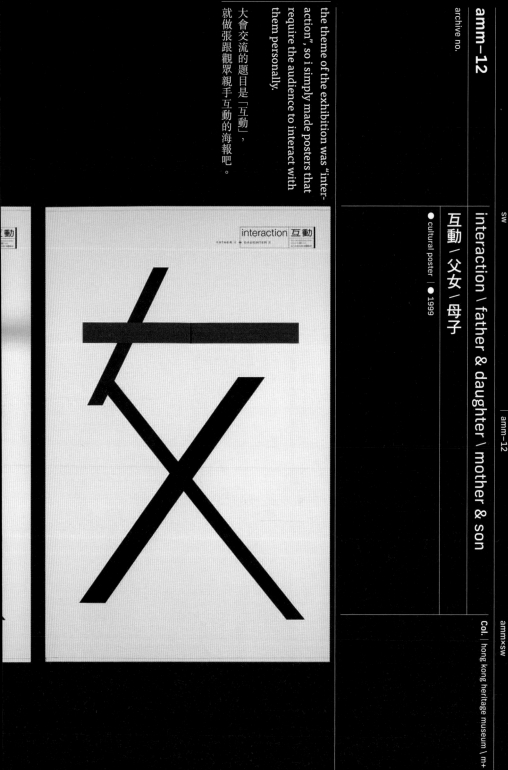

amm-12

archive no.

interaction \ father & daughter \ mother & son

互動 \ 父女 \ 母子

● cultural poster | ● 1999

Col. | hong kong heritage museum \ m+

the theme of the exhibition was "interaction", so i simply made posters that require the audience to interact with them personally.

大會交流的題目是「互動」，就做張跟觀眾親手互動的海報吧。

MOTHER IS + SON ?

amm–13

archive no.

no paper

● cultural poster | ● 2006

amm×sw

Ex. | ningbo international poster biennial 2006 ("no paper" new media experimental poster exhibition)

in the past decade on my creative journey,
i have been asked countless times:

are your work design or art?
are your work art or design?
are these "cutting and pasting" of "red white blue" considered posters?
indeed.

i have not attempted to differentiate between design and art,
design can be art.
art can be design.
i only differentiate between my commercial work
and my personal work.
i don't want to bother with conforming to
the rules and limitations of forms and functions.

isn't creativity supposed to be boundless...

the theme of no paper gives me a chance to explore
not only the idea of "no paper, not paper"; from no paper and no printing as a
starting point, this exercise is an attempt: to explore the possibility of
"having no creativity" as being a creative idea?
can the plain and simple experiences in everyday life become creative
concepts and inspirations?

can life be expressed in posters?
can posters be filled with life?

my answer is: why not!

sw

amm-13

ammxsw

過去十年創作旅途中，
被人問了無數千百次的問題：
你這些是設計還是藝術？
你這些是藝術還是設計？
你這些「紅白藍」剪剪貼貼是海報嗎？

創意不是無限的嗎⋯
是次《no paper》的題目給我探索的
不止「沒有紙張，不是紙張」這形式上；
從不印刷沒紙張這起點，
借這習作嘗試⋯

不錯。
我沒有意圖去區分設計和藝術之間，
設計可以是藝術。
藝術可以是設計。
我只會分別甚麼是商業創作；
和甚麼是個人創作。
我甚至十分疲倦關於形式或手段上
的所謂共識和規限。

沒創意為創意是可能的嗎？
生活上的純粹和經驗可化成
意念和靈感嗎？
生活可附於海報？
海報可盛載生活？

我的答案是：why not！

amm–14

archive no.

back to the future \ tai chi | 回到未來 \ 太極

● video | 6'28" | ● 2014

▶ video

BACK TO THE FUTURE / TAI CHI
回到未來／太極

c.c. | samuel f.s. cheng [tai chi consultant] \ nicky lau \ joe leung \ don ma \ henry chan \ arkin au \ jojo chi [animation production] \ lindsay lai [music]

s.t. | cityu exhibition gallery (hk)

back to the past, back to the future.
back to the ultimate speed of light, back to the basic.
running forward...
is fast. is exploration.
looking backward...
is slow. is inspiration.

回到過去，回到未來。
回到光速極速，回到基本還原。
向前走⋯
是快。是探索。
往後看⋯
是慢。是靈感所在。

amm—15

archive no.

form. emptiness. | 色。空。

● video | ● 2010

▲ video

c.c. | zheng hui-ping [calligraphy] \
kung chi-shing [music]

aw. 2011 hkda global design awards biennial \ new media \ beyond the boundary
\ silver \ hk best
2012 tokyo type directors club annual awards \ tdc prize
2017 gdc \ selected

water calligraphy.
since i first experienced it
in guangzhou park years ago,
it has appeared in my mind now and then.

it is the most intriguing expression of
form and emptiness in buddhism.
everything from no matter to matter,
from matter to no matter.

form is emptiness.
emptiness exists in form.

not only is
its history and civilisation.
not only is it development and conservation.
not only is it a buddhist-like meditation practice.

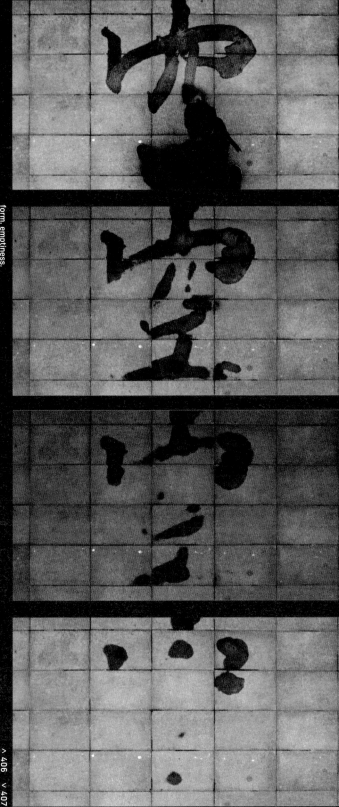

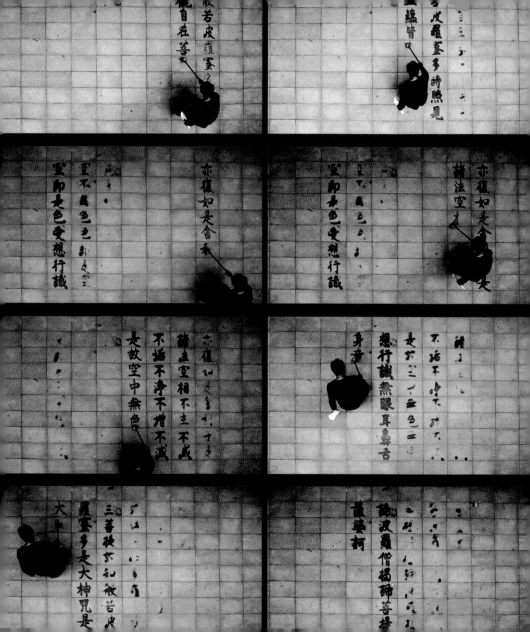

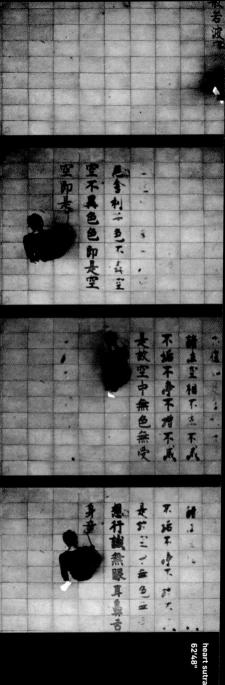

般若波

舍利子
色不異空　空即是
空不異色　色即是空

諸法空相　不生不滅
不垢不淨　不增不減
是故空中無色無受

想行識　無眼耳鼻舌
身意

heart sutra
62'48"

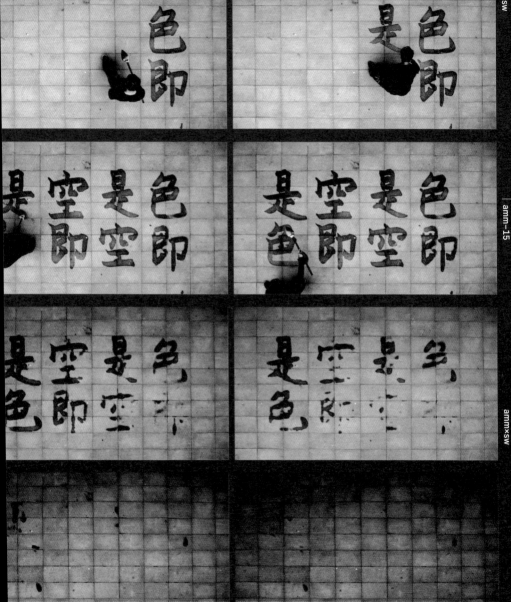

水書法。多年前在廣州公園
親歷其境後，
一直都在我腦裡
出出入入。

它正是
佛法中色空
最微妙的對應。
一切從無到有，
從有到無。

amm−16

archive no.

ingenuity. nature. | 妙法自然

● cultural poster | ● 2012

col. | hong kong heritage museum \ m+

aw. | 2011 hkda global design awards biennial \ bronze
2011 gdc \ nomination
2012 d&ad \ poster \ selected
2012 design for asia hkdc awards \ posters \ silver

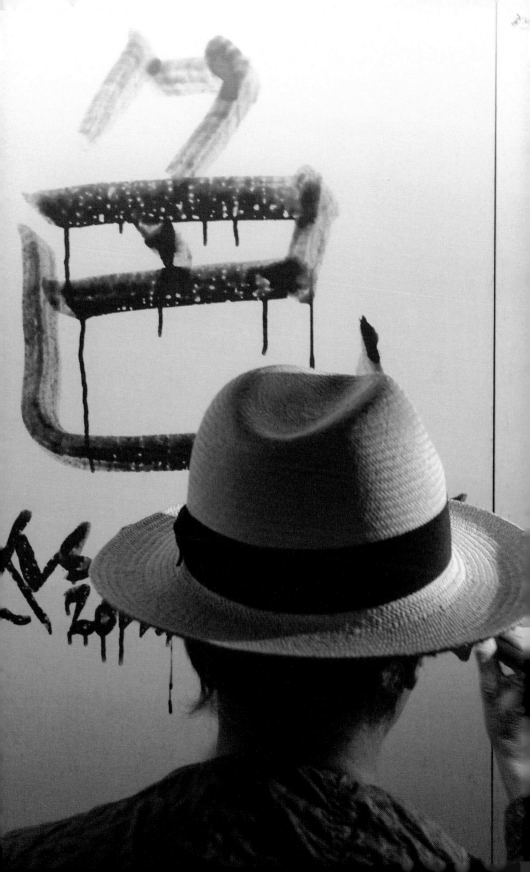

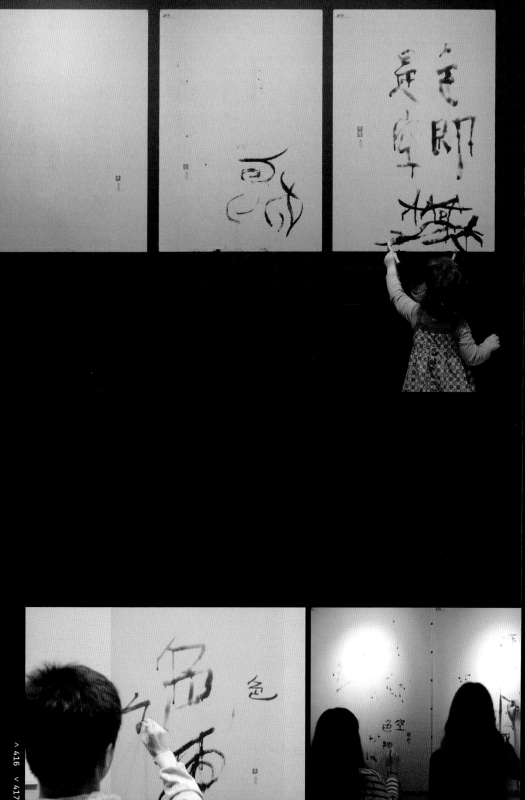

WHAT'S NEXT
三十×30

sw

what's next 30×30 | what's next 三十乘三十

● curation [dialogue \ exhibition] \ exhibition design | ● 2011

aw. | 2011 design for asia hkdc awards \ branding \ gold
| 2011 hkda global design awards biennial \ environmental graphic \ bronze \ hk best
| 2011 gdc \ hybrid \ nomination

s.t. | the oct art & design gallery (shenzhen) \
| artistree (hk)

it is for an excuse, it is for one reason... the excuse:

i needed to make a (small) summative of 30 years of my creative work, and then move on.

the reason:

i kept thinking, why don't i take a macro-look at the way of life of our creative village — its past, its present, its future and how we should embrace "what's next".

in the thirty years of my creative journey, i have had many encounters with many contemporaries and comrades with different ideals and goals. many are very successful. many, i respect. and many, i admire. the energy and motivation of this small creative community, sets them

apart from the rest of the crowd. their commitment and perseverance have encouraged and driven me to stay firm on my duties and responsibility...

three years ago, i started having the thought of convening a contingent of people with similar visions and aspirations together to make a louder voice and more powerful "calling", that's how what's next 30×30 came to take shape. slowly.

my sincere gratitude to the 32 people (who made up the 30 units) for their support and participation. the group spans four generations and they have given meaning to every step i made on my journey. they have inspired,

taught and encouraged me. they have touched my heart and they have given me hope.

there is something else i am really grateful for.

due to my curiosity, my work in the advertising, and luck, i have walked, flown, seen more people, things and emotions than many people... for thirty years, i have been asking: what is creativity? why create? creative, is a commercial tactic. creative, is history, culture and personal feelings.

creative, is inspiration, dialogue, expression on social issues... creative, is about life.

just because i have ventured far, it does not mean that i cannot find my way home.

now, standing at my own doorstep, with all my heart. i am sharing it with you.

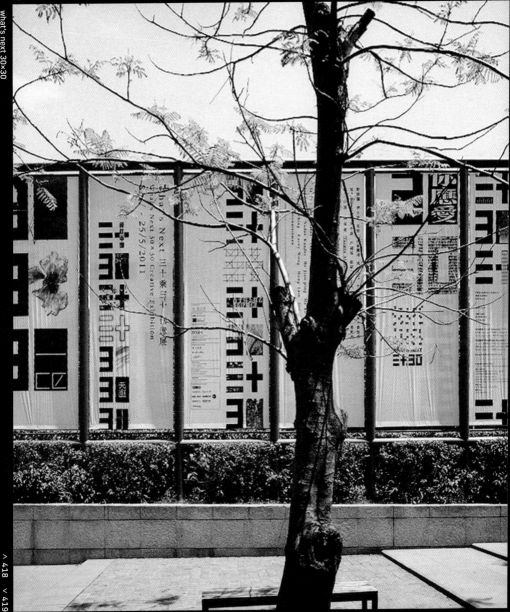

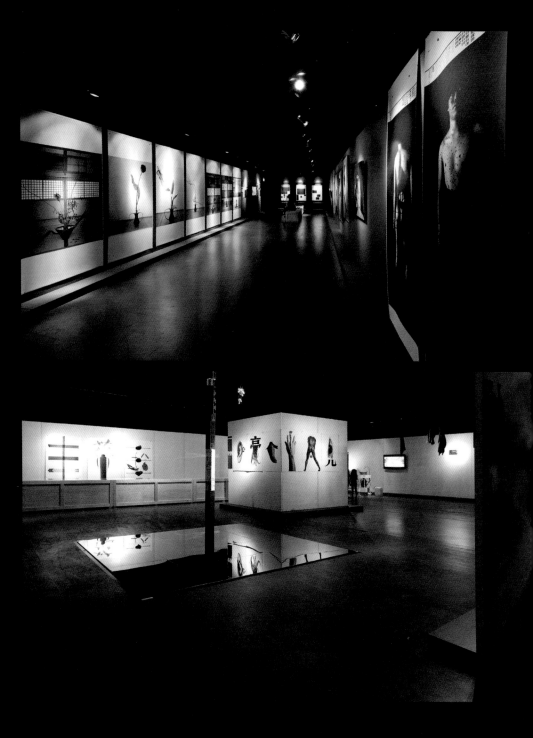

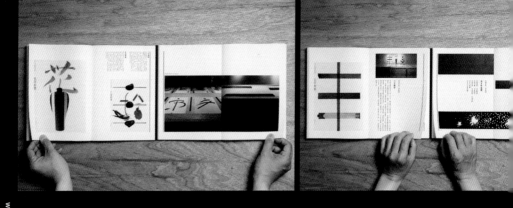

反正都是一個借口，皆因一個理由⋯

借口：

我要為自己做三十年創作來個（小）總結，

然後再上路。

理由：

然後想了又想，何不宏觀地看看創作村的生態，

過去和現在，正在怎樣迎接明天。

三十年路途上遇過很多不同目標的創意同業，同志。

很多成功的，很多我尊重的，更有我敬佩的，

一小族群的創作理念原動力，亦有別於其他大隊中人，

其堅持和執着每每在鼓勵和鞭策我自己堅守在本份上⋯

三年前就開始了這個構想，集合一群志向相同的人，

發一個更大的聲音和呼喚，

於是《what's next 三十乘三十》就慢慢推進。

多謝三十單位（共三十二人）共同參與和支持，

這橫跨四個單位世代的族群，對我行過的每一步意義重大，

包括着啟發，感動，教誨，激勵和希望。

有一點我倒為自己慶幸；

因為我好奇，因為我的廣告工作，因為運氣

三十年來行過，飛過比很多人多的路，

見過很多人、情、事⋯

三十年來不斷地問：

何謂創作，為何創作。

創作。是商業的手段。

創作。是歷史、文化和個人情懷。

創作。是社會議題的靈感、對話、發聲⋯

創作。是關於人生的事情。

看着自己，沒因走到太遠，不懂路回家。

當下，我站在自己的家，自己的心田

與大家共勉。

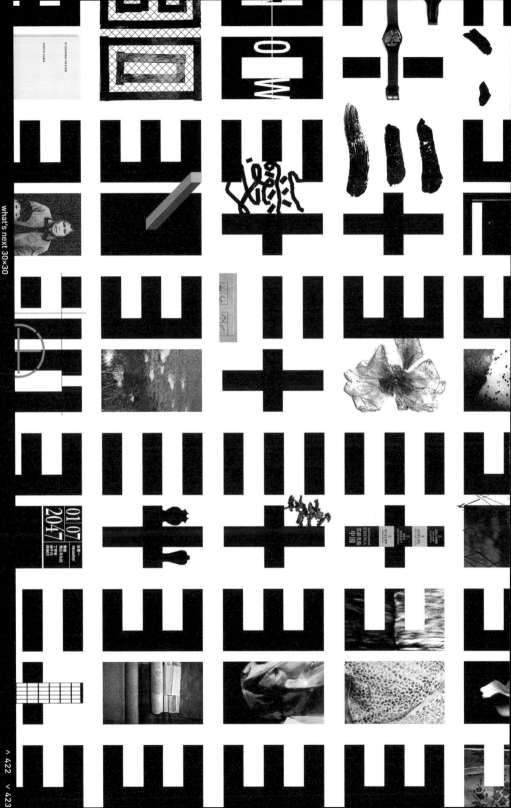

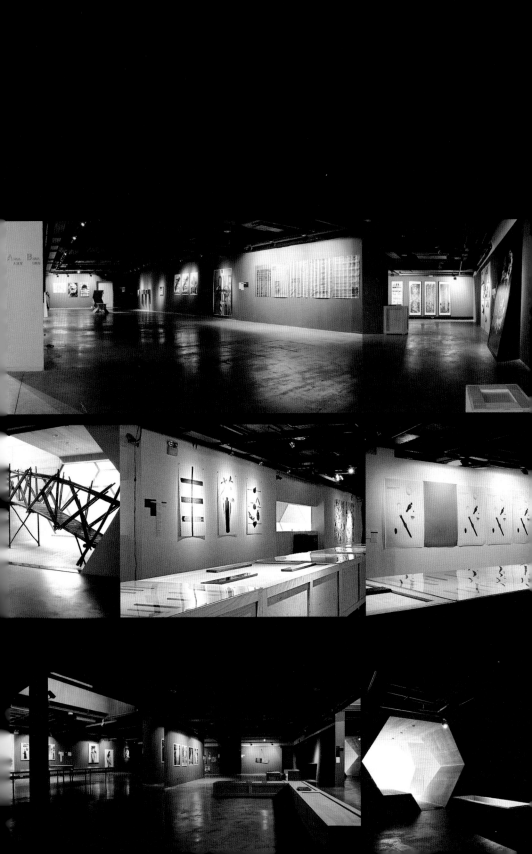

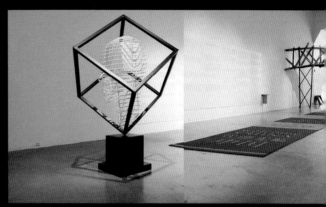

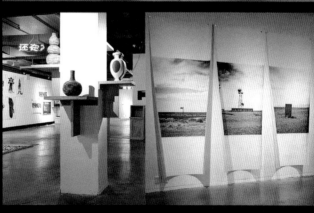

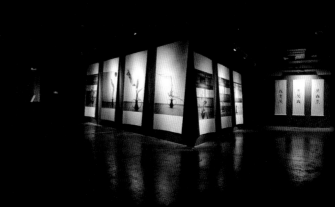

amm–18

archive no.

life, is like a ping pong match.

人生，有如一場乒乓球賽。

● object | ● 2011

at a presentation by master asaba, he said,
"life, is like a game of ping pong.
the ball is now at your side of the table, you strike it back.
the ball is here again, and again you strike it back..."
his words were imprinted on my mind.

life is so unpredictable,
and events can catch you by surprise,
one after another.
the volcanic eruption of iceland,
earthquakes in various countries and the tsunami in japan.

just when you thought we knew the rule of the game,
the rules are changed, demanding double effort.
will you still take the challenge?

聽了淺葉克己老師一次演講這樣說：

「人生，有如一場乒乓球賽。

球過來，你就推過去。

球又過來，你又再推回去⋯」

很深刻的記在心裡。

人生無常，

世間無常之事接二連三，

冰島火山爆發，

不同國家之地震和日本海嘯。

當大家認定了球賽的規則時，

突然發現被改加了一倍難度；

你可還落場應戰這場遊戲嗎？

amm-19

archive no.

tribute to master | 向大師致敬

s.t. | tokyo ginza graphic gallery

● book design | ● 2015

aw. | 2016 hkda global design awards \ book design \ judges' choice \ gold \ hk best ·
photography \ silver \ hk best

it would take more than ten pages for me to list all the japanese creative masters that i have great respect for...

design master kohei sugiura, tanako ikko, tadano riyokoo, issey miyake, my friend and teacher—shin mastsuna-ga, the late shigeo fukuda and many many more....

you enlightened me to move on when i embarked on my journey, leading me into the fascinating world of design, to explore the unlimited possibilities of creativity...

for thirty-five years, through visual

creative, the only thing that i know well, i have lived, breathed and inter-acted with the community every step of the way.

thanks to ggg gallery for the invitation and the chance for me to really review my past creations, some works are extremely commercial, some are pure-ly utopian, and some are a mixture of both...

looking back to the early 80's when i first started, i have been most influ-enced and taught by these great japa-nese artists. we have shared the same seeds, sprouted and grown together.

it is fate that my little overview takes place in tokyo, japan. it seems like i have come full circle, returning to my humble beginnings, giving me an opportunity to sincerely express my appreciation and gratitude to all of my teachers in japan.

a most sincere "thank you" to :
kazumasa nagai \ ozu yasujiro \ katsumi asaba \ yohji yamamoto \ rei kawakubo \ hiroshi sugimoto \ ter-unobu fujimori \ makoto saito \ kenya hara \ naoto fukasawa \ kaoru kasai \ hideki nakajima

i wholehearted agree with what hideki

nakajima, my dear friend said in his wcrk, "my life is made with fate and the oxygen which everyone has given me!".

looking ahead, i shall carry on with my work in the direction of eastern beauty, philosophy, values.

thank god.
anothermountainman
palms together

天の恵みに感謝を込めて

又一山人　合掌

今後も、東洋の美意識、東洋の思想や価値観、ヒューマニズムを追究すべく、一途に邁進して参りたく存じます。

親友の中島英樹氏は、自らの作品デザインについて「周囲の方々に育てられて成長してきた。ひとえに縁の巡り合わせだ」と語っておられますが、私もまったく同感です。

中島英樹

to honor those japanese creative masters, it might take no less

miyake; a friend-like teacher shin matsunaga, the deceased shigeo fukuda and many other names that would overwhelm my pen, you all enlightened me at the beginning of my career, leading me to the grand showroom of design and letting me inspired by the unlimited possibilities in creation.

for 35 years, i make visual creation as my means to interact with life and society, my deepest gratitude to ginza graphic gallery for their invitation to organize this retrospective exhibition including works of commercial, utopian or even commercial and social values combined throughout my artistic trajectory,

looking back, at the beginning of my career in the 1980s, i received most of the influence and inspirations from the mentioned japanese established and contemporary designers, we share the same passion and vision, progressing in a same

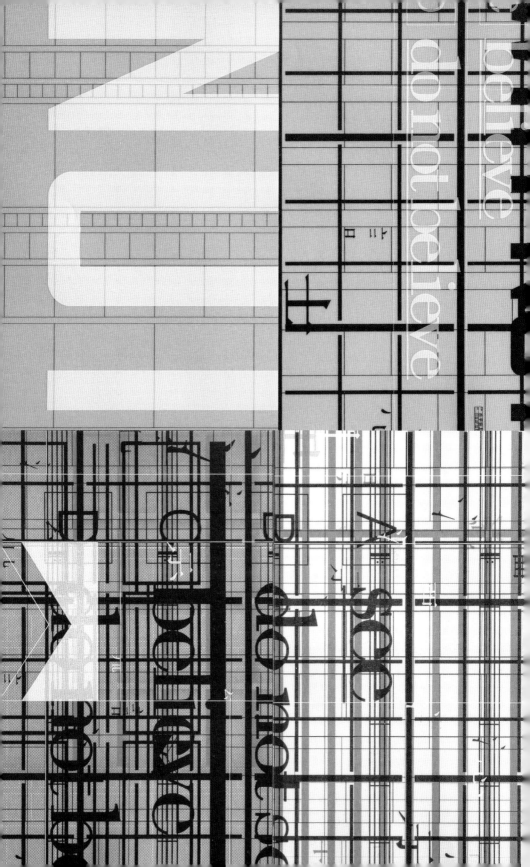

黒は一切
黒は皆無
黒は神秘
黒は深遠
黒は危険
黒は安全

黒は沈黙
黒は開放

貴兄の黒は
私に一筋の光をもたらしました。
山本耀司様、親身に導いていただき、
本当に感謝のことばもございません。

又一山人

完元単

（裏返し）。

要數我尊敬的日本創意大師，可能寫上十頁紙也未能詳列⋯

設計巨人如杉浦康平及田中一光先生、橫尾忠則先生、三宅一生先生，實在不能一一盡錄，亦師亦友之松永真先生及已去世之福田繁雄先生，你們都是我起步時期的啟蒙前行者，給我進入設計「大觀園」，嘗創意的無限可能⋯

三十五年，藉着我唯一懂的視覺創作一直跟生活、社會同步呼吸，互動。

感謝 ggg 畫廊禮重之邀，能讓我好好為自己總結過去的工作，有極商業的，有極理想烏托邦式的，也有商業跟社會價值並存的⋯

驀然回首，我成長八十年代初的路上，受感染的，受教的，心有共同種子，一起萌芽的，其實大都是來自日本的前輩和同輩，天意正好安排我這小總結在日本東京跟大家見面，能像一個圓圈走了一轉似的，帶回我對各老師，大師的一點敬意，鄭重向

各大師說一句感激。
萬分同意老友中島英樹先生在設計作品説：
「我的一生，都是大家給我氧份！因緣和合而成！」

往前看，堅定在東方美學，東方哲學價值，人文方向一直前進。

感恩上天
又一山人　合十

藤森照信／Makoto Saito ／原研哉／深澤直人／葛西薰／中島英樹
永井一正／小津安二郎／淺葉克己／山本耀司／川久保玲／杉本博司／

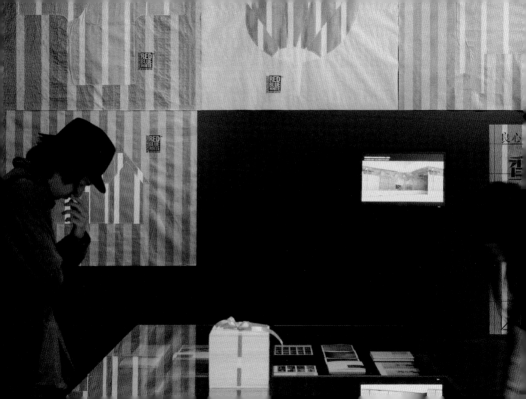

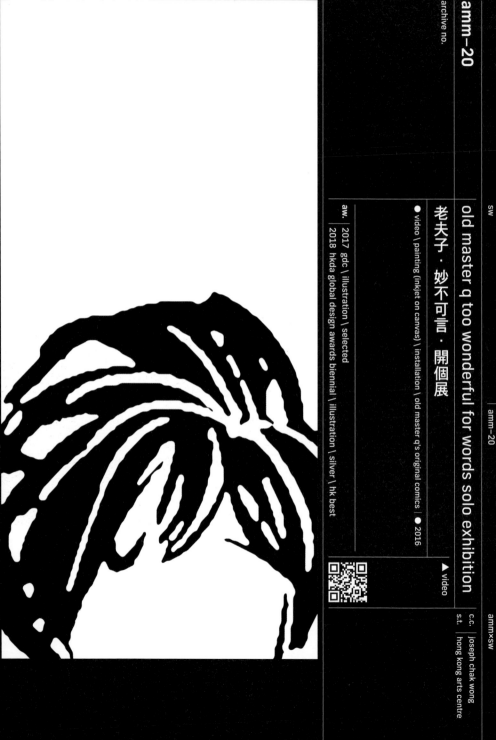

old master q too wonderful for words solo exhibition

老夫子・妙不可言・開個展

● video \ painting (inkjet on canvas) \ installation \ old master q's original comics | ● 2016

▲ video

aw. | 2017 gdc \ illustration \ selected
2018 hkda global design awards biennial \ illustration \ silver \ hk best

c.c. | joseph chak wong
s.t. | hong kong arts centre

i am ellsworth kelly from the east / big potato
inkjet painting

i am ellsworth kelly from the east / mr chin
inkjet painting

since 2000, i have been active on the contemporary art scene in hong kong, mainland china and overseas.

undoubtedly, i have been given a lot of chances to express my views on social issues and values of life...

and i am well aware of my position, my work is personal and i never claim that i am an artist, or that i am a creator in arts. i am not too concerned with whether my creation is a work of art.

in 2012, i described the meaning of art as: to me, art is... any people, emotions, things that accumulate, rise and is then uplifted to a new level which others can feel, and be moved, affected, inspired and elevated by it.

wong chak, senior and wong chak, junior are the creators of old master q, through master q, they immerse themselves in the reality of the comic world and project their values. a big thanks to master wong chak for referring anothermountainman (the outsider), with his help, master q can finally make a decision, or be an artist for once.

master q is very impractical, is a loser. is this his fate this time? can master q lead up and be an artist just for once? can he be an artist? who decides who is an artist? who decides what is a work of art?

自二千年開始，開展及活躍於香港、國內以至海外當代藝術舞台。

沒錯，我爭取到很多的機會發聲，社會議題的，或人生價值觀點⋯而且，我很清楚自己的立場，做的是個人創作，從沒有自稱藝術家，藝術工作者，做的是不是藝術品，我也不大關心。

二〇一二年也就藝術的意義作過以下的描述：

藝術者，於我來說⋯凡任何事、情、人，一直沉澱，一直提升，昇華到一個境界，令人能感受到，或感動到，或感染到；或能引發靈感，帶動到另一個點，這就是藝術。

老王澤和小王澤是老夫子背後的創作者。藉着他，化身自己在漫畫事實中，甚至情感價值之投射。多謝王澤老師將

老夫子轉介「路人乙」又一山人，由他推波助瀾，讓老夫子主張一次，或者自以為是藝術家一次。

老夫子不很實際，失敗者的形象，今趟可不是宿命？老夫子可不可以走在人前，做一次藝術大師？老夫子做不了藝術家？誰決定誰是藝術家？誰決定甚麼才算是藝術品？

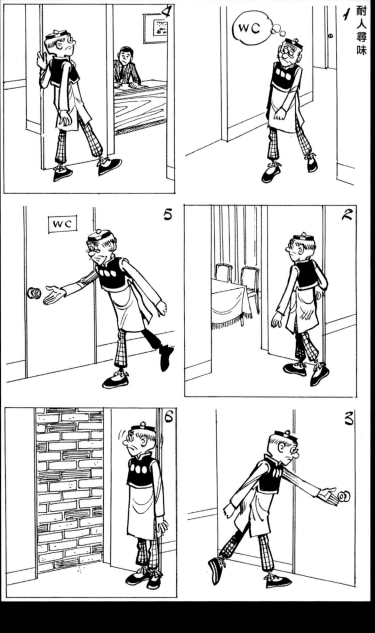

amm–21

archive no.

reborn ikebana \ anothermountainman × shuho

再生花 \ 又一山人 × 佐野珠寶

● ikebana \ photography | ● 2011

c.c. shuho [ikebana] \ anothermountainman
[photography]

s.t. 銀閣慈照寺 [cooperation] \ 西畠清順 \ 福田直男
[plant hunter] \ 長艸敏明 + 長艸純惠 [costume]
\ 宇命 [chanting] \ 宮田まゆみ [video music]

heaven and earth and i are from the
one and same beginning, all things
and i belong together
– shuho

empathy and compassion for all is
kindness and mercy
– anothermountainman

this is a courtesy, this is practice.
this is a story about roots, love,
gratitude, impermanence and rebirth.
sincerely connecting with Japan and
all the victims of natural disasters.

天地與我同根 萬物與我一體適用

——珠寶

無緣大慈 同體大悲

——又一山人

這是一個禮儀，這是一個修練。
這是關於根、愛、感恩、無常、再生的故事。
誠心迴向日本，及天災受苦眾。

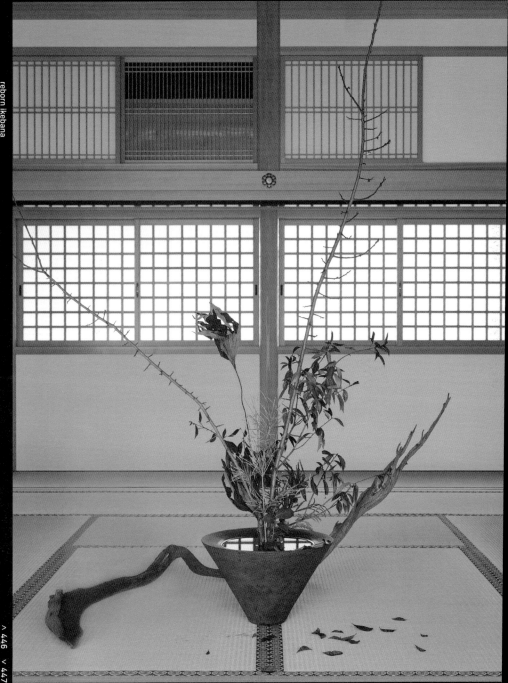

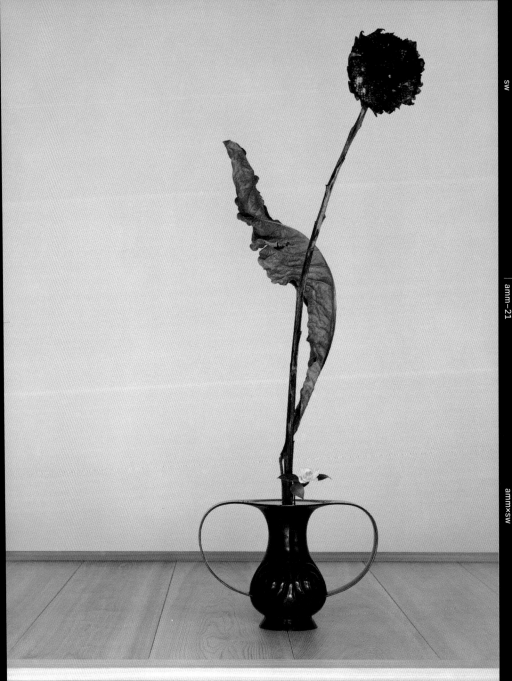

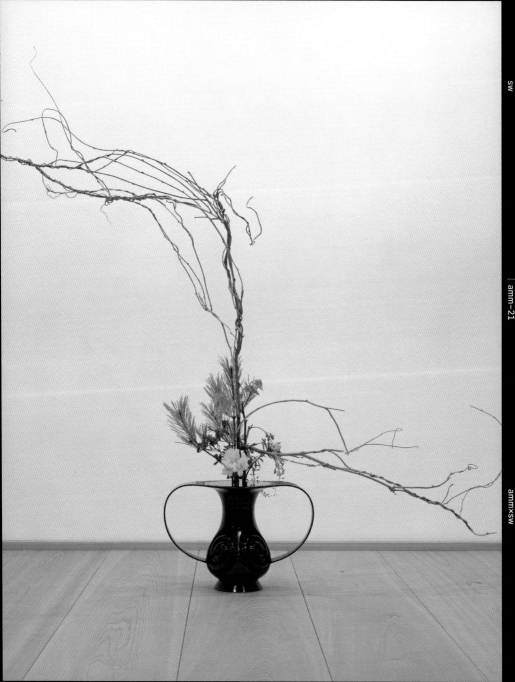

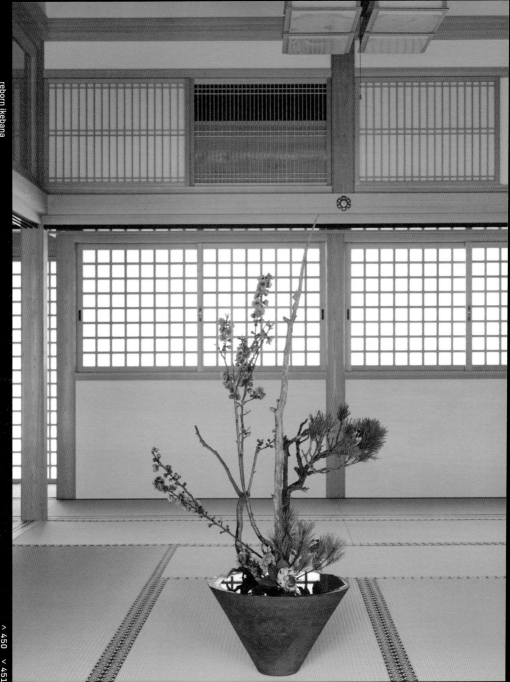

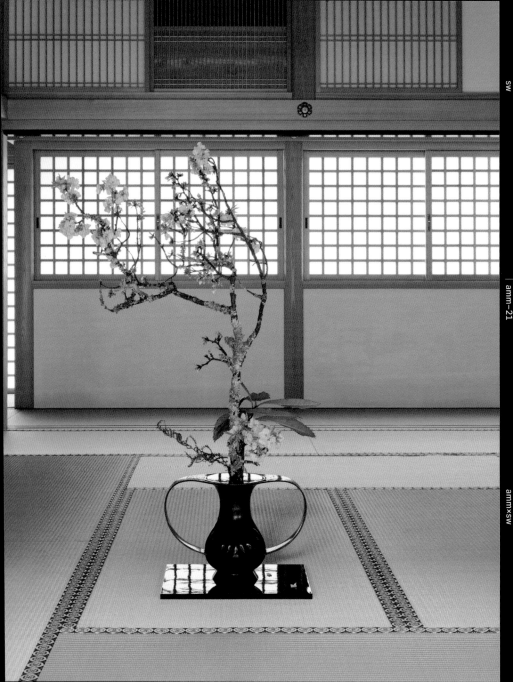

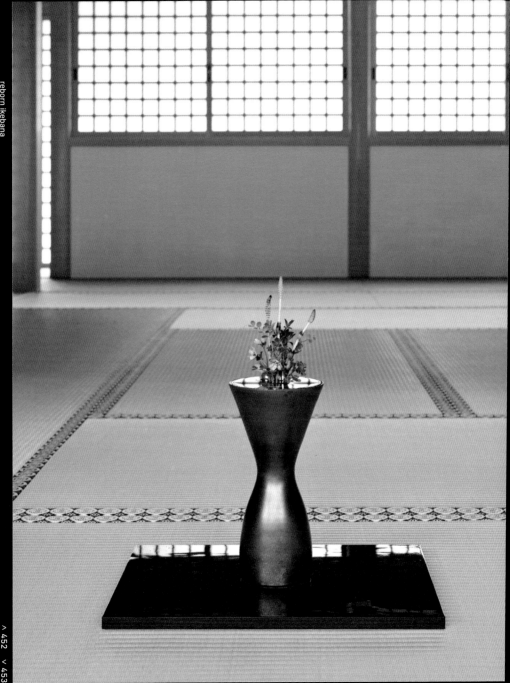

不為甚麼。為的是珠寶她一生專注，對大地平等的愛這信念⋯

二○一○年十二月十一日——在香港大學美術博物館觀看珠寶示範銀閣寺傳統花道。這是關於大地、愛、平等、無常⋯隔一天晚上在朋友家跟她長談。

二○一○年十二月十三日——朋友 abbie 送她到機場回日，並留口信給我，想跟我一起做點事（其實我心也是這樣想）⋯

二○一○年二月八日——正式邀請珠寶成為「what's next 三十乘三十」項目之嘉賓，並獲接納。然後展開對話。

二○一一年二月九日——跟我《拾吓拾吓》系列，「存在就是珍惜尊重」的概念下，提出共同合作再生花道 (reborn-ikebana)，由她用拾來枯枝花屍出發，並由我攝影。訂於二○一一年三月十九至二十日在京都拍攝。

二○一一年二月二十日收到對話回覆，是一封毛筆書法信箋⋯

二○一一年三月十一日——日本地震，引發海嘯，因災害情況不明朗，行程延遲十天。

二○一一年三月十九至二十七日——電郵通訊，殤國難之餘，我們深信這「再生」是向日本致意的。雖然香港朋友家人一再叫我三思要出發京都做這項目，我回應是：為日本人堅強之精神，一定出發。

二○一一年三月二十九至三十日——一早來到銀閣寺，喝茶⋯禮佛，遊花園⋯平靜下來⋯一眾團隊圍在一起，由宇命老師開始領經：六根清淨／hi fumi 歌／神實 (kantakara)，作洗淨及迴向國家災難眾，珠寶身穿一套由長岬敏明 (toshiaki nagakusa) 和長岬純惠 (sumie nagakusa) 老師造的純白禮服開始其再生花，七個過程由枯死到初生成長⋯一個生命的循環。

for no other reason, only for shuho's lifelong dedication to the belief of equal love on earth...

11th december, 2010
i watched shuho's demonstration of traditional ikebana at the university museum and art gallery of the university of hong kong, it is about earth, love, equality, impermanence...the next night, i had a long talk with her at a friend's house.

13th december, 2010
my friend, abbie, took her to the airport and left me a message. shuho would like to collaborate with me on a project (that was what i was thinking too) ...

8th february, 2011
i officially invited shuho to be a guest artist for my exhibition "what's next 30x30". she accepted. our dialogue began.

9th february, 2011
under the concept of "existence is respect" for my scavenging series, i came up with the idea of "reborn-ike-bana" with me photographing the dried flowers-ikebana. the shooting session was planned to take place on 19th– 20th march, 2011 in kyoto.

20th february, 2011
i received shuho's response in a letter, written with a calligraphy brush...

11th march, 2011
earthquake in japan followed by tsunami. due to the uncertainties, we postponed the trip by 10 days.

19th – 27th march, 2011
through email, we believed that at a time of national grieving, the theme "reborn" could be a tribute to japan. although my friends and family in hong kong urged me to reconsider my trip to kyoto, i insisted on going for the fortitude of the japanese.

29th – 30th march, 2011
arrived at the ginkakuji temple. we had tea...a buddhist prayer session... a garden tour...and then we settled down...

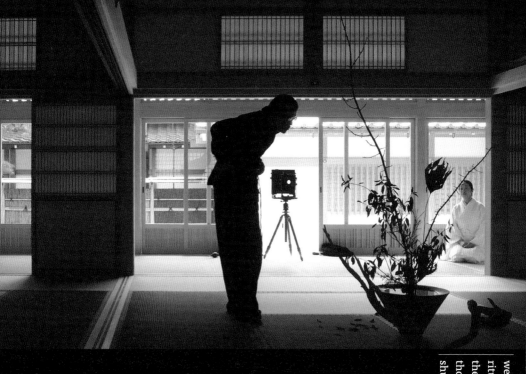

we gathered around with uma, the ritual master leading the prayer: they chanted, purified and sent our thoughts to the victims of the disaster. shuho, clothed in a white ceremonial gown, began the "reborn-ikebana". the seven steps in the process started with withering, then sprouting... a life cycle.

amm-22

archive no.

tomorrow's daily
明天日報

amm-22

● concept \ curation | ● 2007 \ 2017

c.c. | ahy \ aruniminifumi \ craigau-yeung \ hamletau-yeung \ cd \ fachan \ harveychan \ chanka-yan \ chankin-wah \ kurtchan \ chansze-chi \ chanya \ chengwai-sum \ cheungsi-wan \ chihoi \ chowyiu-fai \ hugochu \ hoyat \ hoying-fung \ honggingtian \ k \ leonieki \ firenzelai \ aubreylam \ carollam \ fredlam \ lamhek \ pierrelam \ lauching-ping \ lauchui-yi \ lauwan-tung \ lawwai-ming \ leungman-tao \ andyliu \ markio \ lujah \ lungking-cheong \ maka-fai \ makon \ micjoseph \ bonnieng \ ngfar \ lulungai \ lawrencepun \ tangching-kin \ garytang \ tsangchung-kin \ tsangman-tung \ tsangsui-lun \ tsuidoi-ling \ bensonwong \ derekwong \ garywong \ jessicawong \ justinwong \ michellewong \ peterwong \ yankwong \ wansiu-fung \ wenyau \ mathiaswoo \ xingliang \ dannyyung \ zhangtieh-chih \ zurzi \ 小 c 妹 \ 小 土 \ 文化斗力 \ 立口口貝 \ 冥虎太

col. | m+
s.t. | artmap

i believe, therefore i see.

forty years ago today, i boldly entered the world of journalism, and published the newspaper "tomorrow's daily". it has been said that publishing a newspaper is a gamble. it is not a profit-making business. it has also been said that the purpose of publishing a newspaper is to control and create public opinion.

in 2007, the whole town was reflecting on the ten years following the handover, criticising and discussing the "hong kong's decade". indeed, if it was done with good intentions and a positive attitude, i was sure we could learn something good from the experience. to me, the question of how much positivity was in the discussion was already a topic in itself, a topic on "hong kong affairs" that i am interested in and concerned with.

luckily, a group of "reporters" and "commentators" came to my rescue. they started writing articles on the unknown, tomorrow's news, the hong kong news on 1st july, 2047 – the day when "one country two systems" officially ends.

this was not as ridiculous as it sounded. it was an exercise of revisiting experience and formulating vision. it is a reflection on what the future might hold. the group of about 20 contributors include young and experienced writers, socio-political commentators, artists, advertising creatives, and secondary and university students. they wrote the news with their imaginations from different perspectives, representing a small but macro view of our group on the hopes and aspirations for what tomorrow might bring...

people usually believe because they see. that is how they view people, hong kong, chief executive and china. but when things go awry, willpower becomes handy – "i see, therefore i believe" but at the same time, "i believe, therefore I see." as a joke, isn't "i believe, therefore I see" the philosophy that underlies the speculation of stocks and shares?

so, at that time, it was out of the belief that "i believe, therefore I see" that tomorrow's daily was born. we put everyone's thoughts together and tried to show the mentality of different generations. we wanted everyone to think about their own predicament, what "loving hong kong, loving the country" really means.

in buddhism, this is karma.the future of hong kong is in your hands, in your mind, in your heart, i hope the positive willpower of 7 million people will be with me.

i hope that tomorrow's daily will meet with everyone every ten years.

明天日報 2.0

tomorrow's daily

本報內容：頭條 社論 要聞 港聞

香港建造
香港20

天氣預測：

電郵：tomo...

sw | ammx—22 | ammxsw

我相信所以我看見。

四十年前的今天，我勇敢地踏足傳媒，辦了份叫《明天日報》的報章。人們常說辦報是賭博，賺不了錢。又說辦報是為了控制社會言論和製造及創造社會聲音。

在二○○七年，全城都在回想回歸剛過去的十年，或檢討批評這個「香港十年」，鬧得熱烘烘的。

無可厚非，用正面積極的平常心一定可以從中溫故知新，從經驗中學習。對我來說，當年的香港正面積極之心有多大就是一個議題，一個我關心的「香港事務」。

幸好得到一班「記者」及「評論人」接受我的邀請，齊齊動筆寫未知的明天新聞，寫關於二○四七年七月一日，就是一國兩制正式完結當天的香港新聞。

這不是一般看來的荒唐無稽，天馬行空的不着邊際。這反而是一個「瞻前顧後」的學習，對未來的正面和希望的一個反射…

特約記者、評論員及編輯隊伍是由二十多位資歷有深有淺的作家、社會評論專家、非文字創作人、廣告人以至大學、中學生組成。他們想像的新聞從不同角度，作出一個小小的宏觀，代表了我們不同年代的狀況，亦想就此叫大家想一想自身，想一想甚麼是真正的「愛港愛國」。

叫大家集合眾人的思維，反映一下每個對香港的心情，對香港的憧憬和我們對未來的期盼…

人們的想法總是「我看見所以我相信」，對人對港對特首對中國如是。但當時勢不就的當下，「念力」就要派上用場：我看見所以我相信，同時極應做到「我相信所以我看見」不曾就是大家用來炒樓炒股的哲學觀嗎？

佛說這叫做業力（karma）。我們香港的共業在你的手上，你的腦袋裏，你的心中。

願七百多萬個正面積極的念力與我同在。

願這份《明天日報》能在每個十年，甚至每年與大家再次見面。

amm-23

archive no.

united colours of 193 | 共融\ | 九三

● video | 3'32" | ● 2017

▲ video

red, white and blue signify freedom, equality and fraternity, the yellow stars are the party, the working class, the peasantry, the urban petite bourgeoisie and the national bourgeoisie...

the colours and images on the national flags are the symbols of the utopian dreams and ideals of the nations. yet, once manifested in international economic and political context, the "countries" represented by the 193 national flags, become engaged in an unending contest of status, power, contention and even conflict.

the source of man's wisdom, after flowing through millions of years, has extended, expanded, and diversified

into countless estuaries of cultures, histories and civilisations.

can this wisdom, concordant yet varied, be renewed and practised in the global village of today?

can we set aside the cultures, histories and ethnicity that divide and in mutual acceptance, unite under the spirits of our national flags, and begin a dialogue on the subject of "you" and "i" ...

● 00923f / 69%
● f8c300 / 17.4%
● 28166f / 12%
● ffffff / 1%

紅白藍是自由、平等、博愛。
黃星是黨、工人、農民、城市小資產階
級和民族資產階級之團結⋯

各國國旗上的顏色，
圖像都象徵着烏托邦的理想和目標。
但落到國與國之間的概念，
經濟、政治角度，一百九十三支國旗所
代表的「國」就變得沒完沒了的身份，
權力、角力以至紛爭。

人的智慧由來，
千萬年分流後之文化，歷史百花齊放，
這和而不同的精神，
可否重新在今日地球村派上用場？

暫且收起各自文化、歷史、民族底蘊，
將大家國旗來一次解構共融，
以同一語境對話，
面對何謂「你」和「我」的課題上面⋯

amm–24

archive no.

lanwei | 爛尾

● photography [conceptual] | ● 2006 → 2012

▲ slide

aw. | 2007 hkipp asia photo awards \ photography \ bronze
2009 hkda asia design awards \ photography \ gold
2009 gdc \ photography \ silver
2013 hkda global design awards \ photography \ silver \ hk best

abortive building (lanwei) projects are the "fruits" of two to three decades of fruitless chase after a future, an opportunity, desires and dreams in a liberated society, at a time of seemingly limitless economic expansion.

buildings can be aborted, so can projects. plans may be aborted. so may hopes. ties between people could be aborted, so could relationships. life, i guess should not be aborted.

(P.S. i have been harbouring the concept of shooting abortive building projects in my mind for five years. fortunately, on the eve of government actions to clean up the mess, this concept finally became a reality, sparing it from being yet another abortive attempt.)

在社會的開放，
或者經濟極速發展的背景底下，
爛尾樓正是過去兩三個年代，
一群活在大時代的人對
前景、機會、人心和夢想的
一場搏鬥沒結果的結果。

建築會爛尾。工程會爛尾。
計劃會爛尾。希望會爛尾。
關係會爛尾。人情會爛尾。
人生。我想不應該爛尾吧。

（P.S. 這個在腦袋不斷浮現的爛尾攝影念頭，不覺
已經超過五個年頭。幸好終於在政府收拾爛攤前在
現實中實現出來，不致爛尾收場。）

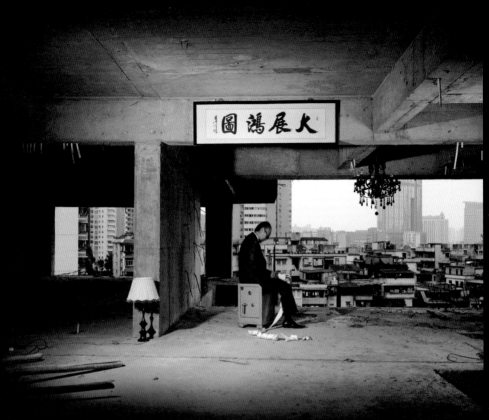

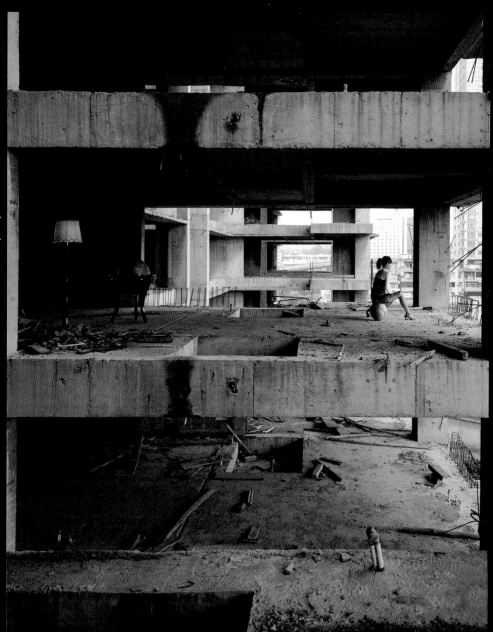

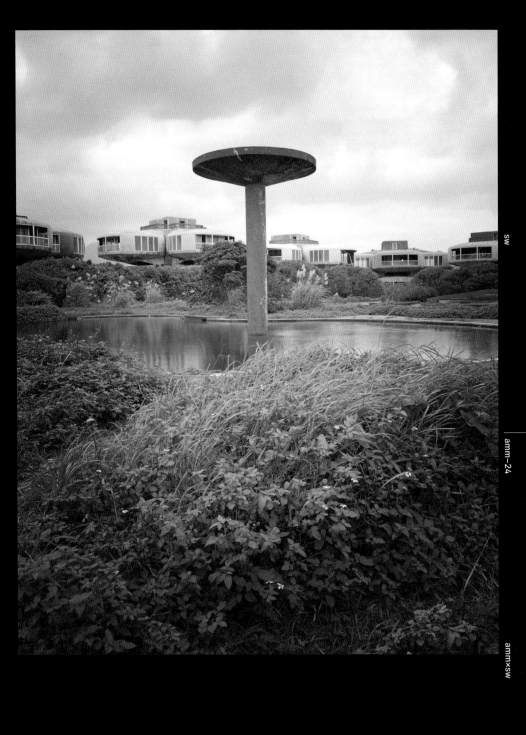

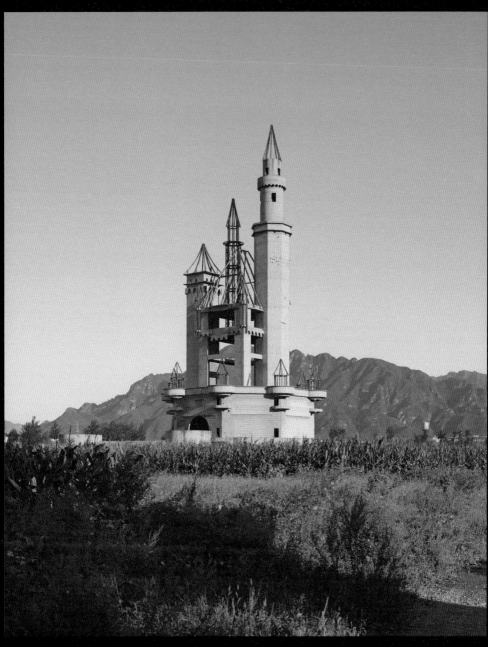

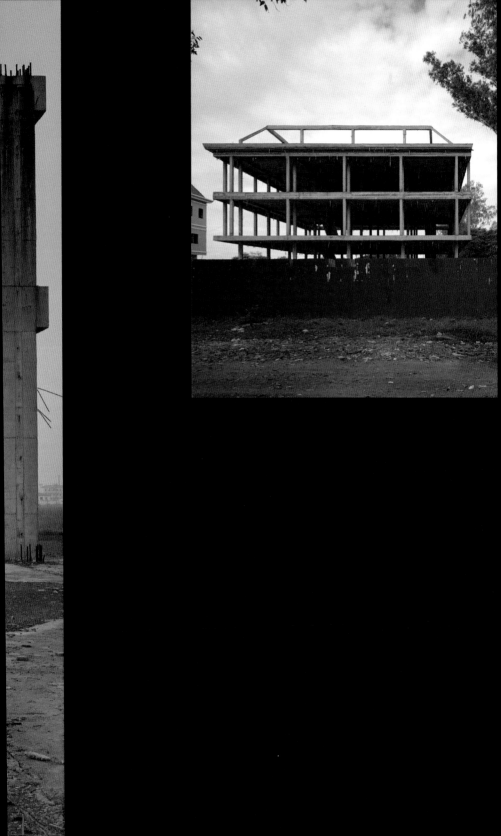

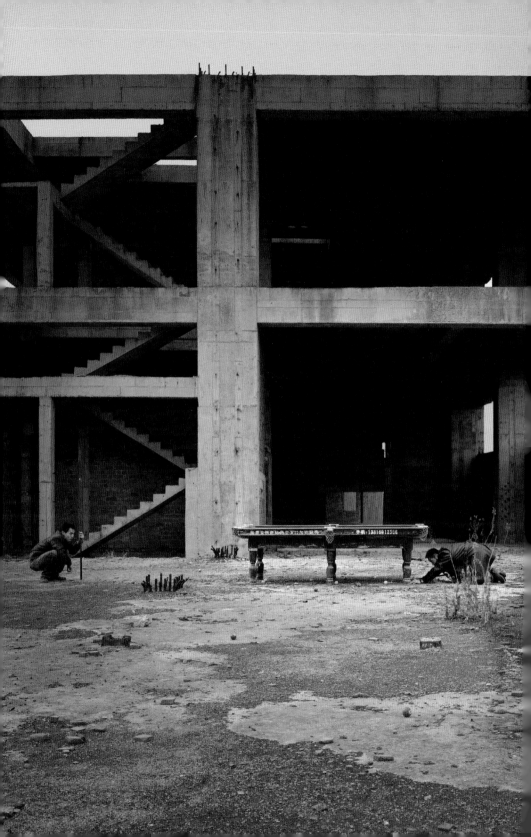

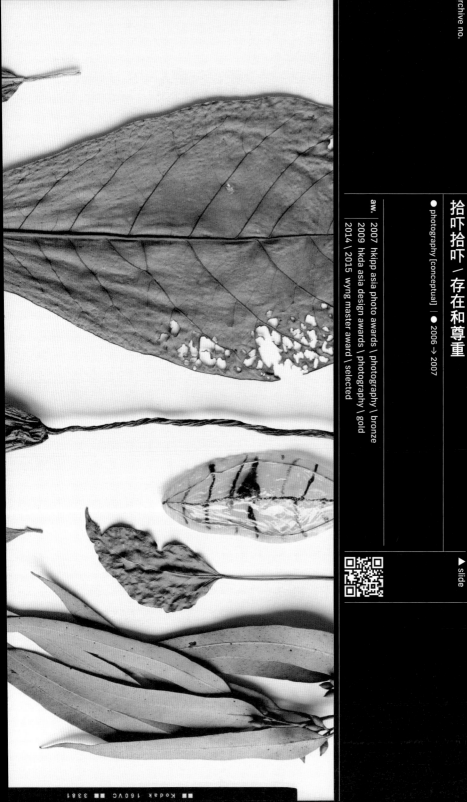

sw | amm—25 | amm×sw

scavenging \ existing in respect

拾吓拾吓 \ 存在和尊重

● photography [conceptual] | ● 2006 → 2007

▲ slide

s.t. | milk (magazine)

aw. 2007 hkipp asia photo awards \ photography \ bronze
2009 hkda asia design awards \ photography \ gold
2014 \ 2015 wyng master award \ selected

without realising it,
i have been doing this for over 10
years,
picking them up bit by bit...
picking up their beauty.
picking up a story that i would never
know.

picking up.
just because it exists.

picking up.
because i believe life is beautiful.

(paying respects to existence,
even though it is something that we dispose of.)

不知不覺，
拾吓拾吓，
拾了十多年⋯
拾回它的美。
拾回它背後我沒法知的故事。

拾回。
只因它存在。

拾回。
只因我相信 life is beautiful。

（存在應得到尊重，
那怕是我們廢棄的物質。）

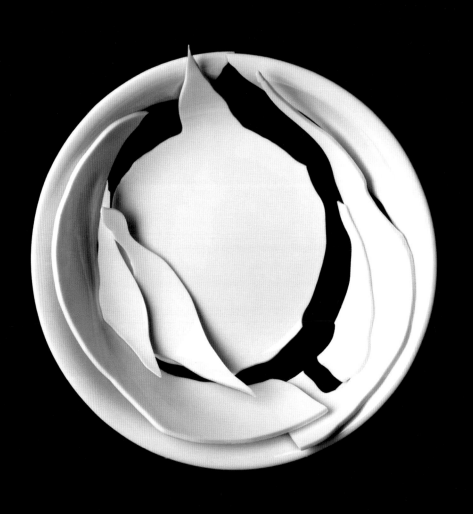

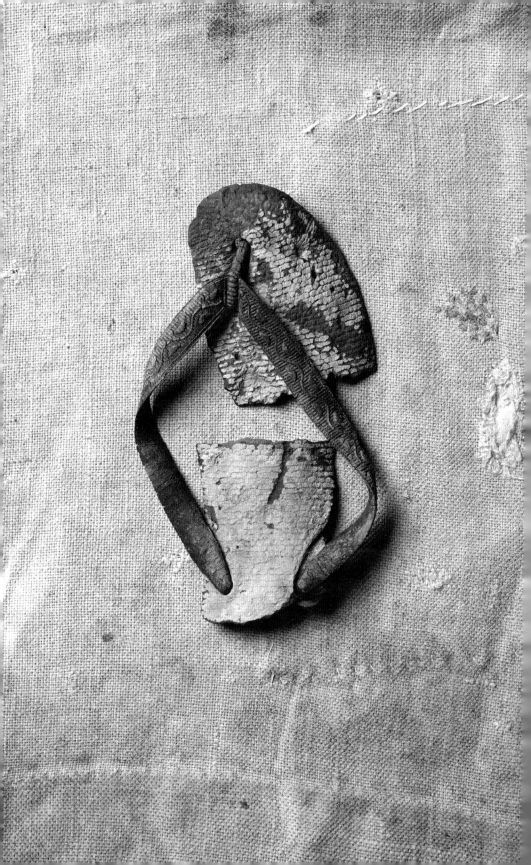

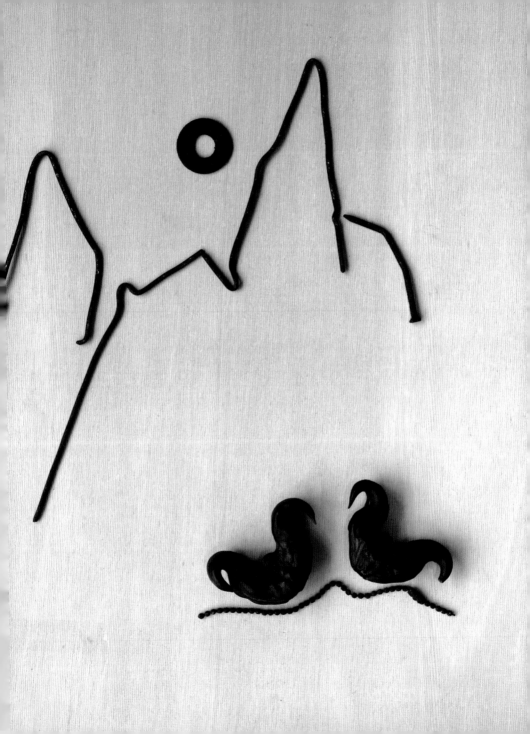

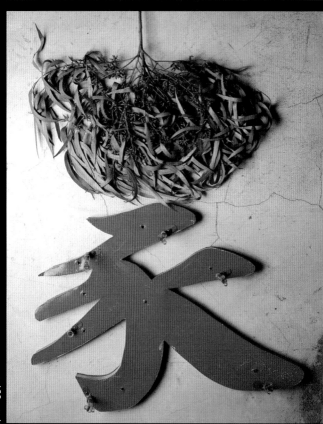

amm–26

archive no.

dunhuang on the way again | 敦煌再上路

● photography (conceptual) | ● 2010

once upon a time,
this used to be a place of prosperity.
once upon a time,
this used to be a place where the east meets the west,
commercially, culturally, religiously...

today,
this is a place yet to be developed.

today,
this is a cultural treasure being marginalised.

a place that once bridged different worlds together,
is now ready to build its own bridge and be back on its way again.

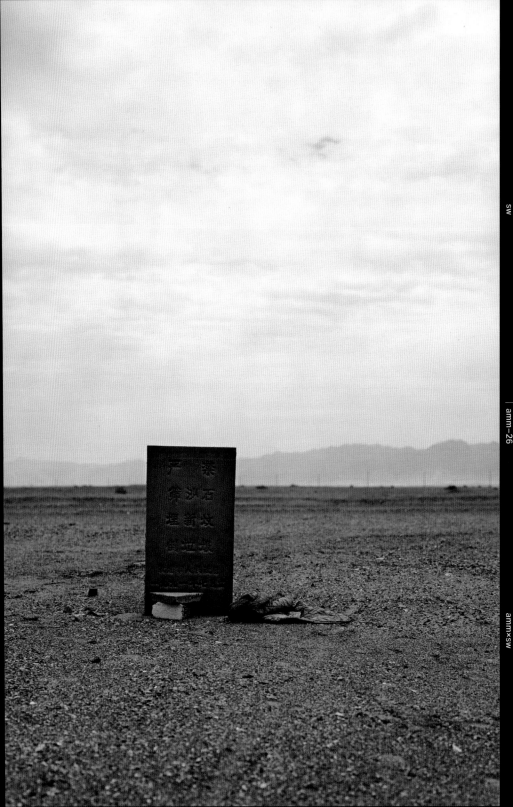

曾幾何時，
這是一個興盛的地方，
曾幾何時，
這是東西交會的地方
經濟的、文化的、宗教的⋯

時至今天，
這是一個待再發展的地方。

時至今天，
這是一個被邊沿的一個文化寶藏。

當日為世界搭橋的地方，
今天正為自身重新搭橋再上路。

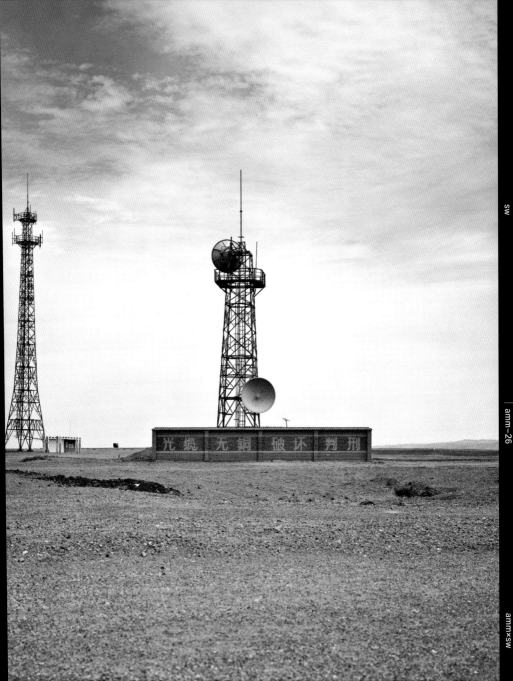

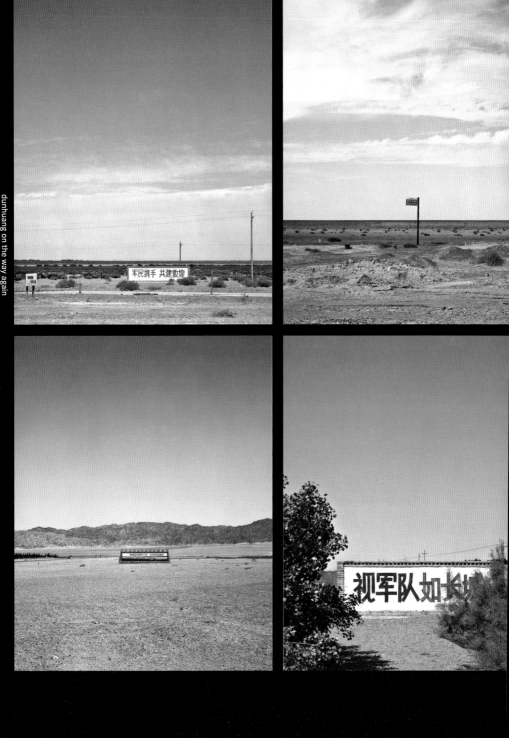

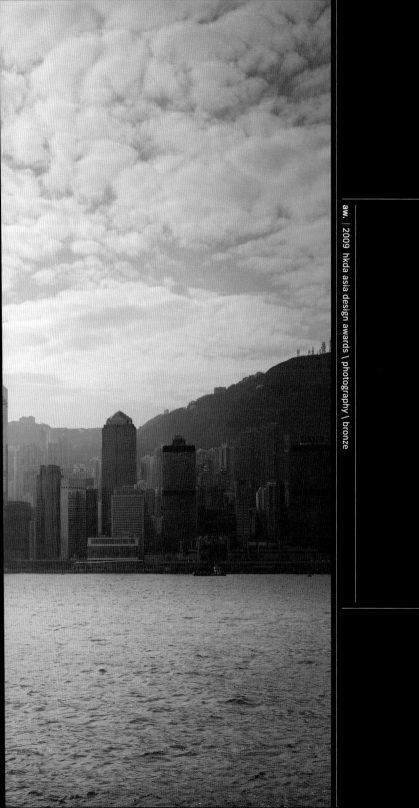

amm–27

heaven on earth | 凡非凡

● photography [conceptual] | ● china \ 2007 → 2009 | singapore \ 2012

aw | 2009 hkda asia design awards \ photography \ bronze

s.t. | nanyang academy of fine arts, singapore

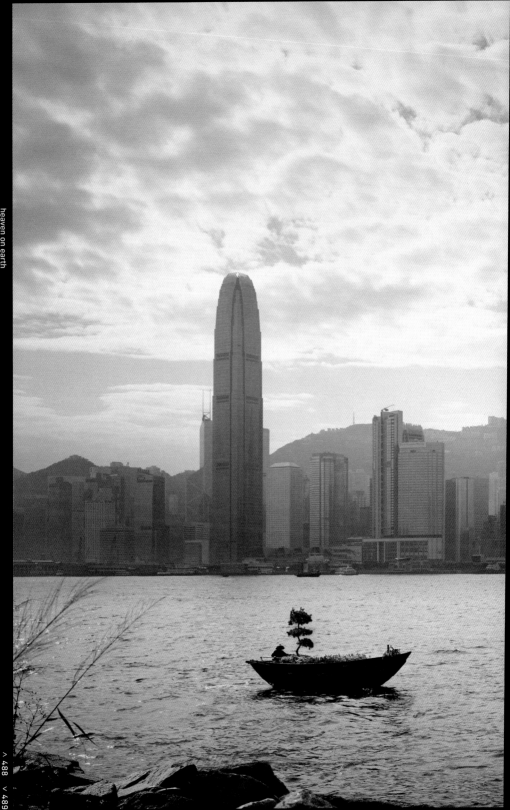

sw

amm-27

ammxsw

他看。海市蜃樓。
你看。汪洋綠洲。
我看。人間淨土。

he sees, mirage.
she sees, oasis.
i see, heaven on earth.

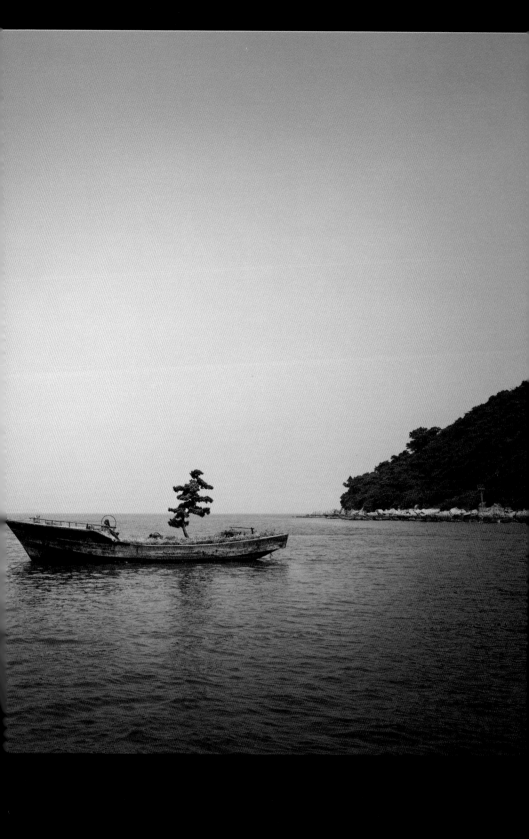

heaven on earth

amm–28

archive no.

to begin with, there's no matter. | 本來無一事

● photography (conceptual) | ● 2007 → 2010

aw. | 2009 hkda asia design awards \ graphic \ 2 × judges' choice · photography \ gold | 2013 hong kong contemporary art award \ selected

important matters. small matters.
family matters, matters of the nation.
co-workers sorting out matters togeth-
er. strictly business matters.
doesn't matter, avoid the matter.
simplify the matter, ignore the matter.
dealing with people matters is the
matter of trying our best,
the matter of getting the right facts
and making the facts right.
no matter what,
it's never a matter of course,
sometimes,
matters work against our will,
other times, it's mind over matter.
inspirations scatter over no-matter
notice boards:
there's never a matter?
stirring up matters? causing matters?

take advantage from matters?
that it's not a matter,
no serious matter,
anyway,
in our world,
there's no matter to begin with...

ammxsw

香港警察隊員佐級協會通告

PSU2 CDIV

PSU2 CDIV

大事小事。家事國事。
同事共事。公辦公事。
費事、怕事。
多一事不如少一事。
做人處事，盡人事，
實事求是。
難料世事。
有時事與願違。
有時事在人為。
壁報板啟事⋯
相安無事？造謠生事？鬧事
若無其事。不當一事。
反正，
世間本來無一事⋯

amm-29

a poster a week | 每周出海

● poster | ● 2018 → 2019

c.c. | all works from masters which inspired me, and touched me.

creating a poster each week, (poster in chinese " 海報 " means "sea-bulletin") creates ripples in my mind, like the ebbing and flowing of tides along the beach.

amongst them are ones that I have loved, respected, appreciated, and have been touched by in the last 60 years; there are ones from the folks and from the masters.

52 weeks of snapshots evokes images similar to the flashbacks in the moments before dying.

after 52 weekly cruises, i officially step into my 60th year. rebirth of creativity, from the heart, rebirth.

每周做出一張海報，腦裡鈎起翻起的，就像灘邊海水來回蕩漾。

裡面有六十年來喜愛的、尊敬的、欣賞的、感動的。有民間的和大師的。

五十二周快速搜畫，聯想到人家說死前腦裡重現一生片段的情景。

每周出海之後，就讓我踏入六十之年。創作重生。從心，重生⋯

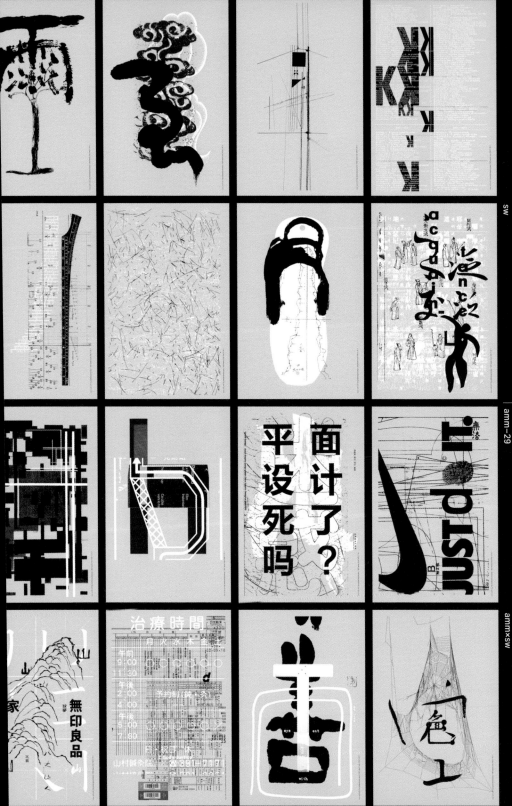

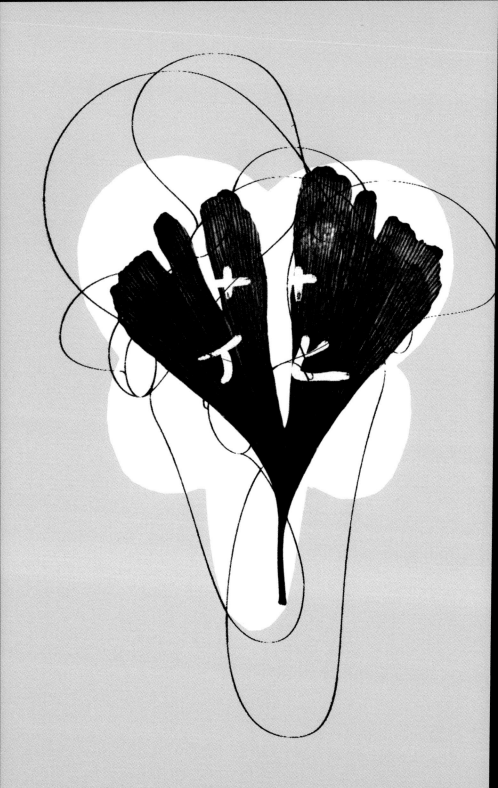

amm–30

from su shi to bada shanren ｜ 從蘇東坡想起八大山人

s.t. ｜ blindspot gallery

● photography [conceptual] ｜ ● 2013

▲ slide

what is painting?
realistic painting or abstract painting?
what is a painting?
is capturing a moment with the camera a photo,
or a painting?

a painting, something that can be seen,
painting, an ongoing process?

a painting, from the song dynasty to the ming,
qing dynasty to the 21st century.

painting, where we come from. what we are doing.
then why bring one more painting to this world?

何謂畫？
在實物上畫，可是作畫？
何謂畫？
以攝影程式實錄是照片，
或是畫？

畫，是可觀物？
畫，是無形過程中？

一張畫，
由宋到明、清，畫到廿一世紀。
畫，我們根本地；
為何要帶來世間多一張畫？

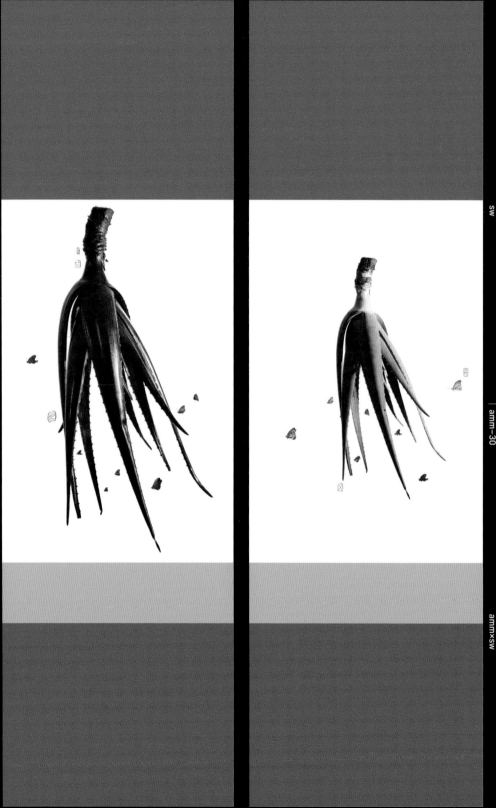

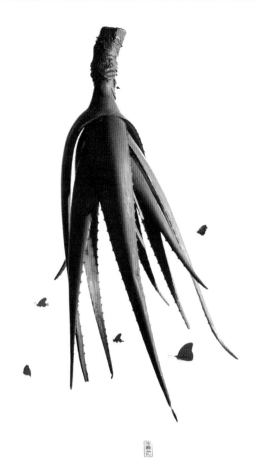

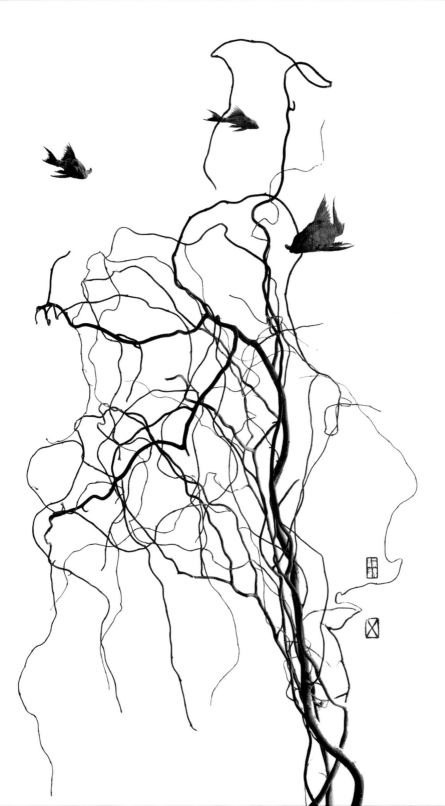
ammn-30

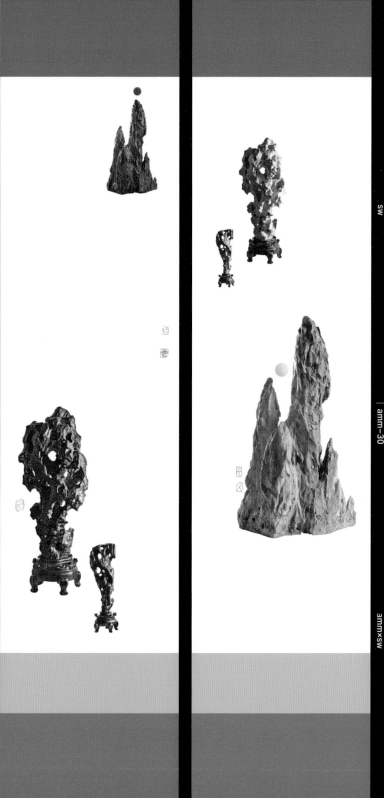

amm-31

archive no.

time will tell : 80 \ 20 enlightenment. forty years

時間的見證 ‥ 80 \ 20 明心見性・四十年

● photography [documentary]　●　1980 → present

c.c. | lujah [poetry]

among the street photos collection that i have taken over the past 40 years, i have chosen around 10,000 photos to share with you. these photos focus on the process of constancy and continuance, instead of results. (the taiwanese buddhist master, master sheng-yen granted me the buddhist name of chang-chi "constancy always")

or, from another perspective, if there had not been the people, emotions and events that i personally witnessed constantly unfolding, galvanizing, brewing in the background, there would not have been the concepts and ideas in the photography series that appeared later.

i have chosen "enlightenment" as the title for this twenty-volume series. of course, it is nothing compared to the enlightenment, nirvana and the ultimate truth expounded in buddhist teachings. nevertheless, after 40 years of pho-to-taking on what i like, what i care about; on things that i am curious about, things that moved me, this conversation i have with myself can be the funda-mental level in "understanding myself", "seeing myself".

在過去四十年紀錄街拍的眾多相片中，選了約一萬張給大家分享，着眼點是恆常和持續的過程（台灣聖嚴法師給我的皈依名字「常持」），而不是結果。

又或者，換個角度說，如果沒有背後，日復日在途上親心見證過的人、情、事，就不會沉澱，發酵發展，歸納到往後的題材性的、觀念性的攝影系列⋯

我選了「明心見性」給這系列二十本書。當然這跟佛法中理解的覺悟、解脫和究竟完全不能相提並論。然而，拍了四十年照片，甚麼我喜歡，甚麼是我關心，甚麼給我好奇，甚麼令我感動⋯自己跟自己對話了四十的過程中，也算是最低層次的「明白自己」和「看見自己」。

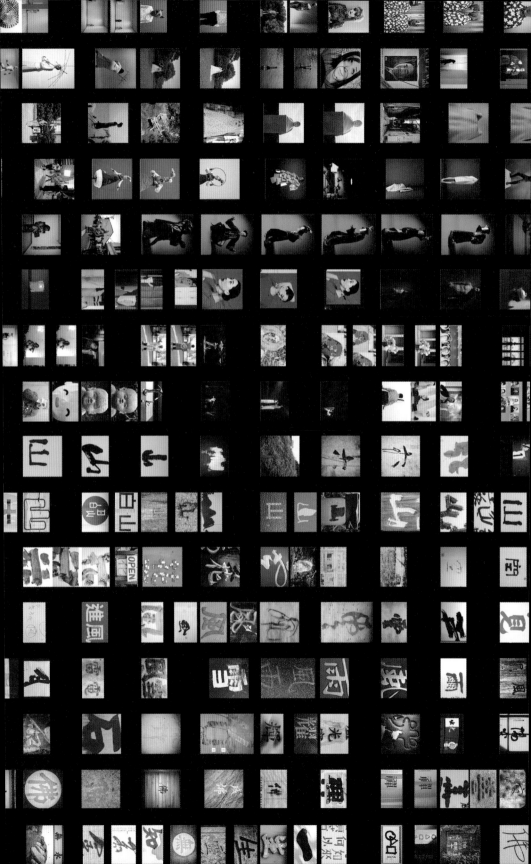

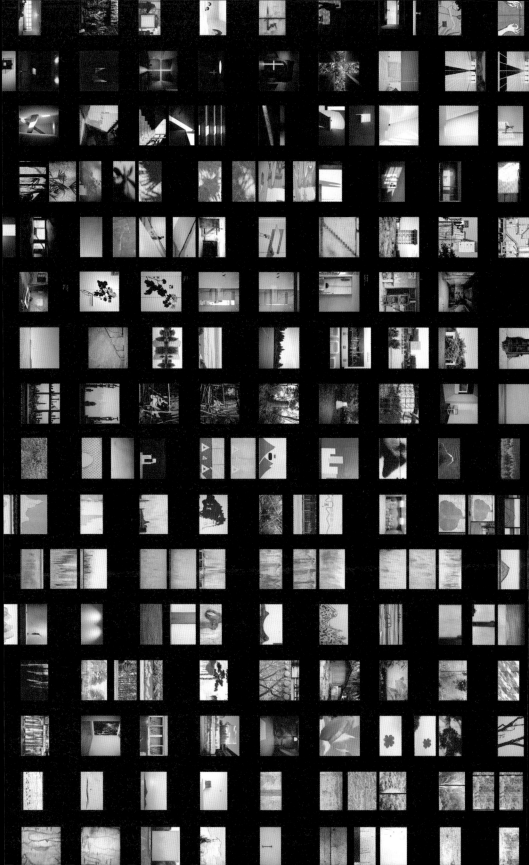

impermanence | 無常

● installation | ● 2009

aw. | 2009 gdc \ product \ bronze
| 2012 hong kong contemporary art award \ gold

col. | hong kong museum of art \ oct art and design
| gallery (shenzhen)

cause-and-effect.
all because of a subjective wish, a
wishful thinking...
over a decade ago, i discussed with
my friends on how our funerals would
take place and how to say the last
goodbyes.
i talked about my concerns:
i do not want it to be morbid,
i do not like the candles and ashes,
i do not like the colourful traditional
chinese funeral...
once the discussion started, i told my
friends,
let's continue some other time.
the more i thought about it, the thing
that would bother me most

would be the coffin.
couldn't accept the fact that it is not
environmentally-friendly enough,
even those that claim they are good
for the environment.
a coffin is a commercial product that
is produced for "death",
and it can only be used once.
i couldn't accept that coffins looked
too complicated, too curvy,
(that was before the minimalist paper
coffin design appeared)
because i have always
been a perfectionist who swears
by right angles and straight lines.
but the worst thing about the coffin is
the sense of estrangement.

i wondered:
in my final hours, why would i want to
be enclosed in
an object that has nothing to do with
me?
why would i let something that i have
no feelings for to be at
my side during my last moment in this
world?
after lengthy deliberation,
i decided on a sofa bed which i would
use for thirty, maybe fifty years, and
then, at the end, get
packed up with it and go.
how nice, how intimate
and environmentally-friendly...

what's more, as i get more involved
with the sofa bed day in day out,
i get a first-hand experience of death
as part of living, and at the same time,
take a close reexamination of my own
life.

impermanence is in-between the sofa
bed and the coffin.
impermanence is in-between life,
death and next life.
and in-between, is to cherish...
to be positive... proactive... free...
impermanence. is to experience life.

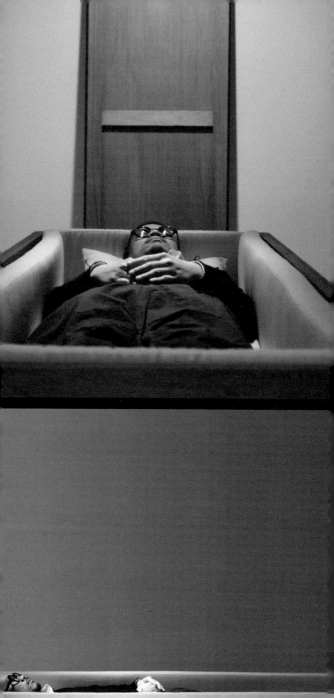

IMPERMANENT/A	SOFA / COFFEE TABLE / BOOK SHELF /
無常 / A	椅化 / 茶几 / 書架 /

COFFEE TABLE
IN LIFE
生前用的茶几

BOOK SHELF IN LIFE
生前用的書架

SOFA IN LIFE
生前用的椅化

IMPERMANENT / B	THE BOX THAT ONE WILL GOING AWAY TOGETHER WITH, FROM THIS EARTH… /
無常 / B	每個人離開世間時身跟的箱子 /

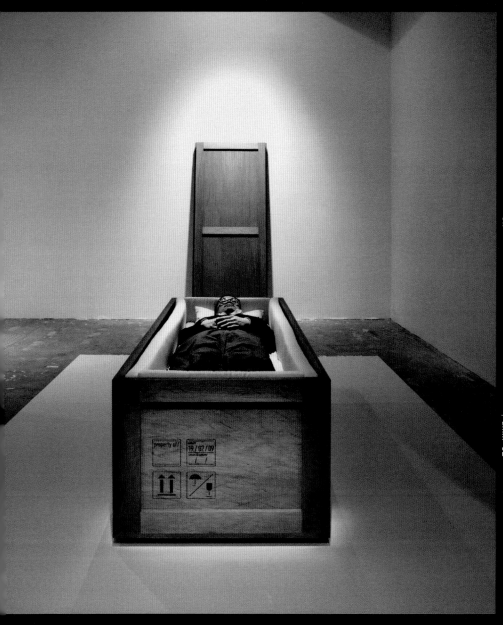

緣起，
只因主觀願望，只因一廂情願⋯
十多年前與朋友說起葬禮的形式，
如何與他人見最後一面。
表白了我關心的是：
怕悲情、怕香燭煙火、
怕傳統中式葬禮的多顏色⋯
開了話題，拜託了朋友，
往後再看吧。
再想下去，
最不安的要算是棺木這環節吧。
接受不了它不夠環保，
就算是近年面世的環保棺材，
也是因死而「生」的市場產品；
只可使用一次的奢侈產品。
接受不了它不夠簡約和
多弧線外型的設計（當時還未出現紙棺
材這比較簡約的造型），
正因為一向自知是個對直線、
四正追求「完美」主義者。
最最接受不了的是陌生感受。
心裡問：

為何在離世的最後一刻、
伴着的空間，
竟是被那個與一生無關、
沒時日感情、
沒感覺的東西包圍着。

想了想了，決定做張梳化床，
用它裹身一同離去。
然後三、五十年，
符合環保原則，
多麼親切，多好⋯
再想，藉着每天親近
梳化床的互動，親身感受「死」
是人生的一部分這概念；
親近面對自己人生的一個功課。

無常。是梳化床和棺木之間。
無常。是今生和死亡和來生之間。
之間。應該是珍惜⋯
是正面⋯是積極⋯是自在⋯
無常。是體驗人生。

impermanence

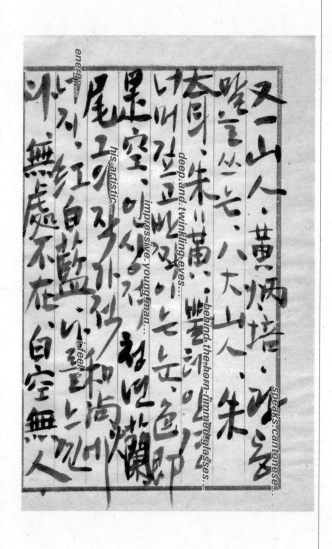

● Ahn Sang-soo │ 安尚秀

Korean. Typographer… Graphic. Designer… Director. of. PaTI… (Paju. Typography. Institute)…

韓國字體設計大師…平面設計師…坡州字體設計學院「PaTI」總監…

又一山人 . 黃炳培 . 광동말을 . 쓰는 . 八大山人 . 朱耷 . 짧은머리 . 朱＝黃 . 뿔테안경 . 色卽是空 . 인상적 . 청년 . 蘭尾 . 그의 . 작가적 . 和尙 . 에너지 . 紅白藍 . 나를 . 느낀다 . 無處不在 . 白空無人 .

anothermountainman. Wong Ping-pui. Speaks Cantonese. With short hair. Bada Shanren, Zhu Da, Zhu = Wong. Over the horn-rimmed glasses, deep and twinkling eyes. Form is emptiness. Impressive young man. Lanwei, his artistic energy, redwhiteblue. I feel that it is everywhere, no one like him under the clear sky.

又一山人。黃炳培。説廣東話。短髮。八大山人，朱耷，朱＝黃。黑框眼鏡，深邃閃爍的眼神。色即是空。令人印象深刻的年輕人。爛尾，藝術能量，紅白藍。我覺得，無處不在，白空無人。

very good at operating cameras, but because of his eye, which easily discovers that which is beautiful. For a talent who can see and choose beautiful things, photography is nothing more than a device for capturing them alive. So by simply following in his wake, people can learn a splendid way of seeing and feeling the world. What joyous qualities he has.

On the other hand, the many sins and mistakes mankind has committed must be seen by Wong, more than by most, and his soul must be continually pained by these. In the background of his work, I sense a warning against this state of affairs. However, he never acts like a critic, offering harsh opinions or advice; instead he comes up with guidance toward a humanistic suggestion that perhaps we might consider a certain way of doing something, which I think is simply marvelous.

When encountering materials like cheap protective construction sheets, which precisely because of their commonplace qualities emphasize his creativity and modeling abilities, Stanley makes pieces that prove that if one simply has the will to make the world more abundant and rich, all sorts of possibilities arise. It seems that his work is thought to represent Hong Kong's identity, but I cannot help thinking that his red, blue and white work is an insignia identifying the universal reason hidden in the souls of all people around the world.

A creator is not someone who is skilled at modeling or expression, but someone who is blessed with the sort of nature and qualities that lead people around the world to recognize him as someone on whom they can safely rely in this world. Stanley Wong is just this type, a talent rarely encountered.

I would like to express my deepest respect, from the bottom of my heart, for the strength, kindness, and nourishment of his work and through it, the message he sends out to the world.

|

Stanley Wong 總是熱情和藹，慷慨大方，同時有着一位才華洋溢、無所不能的藝術家所擁有的特質，就是秉持為人服務的精神。他時常面帶微笑，眼鏡背後一雙深邃的眼睛，好像總是寬恕這世界的一切，但對自己卻似乎很嚴苛。有一次，在不知道他茹素的情況下，我竟然在一間沒素菜提供的餐廳招待他，着實尷尬，但我亦因而感受到他自律的本質。

Stanley 的攝影作品出色，但並非因為他善於操控相機，而是他的眼睛往往能夠發現美麗的事物。對於一名能夠看見和挑選美好事物的人才來說，攝影只是捕捉這些東西，令它們栩栩如生的工具。所以只要跟隨他，就可以學到用一種非凡的角度去觀察和感受這個世界。那是多麼令人喜悅的一種特質。

與此同時，Stanley 必定比大多數人見證過更多人類的罪過和錯誤，而且一直感到痛心。在他的作品背後，我察覺到他對此有

● Kenya Hara ― 原研哉

普遍的な理性の旗印

An insignia of universal reason ｜ 普遍理性主義的標誌

Designer, (b.1958) emphasizes the design of both objects and experiences. He produced the exhibition "RE-DESIGN-Daily Products of the 21st Century" in 2000, which successfully presented the fact that the resources of astonishing design are found in the context of the very ordinary and casual, and began acting as MUJI's art director two years later. Much of his work, including the program for the Opening and Closing Ceremonies of the Nagano Winter Olympic Games is deeply rooted in Japanese culture.

設計師，一九五八年出生，重視「物」和「事」的設計。二〇〇〇年策劃舉辦「RE-DESIGN──日常生活中的廿一世紀」展覽，提出日常生活千絲萬縷中，蘊含著驚人的設計資源。二〇〇二年成為無印良品顧問委員會成員，開始藝術指導工作，並從事許多扎根於日本文化的工作，包括設計長野冬奧開閉幕式節目紀念冊等。

スタンリー・ウォンは、いつも優しげで、才能を持て余し、何でもできてしまうアーティストに特有の、サービス精神にあふれた気前の良さを持っている。太いメガネの奥の目はいつも世界に赦しを与え続けるように微笑んでいるが、実は自分にはとても厳しい人ではないか。かつて僕は、スタンリー・ウォンが菜食主義であることを知らず、彼の食べられないものだらけを供するレストランで彼をもてなした苦い経験があるが、その時にそう感じたのである。

スタンリー・ウォンの撮る写真は素晴らしいが、これは写真機の操作に長けているのではなく、美しいものが簡単に発見できる目によるものである。美しいものを見立てることができる才能にとって写真は、それを生け捕りにするための装置に過ぎない。だから人々は、彼の後ろをついていくだけで、世界の素晴らしい見方や感じ方を学ぶことができる。何と幸福な資質であろうか。

一方で、人類がおかしてきた幾多の過ちも、スタンリー・ウォンには人一倍、よく見えているはずであり、それに心を痛め続けているはずである。彼の仕事の背景には、そういう状況への警告を感じる。しかしながらそれは、何かに苦言を呈するということではなく、こんな風なやり方はどうだろうかという、前向きでヒューマニスティックな提言に満ちているところが素晴らしい。

スタンリー・ウォンは、工事用のシートという、いかにもチープであるが、それゆえに彼の創造性や造形力を際立たせてくれる素材と出会い、世界を豊かにしようとする意志さえあれば、いかようにもそれが可能であるということを証明する作品を作り続けている。これは香港のアイデンティティを示す作品と思われているようだが、僕には彼の「赤・青・白」の仕事は、世界のあらゆる人々の心に秘められた「普遍的な理性」をアイデンティファイする旗印のように思われてならない。

クリエイターというのは、造形や表現が上手い人のことではない。世界はこの人に任せておけば安心であると、世界中の人々が思ってしまうような人にその資質がある。スタンリー・ウォンとはそのような類の、簡単には得難い才能である。

彼の作品と、そこから世界に向けて発信されてきたメッセージの強さ、優しさ、そして心地よさに、僕は心から敬意を表したい。

Stanley Wong is always warm, gentle and generous of spirit, brimming with a service ethos that is characteristic of an artist who has unimaginable talent and the ability to do anything. He smiles readily, as if always offering forgiveness to the world from his deep eyes behind thick glasses, but I wonder if he's actually hard on himself. Once, not knowing that he was a vegetarian, I had the bitter experience of taking him to a restaurant offering nothing but things he couldn't eat; this is when I sensed his disciplined nature.

Wong's photographs are terrific, but this is not because he's

所警惕。然而他從不批判，不說出苛刻的意見，而是從人性的角度，指引別人用不同方法處事，我認為這確實了不起。

紅白藍帆布為廉價物料，但正正因為它的普通，凸顯 Stanley 的創意和創造力，創作出《紅白藍》系列作品，足見只要有決心，總可以造出令世界更豐富，更多姿多彩的作品。有人認為他的創作代表香港，但我覺得《紅白藍》系列更像一個標誌，代表着世上所有人心底裡的普遍理性主義。

一個創作人並非單指擅長塑造或表達，而是有幸擁有某種特質和性格，令所有人都能夠安心信賴。Stanley Wong 正是這種人，難能可貴的人。

Stanley 的作品滿載力量，善意和養分，並能向世界傳達發聲，對此我由衷致敬。

anothermountainman. my brother.

I am lucky to have anothermountainman as a brother. He is also the godfather of my daughter. In the over 20 years of our friendship, we have always helped and supported each other.

Anothermountainman has always been my guidance and my buddy in both the design world and at the artistic level. We have a common belief. We hope that more people will have the opportunity to participate in self-cultivation and the artistic practice.

The Exception project gave us a chance to start working together. He incorporated many forward-looking concepts into building Exception's cultural and world view. From the relationship between man and nature, to "Different Worlds Under the Same Sky", to "Life is Beautiful", to "I Think, Therefore I Am", we infused the universal values of the world with oriental philosophy and the natural way of life, integrating the concepts of people, nature, and ecology into our design.

In "Different Worlds Under the Same Sky", the theme book of the brand, he combined a collection of photos of the sky and clouds that he took from different countries over the years into an Exception diary. Since then, our colleagues have developed the habit of observing nature and appreciating beautiful scenery.

When I was at the important turning point of my career and my view of the world, anothermountainman was always the first to stand and back me up. In the 2011 Fangsuo project, both of us realized that it was something very significant. It was a space for us to pay back to the society and to promote of Oriental philosophy. Without hesitation, I fully participated in the project, from concept development to overall design.

anothermountainman. same vision.

Due to our common and consistent goals, perhaps, anothermountainman and I worked even closer in the 10 years following the establishment of Fangsuo. Together accomplished a lot of incredible feats, including YMOYNOT, a brand that is a platform for the young Asian design power that was set up with the support and participation of Mr. Yohji Yamamoto. anothermountainman devoted himself in variius joint projects in cultivating new generations of designers, introducing them to the world.

I wish to have a dialogue with the world, to create an occasion to express the aesthetics of contemporary life. In my journey of endeavor, anothermountainman would always be by my side. We would be on the stage together, whether it was a press conference in Petit Palais, in Centre Pompidou, a co-exhibition

anothermountainman. the man.

A man who shares the same ideals and interests,
A Hong Konger who shares the same ideals and interests,
My earnest gratitude to Mr. Wang Xu for bringing us together.

I could already feel the talent of anothermountainman in our first project, through which we discovered we had a common way of communication.

I was first impressed by anothermountainman when I took him to visit the Yu Yam Ancestral Garden, a famous garden in Guangzhou, for the first time. He figured out the angle from which the sun would beam and stood there for over 20 minutes just to wait for the sunlight to come. It was midsummer, and anothermountainman's long-sleeved shirt was drenched with sweats. How determined and focused he can be for a good piece of work!

anothermountainman is very demanding and serious about himself and his work. No matter how late he worked till the night before, under whatever circumstances, he would always arrive and start according to schedule. He is one of the few artists in Hong Kong who puts artistic pursuit before commercial success.

anothermountainman. the gentleman.

Meeting him, working with him, understanding him.
It is my honor to have known him.

As the name "anothermountainman" suggested, he has the true nature of a gentleman. His character is like the artistic idea of the famous painter in the Ming Dynasty, Zhu Da (朱耷), also named Bada Shanren (the mountain man of the eight greats) (hence the name anothermountainman).

His attitude towards his seniors and the younger generations is always peaceful, modest, supportive, selfless, never holding back. He helps people from all walks of life. He volunteers in different sectors of the community.

The longer I collaborated with him, the more I realized his self-demanding and self-discipline. His seriousness and discipline, the enthusiasm under his coolness, touches everyone. His self-restraint and respect for civility makes him a kind man. His virtuous character created a rapport and understanding in me.

To me, for a person to be respectable and appreciated, his morality and character is always more important than talents and ability.

Practicing together, experiencing together, regardless of the results, builds a man and nurtures people.

● Mao jihong | 毛繼鴻

Founder & President of EXCEPTION de MIXMIND, Fang Suo Commune, YMOYNOT and The Mix-Place, as well as the Founder & President of Maojihong Arts Foundation, Vice President of China National Garment Association, Dean of China Fashion Research Institut etc. Mao holds the international membership of French Pompidou Art Center "Pompidou of the friends", and had been the judge of 2017 Prix Marcel Duchamp.

EXCEPTION de MIXMIND 例外、方所、YMOYNOT、衡山和集等品牌創始人、毛繼鴻藝術基金會創始人及主席、中國服裝協會副會長、中國時尚研究院執行院長等。現為法國蓬皮杜現代藝術中心「國際蓬皮杜之友協會」會員，曾於二○一七年擔任法國「杜尚獎」評委。

其人 其君 吾兄 同道

the man. the gentleman. my brother. same vision.

山人吾兄：

幸與山人為兄弟，也是我女兒的乾爸，二十餘載的情誼，從沒有過半點推託。

在設計界，在藝術層，山人都是我的引路人與同道人。我們有共同的信仰，希望讓更多人有機會去參與人的修養與美育的實踐。

從例外開始我們有緣共事，他將很多非常先進的觀念融入到例外的文化建設及世界觀的建立，我們從自然與人之間的態度，到「同一天空下不同的世界」，到「生命是美麗的，活在當下」，到「我思故我在」，將世界的普世價值與東方哲學、師法自然的生活方式結合在一起。

將人與自然、與生態的觀念融入我們的設計中。在「同一天空下不同的世界」的品牌主題冊中，將他歷年積累下來關於不同國家的天空和雲朵的照片，結合為例外的一本日記本，從此讓我們所有的同事開始養成了去觀察自然、留心美景的習慣。

當我處於事業與世界觀轉折的關鍵時期，山人總是第一個站出來支持我。2011 年做方所，我們都意識到這是一個非常重要的事，還我們回報社會，傳播東方哲學的共修之所，他義無反顧全力參與整個過程，從理念創立到整體的設計。

山人同道：

可能是我們倆願力一致，在成立方所後來 10 年的時間裡，更加密切地共創很多大家都認為不可思議的事情，包括 2012 年一起建立，山本耀司先生支持並參與的一個為亞洲年輕設計力量提供平台品牌 YMOYNOT。山人全心投入參與合作專案，培養新生代設計師，嶄露頭角於世界。

我希望與世界對話，去創造一個表達當代生活美學的場合，山人總會在我身邊，我們一起同台，不管是在法國巴黎小皇宮裡的發佈會，還是在蓬皮杜藝術中心，以及英國 V&A 美術館裡的展覽合作，中國駐英國大使館裡的時裝發佈…我們希望作為一個「當代生活美學」的倡議者和推動者。

與其道合，在創作之餘，我們常常探討佛教裡的大乘問題，希望讓更多人得道受益。

我們有着共同的志向，就是希望通過我們對當代生活美學的表達，能讓國人的素養得到提升，直至我們可以同道，可以彼此分享生命的美麗。

in the V&A Museum London, or a fashion release in the Chinese Embassy in Britain. All in all, we hope to be the advocates and promoters of "Contemporary Living".

Throughout our times of working together, we always shared our common views on life and explored the Mahayana issue in Buddhism together. We hope that more people will understand and appreciate the benefits of the theories.

We share a common ambition - to improve the quality and level of self-cultivation of the Chinese people through our expression of contemporary life aesthetics. We will strive towards the goals until we can all possess common views and share the beauty of life with each other.

山人其人：

一個志同道合的人，

一個志同道合的香港人，

非常感謝王序先生讓我們相識，

第一次合作，便可以感受到又一山人的才華，我們很快就找到了靈犀一點通的溝通方式。

記得山人第一個讓我感動的事情，帶山人第一次去廣州名園「餘蔭山房」，他忽然看到陽光下的角度，為了等待光線，足足站了二十多分鐘，當時正值炎夏，山人的長袖衫已經被汗濕透，為了一個好的作品，可以如此專注。

又一山人對自己的嚴格要求，其嚴謹態度，作為一個創作人，不管在甚麼樣的條件下，前一天不論加班到凌晨幾點，第二天一定按照團隊要求準時到達，準時開工。

他是香港人中少有對藝術的追求高於對商業的追求的人。

山人其君：

從相識、相處到相知。

與君相識，是我一生的幸事。

其君，君子，如其名號「又一山人」，其品德有如所呼應的明代畫家「八大山人」朱耷的藝術主張。

對前輩、晚輩的態度平和，謙遜，全力幫助，無我，忘我的指教，幫助各界的人，在不同階層做義工。

與他合作越久，就更認識到他的嚴格克己！那種克己與嚴謹讓人非常感動，冷靜中的熱情。克己復禮，以為仁。

因有其君之品德，才有吾之共識與共知。

一個值得尊重珍惜的人，於我而言，其為人與品德比才華能力更為重要。

共修，共渡，不計較個人得失，成己樹人。

planning the "treasures" of "life", I invited 100 Chinese contemporary creators to talk about their most cherished objects and the objects that influenced their lives. While most people cherished trivial items, only anothermountainman gave the answer of "trash that I can find from anywhere".

"The way you treat an object is the way of how you treat the world. So please talk to yourself from the perspectives of how to see the trash and any other items around you." anothermountainman seems to be thinking from the opposite direction, which is itself a study of equality, just like how he treats "Red, White and Blue". What made us think was behind these abandoned objects was the condensation of multiple historical and cultural values, social forms, and views on beauty through a wide range of perspectives. After re-creation, the beauty is magnified by art form to enhance the artistic interpretation of the works. It is anothermountainman's sense of existence.

Mutual practice is the idea put forward by anothermountainman during his time as the artistic director of Fangsuo. He collected the bowls from all colleagues and customers of the Fangsuo and asked them to plant their chosen plants in those bowls. anothermountainman later made sculptures for each of those bowls. As a result, each bowl was given a new life as an outcome of mutual practice. Being subtle and modest is the secret in spiritual practice. Real artists know how to become an expert in the subtle spiritual practice. Although not saying much about their fields of spiritual practice, they know exactly what they are doing. anothermountainman obviously places more emphasis attention to internal rather than an external spiritual practice.

In his book "The Infinity of Lists", Umberto Eco gave us some references for life practice. Eco, also known as "Contemporary Da Vinci", published more than 140 books in his life. With rich knowledge that spanned multiple fields, he listed all things based on his judgment that "lists are the root of culture". Starting from the gesture and meaning of the "bada shanren", anothermountainman climbed through mountains in his exploratory journey and overcame challenges in his creative career. As he said, "Life is a journey of constant choices. Like a circle, there is neither a clear starting point nor an absolute end."

Just like 84,000 miles is a long way to go, spiritual practice is an awe of infinity. After forty years, we can see that the journey of anothermountainman's unlimited creation is still a continuing process. This infinity is not only applicable in anticipating the "future", but also for describing the "past".

● Rocky Liang ｜令狐磊

又一山人又一山

anothermountainman see another mountain

As the director of Cultural Power Institute, Rocky Liang is the producer of Cultural Power Review. He was the creative director of New Weekly and the Modern Media Group, as well as the co-founder of Life Magazine. Now Rocky is the Creative Director of shanghai culture and fashion collection boutique Mix-Place and the future cultural hub Shanghai Fangsuo Pudong.

方所文化力研究所所長，《文化力評論》總監製，曾任《新周刊》及現代傳播創意總監，參與創辦《生活月刊》。現為上海精選時尚文化集合店「衡山·和集」及上海浦東方所項目創意總監。

A man with two names (Stanley Wong, anothermountain-man), three identities (design artist, social worker, educator), four fashion dreams (Exception De Mixmind, YMOYNOT, Wang Wen-hsing Series, YNOT/T), and five visual domains (design, photography, art installation, video, calligraphy). Ten years ago, he planned and curated the exhibition of What's Next 30 X 30 at the OCT Art and Design Gallery. At the ggg studio in Ginza, Tokyo, he used the name of "2 Men Show" and printed "Three-woone Film Production and 84000 Communications" on his name cards. The name 84000, which represented "tonnes of worries", originated from the Buddhist World.

For anothermountainman, 'numbers' has always been a fascinating element for thoughts. In the forty years of his creative journey, anothermountainman has put them into a semi-autobiography entitled "囉囉唆唆 (meaning "chattering and rattling"). To me, it was a kind of "84000" that was complicated and difficult to define through a simple and typological way.

As far as the outside world is concerned, the way to define the identity of "anothermountainman" is very complicated. He himself has summarized his identity as a visual communicator, a photographer, a creator, and a social worker. Because of his frequent new works that always stunned everybody, he was my favorite interview guest when I was working as a magazine reporter. After joining Fangsuo, I discovered that he was actually an amiable and respectable mentor.

Among the artists and designers who were born and raised in Hong Kong, the existence of anothermountainman was "natural and complete" for he is naturally awake yet completely alone. He said, "I see, so I believe. I believe, so I see." As a designer who shows the attributes of a philosopher, he trusts and abides by his beliefs while following the mindful Zen thoughts of Zen Master Thich Nhat Hanh and Master Sheng Yan.

Time is the design direction of anothermountainman. His clock always jumps between in NOW HERE and NOWHERE as he writes about the future and the past. In my transition stage from the magazine industry to the cultural space, he gave me a YMOY-NOT shirt that he designed. On the front, there was NOW HERE, and NOWHERE was printed at the back. Seize the present moment, for the future is full of uncertainties. Meanwhile, I also like another shirt named "existence / nihility". It accompanied me to various cultural lectures and activities and seemed to always release energy in silence. In fact, the works of anothermountainman represents the confrontation of ideas.

"Love, You Should Love" was a consistent implementation of anothermountainman's concept of all things. When I was

140 多部著作，學識橫跨多個領域，他為萬物開列清單，是基於「清單是文化的根源」的判斷。從「八大山人」的形與義出發，「又一山人」為號的創作者在其探索的一座又一座的山中不停的翻越，翻過一山又一山，就好像他所言：「生活就是一個不斷選擇的旅程，就像是一個圓圈，沒有清楚的起點，也沒有絕對的終點。」

　　八萬四千何其遠，修行是對無限感的敬畏，四十年後，我們可以看到又一山人的無限創作旅程仍在延續，這個無限既是「未來」的無限，也是對「過去」的無限。

　　一個人，兩個名字（黃炳培、又一山人），三重身份（設計藝術家、社會工作者、教育工作者），四個服裝夢（例外、YMOYNOT、王文興系列、練功 Tee），五種視覺領域（設計、攝影、藝術裝置、影像、書法），十年前策劃華·美術館展覽的三十乘三十藝術聯展，在東京銀座的 ggg 畫廊，他以「2 Men Show」為名，他的名片上印：三二一聲畫製作和 84000 communications，而八萬四千是源自佛界中的「煩惱極多」。

　　數字，似乎始終是又一山人始終着迷的思考元素。四十年的創作心路歷程，又一山人把它們放置於一本半自傳之中，名叫《囉囉唆唆》，我感覺是其繁複、難以用簡單、類型學的方式來定義的一種「八萬四千」。

　　於外界而言，怎麼定義「又一山人」的身份，就很複雜，他自己歸納過是：視覺溝通人、攝影師、自由創作人、社會工作者；於我而言，因為之前做雜誌的時候，他是我最心儀的總有令人驚嘆的新作的報導對象，在加入方所工作之後，他又是可親的同人、可敬的導師。

　　在香港生長的藝術家／設計師中，又一山人是「自然，全然」的存在，自然清醒，又全然獨自一人，他說「我看見，所以我相信。我相信，所以我看見。」哲學家型的設計師，他信守內心，跟隨一行禪師及聖嚴法師的正念禪思。

　　時間，是又一山人的設計流向。他的時鐘，永遠在 NOW HERE 與 NOWHERE 中跳轉，他寫未來與過去，在我從雜誌業來到文化空間的轉換階段，他給我一件他設計的 YMOYNOT 恤衫，前面是 NOW HERE，後面是 NOWHERE，現在此時，往後無定。

　　而我亦喜歡另一件恤衫「無／有」，它伴隨着我出席各類的文化講座活動，似總在無聲中釋放能量。又一山人的作品，是觀念的交鋒。

　　愛，你應愛，是又一山人貫徹於他對萬物的觀念。我在做《生活》的「珍物」策劃時，邀請 100 位華人當代創作人來談他最珍視的物件，影響他一生的物件是甚麼。大部分人都是惜珍細品，只有又一山人交來的答案是：隨手撿來的垃圾。

　　「你如何看待一個物品，你就如何看待這個世界。所以請用看待垃圾的角度，物品的角度與自己對話。」又一山人似是逆思，更是一個平等觀念的研習，就如同他看待「紅白藍」那樣。引發我們思考的是，在這些棄物背後，凝結多重歷史文化價值、社會形態，多種遼闊視角下對待美的觀點，而經過再創造，用藝術形式將其放大，增進對作品藝術性的解讀，是又一山人對存在的體味。

　　共修，是又一山人擔任方所藝術總監期間，提出的理念。他向方所所有同仁和顧客徵集家中的碗，種上各自選的植物，又一山人為這些碗一一造像。一個碗，也得到了宛若得到新生的共修。修行的門道在於隱，真正的藝術家懂得如何成為隱修行的專家，不事張揚，卻對自己修行的領域瞭如指掌。又一山人顯然更看重內修而非外修。

　　作家翁貝托·艾柯在寫下其《無限的清單》時，我們可以看作是人生修行的參照物。被譽為「當代達·芬奇」的艾柯，出版過

● Venerable Chang Zhan ｜ 常展法師

A disciple of Master Sheng Yen, the founder of Dharma Drum Mountain. He obtained his Master of Arts degree from the University of the Arts London and graduated from the department of Chan, Dharma Drum at Sangha University. He is currently the Director of the Dharma Drum Mountain Hong Kong Centre.

"Mountain Man" or Stanley – I prefer calling him Mountain Man for its ethereal feel but I don't think I know for sure what kind of a person he really is. I remember him not just because he is well-known, but also because of the vivid sense of determination and modesty in his works.

Humans have never stopped exploring. We are never satisfied with the world we see. We want to seek out a deeper or more precise truth. We do not know whether this truth exists, but it is almost certain that without exploring, we will never find out what life really means.

Artists and designers should have their own unique way of exploration. Their body and heart act as the tool, the medium of exploration. The first step in exploration and creation is to sharpen this tool or to familiarize oneself with this tool. By sharpening our senses, we become conscious of our awareness, and so break through the barriers and falsities of the physical world... as Mountain Man has said many times, "see with your heart", "put it in your heart", "listen to your heart", "set off from your heart"... this is easy to say, but when you are on this exploration, it is a long and lonely journey.

So, what lies at the end of the long journey of life? What a bore it would be if we already knew in advance. Life is full of limitless possibilities – no two persons look alike, no two lives are exactly the same. We are influenced by the past and we create the future with our mindfulness of the present.

If there is an end to life, don't we only know when we get there?

法鼓山創辦人聖嚴法師弟子，英國倫敦藝術大學藝術碩士，法鼓山僧伽大學禪學系畢業，現任法鼓山香港道場監院。

「山人」或者 Stanley，我較喜歡稱呼他做山人，有一種出脫的意味，但他是怎麼樣的一個人，我無從確定，今天我能夠記住這個人，除了他是名人，就是因為他作品裡有一股鮮明的倔強和質樸。

人類長久以來都沒有停止過探索，我們總不滿足於表象的世界，需要探索一個更深入或更精準的真實；儘管我們不能確定有沒有這個真實，但幾乎可以肯定的是，不去探索，我們就沒法確定生命是怎樣的一回事。

藝術家或者設計師應該有自己獨特的探索方式，他們的身心本身就是個工具和媒介，探索和創作首先就需要磨利這個工具或者熟悉這個媒介；由磨利我們的感官，繼而熟悉我們能夠覺知的心如何運作，進而打破身心世界的藩籬和虛妄⋯正如山人多番提到的「用心看」、「放在心裡」、「聽自己的心」、「從心出發」⋯這是說起來簡單，實行起來卻是一場孤獨的長征。

那麼，生命長征的盡頭會是甚麼？哈哈哈！如果一早就知道了，那會是多麼的無趣。生命是無限的可能性，沒有人跟另一人長得一模一樣，沒有兩段的人生是相同的；我們受過去的影響，也依靠現在的心念創造未來。

生命的盡頭，假如有的話，不是要到了才知道嗎？

Role reversal. The artist informing the art director.

That defines the inspiration behind the continuing story of the commercial Stanley Wong.

Designer, art director, creative director, film director.

From a short film for Sun Life Financial insurance, which was inspired by his 'Painting By God' series, to in-store branding design work for clients like Café de Coral, Stanley's continuing story as a brand consultant reveals a more mature, less naïve aspect to his ideas and expression of them.

Can the two personas coexist? Sure. But only when the barriers and restrictions are removed. When the expectations are less preconceived.

Still the passion is there. Unlike the contemporary world of creative advertising, it's not about the money.

He selects his projects with great care. Never the bland. Never the ordinary. The artist must be given room to express as well.

|

商業設計與藝術創作是否必然對立？

黃炳培與又一山人重新界定商業藝術。

近年黃炳培不單單是設計師，更是藝術指導、創作總監和導演。

為永明金融執導的短片啟發自「神畫」，以至大家樂的品牌定位及設計，黃炳培為企業擔任的不僅是設計和創作，更是建基於生活和社會價值的品牌形象。

黃炳培打破兩者之間的隔閡，將藝術創作融入於商業世界之中。

多年來對藝術的追求從未減退，身處商業世界卻不只談利益。

黃炳培挑選有價值的項目和工作，不隨波逐流，堅持對普世價值與藝術創作空間。

● Chris Kyme｜關思維

Chris has worked in advertising in Asia for over 30 years as a Creative Director with global agencies such as Leo Burnett, Grey and FCB, creating some of Hong Kong's best loved work in the 1990s. He has been Chairman of the Hong Kong 4As Kam Fan awards several times, and is the author of a book on Hong Kong creative advertising called "Made in Hong Kong".

關思維於廣告業界打滾逾三十年，曾在亞洲出任多間跨國廣告公司創作總監，如 Leo Burnett, Grey 及 FCB。不少九十年代為人熟悉的作品都出自其手筆。曾多次擔任 4As 金帆廣告大獎主席，並就香港創意廣告出版《Made in Hong Kong》一書。

XXI

又一山士丹利。混合體

anothermountainstanley. the hybrid.

amm × sw

anothermountainman × stanley wong

2000 > present

amm × sw—01

archive no.

exception de mixmind | 例外

cl. | mixmind art & design co., ltd.
c.c. | exception marketing & design team \ anothermountainman [photography] \ 84000 communications ltd.
col. | hong kong heritage museum

● brand consultancy \ graphic design \ interior | ● 2010 → present

aw. | 2002 hkda design show \ photography \ silver
2006 the most beautiful book in china
2009 perspective award \ retail design \ gold
2012 design for asia hkdc awards \ publications \ bronze

thank you wang xu for inviting me, in 2000, to be the photographer for a project of his client "exception", a china-based fashion brand.

from that day on, i walked a new and important path in my creative career. on the way, i witnessed the co-existence of the economic boom and cultural living in china.

on the way, i saw the example of hong kong – how, after the rise to the status of an international city, the cultural and human values of hong kong have been compromised – being repeated in china the chase for hedonistic lifestyle and westernised trends. hopefully, through the strong oriental aesthetics in this brand, the values of cultural

and societal values are exemplified: life is beautiful, live now...

on the way, i also assisted ma ke in planning her first show in paris, a dramatic exchange between the east and the west.

walking on the road of "exception" for 20 years, i never thought that one day, i would be able to bring the philosophy and values of life of a branded product in china to a property project (upper hills \ amm×sw-05) and even back to hong kong and have it materialised in the iic (amm×sw-08) and café de coral project (amm×sw-09).

on the way, i saw my tenacity in having humanity, simplicity, society as the starting point.

感謝王序大哥在二千年邀請我為他的中國國內品牌客戶「例外服裝」的一個項目出任攝影師。從那一天起，帶我進入創意生涯的另一條重要道路。

路途上，見証了中國經濟起飛和文化生活之間的共存。

路途上，我將眼見經歷過香港成為國際都會之後，文化、人文價值被「平衡」下去這實例，套在中國正在發展的物質和西方潮流市場中，希望藉着這富東方美學內涵的品牌，發聲放大人文及社會價值：life is beautiful，同一天空下，活在當下…

路途上，也協助設計師馬可，共同策劃其「無用」系列第一次巴黎發佈觀摩，一次具戲劇性東方跟西方的交流體驗。

近二十年的「例外」之路，也想不到有一天，將在中國市場實踐過的生活哲學價值觀，帶回文化品牌以外的地產項目（深業上城／amm×sw-05）以至帶回香港市場，極其幸運和難得，落實如 ific（amm×sw-08）和大家樂（amm×sw-09）項目中間。

路途上，看見自己對人文、質樸、社會出發的堅持和堅定。

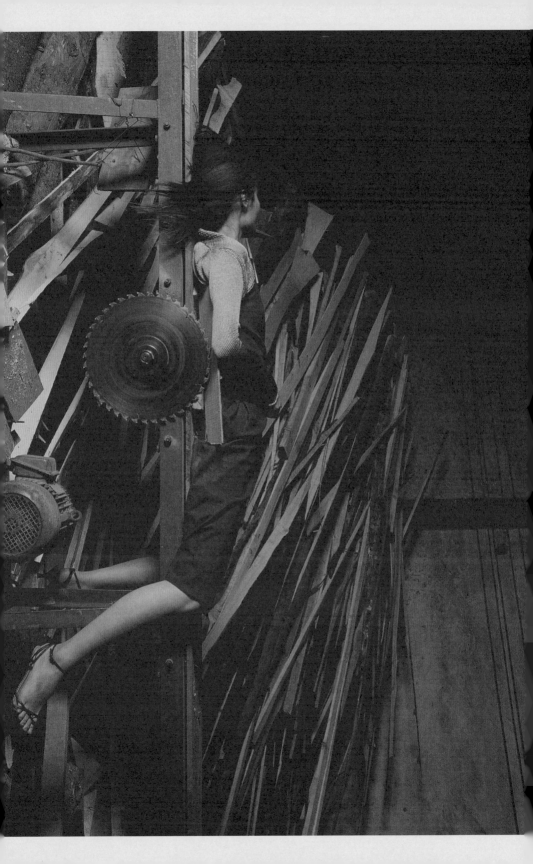

MA KE POINT ONE VOLUME ONE

MAP BOOK PUBLISHERS

MA KE POINT ONE VOLUME TWO

MAP BOOK PUBLISHERS

新生十二

例外十二周年慶太原店舉辦

一 階物前通立包廂的大廳

舖展延月色的翻滾思量的四季

張弛在嘴旁文化，其學舖致生活

有酒有肉有毛之靈柏

也該蕉一段像下千千亦樽才

電視搭亦子羅沢拉搭主

滿東石全七圭素駋駋許

亟于滿落滿渟澟

游，只魚—保說魅

十一月二十六日
三十六石七三峰
北京市重武區賀江界大九號地塵
四方春盘正二樓例外生活舘

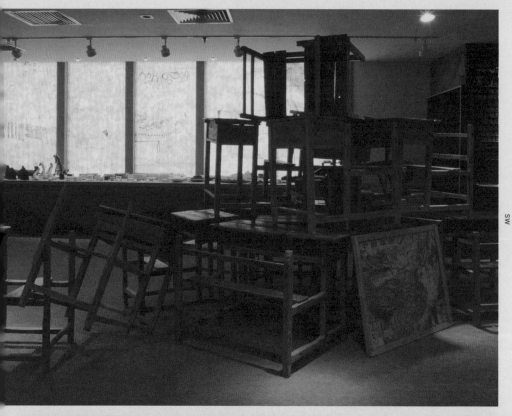

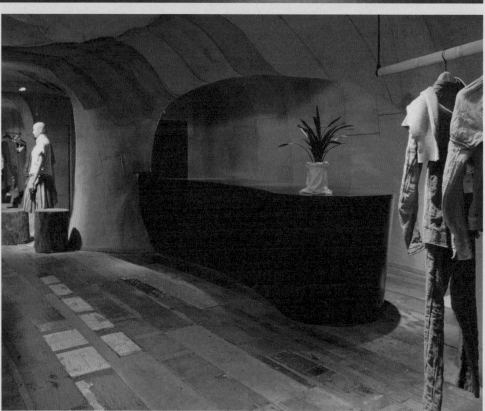

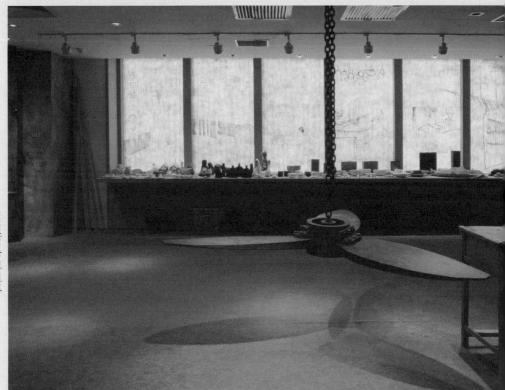

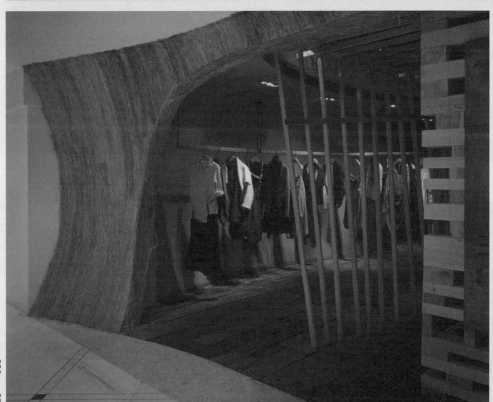

amm × sw-02

archive no.

sw

EXCEPTIONISM × MIX × 出叉思
de MIXMIND

amm

● branding and graphic design \ clothing design \ exhibition design | ● 2012

▲ video

aw. | 2013 hkda global design awards \ fashion \ bronze \ hk best ·
spatial \ silver \ hk best

exception de mixmind × wang wen-hsing × anothermountainman

it is not fashion & trend. the collection is based on the handwriting of a literature writer wang wen-hsing from taiwan who is a very alternative & unique person, committed his whole life on recreating chinese writing in his own style.

he wrote his second fiction *backed against the sea* in 25 years, finish 35 words a day on average... his passion & dedication philosophy is the story & message behind the collection.

這並非時裝或潮流。別樹一格的台灣著名小說家王文興貢獻一生,以獨樹一幟的寫作手法,重現中國文字的魅力,這系列正是以其手稿為基礎。

王文興撰寫第二部小說《背海的人》期間,平均每天寫三十五字,共花二十五年時間完成,當中所展現的熱情和奉獻,為這系列背後的故事和想傳達的訊息。

amm × sw—03

archive no.

TONY YNOT'T

● clothing design \ branding design | ● 2017

mountainman objective

this is not something to attract attention
it is not something to make me look
smarter, more handsome
it is not a slogan tee i use to make a
statement
it serves as a reminder
it is something for me to learn, to
practice

put on YNOT\T
stand in this unpredictable distorted
world
then whisper to your inner self
this is me
survive + live + life
experience all in one goal
why not

十二件練功 T
山人：物：語

這不是一件穿給人家看的衣服
這不是一件令自己更帥更美的衣服
這不是一件表態的 slogan tee
這是一件給自己提示的衣服
這是一件給自己練功和修行的衣服

穿上 YNOT\T
站在這不斷變幻傾側的世界國度
向心裡的自己交代一句
這是我
生存＋生活＋生命
三生一世
why not

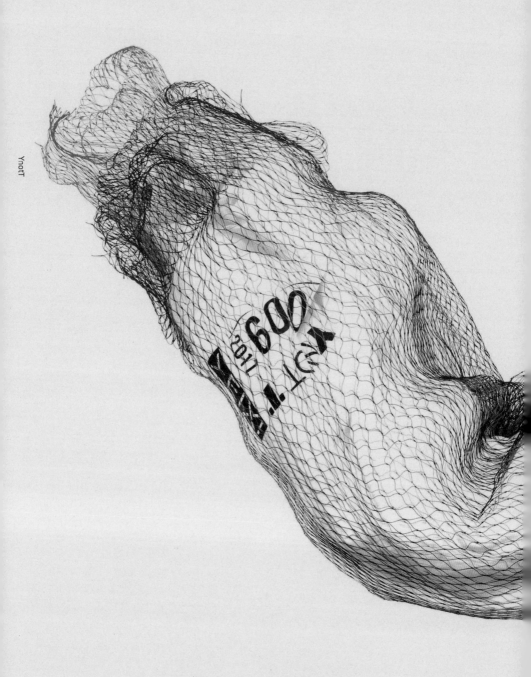

past／future

i am intimately wrapped
between two pieces of fabric
one in front
and one at the back
future in front
past at the back
even if they are hanging only 0.1mm
from my body
they are still away
from me
my mind

live now
explicitly now
focus myself at now
now is this very moment
my thoughts
my muse

put on the
past and future
live now

過去／未來

當兩幅前後布料緊裹我底身軀
前面是將來　後面是過去
只要離開我的身體　我的腦袋
哪管只是零點一毫米的距離

活在當下　清楚當下
將自己凝聚在當下
現在就是這剎那　我的思緒　我的靈感

穿着過去未來　活在當下

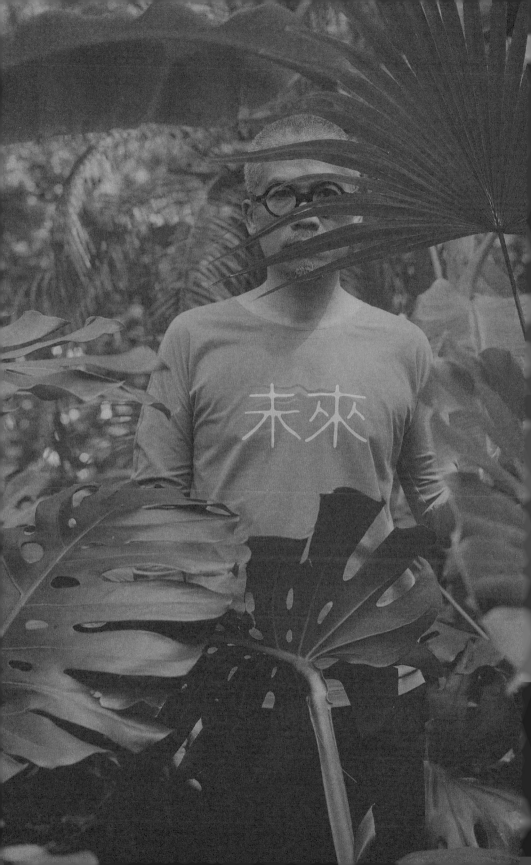

bold and rigorous — 膽大心細

daring but reckless — 膽大心大
ambition could be buried — 可致大志觸礁

timid yet ambitious — 膽細心大
maybe day dreaming forever — 可能一世白日夢者

timid and cautious — 膽細心細
wish you good luck in life — 可說句：人生一場造化

think bold — 大膽假設
verify rigorous — 小心求證
make possibility possible — 可能皆可行
why not

cause and effect \ karma — 前因後果

during lifetime — 人生中
starts from somewhere — 凡事沒有清楚的起點
may ends in elsewhere — 亦沒有絕對的終結

the current effect — 此一個終結：果
may become — 是下一個起點：因
the next cause — 有因有果再成因

with the cause
with the effect
the cycling starts — 沒果沒因怎結果
all over again

without the cause
without the effect
when will the loop
come to its next

existence \ nihility
gaining fame
gaining fortune

richness in material
never goes in the spiritual world

seeking from nothing to everything
no matter what
to create out of thin air

huineng
the six patriarch of buddhism once said:
originally there is not a single thing
where could any dust be attracted?

approaching 'let go' and 'nothingness'
then getting close to existence

有／無
有名是有
有利是有

身外物的有
不及心中富有

追求從無變有
是非虛幻
從而無中生有

六祖説：
本來無一物
何處惹塵埃
往無出發
有即近矣

NOWHERE \ NOW HERE

dead end?
put these all behind
who will care about
going nowhere

journey of thousand miles
starts from the first step
be fast be slow
be flat be rugged

only knowing
roads lie ahead
at this time
this very moment
now here

life
it is up to you

only do what my heart tells me
(lady diana)

starting from brain
normally
would be sensible
keep asking and expecting

starting from heart
definitely
would be no regret
no worry and
no pity

not gaining does not mean losing
encountering is priceless

沒路？
放在背後頭
就管不了甚麼是
行人止步

千里之行就在足下
是快是慢
是平坦是顛簸

只知道路
就在前方
這時這刻這裡

人生
視乎我怎樣看

從腦袋出發
一般是
有意有識 有望有求

從心出發
無疑是
無悔無慮無憾

有得不是有失
有緣便是無價

amm × sw–04

archive no.

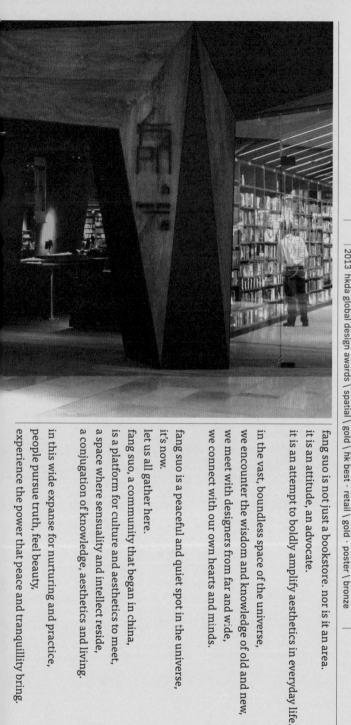

fang suo commune | 定是常住 · 便成方所

● co-founder \ space design \ brand consultancy \ exhibition curation | ● 2011 → present

cl. fang suo commune
c.c. mao jihong [ffounder \ co-space design]
\ liao meili [co-founder \ project
planning] \ alan lam [lighting design] \
anothermountainman [photography] \
fang suo marketing and design team \
84000 communications ltd.

aw. 2012 china modern media \ city magazine \ creative lifestyle award \ best design of the year
2012 perspective award \ gold
2012 world retail awards (london) \ store design of the year
2013 hkda global design awards \ spatial \ gold \ hk best · retail \ gold · poster \ bronze

fang suo is not just a bookstore, nor is it an area.
it is an attitude, an advocate.
it is an attempt to boldly amplify aesthetics in everyday life.

in the vast, boundless space of the universe,
we encounter the wisdom and knowledge of old and new,
we meet with designers from far and wide,
we connect with our own hearts and minds.

fang suo is a peaceful and quiet spot in the universe,
it's now.
let us all gather here.

fang suo, a community that began in china,
is a platform for culture and aesthetics to meet,
a space where sensuality and intellect reside,
a conjugation of knowledge, aesthetics and living.

in this wide expanse for nurturing and practice,
people pursue truth, feel beauty,
experience the power that peace and tranquillity bring.

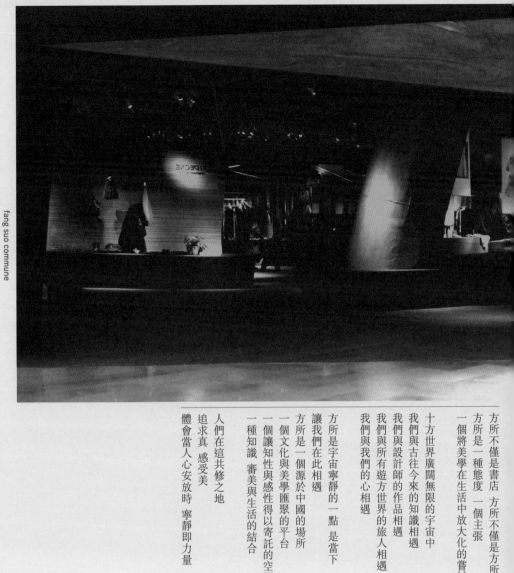

方所不僅是書店 方所不僅是方所

方所是一種態度 一個主張

一個將美學在生活中放大化的嘗試

十方世界廣闊無限的宇宙中

我們與古往今來的知識相遇

我們與設計師的作品相遇

我們與所有遊方世界的旅人相遇

我們與我們的心相遇

方所是宇宙寧靜的一點 是當下

讓我們在此相遇

方所是一個源於中國的場所

一個文化與美學匯聚的平台

一個讓知性與感性得以寄託的空間

一種知識 審美與生活的結合

人們在這共修之地

追求真 感受美

體會當人心安放時 寧靜即力量

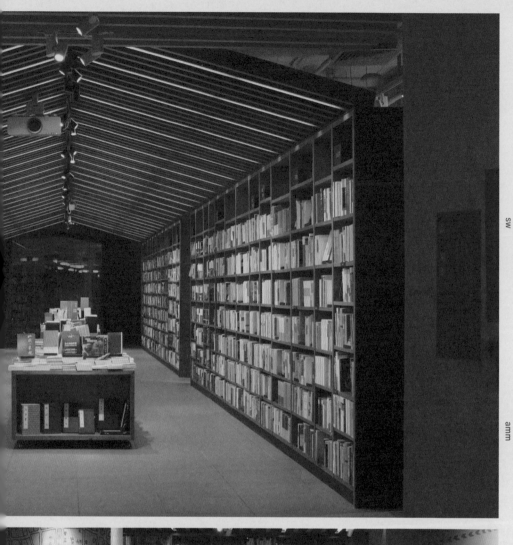

a bowl of life

to have a bowl of rice, life is nurtured.
to take a bowl of tea, body and soul are enlivened.

to inside from outside
from inside to outside
back and forth
give and take

those inside a bowl,
can be consumed
can nurture a life

three people from a family
three generations a family as well
heaven, earth and human a family ultimately
all is a true family

吃一碗飯 生命得以延續
喫一碗茶 身心靈為之飛揚

往內 從外
從內 往外
有來 有往
有受 有施

碗裡頭的
可往肚裡吃
可以栽出生命

一家三口是家
三代同堂是家
大地眾生萬物正是家
大家都是真的家

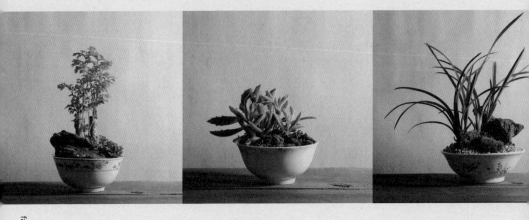

amm × sw–05

upper living │ 尚上生活

● brand consultancy \ brand communication │ ● 2013

▲ e-mag

cl. │ shum yip land company limited
c.c. │ norman chan \ emily mok [space design] \
henry chu [website design] \ rcky liang
[editorial writing] \ peter kok [project
planning] \ centro digital pictures ltd. [film
production] \ 84000 communications ltd.

unlike the general brand positioning
of property projects which market lux-
urious, materialistic and westernised
lifestyles, the positioning of upperhills
inspires consumers with the pursuit
of spiritual and emotional values.

upperhills is a community in shen-
zhen which includes residential, retail,
commercial offices, hotels and cultur-
al programmes. it is a world class town
planning and architectural project.
we worked closely with our clients,
searching for a new approach, away
from the norm of traditional property
projects, based on the spiritual and
intrinsic values of man. we believe this
is an important concept that inspires
our life and where the turning point of
china, and even the world is.

深業上城的品牌定位與追求西方及奢華、物質生活趨向的一般地產項目投資者不同，是以一個情感與精神價值的追求去啟導中國消費者。

深業上城是一個位於中國深圳的全面生活體驗，包含住宅、零售、商業、酒店與文化項目。有着世界級的城市規劃與建築設計，我們與顧客緊密合作，自尋常地產項目之品牌建設方向（西方生活方式、物質享受）另闢蹊徑，打破傳統，追求人文的精神及內在價值。我們認為這是啟發當下城市人生活重要的靈感，是現在中國，甚至全世界的轉捩點所在。

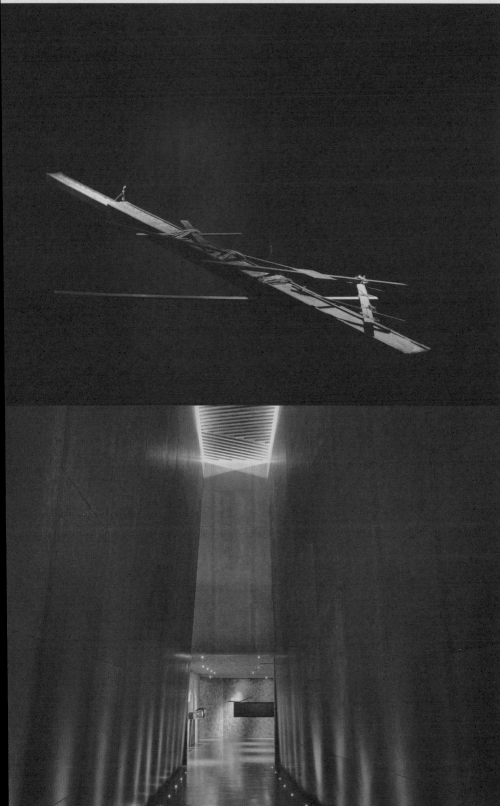

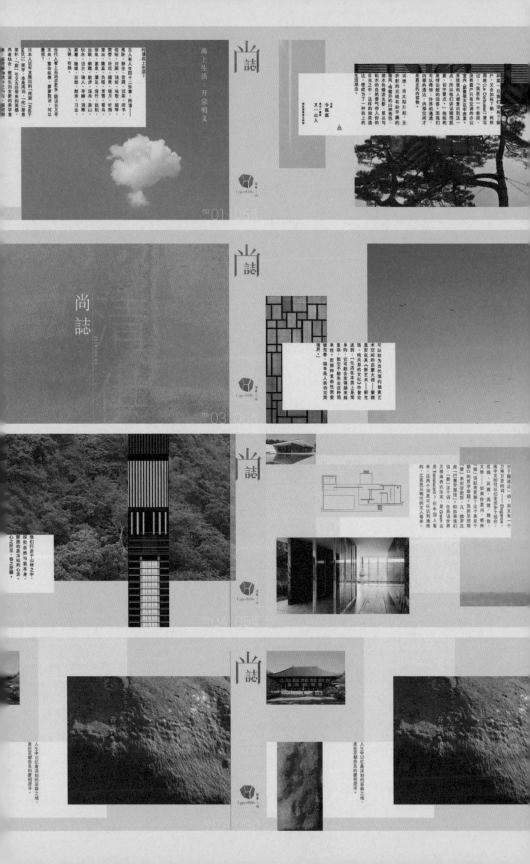

being hong kong | 就係香港。實現可以實現的。

amm

● co-founder \ creative director | ● 2018 →present ▲ video

ammxsw–06

cl. being media
c.c. lung king-cheong [co-founder \ publisher] \
jessica wong [co-founder \ editor in chief] \
being hong kong editorial and design team

a note on first issue 2018.07

when, why, what did you and i do together?

in 2003, i first collaborated with yesi. he wrote the redwhiteblue poem for my redwhiteblue show flat installation and they were on show side by side.

in 2005, he came to the opening of the venice biennale show of the two representatives from hong kong. kurt chan and i, there, before an international audience, he recited his poem of hong kong.

both of the above exhibitions were curated by sabrina fung and through her, yesi and i became acquainted.

in 2012, my good friend paulo pong, a wine connoisseur, asked me to design some wine bottles labels for him. an idea came to me – isn't wine tasting the best mood for poetry too? rather than just gazing at the beautifully designed wine bottle, why don't we "liberate" a poem instead. wine and poetry–a rare moment in life. immediately coming to mind was my friend yesi – a poet who likes food and wine. i met him, took two minutes to explain the concept and he said, "let me go back and find two wine-related poems for you." later, he emailed two poems to me, wine tasting and tasting new wine with mio. reading the poems, i kept on trying, i kept on working. when it was completed, yesi also completed his journey in life. i wrote in my artist statement, "dear brother, this is my ultimate tribute to you. inside the bottle, a white and a red. outside the bottle, a black and a white. life is never certain. a toast to you in heaven."

the two bottles of wine were there in his retrospective exhibition, *leung ping kwan, a retrospective*, my lanwei dunhuang photographs also sat next to his poem, *abandoned houses in dunhuang* in the exhibition.

with life, you never know. due to our project being hong kong, "the ultimate of ultimates" tribute to yesi has appeared. We have used two of yesi's poems for the main thematic video. what you see is the hong kong in his heart. and it also expresses the attitudes and hopes of everyone involved in the being hong kong project...

achieve what is achievable.
sometimes i walk to the hillside to look at
rocks
and learn to be as hard as rocks.
life is a series of hammering.
too many barriers, too much breaking,
and i am not a very competent rock
sometimes i want to be soft
sometimes i want to fly
(at noon in quarry bay, 1974)

caught in the words of others
some words are hard to say
they want to redecorate this room
we look, we look for–
(image hong kong, 1990)

as the director of this film, i hope
that in the process of shooting, i can
carefully think about his every line
and word, and reflect on where the
hong kong that i know should go. this
is also what motivated this group of
friends, who still have hopes in this
city, to embark on the project. we have
heard about crossover, collaboration
a thousand times. perhaps, it is worth
thinking about what selfless collab-
oration really means. the hope for
my city is not in me alone. the key is

in you and me. in the past 6 months,
from conceptualising to actualising to
publishing, i am very grateful and glad
that all our supporting groups whole-
heartedly worked with us. lolo (lowell
lo kwun-ting) and susan tang's music
was another good start.

yesi, my dear brother, our collabora-
tion is now "worlds apart". shooting
this thematic video can be considered
a transcendental collaboration. taking
your open-minded, forward-looking
attitude as the spirit for "being hong
kong", let's stride forward with each
other's support.

bluewhitered, bluewhitered,
white is so gentle,
blue is so rustic,
red is so tough?
how much longer can we hold on?
how much more stress can we bear?
how much more content can we carry?
reddish red fades in the sun,
whitish white words getting less,
bluish blue ages in the dust
can we resemble red blue red blue can we
can we?
tailor made blue white blue white into
new clothes?

speak speak white red white red as new
language?
(redwhiteblue poem, 2003)

when i read the redwhiteblue poem
again, these few lines deserve more
savouring. what does survival, liv-
ing and life of the hong kong people
mean? what is "revisit, rethink and
recreate"? i hope being hong kong can
bring some thoughts and inspiration.
when, why, what do you and i have to
do together?

BEING
HK

就係 香港

紙本 | 文本 | 人本

000 2018 女 試刊特別號 定價 HK$100

REvisit REthink REcreate// 大會堂
REdiscover// 美好就在身邊 / 林超英 / 再見吾藻 / 又一山人
REdefine// 李嘉誠時代 / 蔡東豪
REfresh// 午間輕小說 / 陳慧 Print Matters // 書店風景 Mosses
REspect// 人間國寶白雪仙 / 劉培基
REvive// 粵菜，還是香港最好 /
大師姐 / 葉一南 / 伍柏基 / 徐滘業 / 姚敏
REedit// 生命地圖．電影地圖 / 趙良駿 REfraction// 盛夏 2018 REprint// 曾杜財
REsonance// 盛夏日之夢 // 盧冠廷 / 唐書琛
REference// 安尚秀 //REread// 也斯

別冊 《與也斯重遊》/ 李家昇
別冊 《Create Recreate / Side A Side B》

ISIT

RESERVOIR AND DAM AT TYTAN.

VIEW OF THE CONDUIT-ROAD FROM THE MAN-OF-WAR

THE WATER SUPPLY OF HO

賈樟柯

MYHK

編按：坐在九龍半島酒店的大堂，賈樟柯和我們分享他挑選中最得引的音像時，思牌言談也段有離開過九龍半島漁夫村，穩住七十座內地球旗的「香港煙權」，有家有無敷改來進旅行和公將的記憶，更有著較不語的懸像和省郜，開中穿揉來扣，是前金粉張擺李纓洋，還有吳宇森杜湛筆……

快樂

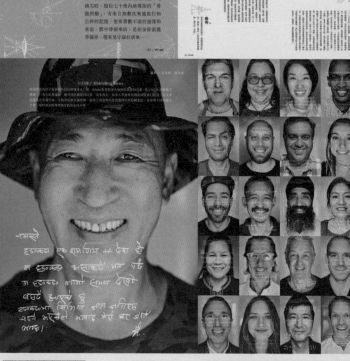

RECREATE

笑中有淚．淚中帶笑
波叔演活了香港人

白雪仙
粵劇藝術的「人間國寶」

REspect

RETHINK

Mike Chu 啟示錄
一起廣告的日子

RE

A TIME TO HEAL
A WALK TO THE RESERVOIRS

REdiscover

藝術讓我成為更好的自

ART IS WELL BEING

REsilience

Mindmapping
過去．現在．未來

BEING HK

就係香港 一

人本｜文本｜紙本

在今生像河與海

隨書附送 //
香港古地圖行山方巾
少數族裔生活地圖

001 / 2018 冬 / 定價 / HK$100
BeingHongKong

BEING HK

香港

紙本 | 文本 | 人本

REvisit **RE**think **RE**create // 洛戶 香港

FACES // 印度 / 巴基斯坦 / 尼泊爾 / 泰國 / 菲律賓 / 日本 / 韓國 / 美國 /
俄羅斯 / 荷蘭 / 美國 / 土耳其 / 墨西哥 / 南非 / 秘魯 / 越南 / 法國 /

三色咖啡南亞人 / 點滴的新馬及印尼華僑 /
岑建勳 // 其他音樂 / 打造香港 Band Sound

REdefine // 鄧永鏘幻象 /

REedit // 在今生像河與海 /

REdiscover // 香港山之音

REsonance // Better Days 共融之歌 /

× 菲尼斯 Chris Polanco / 尼泊爾 Sanjeev Gurung / 尼日利亞 Jesse

sw

amm

ammxsw-06

隨書附送 //
香港古地圖行山方巾
少數族裔生活地圖

001 / 2018 冬 / 定價 / HK$100
BeingHongKong

BEING
HK

就係
香港

紙本 | 文本 | 人本

REvisit **RE**think **RE**create// 落戶香港

FACES// 印度 / 巴基斯坦 / 尼泊爾 / 拉脫維亞 / 委內瑞拉 / 索馬里 / 日本 / 韓國 / 瑞典 / 德國 / 泰國 /
俄羅斯 / 荷蘭 / 美國 / 土耳其 / 意大利 / 澳洲 / 印尼 / 越南 / 法國 / 英國 / 澳洲 / 葡萄牙 / 菲律賓 /

三色咖喱南亞人 / 隱蔽的新馬及印尼華僑 / 顯而不見 猶太人 /
岑建勳// 菲律賓樂手打造香港 Band Sound

REdefine// 鄧永鏘幻象 / 陶傑

REedit// 在今生像河與海 / 卓韻芝

REdiscover// 香港山之音

REsonance// Better Days 共融之歌 / 盧冠廷

× 多明尼加 Chris Polanco / 尼泊爾 Sanjeev Gurung / 尼日利亞 Jesse Clement

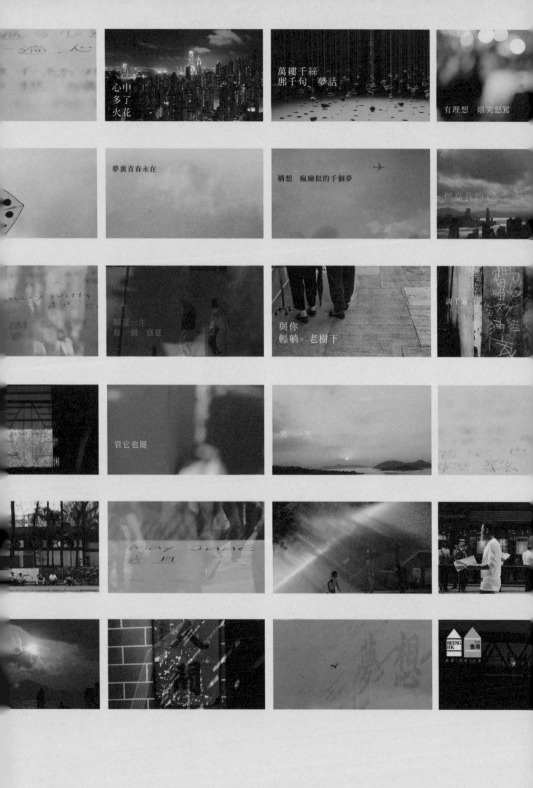

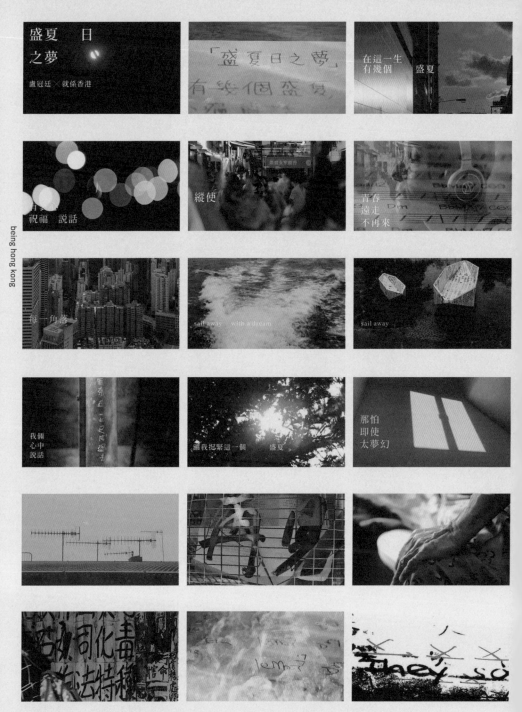

summer dream mv │ 盛夏日之夢 mv │ 2'47"
c.c. │ lowell lo [music]

在甚麼時空，為了甚麼，我和你一起做些甚麼…

跟也斯第一次的 collaboration 是 2003 年。他寫了首《紅白藍詩》，送給我的裝置《紅白藍之示範單位》並同場展出。

然後二〇〇五年，他專程來到威尼斯藝術雙年展，為我和陳育強兩人代表香港的藝術展覽開幕交流表演，在國際觀眾前，朗讀他的《香港之詩》。

恰巧，以上兩個展覽都是也斯好友馮美瑩策展和為我們穿針引線。自此我和梁兄建立了我們的君子之交。

二〇一二年，好友酒專家 paulo pong 請我設計酒瓶裝潢。想了又想，品酒當下，不是吟詩作對的最佳時刻嗎？與其看着面前怎樣時尚美麗的設計，何不「解放」出一首詩篇。杯酒當詩，人生幾何…說到詩，就想到老友也斯，一個喜歡喫、喜歡唱的詩人。約了他，解釋了兩分鐘，他就說：「就這樣，我回去找兩首與酒有關的詩給你。」之後他電郵我，落實了《試酒》和《與羽仁未央試新酒》。對着詩，一直試；做完時，也斯也完成他的人生路。我還在我的創作感言說了句：「老兄，這算是我對你的終極致意，樽裡一紅一白，樽外一黑一白。世事…何曾是絕對。與遙遠天國的你乾杯。」

在也斯的紀念回顧展《回看也斯》出現了這兩瓶酒外，也同時展出了我的《爛尾之敦煌》照片配在他的《敦煌棄宅》詩旁。

世事真的沒絕對。對他的終極致意，因今天我們的《就係香港》而出現了「再終極」。我們的主題片選了兩首也斯詩句，大家看到的是他心目中的香港，也正能表達《就係香港》全人對香港的態度和期盼，實現可以實現的…

有時我走到山邊看石
學習像石一般堅硬
生活是連綿的敲鑿
太多阻擋 太多粉碎
而我總是一塊不稱職的石
有時想軟化
有時奢想飛翔
（中午在鰂魚涌，一九七四）

雜在別人的話中
為甚麼有些話難以言說
他們打算重新佈置這房間
我們抬頭，尋找—
（形像香港，一九九〇）

作為這片的導演，能在我拍攝的過程，切切實實思考你的字裡行間，亦自我一再沉澱我心中的香港何去何從，這更加是我們一群對我城還寄予希望的友好之所以啟動《就係香港》的初衷。當然大家已聽過千萬遍甚麼 crossover、col-laboration，或者，值得我們思考和珍惜，甚麼是無私的協作。我城的唯一希望，不在於我，關鍵是你跟我。在這大半年從概念到落實並出版試刊的過程，感恩和安慰，不少支持並出版試刊的單位都是跟我們「從心出發」，lolo（盧冠廷）及唐書琛以歌會友，便是另一個好的開始。

也斯老兄，我們的合作路途也算得上「天一半，地一半」。拍攝這主題片，也算是我們一次神交吧。就借你豁達往前的態度，作為《就係香港》的精神，跟今天香港大家互相推動並前行。

藍白藍白藍白紅
白得紅白紅
藍得這麼柔
藍得這麼土
又紅得這麼靭
可以撐得住多一刻？
可以抵得住多一分壓力？
可以承載多一點內容？

白白白話愈來愈少
藍藍藍藍老在灰燼裡
可否重組紅藍紅藍可否？
裁剪紅藍白成為新的衣裝？
說出說出白白紅白紅新的語言？
（紅白藍詩，二〇〇三）

再回看《紅白藍詩》，這幾句也值得我細嚼，何謂香港人的生存、生活、生命：甚麼是 revisit、rethink 和 recre-ate。希望《就係香港》能為大家帶來一點思考與靈感…在甚麼時空，為了甚麼，我和你一起要做些甚麼的事情。

紅紅紅烈日下褪色

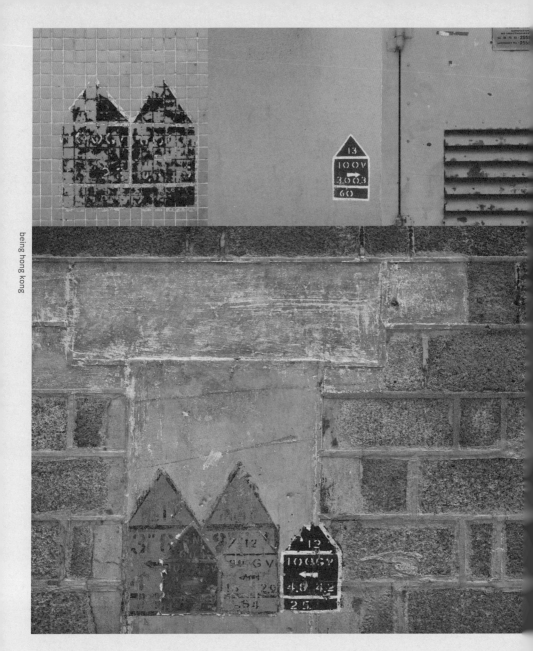

amm × sw–07

archive no.

painting by god \ jing yat | 神畫 \ 正 |

● installation \ photography \ corporate promotional film [creation \ direction \ production] ● 2008 [installation] \ 2012 [short film] \ 2017 [photography]

▲ film

aw. | 2011 hkda global design awards biennial \ photography \ bronze 2012 hk 4a's creative awards \ tv \ silver · film direction \ gold · editing \ silver · cinematography \ silver

cl. | sun life financial
c.c. | cheung siu-hong [art direction] \ kwan pun-leung [cinematography] \ chung [music] \ nathan sham [editing] \ 84000 communications ltc.
a.c. | kymechow communications limited

seeing light, i believe in divinity.
seeing land, i believe in time; the past, the present, and the future.
seeing the wind rise, i believe in breathing and life.

seeing happiness, anger, sadness and gladness,
i believe in the communication of the soul.
believing that life is beautiful, i see the light ahead.

i see, therefore i believe.
i believe, and so i see.

看見光，相信有神。
看見大地，相信時間；昨天今天明天。
看見風動，相信呼吸和生命。
看見哀樂喜怒，相信心靈之溝通。

相信生命是美麗，
看見前面一道光。

我看見，所以我相信。
我相信，因此我看見。

painting by god
arranged by anothermountainman
date | | | time
location | °N
work exhibits on sunny day only

from my 2008 installation painting by god, my 13-minute short film, jing yat evolved. they carry the same message: embrace life, embrace nature.

jing yat, born in hong kong in the 1960s, was created based on my personal background, experiences, relationships, friends and dreams. things that have not changed in my life in the past 50 years, things that i have held firmly to…

jing yat | 正一 | 12'51"

由我二〇〇八年開始的裝置創作《神畫》，
到今天轉化為十三分鐘的短片《正一》，
信息都是同一個：
擁抱生命，擁抱大自然。

正一生於一九六〇年代的香港，
是從我自身的背景出發，
中間的生活點滴、親情友情、夢想，
都是我五十年來一直沒有改變過，
堅定的…

amm × sw−08

archive no.

life is beautiful | 生命是美麗的

● branding promotion | ● 2016

▲ tvc

cl. ifc development ltd
c.c. anothermountainman [film direction] \
eddie chung [music] \ henry chu [website design] \ touches limited [editing] \
84000 communications ltd.

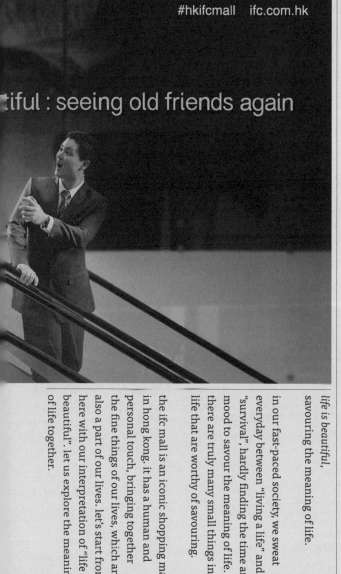

#hkifcmall　ifc.com.hk

tiful : seeing old friends again

*life is beautiful,
savouring the meaning of life.*

in our fast-paced society, we sweat everyday between "living a life" and "survival", hardly finding the time and mood to savour the meaning of life. there are truly many small things in life that are worthy of savouring.

the ifc mall is an iconic shopping mall in hong kong. it has a human and personal touch, bringing together the fine things of our lives, which are also a part of our lives. let's start from here with our interpretation of "life is beautiful". let us explore the meaning of life together.

life
is
beautif u
ifc

《生命是美麗的》細味生活的意義。

今天在步伐急速的社會中，大家每日於「生活」與「生存」之間疲於奔命，鮮有心思時間細味生活的意義，感受人生。事實上，生活當中種種的細節，都值得大家細心欣賞。

ifc 商場是本港具代表性的商場之一，具有親和力及人性化的一面，匯聚大家的生活點滴，亦是大家生活的一部分。正好以此出發，演繹「生命是美麗的」，與大眾正面探討生命。

life is a
fresh
batch of
cookies.

ifc

life is
beautiful
when dancing
to your
favourite tune.

ifc

MORE INFO

Stranger On Earth

In Theaters

life is beautiful,
like an
inspiring movie.

ifc

Likes　Rate　Comments

:NOW

life is beautiful.

COSMOPOLITAN

this
minute.
right
now.

:NOW

#hkifcmall ifc.com.hk

beautiful : more. more. more.

#hkifcmall ifc.com.hk

eautiful : homecoming

life
is
beautiful
ifc

sw

amm

amm×sw-08

beautiful : good health

beautiful : seeing old friends again

beautiful : planning a holiday

beautiful : planning a holiday

beautiful : homecoming

life
is
beautiful
ifc

life is beautiful | **1'30''**

beautiful : talking heart to hear

beautiful : like father like son

beautiful : good health

beautiful : first gift to daddy

beautiful : changing seasons

life
is
beautiful
tfc

amm × sw–09

archive no.

together & happy. 18 districts | 大家樂・十八圍

● brand positioning \ space visual design \ graphic design | ● 2017

▲ video

cl. | café de coral
c.c. | anothermountainman \ fa chan \ kwok
wai-ki \ melvin li \ leung yau-cheong
[photography] \ landini associates [space
design] \ 84000 communications ltd.

大家，樂也融融

大家樂跟香港人一起生活快將五十年，
半個世紀中⋯

大家一起拼搏，由漁港變成今天大都會。

大家守望相助，傳承「獅子山精神」。

大家共同度過，風風雨雨起起跌跌的日子。

大家。共融。

相信是今天香港人生活的重大課題。

面對眼前種種同時，

騰出心情讓大家走進大家樂內，

意識香港一家人，

大家樂也融融的昨天、今天、明天。

有大家，才有快樂。

café de coral,
a place where everyone finds joy.

for almost fifty years,
café de coral has been a part of hongkongers' life,
in this half century...

together, we have strived,
turning a fishing port into the metropolis that it is today.

together, we have supported each other, passing on the "lion rock spirit".

together, we have gone through ups and downs, good days and bad days.

together, we live in harmony.

this is an important issue for hongkongers today.

with everything that is going on before our eyes,

let us get into the mood and walk into a café de coral together,

all hongkongers being together as a family,

sharing our happy yesterday, today and tomorrow.

when there is everyone, there is happiness.

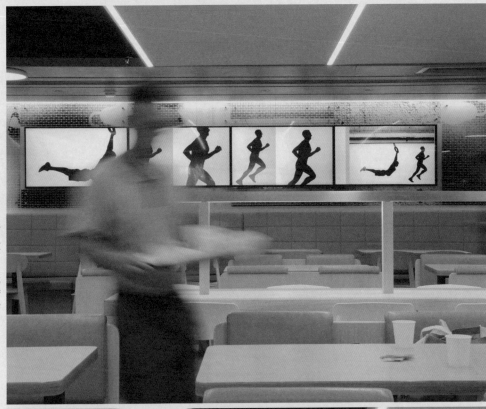

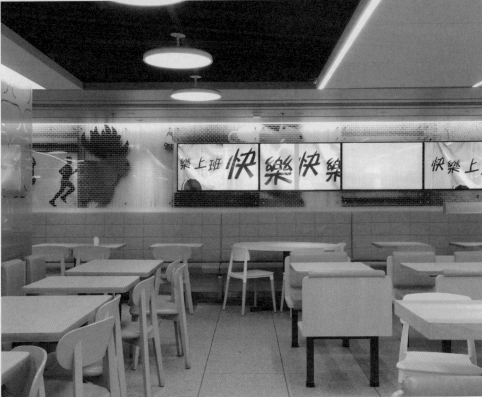

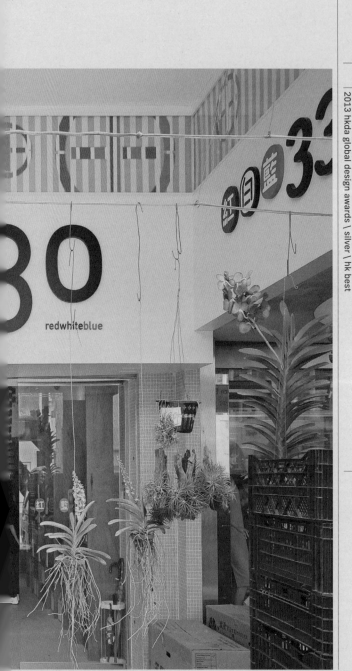

sw

amm

amm×sw – 10

redwhiteblue 330 | 紅白藍 330

● brand curation \ product design \ ● 2011

cl. | new life psychiatric rehabiliation
association

c.c. | new life marketing team \ new life
sheltered workshop students \ carmen
au ka-man \ leung mei-lin [production
supervision]

aw. | 2012 hkdc award \ branding \ bronze
2012 design for asia hkdc awards \ branding \ bronze
2013 hkda global design awards \ silver \ hk best

redwhite**blue**

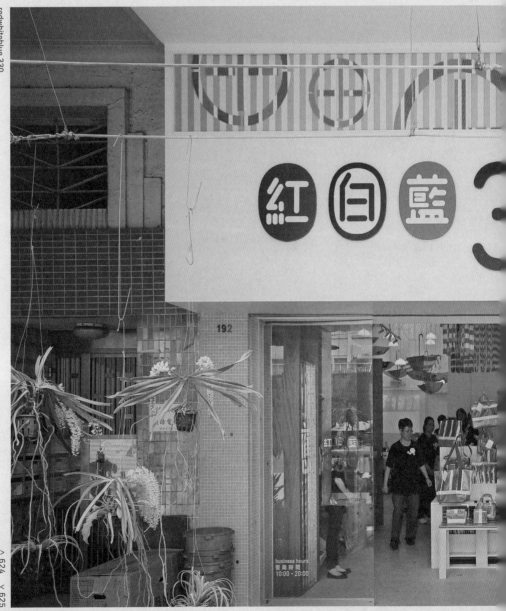

positive hongkong, redwhiteblue
redwhiteblue is existence, participation,
dedication and giving.
redwhiteblue is perseverance, diligence and endurance
redwhiteblue represents each and every hong kong people of the 1960s and
1970s
after the handover, 50 years unchanged...
positive, motivated
\ anothermountainman

rwb330
redwhiteblue body heart soul
tough and dependable, but flexible and adaptable.
the redwhiteblue series not only symbolise the perseverance,
flexibility and diligence of the hong kong people,
it also represents the hard work
that the rehabilitated patients of mental illness
gave in making these fabric products,
it is an important first step in achieving self-recovery
and rebuilding the health of the "body heart soul"
\ new life association

⊕
那
怕
再
重

紅白藍
330
×
ᄉΣIƐㅅ

正面香港 紅白藍

紅白藍是存在、參與、耕耘和付出

紅白藍是堅持、拼搏、和捱苦

紅白藍是代表我們香港六、七十年代的每一份子

這是我們香港回歸後

應一直保持五十年不變的⋯

正面積極

／又一山人

紅白藍 身心靈

堅韌可靠，卻又靈活多變的

紅白藍系列不僅象徵着香港人堅毅不屈、

靈活變通的拼搏精神，它亦代表着

精神病康復者為製作出

精心布藝產品而付出的不懈努力，

為自我復元、重建健康之「身心靈」

踏出重要的一步

／新生會

amm × sw–11

archive no.

dance goes on | 冇照跳

● film creation \ film director \ co-producer | ● 2017 | 81'

▲ trailer

aw. 2019 hong kong international documentary festival \ chinese doc competition \ features \ second runner-up

cl. city contemporary dance company [co-producer]

c.c. mui cheuk-yin \ yuri ng \ xing liang [main cast] \ anothermountainman \ leung yau-cheong [cinematography] \ kung chi-shing [composer] \ nathan sham [editor]

dance goes on is my first full length movie. it is a documentary, but i think it is more than a documentary. ccdc originally invited me to make a short dance film, and i said a short film is too brief to contain much. when i watched pina directed by wim wenders, i felt the length of a feature film allows room for the power of the narrative to expand (sure i were not dare and meant to compare with wim wenders, the master) and the attractions and inspirations that came from the city in that film. so, we started this three-year project.

my story is about three artistic friends of mine – mui cheuk-yin, yuri ng and xing liang. i did have a script in my heart. it was the words "dance goes on" and the attitude, perseverance and value of the three artists.

the opening sequence, shot in 2016, i brought up the phrase "dance goes on" on the first day and told them this is the film title. i asked them to think on these words and assigned an aspect of "people, objects and space" for them to make preparation. a month or two later, we met again to talk about "dance goes on", and discussed how their thoughts on "people, objects and space". mui selected a chair, a paper fan and aluminum foil... and mentioned the word "subversion". i suggested to film in an urban area, she asked me to decide the location and give her the address one day before shooting and she would improvise with that place. yuri wanted to dance with his mother as a way to communicate – he told me about it when we worked together four or five years ago. i brought this idea up again and asked him to considerate it. in the end, he decided to work with his brother, to teach him how to dance. he also asked his students and young choreographers to interact with him – an aging dancer, an aging body. when i met with xing, he gave me a big surprise. he wasn't interested in thinking about the three dimensional world, he wanted to talk about "thinking space" and shared two ideas. first, let the cinematographer move, we shall shoot his movement too. second, cinematographer usually controls the camera's movement, why don't we blindfold movement, why don't we blindfold him and i as the dancer lead the camera's movement. my immediate response was, "totally out of the box, seeing things in reverse". he didn't dance within the usual rules, and he named his requests clearly, asked for my thoughts and responded to them.

in april 2017, we began the second stage of filming. no rehearsal. no second takes. i had been communicating closely with my co-cinematographer and crew on camera positions, angles and how to frame the shots, assigning each carefully. we filmed with three to five cameras simultaneously.

yuri's section was a complete unknown. i don't know with yuri, three choreographers and dancers, and me,

where we would end up going, in the end. i got the word "reconnect" – i greatly appreciate it, and it tells what i concern – the things among people nowadays.

the location i chose for mui is very special for me, amidst the changes in hong kong, perhaps it was fate, i didn't know mui lived on johnston road when she was a child, or she has lived near the graham street wet market in central. the hong kong city hall means a lot to her too, so she responded to my questions after dancing with her personal experience and feelings.

on the first day of shooting with xing, we realized the two ideas he raised at our last meeting. he truly lives in the moment. on the second day, after he arrived at the studio and warmed up. he didn't ask about the filming plan, he simply waited patiently and silently for the crew to set up lights and cameras. i told him: i've prepared some sound and video clips, when the audio and projection begins, you can start. i chose my footage of "form/emptiness" and buddhist chants by thich nhat hanh plum village monastics as a mean to conduct our heart-to-heart dialog through our shared religious belief. i care about hong kong, so i also selected some audio clips from the news in the umbrella movement two years ago, because i wanted to see how my fellow buddhist artist would respond. we watched him struck the stone wall, threw his body against the stairs, we were all incredibly moved... he said afterwards, "to see the world from another's perspective" – this is also one of the most memorable lines in the film to audiences.

this film shows the five of us (including composer kung chi-shing), how we see our everyday lives, our city and life. it is a sincere journey between five friends – inspire and be inspired. this production comes from mutual trust, inclusion and respect, and these are the values hongkongers need.

hong kong hasn't followed the former leader of china, deng xiaoping's expectation to dance as usual. however, we can always dance in our own way. a message for fellow hongkongers – life goes on...

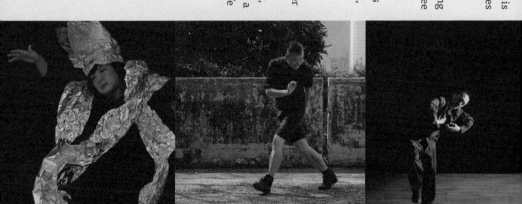

《冇照跳》是我的第一部長篇電影。它是一齣紀錄片，但在我心中又不盡是純紀錄。當初城市當代舞蹈團邀請我拍一段舞蹈錄影短片，我說篇幅太短不能說到甚麼，看 wim wenders 的《pina》長篇電影可讓深度闊度的敘事發揮（當然我不夠膽將自己跟 wim wenders 相提並論），只是看到長篇電影的力量和他的電影中城市參與的感染力和靈感。之後，就在三年前開始了這個計劃。

我的故事當然是他們三位藝術家老朋友—梅卓燕（小梅）、伍宇烈（yuri）及邢亮。但我心裡是有劇本的，是「冇照跳」三個字和我認識他們三個人的做人態度、堅持和價值觀念。

開頭序幕 sequence 是二〇一六年兩次在攝錄機前面談。第一天，我帶了「冇照跳」三個字對他們說：這是電影的名字，請他們參一參中間可有所領會，並分派了人、物和空間範圍給他們各自準備。一兩個月後，各自歸來回應他們對「冇照跳」的感受，並大家商量怎樣演繹他們各自的人、物和空間。

小梅一如過往，選了樽、扇、錫紙……說了「顛覆」兩字。我提出在城市中拍攝，她請我選址，她不過問，然後拍攝前一天晚上給她地址，來到現場就即興開拍。yuri 想跟母親跳舞作為溝通方法，是我跟他四、五年前一起工作時知悉的。當我回到這個點子時，他就再三考慮，選了自己的弟弟，教他跳舞。另外選了徒弟及年青編舞者，為年長及老化的他去編舞互動。這會面環節邢亮給我最大的震撼，因為他沒有從長闊高空間出發，他只想跟我溝通「思考空間」，並拋出了兩個點子：拍攝時攝影師身體也在動，來拍攝影師舞動吧。另外攝影師主導鏡頭是正常的，可不可以讓他蒙上雙眼，我作為舞者，主導鏡頭內外的發生。我即時反應是 totally out of the box, seeing things in reverse。沒有跟常規地跳。邢亮並清楚說出要求，要我給他我的看法，由他來回應。

第二階段在二〇一七年四月正式開拍。邢亮那段的第一天拍攝，就真的實現他在對上一次談話中拋出的那兩個想法。他真的很活在當下，第二天去到 studio，做好熱身，一句不說不問今天會拍甚麼，沉靜地等團隊整理燈光和攝影機。然後我跟他說：今天我準備了一些聲音和一個錄影片段，它們開始，你便開始吧。

個是 tight，分配得很仔細清楚。每次選自己《色／空》的錄影和一行禪師梅村僧團唱頌，是想跟我們共同的宗教信仰來一次「神交」。我關心社會，也選用三到五部機器同時拍攝。

yuri 的部份一直都是未知之數，不知道他要往哪走。我加他加三個編舞及舞者，會走到哪一個方向。但最後得到 reconnect 這個字，我十分安慰，此段亦能代表我自己所認同的，今天人與人之間的種種。

了兩年前街頭運動的新聞錄音，看另一個佛教徒對藝術家回應。現場大家看着他猛力手打石牆，身體撞擊樓梯，無不心酸動容…之後他說的從「別人視窗」觀看世界，也是很多觀眾能記着想着的一句話。

我選給小梅的地方都是我深有感受的，在變遷中的香港。也許是天意：我不知小梅年幼時住在莊士頓道，也在中環嘉咸街街市附近住過。香港大會堂對她意義同樣之大，所以跳舞後回應我的問題時都能給我第一身的感受。

這是我們五人（包括音樂創作的龔志成）對生活、對我城，以至對生命的心聲和看法，是五個朋友一次真摯的旅程，inspire and be inspired。製作背後是彼此的信任、包容和尊重。這也正是今天香港人最需要擁有的。

跟我聯合合作的攝影師及團隊事前考察因為沒有綵排，沒有 take two，一直都清楚，鏡頭在哪裡，哪個是 wide，哪

我城沒有跟中國前領導人鄧小平先生期許的不變，舞照跳。然而，也可以用自己的方式、方向跳下去吧。寄語香港，life goes on…

2 men show \ stanley wong × anothermountainman

雙人展 \ 黃炳培 × 又｜山人

● exhibition curation \ graphic design | ● 2015

aw. | 2015 design for asia hkdc award \ poster \ bronze
| 2016 hkda global design awards \ poster \ bronze

▲ video

DESIGNED BY STANLEY WONG × ANOTHERMOUNTAINMAN PRINTED IN JAPAN BY DAI NIPPON PRINTING CO., LTD.

2 MEN SHO

stanley wong × anothe

GINZA GRAPHIC GALLERY 345TH EXHIBITION
MAY 9 SAT **- MAY 30** SAT **/ 2015**

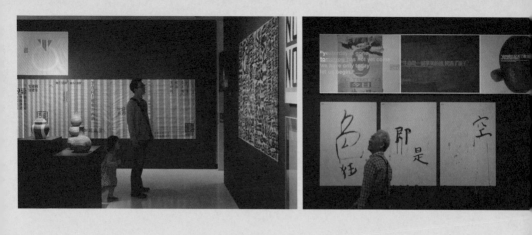

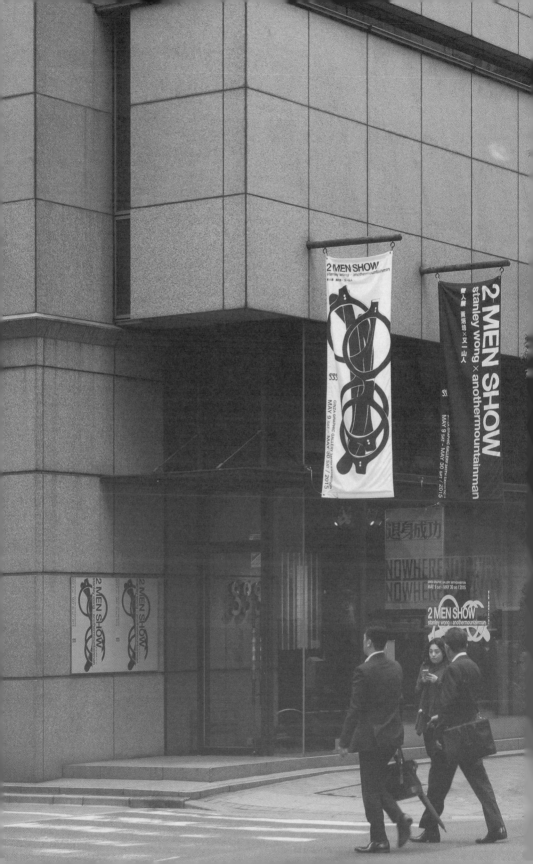

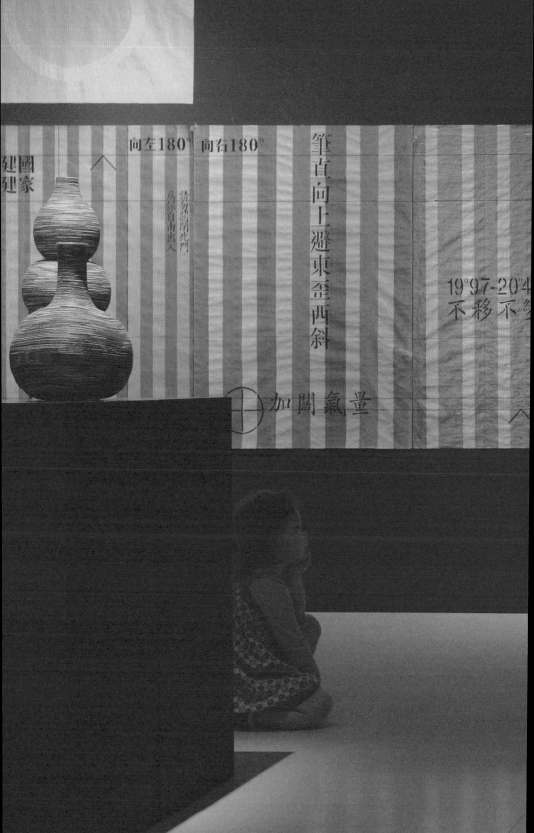

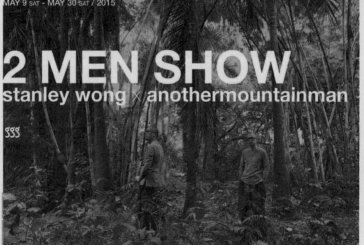

amm × sw−13

archive no.

sw

amm

amm×sw−13

TIME WILL TELL: anothermountainman × stanley wong

\ 40 years of work

時間的見證：又一山人 × 黃炳培　四十年創意展

● exhibition curation \ graphic design \ co-space design | ● 2019

c.c. | michael leung [co-space design] \
kung chi-shing [soundscape] \
hk heritage museum design team

ex. | hk heritage museum

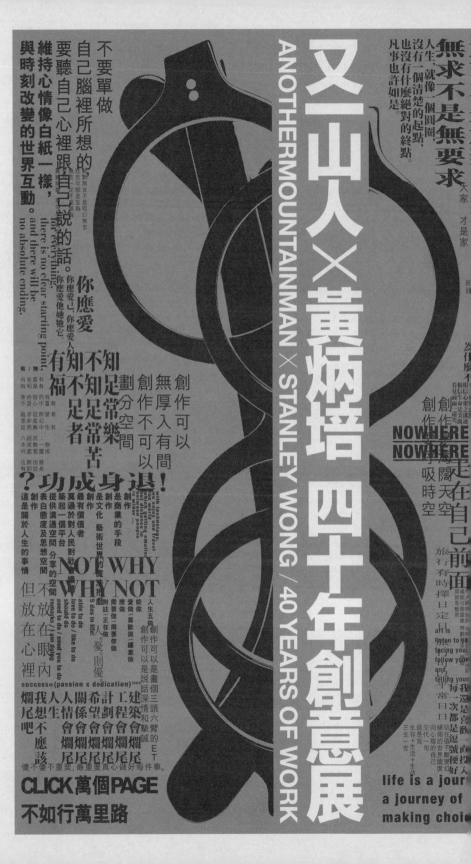

acknowledgement

Thank you all the mentors and teachers who have supported me throughout my forty years of creative career; the curators, museums, galleries, my former bosses and seniors who have given me the chance and their trust; the film directors, photographers and illustrators, editing and production teams who helped me on my earlier projects; the partners and colleagues whom I have worked with at different stages, and everyone whom I have worked with.

Finally, I am grateful for the forty years of support, encouragement and advice from my wife (anothermountainlady). Her tireless assistance is what made this exhibition and publication possible. Without you, there would not be these forty years of excercises and works. My heartfelt gratitude.

anothermountainman × Stanley Wong Palms together

感謝

感謝過去四十年創意生涯中,給我扶持的啟蒙者和老師們,給我機會和信任的策展人、藝術館、畫廊、前老闆、上司;實現我早期創作的廣告導演、攝影師及插圖師、剪接和製作團隊,不同階段合作的夥伴和同事各人,以及所有跟我合作的朋友大家。

最後,感恩太太(又一夫人)四十年來的支持、鼓勵和提點;以及她不眠不休的協助,令是次展覽和出版順利誕生。沒有你在旁,這四十年的習作和功課是不能出現的。無言感激。

又一山人 × 黃炳培 合十

father passed away last year.

in chinese tradition, the funeral of a 92-year-old is considered a blessed event. the ceremony was peaceful and calm. his funeral portrait stood in the centre of the funeral hall. it was a passport photo from some years ago. he had a peaceful smile, just like his name, "wong cheung (cheung=祥, meaning peace)". peacefully, he came. peacefully, he left.

at mother's funeral, we had a hard time looking for the right portrait. it was over twenty years ago. a kidney disease took her life. in her final years, her health was very unstable. i did not have the courage (or find an excuse) to take a portrait of her for 'future' use. although we all knew it would happen, we, her children, were afraid to bring up this need. eventually, we found a photo that she took on a certain occasion. we enlarged it again and again, and then cropped it out from the background and touched up the lighting in order to get a decent funeral portrait for her.

the end of a life, to us (chinese, orientals, maybe the world), is a node in the heart, be it due to fear, shock or not wanting to let go…

having lived half a century, i started to ponder… someday, i will leave, just like father and mother did, just like the clear sky after the rain, the blooming and withering of flowers. life is ever changing. it is the fact, the reality. other than not being able to take care of my other half, anothermountainlady or not being able to interact with young people, not being able to pursue our dreams together, and make our global village a better place, i see the end as only a suspension or vacation in our duties and responsibilities.

after much thought, i have decided that on my every birthday, i will take a good look at myself. have i lived my life to the best that i can? have i been good to myself? have i lived according to my principles and values? each year i will take a self-portrait. who knows which one would be the final one…

i decided to name this collection the "final project". it will be released in my funeral and they will be my funeral portraits. come, feel my idea of living, experience the free-spirit of my life.

thankfully, i will still live each day and year fully and well.

anothermountainman palms together 2012

爸去年走了。

九十有二的笑喪，後事在平靜的空氣中度過。靈堂上放着的遺照，是他某年的證件相片，笑容和祥；正如他的名字：黃祥。來是祥，走也是祥…

回想媽走的時候，遺照這環節就沒這麼順利。那是二十多年前的事。她給腎病拖着走了最後幾年。時好時壞的日子，我沒有勇氣為她（或找個藉口）拍一張「將來」要用的近身照。姊弟間也不敢提出這急切性的項目；縱然家人都知這是遲早的事情。最後要從生活照放大再放大，再去背景，再調光度才辦妥。

生命之終結，始終是我們（中國人、東方人，可能全世界人類）心中的結。不管是因為恐懼，不預知，還是不想失去…

半百的我坐着想着…有一天我都會像媽、爸離開。雨過天青，花開花落…無常世間是事實，是現實。除了不能繼續照顧身跟又一夫人，不能繼續跟年輕人互動，不能和大家共同追尋、參與啟動「好一點」的地球村；完結，只是被安排的工作暫時停工或休假吧。

想了又想，然後決定每年生日，坐下來，好好面對自己，想想我真的有好好活着？為自己活着？為我認知的身跟活着？拍張自拍照，不會知哪一次是最後一次…

決定叫這組照片《最後習作》，在我喪禮發表，當然它（們）也將會是我的遺照。來，感受一下我活着的概念，活着的自在。

感恩。我仍好好過着每一年、每一天…

又一山人　合十 二〇一二

黃炳培，又名又一山人，一九六〇年於香港出生，在港接受教育及專業訓練，是土生土長的藝術家及設計師。

一九八〇年畢業於香港工商師範學院。從事平面設計工作五年後，投身廣告創作行列，往後十年曾擔任多間國際知名廣告公司的創作總監，包括精英（香港）、智威湯遜（香港）等。

一九九六年移居新加坡，加入英國 bartle bogle hegarty（亞太區）廣告公司為亞太區創作總監，為歷來首位華人受聘此海外職位。至一九九八年回港，出任 tbwa（香港）廣告公司之行政總裁及行政創作總監。

二〇〇〇年，黃氏加入先濤數碼出任創作總監及導演，初嚐執導的喜悅。兩年後，成立三二一聲畫製作有限公司，專門製作廣告片，

多年來製作超過二百個電視廣告。

二〇〇四年，獲邀加入集合全球最優秀平面設計師的殿堂級組織，成為國際平面設計聯盟 agi 會員，並自二〇〇七年起，連續四年擔任 agi 國際執行委員會成員。

二〇〇七年，成立八萬四千溝通事務所，從事各方面設計工作。歷年來，黃氏的平面設計、廣告及藝術創作在本地及國際間屢獲殊榮，獲頒超過六百個獎項，包括 d&ad 黃鉛筆獎、東京 tdc 獎、兩項 one show 金獎等。

除設計及廣告創作外，黃氏同樣熱衷於藝術創作及攝影，尤其專注以社會狀況為題材，作品充分反映他對出生地的感情。

過去近二十年間，以「紅白藍」系列作品推廣正面香港精神，在本港及國際社會備受讚譽，更於二〇〇五年代表香港參展第五十一屆威尼斯雙年展。

其作品多次在香港及海外展出，參與過逾一百五十場展覽，包括二〇一五年在東京 ginza graphic gallery（ggg）舉行個展。部分作品獲香港外地博物館永久收藏，包括英國 victoria & albert museum，及德國、荷蘭、新加坡和內地等多間美術館。

二〇一二年五月，獲頒授香港藝術發展獎之二〇一一年度最佳藝術家獎（視覺藝術），以及香港藝術館頒發的香港當代藝術獎二〇一二。

由二〇〇〇年起，黃氏穿梭各大本地及海外院校，舉行講座和工作坊，將為設計教育作出貢獻視為其下半生重要的工作一環。

born in 1960, stanley wong ping pui, better known as anothermountainman on the art scene, is a homegrown artist who received his education and professional training in hong kong.

following his graduation from the hong kong technical teachers' college [design & technology] in 1980, stanley worked as a graphic designer for 5 years before embarking on what was to become a productive and rewarding career in advertising.

over the next 10 years, he was on the creative teams of some of the most distinguished advertising agencies in town, including grey (hk) advertising, j. walter thompson (hk) advertising limited.

in 1996, stanley was the first chinese to undertake an overseas position in the asian advertising industry when he became the regional creative director of bartle bogle hegarty (asia pacific) in singapore. he returned to hong kong in 1998 as chief executive officer and executive creative director at tbwa (hk) advertising.

in 2000, stanley joined centro digital as chief creative officer / film director. there, he experienced for the first time the joy of directing, two years later, stanley set up threetwoone film production limited, specializing in advertising film production. since then, stanley has produced over 200 tv commercials.

in 2004, stanley was inducted into alliance graphique international (agi), a prestigious institution whose membership comprises the most elite graphic designers from around the world. also, he was honoured to be agi international executive committee (iec) for 4 years since 2007.

in 2007, he established 84000 communications. throughout his career, he has won more than 600 awards in graphic design, advertising and fine art at home and abroad, including d&ad yellow pencil, tokyo tdc award, and 2 one show gold awards.

apart from his commitment to advertising, stanley has a passion for fine arts and photography, often focusing on social issues. his affection for his birthplace is strongly reflected in his design and art creation.

over nearly two decades, his 'redwhiteblue' series, depicting the positive spirit of hong kong using the ubiquitous tri-colour canvas, has won critical acclaim both locally and internationally, and presented in the 51st venice biennale in 2005 representing hong kong.

many of his art works have been exhibited in local / overseas galleries and museums in more than 150 shows, including a solo show in tokyo ggg gallery in 2015, a selection of works are permanent collections of museums in hong kong, the victoria & albert museum in england and other museums in germany, the Netherlands, singapore and mainland china etc.

in may 2012, wong was awarded the artist of the year 2011 (visual arts) from hong kong arts development awards, and the hong kong contemporary art awards 2012 from hong kong museum of art.

since 2000, stanley presents talks and workshops through numerous colleges and universities in local and overseas, continuous contribution to creative education will be a major segment in the rest of his life.

solo exhibitions

2019 \ 11	time will tell: anothermountainman × stanley wong \ 40 years of work	art \ design	hong kong \ hong kong heritage museum
2017 \ 03	one day shoot, one day show.	photography	hong kong \ fringe club
2015 \ 09	redwhiteblue	art \ design	guangzhou, chengdu \ fang suo
2015 \ 05	2 men show: stanley wong × anothermountainman	art \ design	tokyo \ ginza graphic gallery (ggg)
2014 \ 01	perceive emptiness	art	singapore \ nanyang academy of fine arts
2013 \ 10	show flat 04	installation	singapore \ hermès gallery
2013 \ 05	from su shi to bada shanren – the portrayal of illusion	photography	hong kong \ art basel \ blindspot gallery
2012 \ 10	lanwei	photography	hong kong \ blindspot gallery
2012 \ 05	building hong kong redwhiteblue 26 \ show flat	art installation	hong kong \ art basel \ absolute
2011 \ 11	traces: on the road again	photography	hong kong \ future industries
2010 \ 08	to begin with, there's no matter.	photography	hong kong \ goethe–institut
2010 \ 04	lanwei \ decaying end	photography	manchester \ chinese arts centre
2009 \ 09	lanwei	photography	toronto \ lee ka-sing gallery
2007 \ 09	of things present	photography	s ngapore \ nanyang academy of fine arts
2007 \ 08	lanwei \ abortive buildings	photography	hong kong \ goethe–institut
2006 \ 09	future tense: redwhiteblue	photography	toronto \ lee ka-sing gallery
2006 \ 02	building hong kong 16 \ rebwhiteblue \ faith\ hope\ love	installation	hong kong \ mtr arttube central station
2005 \ 11	from london to hong kong to london	installation	london \ edit gallery
2005 \ 07	building hong kong 13 \ what is the next stop?	installation	hong kong \ lane crawford central
2004 \ 11	redwhiteblue	installation	hong kong \ bodw \ detour \ idn
2004 \ 09	here there everywhere: redwhiteblue	photography	toronto \ lee photography gallery
2004 \ 03	here there everywhere: redwhiteblue	photography	hong kong \ fringe club
2003 \ 10	building hong kong 10 \ zou ma kan hua	installation	hong kong \ fabrica features
2003 \ 03	redwhiteblue	poster	hong kong \ 115

Category	Date	Title	Medium	Venue	
major exhibition curation	2009 \ 12	bring your own biennale \ hk & sz b-city biennale of urbanism \ architecture	installation \ performance	hong kong \ west kowloon victoria harbour	
	2009 \ 02	charming experience	installation	hong kong \ hong kong museum of art	
	2008 \ 07	memoria – casting a gaze	photography	kumamoto \ kumamoto contemporary art museum	
	2008 \ 05	constant stream	photography	london \ london royal college of arts	
	2008 \ 04	go china: new world order	installation	groningen \groningen, groninger museum	
	2008 \ 01	hongkong & shenzhen bi-city biennale of urbanism	photography \ installation	hong kong \ central police station complex	
	2007 \ 02	thermocline of art. new asian waves	photography \ installation	karlsruhe \ zkm, center for art and media	
	2007 \ 02	victoria prison art museum group installation art exhibition	installation	hong kong \ victoria prison	
	2006 \ 12	contemporary ink biennale	art	shenzhen \ guan shanyue art museum	
	2005 \ 12	1st shenzhen biennale of urbanism	installation	shenzhen \ oct contemporary art terminal	
	2005 \ 12	dada \ force of hangul	art	seoul \ the loop alternative	
	2005 \ 06	investigation of a journey to the west by micro+polo: redwhiteblue \ tea and chat group	installation	venice \ art biennale	
	2004 \ 11	building hong kong redwhiteblue	art \ design	hong kong \ hong kong heritage museum	
	2003 \ 10	2 or 3 things about hong kong	art	hong kong \ city university of hong kong	
	2002 \ 12	episode 2: superwoman \ hong kong poster league poster group exhibition	design	hong kong \ hong kong heritage museum	
	2000 \ 12	design impact \ contemporary hong kong art	art	hong kong \ hong kong museum of art	
	2000 \ 07	festival of vision: cities discoveries	art	hong kong \ times square \\ berlin \ house of world culture	
	2000 \ 01	episode 1: people	design	hong kong \ hong kong university gallery	
major exhibition curation	2017 \ 06	very hong kong very hong kong [hong kong creative group show] co-curated by alan chan & stanley wong		hong kong \ city hall	comix homebase
	2017 \ 06	bring me home - the story of hong kong culture, art & design [art & design group exhibition]		hong kong \ hong kong heritage museum	
	2012 \ 10	from queens road to daido \ moriyama response exhibition [photography group show]		hong kong \ hong kong artistree \ hong kong international photo festival	
	2012 \ 05	to see : to be seen [photography group exhibition]		hong kong \ hong kong art center \ fujifilm	
	2011 \ 04	what's next 30 × 30 [art & design group exhibition]		shenzhen \ oct gallery \\ hong kong \ artistree	
	2004 \ 11	building hong kong redwhiteblue [art & design group exhibition]		hong kong \ hong kong heritage museum	
major auctions	2005 \ 2007 \ 2010 \ 2012 \ 2017	asia art archive annual fundraiser auction			
	2015	hong kong cancer fund charity auction			
	2007 \ 2008	para\site art space annual fundraiser auction			
	2008 \ 2012 \ 2016 \ 2017	the design trust ambassador's ball benefit auction			

major creative awards			
	london	d&ad awards	yellow pencil
	new york	one show	2 gold pencil
	tokyo	tdc design international awards	tdc award \ 4 nomination award
	shenzhen	graphics design in china	4 gold \ 2 silver \ 1 bronze
	hong kong	hong kong global design awards	8 judges awards \ 11 gold \ 11 hong kong best
	hong kong	design for asia awards	2 gold \ 4 silver \ 4 bronze
	hong kong	hong kong 4a advertising creative awards	best single tv of the year \|\| best chinese tv of the year \|\| best film direction \ gold
	hong kong	media asian advertising awards	4 spikes
	hong kong	hong kong poster triennial	2 gold \ 1 judges award
	hong kong	hkipp photography awards	2 gold
	hong kong	hong kong art biennial	award winner \ 3 selected
	hong kong	hong kong perspective awards	2 gold

major personal achievement awards				
	2016	culture and creative award	winner [design]	hong kong association of cultural industries
	2012	creative lifestyle award	best designer of the year	china modern media \ city magazine
	2011	hong kong arts development awards	award for best artist of the year [visual arts]	hong kong art development council
	2008	hong kong print awards	the outstanding achievements award	graphic arts association of hong kong, hong kong publishing professionals society, hong kong trade development council, hong kong leisure and cultural services department

major collections			
	2019	from su shi to bada shanren – the portrayal of illusion [photography]	by cathay pacific airways
	2016	design works [40 items]	by hong kong wkcd m+ museum
	2013	impermanent [installation \ object]	by hong kong museum of art
	2013	lanwei [photography, series of 43]	by hong kong wkcd m+ museum
	2011	redwhiteblue \ back to the future [object]	by deutsche bank collection \ hong kong
	2011	heaven on earth [photography]	by deutsche bank collection \ hong kong
	2011	impermanent [installation \ object]	by shenzhen oct art and design gallery
	2011	extra long ping pong table [object]	by shenzhen oct art and design gallery
	2011	rwb book [redwhiteblue here \ there \ everywhere]	by victoria and albert museum \ london
	2010	impermanence [installation \ object]	by beijing today museum
	2008	redwhiteblue [culture posters]	by groninger museum
	2008	lanwei [photography]	by hong kong heritage museum
	2008	redwhiteblue \ back to the future [object]	by hong kong heritage museum

2006	striking lines [ink work]	by shenzhen guanshanyue art museum
2005	redwhiteblue ∞ [culture posters]	by victoria & albert museum \ london
2004	redwhiteblue 03 [culture posters]	by hong kong museum of art
since 2003	art photographs	by hong kong heritage museum
since 1997	cultural posters	by hong kong heritage museum
	commercial posters	by hong kong heritage museum

major publications

Year	Title	Publisher	Category	ISBN
2019	luo luo suo suo	joint publishing	design	isbr-978-962-04-4493-7
2015	stanley wong × anothermountainman	ggg books	design	isbn-978-488-75-23869
2014	what's next 30 × 30 \ dialog	hong kong commercial press	design	isbn-978-962-07-5615-3
2014	what's next 30 × 30 \ co-creation	hong kong commercial press	design	isbn-978-962-07-5616-0
2008	hong kong \ china photographers \ two	asia one	design	isbn-978-988-17041-8-4
2005	redwhiteblue here\there\everywhere	mccm creations	art \ photography	isb1-988-97610-6-8
2001	before and after. 522 days of oil street	anothermountainman communications	—	—

educational lectures \ public talks
[2000 → present]

agi open \ seoul	design
ggg gallery \ tokyo	design
pati \ paju typography institute \ seoul	design
guangzhou academy of fine arts \ guangzhou	design and branding
tokyo tdc exhibition \ seoul	design
hong kong designers association exchange \ tokyo	design
icograda world design congress \ beijing	art \ design
agi congress \ hong kong	design
domaine de boisbuchet \ lessac	art \ design
agidea \ melbourne	design
agi congress \ berlin	design
hong kong design centre \ business of design week	design
ted shanghai \ shanghai	art \ design
shantou university \ shantou	art \ design
zhongshan university \ guangzhou	design
nanyang academy of fine arts \ singapore	art \ photography
the hong kong university	art \ design
chinese university \ hong kong	art \ design
the hong kong polytechnic university	design
hong kong art centre, the art school	art \ design
the hong kong institute of education	art \ design

major judging \ design & advertising

city university of hong kong	design
lingnan university \ hong kong	photography
the association of acredited advertising agents of hong kong \ hong kong	advertising creative
c01 design school \ hong kong	design
hong kong baptist university \ hong kong	advertising creative
make a difference \ hong kong	art \ design
buddhistcompassion \ hong kong	art \ buddhism
tokyo tdc design international awards	
graphic design in china	
hong kong international poster triennial	
ningbo international poster biennial	
shenzhen international design show	
hong kong design for asia awards	
hkda asian design awards	
hk4a kam fan awards	
longxi advertising creative awards	
media \ asian advertising awards	
media \ asian graphic awards	
ad fest \ advertising creative awards	
hong kong jumping frames international dance video festival	
hong kong independent short film & video awards	
clio awards \ usa	

public services

friends of dunhuang hongkong	co-founding chairman \ committee member
acad subcommittee on visual arts [sva]	member
new life rehabilitation association [rwb330]	volunteer \ creative director
zuni icosahedron	chairman \ board of director
guangtong museum of art	adviser
guangzhou academy of fine arts	external adviser
hong kong design institute	external adviser
hong kong polytechnic university	external adviser
hong kong leisure and cultural services department	museum adviser (art \ design)
hong kong art school	external adviser
ailliance graphique international [agi]	international executive committee (new member judging panel chairman)
hong kong designer association	committee member

TIME WILL TELL
anothermountainman × stanley wong
40 years of work

時間的見證
又一山人 × 黃炳培
四十年習作

author	anothermountainman (stanley wong)	作者	又一山人（黃炳培）
book design	Mak Kai-hang	書籍設計	麥綮桁
executive editor	Brenda Choi	責任編輯	蔡柷音
publisher	The Commercial Press (H.K) Ltd., 8/F, Eastern Central Plaza, 3 Yiu Hing Road, Shau Kei Wan, Hong Kong	出版	商務印書館（香港）有限公司 香港筲箕灣耀興道 3 號 東匯廣場 8 樓
distributor	The SUP Publishing Logistics (H.K.) Ltd., 3/F, C & C Building, 36 Ting Lai Road, Tai Po, New Territories, Hong Kong	發行	香港聯合書刊物流有限公司 香港新界大埔汀麗路 36 號 中華商務印刷大廈 3 字樓
printer	Elegance Printing Block A , 4th Floor, Hoi Bun Building 6 Wing Yip Street, Kwun Tung Kowloon, Hong Kong	印刷	美雅印刷製本有限公司 香港九龍觀塘 榮業街 6 號 海濱工業大廈 4 樓 A 室
isbn	ISBN-978-962-07-5845-4	國際書號	ISBN-978-962-07-5845-4
edition	First Edition, First printing, November 2019	版次	2019 年 11 月第 1 版印刷

should there be any errors or omissions in the contents and credits, please accept our apologies, and kindly contact the author (at 0002@84000.com.hk) for corrections.

書中所載資料或名單如有錯誤或遺漏，敬請見諒，不吝指正，可聯絡作者（電郵：0002@84000.com.hk），以便更正。

to

authorized signature

date